PRAISE FOR

BECOMING MODIGLIANI

"Unique and important...art lovers, history buffs, scholars, healthcare, and social sciences readers alike will find much to appreciate in this biography."

— DIANE DONOVAN, Senior editor, *Midwest Book Review*

"Does the state of health influence creation? Does it condition the evolution of a work? These are questions Henri Colt tackles with circumspection."

— ALAIN AMIEL, art critic and author of *Modigliani on the Côte d'Azur*

"What came first—a crazy drug/alcohol abusing lump or an avant-garde creative? In *Becoming Modigliani*, physician-author Henri Colt brilliantly offers a third option."

— SEPTEMBER WILLIAMS, MD-Writer

"Henri Colt's comprehensive expertise as a physician, his consummate erudition as a scholar, and his sympathetic sensitivity as an art historian and connoisseur--these skills are brought splendidly together in his insightful and engaging study of Modigliani."

— LEE SIEGEL, author of *Love in a Dead Language*

"This illuminating biography of Amedeo Modigliani, the Italian painter and sculptor who died at age 35 with a reputation as a Casanova-esque bad boy of fin-de-siècle art, urges a reconsideration of the artist's life

by emphasizing the reality of tuberculosis and what it's like to live with a deadly diagnosis and a wrenching, tell-tale cough certain to prompt one's ostracization in society."

— *BookLife Reviews* (*Publishers Weekly*)

"Colt is an engaging writer who successfully penetrates the surface of his subject's story—which, despite the author's meticulous thoroughness, remains eminently readable. The book is exhaustive, though not exhausting, and stands as a definitive work about a complicated and remarkable artist who was 'young, handsome, absurdly talented, charismatic, resilient...and troubled.'"

— *Kirkus Reviews*

"An insightful look at Modigliani's life! Dr. Henri Colt's "Becoming Modigliani" is a well-researched masterpiece. Fans of art history will enjoy having an opportunity to learn more about the life of this amazing artist, and the era in which he lived among other notable artists. I look forward to reading more from this outstanding author."

— PAIGE LOVITT, *Reader Views* (5-stars)

"In this informative biography of Modern Italian master Amedeo Modigliani, [Colt] writes with profound clarity, striking a perfect balance between scholarly depth and captivating entertainment!"

— SEPTIMIU MURGU M.D., Professor of Medicine, University of Chicago

"Of the many dozens of Modigliani biographies out there, this is the only one to provide in-depth insight into the illness that plagued him, cutting short an oeuvre that remains at the pinnacle of modernist art. Colt's experience in the medical field, his highly developed literary style, and his compelling empathy and compassion provide this text with a richly layered artistic fabric. This is a literary work of art – and thus serves as a fitting frame for "A Life" of Modigliani."

— ROBERT COUTEAU, author of the memoir *Intimate Souvenirs*

BECOMING MODIGLIANI

Henri Colt M.D.

For information regarding speaker engagements, licenses, copyright, or permissions, contact rakepress@gmail.com.

Printed in the United States of America
First Edition

Cover design by: Greg Shed
Book design by: Richa Bargotra

Library of Congress Cataloging-in-Publication Data
Colt, Henri 1956-
Becoming Modigliani

Names: Colt, Henri, author
Title: Becoming Modigliani / Henri Colt M.D.
Description: First edition. | [2024] |
 Includes bibliographical references and index
Identifiers: ISBN 978-1-959185-01-7 (hardcover) | ISBN 978-1-959185-00-0 (paperback) |
 ISBN 978-1-959185-02-4 (epub) / ISBN 978-1-959185-03-1 (Kindle)
Library of Congress Control Number 2024903419
Subjects: LCHS: Modigliani, Amedeo, 1884-1920. | Artists, French—20th century—
 Biography. | Medicine and Art history—France. | Tuberculosis—Social history |
 French painting and sculpture—Jewish artists.

The publisher has tried to ensure that the URLS for external websites referred to in this book are correct and active at time of going to press, but has no responsibility for such websites and cannot guarantee sites remain live or content is or remains appropriate.

Every effort was made to identify and trace all copyright holders, and to secure permission and copyright release, where applicable If any have been overlooked, this is unintentional and the publisher is pleased to include any necessary credits in subsequent reprints or editions.

Publisher: Rake press, Laguna Beach, USA
www.rakepress.com

CONTENTS

PREFACE

Does the world need yet another book about Modigliani? The answer is yes.

This tuberculosis-plagued, alcohol-abusing painter, sculptor, and philandering bad boy's life has been examined from many angles, but a critical view of the interplay between his illnesses, his environment, and the social fabric of early twentieth-century Paris is lacking.

Assertions have been made so repeatedly by Modi's biographers accentuating the salacious aspects of his existence, his flaws, womanizing, and addictions, that those very assertions became a myth. Unfortunately, too frequently, myths repeated - and unquestioned - eventually become the truth. In *Becoming Modigliani*, my objective is to examine some of these assertions and question the romanticized Modigliani myth-making machine.

Art sells. But art with a story attached to its maker, the life of an artist involved in sex, alcohol, and drugs who succumbed to an early death – sells even better. Trumped-up reputation-making stories by those who could benefit from Modi's work, and others, are not unusual, as evidenced by the blood-in-water churning excitement at auction houses where Modi's paintings garner tens of millions of dollars.

By no means am I lessening the importance of many informative and well-written histories of this complicated, tortured, and highly gifted young man. Nor do I dispute his perceived life of recklessness. I wish only to bring a new light on the emotional, psychological,

physical, and physiological burdens Amedeo Modigliani bore during his life.*

This book takes readers on a journey through Modigliani's brief existence, from his illness-filled beginnings in Livorno, Italy, to his death, presumably from tuberculous meningitis, in a paupers' hospital in Paris three decades later. Looking at Modi through a different lens, a more sympathetic and science-based lens, we can see Modi not as an out-of-control artist, but as a victim and life-long prisoner of the life-threatening infectious disease of his time; mycobacterial tuberculosis.

As a lung specialist, I cared for patients suffering from terminal illnesses, advanced cancers, the debilitating effects of tuberculosis, and the almost inevitably fatal HIV/AIDS epidemic of the 1980s.

As a fellow art lover, I am well-acquainted with this artist's playgrounds, having wandered myself through Livorno, Venice, and Florence, lived in Paris and on the French Riviera, devoured writings by Lautréamont, Nietzsche and Dante, fallen in love in Montmartre and strolled through the Luxembourg Gardens reading poetry with my beloved.

As a writer, in *Becoming Modigliani*, I hope to broaden your empathic understanding of this young man.

Imagine the huge weight thrust upon a boy suffering from illness, struggling to breathe, fearing death, and equally significant, facing the shame of his times in the early 1900s – when the mere mention of a highly contagious respiratory disease such as tuberculosis, could render you homeless, jobless, and ostracized from all.

As if that were not enough, imagine him sexually active, battling drug and alcohol addiction during an epidemic of sexually transmitted illnesses (e.g., syphilis), needing to survive amid the deprivations of war, and burning to excel creatively while remaining true to his uniqueness among many rising stars in the visual arts.

Consider for a moment how haunted Modi must have been by the burden of chronic symptoms and the inescapable knowledge he was

*Pronounced a·meh·day·o mow·duh·lee·aa·nee (the g before the l is silent in Italian).

destined for an early death, what this must have done to his psychological well-being, and how influential this would have been on how he chose to live. It is easy to understand why this knowledge would also have been the catalyst for the frenzied and prolific work Modi accomplished from his arrival in Paris in 1906 to his death on January 24, 1920, at only thirty-five.

Amedeo Modigliani was young, handsome, absurdly talented, charismatic, resilient...and troubled. Some said he was "maudit," which in French means accursed and is a play on words with his name.

He was.

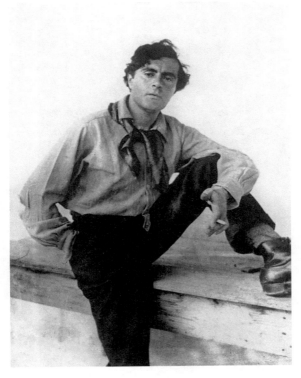

Amedeo Modigliani (1918)

§

*"We are all the product of our times —
and we all carry the burdens of our times."*

A HISTORICAL FICTION

Staggering home on a typically wet January evening in Paris, thirty-five-year-old Modigliani hardly noticed the Colarossi Art Academy where he studied more than a decade earlier. Coughing incessantly, his brain in a fog, he made his way into the building at 8 Rue de la Grande Chaumière. Modi crossed the interior courtyard and struggled up the steep winding staircase to his apartment. Waiting for him was his lover and girlfriend, the twenty-one-year-old Jeanne Hébuterne. While not legally his wife, she was the mother of his fourteen-month-old daughter, and almost nine months pregnant with their second child.

Wrapping himself in blankets to protect himself against the cold, Modi huddled with Jeanne near the coal-burning stove in the corner. In a career spanning fourteen years, artistic stagnation or lack of creativity was not Modigliani's problem, but the lingering and increasingly debilitating effects of pulmonary tuberculosis and alcoholism were. Jeanne said nothing when he took a swig from the open wine bottle on the table. Then Modi took to his bed for what would be the last time.

Did he know?

A few nights earlier, as was his custom he went out drinking with friends. Rather than linger at his usual haunts in the neighborhood, Modi trudged up the hill to Montmartre. Almost twenty years' experience had still not taught him that neither booze, drugs, nor the comfort of a woman's touch could thoroughly quench his nagging cough. His sputum had been tinged with blood for months, but now he couldn't

think straight either. Arriving at a restaurant somewhat short of breath, he loosened his scarf and removed his wide-brimmed hat before setting himself down heavily next to Maurice Utrillo's mother, the painter, Suzanne Valadon. After a while, Modigliani began to softly chant the Kaddish, commonly referred to by the Jewish people as the Mourner's Prayer. Then he leaned his head on Valadon's shoulder, and in his usually gentle, now hollow voice said to no one in particular, "I want to return to the place of my birth, to Livorno… I want to see my mother."

§

PART I

THE BEGINNING
(1884-1900)

CHAPTER 1

—◦◦◦⊰✦⊱◦◦◦—

THE TIMES

"...any man entering the arts, without other means of existence than art itself, will be forced to walk in the paths of Bohemia."

Henry Murger[1]

N othing about Eugénie Garsin suggested she would mother a child who became emblematic of the "bohemian artist" of early twentieth-century France. Born on January 18, 1855, in the raunchy but famous southern Mediterranean seaport town of Marseille, France, Eugénie was raised in a bourgeois Jewish family where she had a British preceptor and attended a fine French Catholic school, quickly becoming fluent in French, English, and Italian. She was fifteen when she met Flaminio di Emanuele Modigliani (1840-1928), who she eventually followed to Livorno, in Tuscany, where the Modiglianis had a home, and the Garsins a family business. Flaminio was born in Rome. He was thirteen years Eugénie's senior and a Jewish mining engineer who became wealthy through family ventures and base metals mining in the northern Italian regions of Sardinia and Lombardy. These business projects kept him away from Livorno for much of his life, which fostered his young wife's already independent and self-reliant nature. Their marriage in January 1872 was an arranged one. "I can honestly say that my husband did not exist for me," Eugénie wrote in a short history of her family's life.[2]

Modern Italy became a nation-state in 1861. It had only recently incorporated Rome and the Papal States into the Kingdom of Italy after France's withdrawal of troops in 1870 as a result of the Franco-Prussian war.[3] Eugénie's move to Livorno coincided with the nation's change in its capital city from Florence to Rome in 1871. Like much of Europe in the later part of the nineteenth century, the country was in flux. Despite the unification of territories under one flag, people in Italy were still divided. Large sectors of the nation's economy, especially agriculture, would soon suffer as the nation was rocked by political corruption, the rise of fascism, and the failures of military campaigns and colonialization abroad. Elsewhere, the economic transformations that accompanied and followed the industrial age led to periods of opulence, but European Imperialism was irreparably affected by the results of military conflicts and social unrest. Widespread inequities and a resurgence of antisemitism threatened much of European society's core, even as foreign colonialism was heralded by many as a major source of economic power.

The time was also one of significant changes in the arts. The nineteenth century was particularly marked by shifts from Neoclassicism, Realism, and Romanticism to Impressionism and Post-impressionist movements, stylistic genres that began in France in the 1870s and soon spread throughout Europe. Shifts in the art world signaled a revolution in how people thought about life, social inequality, and an individual's place in society. Education was increasingly democratized, and literacy rates improved. With increased urbanization and greater economic freedoms, people had more time to pursue leisurely activities and indulge in the cultivation of one's self. Market forces steadily replaced patronage to sustain writers and artists clamoring for recognition and commercial success. A yearning for diversity, personal development, and independence replaced tradition and privilege. In France especially, what would soon become known as "bohemian" represented a world of shifting cultural values on the margins, if not in direct opposition to an entrenched bourgeoisie.

The bohemian era actually began in the 1830s, helping to distinguish Paris as the new center of Western European culture and art. As

a phenomenon of social change, bohemia came on gradually, and for the most part amidst a backdrop of poverty, youth, rebellion, and marginalization, even if some bohemians were viewed as former members of a bourgeoisie, now in disguise. Of course, many artists and literary figures marked as bohemians had flirted for many years with amorality, lack of conventions, and innovative creativity in their pursuit of social, political, and artistic change. Even before becoming postcard-famous, Bohemian Paris had its heroes. One example was Charles Baudelaire (1821-1867), the formerly well-off author of *Les Fleurs du Mal* (The Flowers of Evil, 1857), whose origin was upper-middle class. Another was Paul Verlaine (1844-1896), who, despite alcoholism, poverty, and a troubled life, spearheaded a new form of poetry with its roots in Romanticism. Further shaking the tree was a penniless teenager named Arthur Rimbaud (1854-1891). He arrived in Paris in 1870 and soon struck up a relationship with Verlaine. Rimbaud wrote *Le Bateau Ivre* (The Drunken Boat, 1871) when he was only sixteen, and *Une Saison En Enfer* (A Season in Hell, 1873), his hashish and absinthe-filled autobiographical prose poem about his search for authenticity after breaking-up with Verlaine.[4] A coming-of-age bohemian *par excellence*, Rimbaud described himself as an antisocial and violent vagabond who rejected the ordinary life.[5]

> Once, if I remember well, my life was a feast
> where all hearts opened and all wines flowed.[6]

Bohemia had been initially romanticized by Henry Murger (1822-1861) in his novella, *Scenes of a Bohemian Life*.[7] Originally written for the theater in 1849, this poetic work became famous in the 1890s, accompanied by the popularity of the *La Bohème* operas of Ruggeri Leoncavallo and Giacomo Puccini. Many years later, French novelist Francis Carco (1886-1958), his real name was François Carcopino Tusoli, wrote in *The Last Bohemia: From Montmartre to the Latin Quarter* (1928), that bohemian life was "a perpetual dispersion, with artists drinking their way into oblivion or fame while producing legends of themselves."[8] Sometimes, these legends were self-created. Other times,

they were embellished by friends, writers, and entrepreneurs hoping to tweak the public's interest or garnish greater commercial success. One of the best-known examples of posthumous romanticization is that of the Jewish-Italian artist Amedeo Modigliani, whose many presumably sexual and drunken adventures while living in Montmartre were exaggerated in books such as *Artist Quarter* by Charles Douglas, or in Gustave Coquiot's *Les Peintres Maudits,* and fictionalized in the character of Modrulleau (Modigliani) on the pages of Michel-George Michel's successful 1924 roman-à-clef, *Les Montparnos.*[9, 10, 11]

Bohemia flourished in its counter-imagery rather than by pure opposition with the growing bourgeoisie of the nineteenth century, and in this sense, was very different from what is known today as Bobo, a contracture for bohemian and bourgeois to describe an educated upper middle class with one foot in the world of creativity and the other in the conventions of ambition and financial success.[12] Art historian Phillip Dennis Cate suggests that by the end of the nineteenth century, free-thinking artists and writers formed a camaraderie that defined itself as being against conventional norms.[13] Some were former members of the Left Bank literary club *Les Hydropathes* led by novelist Émile Goudeau. Now they and other "bohemians" chose to live at the northern fringe of the city. They moved to a rural village on a hill known as the Butte-Montmartre, one hundred fifty meters above Paris on the right bank of the Seine (currently in the 18th arrondissement). Since its formal establishment in 1790, this hilltop community grew from being a small wine-producing farmland to an entertainment district where alcohol could be purchased less expensively than in the city below.[14] Urban historian Nicholas Kenny writes, "Artists, writers, and musicians were attracted to the Butte because of the opportunities to exchange ideas and to develop bonds with others who shared their dissatisfaction with the hegemonic culture of the day."[15]

In the nineteenth century, the area quickly became the center of a subversive counterculture of artists, writers, and musicians who reigned within a festive environment concentrated around one of the oldest parts of the village, the celebrated Place du Tertre. With its windmills, open wastelands, and small vineyards, some of which still exist, the

entire neighborhood of Montmartre, from *Mont des Martyrs*, was, and still is, literally a small village with twisting cobblestoned streets, a few open squares, and a number of cafés and restaurants high above the bustle of downtown Paris. The land had been settled on at least since Merovingian times (476-750 CE) and was previously known as Mont de Mercure or Mont de Mars.[16] The neighborhood's name probably stemmed from stories of the martyrdom of Saint Denys (Dionysius or Saint Denis), the Catholic Bishop of Lutetia (Paris), who, along with his colleagues, Saints Rustique and Eleuthère, was tortured and decapitated there by the Romans in the middle of the third century CE.

Montmartre was a thirty-minute walk from the city below, up the steep incline of the Rue Lepic to the Place des Abbesses, and only minutes further to the Place du Tertre. The village's metal-sided shacks, rundown wooden homes, and makeshift gardens, particularly around its hilltop area called La Butte were left untouched by Baron George-Eugène von Haussmann (1809-1891), whose ambitious plans to demolish and rebuild Paris's crowded and unsafe city center changed the city's footprint forever. Hired by the French head of state, Emperor Napoleon III, Haussmann was tasked with modernizing many of the capital's overcrowded, fire-prone, and decrepit medieval-like neighborhoods. For almost twenty years between 1853 and 1870, thousands of working-class Parisians were displaced as whole sections of Paris were reconstructed. Boulevards were widened, apartment buildings were erected, and new lampposts lined the city streets. Modern sewage systems and state-of-the-art water reservoirs were also built to meet the demands of a growing and increasingly prosperous urban population.

Montmartre's still rustic character obviated the need for a Haussmannian facelift. Its neighborhoods at the foot of La Butte had been annexed in 1790, and areas higher on the hill were incorporated into the French capital in 1870. For many years, part of the village's appeal was the absence of excise taxes on alcohol because of its location outside city limits. Today, of course, taxes are everywhere, and lower Montmartre contains family-friendly neighborhoods as well as a few streets lined with nightclubs and cabarets. The upper parts of the village are still filled with cafés, open squares, restaurants, and tourist shops.

In Bohemian times and throughout the earliest years of the twentieth century, Montmartre retained its rural nature, while the Butte itself was mostly a collection of cheap hotels, nightclubs, and inexpensive eateries. Faced with increased urbanization, constant construction work, and the destruction and reconstruction of many buildings and avenues, dozens, if not several hundred writers, musicians and others fled the intellectualized and overpriced Latin Quarter on the Left Bank and migrated to Montmartre. With its winding streets, terraced cafés, and B-movie glamor-type cabarets, the neighborhood thus became an even more attractive breeding ground for a community of free spirits who lived passionate and often self-destructive lives. With the additional influx of working-class types and artisans, the population of Montmartre grew to 225,000 by the mid-1890s.[17] Montmartre's first major nightclub, Le Lapin Agile, was founded in 1870. It was joined by a village cabaret named Le Chat Noir in 1881, and at the foot of the hill in a section of town called Pigalle, the Moulin Rouge was built in 1889. These soon-to-be famous venues that excelled in providing nightly entertainment became popular gathering spots for bohemians and bourgeois personalities looking to party. A cosmopolitan group, indeed, whole generations of artists from the new avant-garde gathered regularly to drink Vouvray, the official wine of La Butte, at the Café Bouscarat and other eateries on the Place du Tertre.[18] By the early 1900s, tourists from all over the world also flocked to the village, where people's lives and adventures were led in open revolt against the conservatism and newfound luxury displayed by the Parisian middle class.

If drink, drugs, sexual freedom, and even criminality governed a somewhat cloistered life in bohemian Montmartre, the contemporaneous yet contrasting lifestyle of *La Belle Époque* consumed the lives and imaginations of other Frenchmen and many Europeans.[19] Overall, the years between the end of the Franco-Prussian War in 1872 and the start of The Great War in 1914 were governed by peace, economic prosperity, and flourishing arts. France, which became a republic in 1875, was the second-largest colonial power in the world. Real estate helped make the fortunes of a growing bourgeoisie whose members

reveled in the nightlife of clubs like the Folies Bergères and the Moulin Rouge. People visited the 1889 World's Fair, and those with increasing wealth purchased fancy clothes in the fashion salons of La Haute Couture. Champagne became the centerpiece of a growing consumer market for luxury goods, while crowds everywhere marveled at the curvilinear art nouveau adornments of many entryways to Paris's new underground Metro stations. People gathered in concert halls, listened to music by Stravinsky, Ravel, Saint-Saens, and Debussy, and gazed in awe at modern moving picture sequences. They immersed themselves in modernistic writings by Proust, Zola, and Colette. When they were not reading, they strolled along the city's grand boulevards in the shadows of the glorious new opera house called Le Palais Garnier (built from 1861 to 1875).

The Parisian literary critic, presumed lover of Victor Hugo's wife Adèle, and physician Charles-Augustin Sainte Beuve (1804-1869) used the word *flâner* to describe "the very art of doing nothing." The poet Charles Baudelaire once said that one who strolls was a *flâneur*: "The crowd is his element," he wrote, "as the air is that of birds and water of fishes ... For the perfect *flâneur*, for the passionate spectator, it is an immense joy to set up house in the heart of the multitude, amid the ebb and flow of movement, in the midst of the fugitive and the infinite."[20]

By the late nineteenth century, hundreds of elegantly clad pedestrians enjoyed open parks, tree-lined squares, and busy shop-lined streets surrounded by fancy horse-drawn carriages, rumbling automobiles, and bicycles with their modern, removable pneumatic Michelin tires. Painters, writers, and musicians flocked to Paris from the world over in search of fame, fortune, intellectual stimulation, and themselves. Physicians came from the United States to learn from some of Europe's best clinicians. French scientists and political authorities pondered how they might compete with Germany's growing influence. Meanwhile, knowledge spillover, that process by which the sharing of ideas inspires innovation, prompted artistic, technological, political, and social changes that would soon define the first half of the twentieth century.

While these were times of fruitful cross-fertilization in the arts, sciences, and literature, the city's *fin de siècle* underbelly was less attractive. As much as La Belle Époque and Bohemia sparked the public's imagination, people living in France experienced the end of a nineteenth century marked by decadence and stained by antisemitism (i.e., the Dreyfus affair), the unfair discrimination of homosexuals which surfaced during the Oscar Wilde trial, as well as corporate and political corruption revealed in part by the Panama Canal scandal. There was also widespread abuse and exploitation of factory workers and women caused by the growing wave of industrialization and the absence of women's rights. Living conditions were miserable for the poor, the oppressed, and the marginalized. A rural exodus created an influx of employment-seeking citizens and immigrants into crowded neighborhoods, many of them adjacent to Haussmann's grand boulevards. Prostitution reigned around the famous Tuileries Gardens and under the arcades of Port Royal, extending even to the city's fresh food markets in Les Halles. Brothels and cabarets flourished. The number of establishments that served alcohol (called *débits de boissons*) grew astronomically, probably reaching one for every hundred individuals.[21] As poverty, poor health, and poor sanitation lurked in much of the city, death rates rose. Dark streets smelling of detritus and human waste became increasingly dangerous, while communicable diseases such as syphilis and tuberculosis were omnipresent within the fabric of society. Along with alcoholism, these formed what venereal disease expert Professor Alfred Fournier then referred to as the "triad of contemporary plagues."[22]

The twentieth century, however, brought with it hopes for a new way of life and a break with traditions in science, medicine, and especially in the world of art and literature. This was particularly marked by the development of a new urban zone on the left bank of the Seine, well south of Montmartre near the intersection of the boulevards Raspail and Montparnasse. Today the area centers around what is now the Place Pablo Picasso. The neighborhood was called *Montparnasse*, from Mount Parnassus, home to the nine muses of Greek mythology. It took less than an hour to stroll from its major cafés and brasseries to

the Eiffel Tower or two hours to walk from Montparnasse to the steps of the white onion dome of Montmartre's Church of the Sacré Coeur on La Butte. Transit between the two neighborhoods became easier after the completion of the North-South Metro Line A in 1910; today it is called the Metro Line 12.

As real estate developers bought properties in Montmartre, rising prices forced many marginalized professionals such as artists, writers, and even avant-garde politicians and philosophers to the newer, hipper Montparnasse. By the end of the first decade of the twentieth century and even before The Great War, the neighborhood's brasseries and eateries attracted working people, politicians, and intellectuals who could gather there for warmth, toilet facilities, and camaraderie. Its most vibrant, large-terraced cafés became watering holes for the working class, expatriates, and an avant-garde population for whom drinking became a vital part of their social lives.[23] Montparnasse quickly became a melting pot of French nationals and émigrés whose original artistic and intellectual activities would collectively become known in the 1920s as the École de Paris (The School of Paris).[24] "Foreigners brought their traditions, the French, their museums and their freedom!" wrote French historian Jeanine Warnod.[25]

Many poets gathered at an open-air brasserie named the Closerie des Lilas on the Boulevard Montparnasse. A seven-minute walk away was the Café du Dôme, where a German group called Les Dômiers included Wilhelm Uhde, an art dealer and early collector of cubist paintings. Across the street at La Rotonde, founded in 1910, owner Victor Libion traded drinks for paintings from impoverished artists whose work he exhibited on the café's walls. In his book, *L'ami des peintres*, the novelist Francis Carco described how a painter named Amedeo Modigliani would pull a sketchbook from his pocket there and trade drawings for as many drinks were on the table.[26]

Less than a minute's walk from La Rotonde was a small side street angled off from the Boulevard Montparnasse. Its name was Rue de la Grande Chaumière. An art academy at n°14 opened there in 1904, offering lessons and opportunities to draw from live models. Two doors down, at n°10 Rue de la Grande Chaumière, was the Académie

Colarossi, an art school developed in the 1870s by the Italian sculptor Filippo Colarossi. For Modigliani and many of his colleagues who studied, worked, and played in both Montmartre and Montparnasse, the Académie and its nearby cafés and brasseries became a centerpiece for their activities.

§

[handwritten annotations, largely illegible: "the e... bohemia ... read ... did he fit? ... don't know yet ... just ... eat."]

CHAPTER 2

THE FAMILY / THE TRIBE

"Quay de mi"

Sephardic/Ladino expression for 'oy.'

Amedeo Clemente Modigliani, nicknamed *Dedo* by his mother, Eugénie Garsin, was born on July 12, 1884, in the cosmopolitan Tuscan seaport of Livorno, in central Italy. He was the youngest of four children, the oldest of which was Guiseppe Emanuele, born in 1872, thirteen years Amedeo's senior and a future Socialist deputy and vigorous opponent of Fascism and Nazism.[1] Dedo's older sister Margherita was born in 1874. Childless and never married, she would later adopt Amedeo's daughter, Giovanna. Six years older than Amedeo, Umberto Modigliani was born in 1878. He would become an engineer.

Amedeo's parents were Sephardic Jews. Both his mother and father were from bourgeois families that settled in the Italian peninsula many years earlier. Some members of the Garsin family still lived in Southern France, but others had immigrated to Livorno in the eighteenth century, probably from Tunisia. Eugénie's parents, Regina and Isacco, were originally from Livorno but were married in Algeria. Eugénie had a number of siblings, including her brother, Amédée, who lived in Marseille, and three younger sisters, Laure, Gabriele, and Clémente, who died in her early twenties. Amedeo's maternal grandmother died from

tuberculosis before he was born. Other family members may have lived in Great Britain, and Amedeo possibly wanted to visit them in London during an exhibit of his art in 1919.

The Garsins were, for the most part, intellectuals, although the family ran a series of credit unions throughout the Mediterranean. According to some stories, ancestors founded a school of Talmudic studies, and one oft-repeated but imaginary tale had Amedeo related to the Jewish philosopher Baruch Spinoza. We know little of Dedo's father, Flaminio, presumably of Romanian descent; a small number of Sephardic Jews lived in Transylvania since the sixteenth century. Biographer Meryle Secrest writes that he and his brothers actively conducted zinc mining operations in Lombardy until the basic-metals market crashed in 1882.[2]

Although Flaminio's business ventures kept him away from Livorno for months at a time, Eugénie was able to raise her family in financially secure, bourgeois surroundings for many years. By the time of Dedo's birth, however, Flaminio's finances had suffered irreparably. A series of bankruptcies and continuous financial difficulties kept him away from the family home, and it seems he was virtually always absent during young Amedeo's upbringing. Dedo, therefore, was raised by his mother, his aunts, and his maternal grandfather, Isacco, who assumed the role of an intellectual companion of sorts, introducing his young grandson to literature and poetry. Sadly, Isacco suffered from neurosis. He died when Dedo was only nine.

Thankfully, the Garsins' love for study and intellectual pursuits extended to every family member. Facing financial difficulties and needing to keep up appearances as well as earn money, Eugénie and her sisters, Laure and Gabrielle, had little problem establishing a home school program for Dedo and other children in the neighborhood. Amedeo thus learned Latin and was exposed to art, philosophy, and literature at a very young age. Home-schooled until he was ten, he became fluent in French and learned English. He was surrounded by books but went without many toys and had little contact with children his age. Dedo's childhood was thus spent living in what his older sister described critically and defensively as "an austere atmosphere of work

and self-denial, which was cheerless but caused neither material deprivation nor damage to his young self-esteem."[3]

It was in a home containing mostly women that Amedeo Modigliani learned his first lessons and experienced three separate life-threatening illnesses. The first time he became very sick, it seems, was at the age of eleven, when he contracted an acute case of pleurisy. This disease occurs alone or in association with lung disease. It is most commonly caused by viral infections such as influenza but is also associated with bacterial pneumonia and other illnesses, including tuberculosis. Even in hindsight, there is no way of knowing whether Dedo's symptoms were due to a self-contained viral or bacterial infection, or an early sign of worse things to come, especially the life-threatening pulmonary tuberculosis he would develop only a few years later.

What is called "pleurisy" is an inflammation of the lining (the pleura) that surrounds the lung and stretches along the underside of the ribcage. This inflammation is often accompanied by shortness of breath and a collection of "pleural" fluid inside the chest cavity. Other symptoms are fever and a usually sharp pain during breathing. A doctor's clinical examination would have shown decreased breath sounds on chest auscultation using a stethoscope and perhaps dullness on percussion. Tapping one's fingers on the thorax to distinguish abnormalities such as dullness (fluid) or hyperresonance (overinflated lungs) had finally become part of standard medical examinations fifty years after being first introduced in 1761 by Viennese physician Josef Auenbrugger.[4] Dedo's physicians would have tried to distinguish his pleural findings from other symptoms involving the lungs. The nature and the extent of his pleural inflammation could not have been determined with precision, however, because chest radiographs were not yet available; X-rays, also called roentgenographs, were discovered that same year (1895) by Wilhelm Roentgen, a Professor of Physics in Wurzberg, Bavaria.[5] Today, doctors not only use physical findings and chest radiographs to make a diagnosis but also to study what goes on anatomically and even physiologically inside the chest by using noninvasive imaging modalities such as computed tomography (CT scans) and ultrasound.

There is nothing in the Garsin's family diaries to suggest Dedo's lungs were affected, so he was likely treated only for pleurisy according to the medical standards of his time. Therapy included bed rest and sudorifics such as plant-derived preparations to prompt sweating in case of fever. He would also have been given small doses of opioids to relieve his pain. The boy's chest would have probably been wrapped with a bandage or belt to constrain his respiratory movements, especially if his doctors thought limiting chest expansion might decrease his pain while breathing.

Dedo recovered, and two years later, the now thirteen-year-old boy had his Bar mitzvah. Although the Garsin-Modiglianis were secular Jews, Dedo's ceremony was held in the widely admired seventeenth century neo-classical Grand Synagogue of Livorno. The building was the second-largest synagogue in Europe. It was partially destroyed by Allied bombs in 1943 and not rebuilt. Like other teenagers of Sephardic traditions, Amedeo would have been called on during the ceremony to read from a Torah kept in its wooden case. His father and other male family members would have been asked to recite the benediction, "Baruch she-p'ta-ra-nee mei-o-nesh ha-la-zeh" – "Blessed is the one who has freed me from punishment of this one," meaning the boy was now a man responsible for his own actions.[6] Also, according to Jewish traditions, on the day of his Bar mitzvah, Dedo would have worn tefillin – black leather straps attached to a set of small boxes on his head and arm and containing scrolls of parchment inscribed with verses of the Torah. During the ceremony, he would have also sung the *Shema*, 'The Lord our God alone is our God,' and the *Kadesh-li*, a reminder of the Jewish people's freedom from Egyptian bondage in biblical times.[7]

A marvelous banquet of Italian, Jewish, Spanish, and Portuguese-inspired foods would have followed. If the family could afford the expense, there would have been music played by a live band, accompanied by much traditional dancing and singing. Conversations would have been in Italian or in the usual Bagitto dialect – a mixture of Hebrew, Spanish, and Italian. Some of the guests would have surely known Ladino, a dialect of Hebrew, Arabic, Turkish, Spanish, French, Greek, and Italian spoken by a few Sephardic Jews throughout

the region for almost a thousand years. Amedeo remained proud of his Jewish heritage throughout his life. "Modigliani, painter and Jew," he would say by way of introduction later when he lived in Paris and surrounded himself with many Jewish artists and friends. As a child, he certainly had no reason to deny his origins because Livorno treated its Jewish population well. They owned property and attended public schools. They were not forced to wear special clothes, and there was little overt discrimination. Even while Jews were being killed in Eastern parts of Europe, Livorno's Jewish businessmen, healthcare professionals, judges, and lawyers were accepted and well-integrated into the city's middle class and higher society.[8]

Dedo finished elementary school when he was fourteen, but he was not particularly interested in further studies. His mother wrote in her diary that he began taking drawing lessons on August 1, 1898. Shortly afterward, however, he became ill again, this time with typhoid fever, an infectious disease that almost took his life.* We know from family diaries that Modigliani was severely ill. Like other victims of typhoid fever, he would have had a high temperature, vomiting, abdominal pain, and diarrhea leading to dehydration. His skin was probably covered by a rose-colored rash made up of flat red spots, and his headaches would have been intolerable. The word "typhoid" of typhoid fever comes from the Greek word *tûphos* (τῦφος) which means smoke, fever, or delusion. This is because a major symptom is having a cloudy mind – in scientific terms, a deterioration in cognitive function that is similar to what many people in the twenty-first century experienced after infection with the SARS-CoV-2 virus.

Formerly known as enteric fever (from the Latinized Greek, *enterikos* – relating to the intestines), typhoid fever is a bacterial disease caused by *Salmonella enterica* serovar Typhi (*S.* Typhi), a human-restricted flagellated Gram stain-negative rod that is distinct from the nontyphoidal *Salmonella* typhimurium, which is usually a food-borne

* Not to be confused with louse-borne typhus disease caused by *Rickettsia prowazekii*, although symptoms are similar.

cause of gastroenteritis.[9] From the digestive system, where the bacteria may cause severe intestinal inflammation, *S.* Typhi penetrates the bloodstream and prompts systemic illness after an incubation time of up to fourteen days.[10] The infection can spread quickly from person to person, although not everyone infected becomes severely ill. Symptoms are often at their worst about three weeks into the infection, and death is a real possibility; typhoid fever kills one in five persons if left untreated.

Descriptions of typhoid (enteric) fever disease actually date back to ancient Greece. Still, it took centuries for doctors to realize that both illness and infectiousness – the propensity to transmit infection, were related to unsanitary conditions and that transmission occurred through human feces. Before 1880, when the bacillus responsible for typhoid was discovered, healthcare professionals had difficulty accepting that disease could be caused by invisible microorganisms related to poor sanitation and (drinking) water contaminated with feces from other victims of the disease. During the Civil War in the United States, for example (1861-1865), almost a third of all Union troops who died from disease succumbed to typhoid fever (infectious diseases were far more deadly than battle wounds throughout a war that killed more than 600,000 Union and Confederate soldiers combined).[11] By the late nineteenth century, however, typhoid fever joined cholera in being declared a public health concern associated with poor sanitation and hygiene. Still, almost fifty years later, between 1900 and 1904, typhoid fever was responsible for 33.6 of every 100,000 deaths in the United States, surpassing the fatality rates of measles, scarlet fever, whooping cough, and influenza.[12, 13]

Today, good hygiene, proper sanitation, modern sewage systems, as well as proper food storage and handling, safe chlorinated drinking water, effective antibiotics, and vaccination have caused typhoid to almost vanish from high-income countries. It is endemic, however, in low-income regions where there is increased drug resistance, an insufficient number of affordable vaccination programs, and inadequate social policies to ensure that populations have sufficient education and training to practice good hygiene. Because typhoid fever is responsible

each year for about 21 million cases and more than 200,000 deaths worldwide, it remains a global threat to public health.[14]

For many years we have known that bacteria are shed in peoples' feces for up to several weeks after infection with *Salmonella* Typhi and that even someone without symptoms may pass along the infection to others.[15] In the early 1900s, anyone suspected of having the disease and those suspected of being infected were physically isolated and quarantined to prevent transmission of the potentially deadly bacteria. The most famous case of someone carrying *Salmonella* Typhi, in other words, being infected with typhoid but without symptoms – also known as an asymptomatic carrier, was "Typhoid Mary" Mallon, an Irish immigrant to the United States. In 1907, Mary was proven to be responsible for contaminating more than one hundred different people and causing five deaths.[16]

Considering the dangers of typhoid fever were common knowledge in the late nineteenth century, the Garsin family naturally feared for Amedeo's life. They would not have known about the live vaccine being tried among British military recruits, however, nor of the experimental but voluntary vaccination program for the United States military that only began in 1909. Because antibiotics were not yet discovered, all Dedo's doctors could do was provide symptom relief, monitor his pulse, and track the sick child's dangerously high fever.

Human body temperature is considered normal at 37° Celsius (98.6° Fahrenheit), although it can vary upwards of 1°C in healthy individuals. Fever is usually defined as a core body temperature greater than 38.3 °C (100.94 °F). The word has its etymological origin in the Latin word for heat. Also called hyperthermia and pyrexia, fever has both beneficial and harmful effects on human and animal metabolisms.[17] Living at a time when infectious diseases were the most common causes of death, Canadian physician and famous medical educator Sir William Osler (1849-1919) began his address to the American Medical Association in 1896 by saying, "Humanity has but three great enemies: fever, famine and war; of these by far the greatest, by far the most terrible, is fever."[18]

Body temperature has both puzzled and intrigued medical practitioners since ancient times. By the start of the twentieth century,

however, fever was better understood than ever before. After the publication of *Temperature in Diseases* in 1868 by German psychiatrist and renowned clinician Doctor Carl Wunderlich (1815-1910), physicians learned that variations in temperature occurred naturally with illness, but that body temperature was virtually constant in healthy persons.[19] This knowledge created an obsession for the international medical community, prompting studies throughout the 1880s and 1890s that focused on the adverse effects of fever on the human body. A doctor's ability to track a patient's fever, prognosticate and treat accordingly became even more exciting after the commercialization of a mercury thermometer that fit alongside the stethoscope in every doctor's medical bag. These two instruments gave physicians a way to clinically assess and monitor their patients' physical findings with greater precision and certainty.

According to what was known from centuries of clinical observation, Dedo's doctors would have expected to find a gradual rise in the teenager's temperature to as high as 40 °C (104 °F) by the end of a week.[20] In addition to abdominal pain, nausea, and vomiting, they would have noticed an acceleration of the boy's heart rate (a rise in heart rate by 8 to 10 beats/minute for each Celsius degree increase in body temperature above 38.3 °C). Today, we know a person's pulse is faster when there is a fever because an elevated temperature represents a complex, acute-phase response to infection.[21] Amedeo's doctors may have been perplexed by the absence of a rise in their patient's pulse rate because they would not have known about the not yet described phenomenon of "relative bradycardia," whereby the pulse rate is lower than expected for a given temperature.[22] Although controversial, this finding may be noted in as much as fifty percent of patients with typhoid.[23]

Dedo was severely ill with a fever for many weeks. According to his family's recollections, he was delirious for over a month. In their attempts to lower his body temperature and needing to treat the teenager's other troubling symptoms of weight loss, abdominal distress, weakness, and a decreased appetite, Dedo's physicians would have suggested he be plunged into a cold bath and given antipyretics, which were the latest trend in medical therapies. They would have prescribed

, Aspirin-like

quinine or teas made from willow bark, the active ingredient of which we now know is salicylic acid.[24] A doctor from Berlin named Riess, who immersed his patients in warm rather than cold baths whenever their rectal temperature was greater than 38.8 °C., showed the bark's favorable effect in four hundred patients with typhoid fever in 1875, almost fifteen years earlier.[25, 26] A better antipyretic, Acetylsalicylic acid, also known as aspirin, was discovered by Dr. Felix Hoffman and manufactured by the Bayer company in Germany. It would not be commercially available, however, until 1899.[27] Amedeo's doctors, therefore, would have prescribed antipyretics such as antipyrine (available since 1884), phenacetin (available since 1887), and acetaminophen (prescribed since 1888).[28, 29]

According to family recollections, Dedo's mother stayed at her son's side throughout his illness and did her best to nurse him back to health. During one of the teenager's typhoid-induced febrile spells, she heard him say he wanted to become an artist. Her son's illness would last many months. Considering he was on the brink of death, Eugénie Garsin-Modigliani did what any mother would have done in similar circumstances; she promised Dedo she would support his dream when he got better.

She vowed to find him "a drawing master."[30]

§

He was 14 when he first mentioned his desire to become an artist; interestingly, he did so while being delirious of his typhoid fever.

CHAPTER 3

MACCHIA – THE BLOT

"Without poets, without artists, men would soon weary of nature's monotony"

Guillaume Apollinaire[1]

By April 1899, Modigliani had fully recovered, but the fifteen-year-old must have thought his battle with typhoid was like a blot on his life. The possibility of ill health and an early death was real. His mother wrote that he abandoned his studies at the Lycée in order to devote his energies to drawing and painting. He enrolled in a small class with a young local artist named Guglielmo Micheli, a follower of the Macchiaioli school. The Macchiaioli – from the word *macchia*, which means stain or blot, were Florentine and Neapolitan painters who used small patches of color as building blocks for their representations of Tuscan landscapes. Many paintings were done on wooden boards or mahogany cigar boxes as well as canvas. They strove to capture the tonal contrasts of natural light by using broad brush-strokes and large patches of bright pastels, often without the luxury of preparatory drawings.

Precursors to French Impressionist and future Modernist move-ments, the Macchiaioli were a group of progressive intellectuals who rebelled against traditional foreign-dominated aesthetics taught in clas-sical Italian art academies. Their movement ran against the neoclassical

and romantic styles of the time. Giovani Fattori (1825-1908), one of the more recognized members of the group, occasionally came to Micheli's studio to work with some of the students. According to the Italian painter Gino Romiti, a friend of Amedeo's who also trained under Micheli, Modigliani's sketching technique came "either indirectly through Micheli or directly from Fattori."[2]

According to friends, Dedo did not particularly enjoy working outdoors. Perhaps he was already developing a taste for painting peoples' likenesses. Considering his mother's knowledge of Jewish culture, he would have been exposed to work by Vittorio Matteo Corcos (1859-1933), a Jewish artist from Livorno who was famous for his portraits.[3] With the help of Parisian art dealer Jean-Baptiste Goupil, Corcos was a success amongst French and Italian high societies of the 1880s. Similar to Modigliani's practice several years later, Corcos scribbled legends across his canvases.

Amedeo was described as an introvert who displayed emotional outbursts and frequent bouts of anger. According to his biographer, Meryle Secrest, his fellow students said he was small and sickly looking. He was "introverted and shy…and his anger was unpredictable – he would start throwing whatever was handy, and he was hard to calm down."[4] The story goes that Amedeo preferred reading to spending time in the artist's studio. He was already well-read and liked to recite long passages from his favorite authors: Baudelaire, D'Annunzio, and Nietzsche, but there is no concrete evidence the teenager was particularly talented. Later that year, however, in 1899, his mother wrote, "He does not paint too badly, and draws very well indeed."

During his time with Micheli, Amedeo admired work by Macchiaioli artists. Like many budding artists, he focused on improving his technique and visited art galleries and museums to copy works from the Italian Renaissance. The authenticity of any existing paintings by Modigliani from these times is open to debate, regardless of whether they are signed or unsigned, even as some hang to this day in museums, are displayed at art exhibitions, or are certified by one of several Modigliani experts. Examples include *Promenade at Livorno*, a clumsy 21 x 40 cm oil on canvas exhibited in Barcelona in 2004

and presumably certified by the expert Christian Parisot and the Institute Modigliani-Kisling in 2002. Another example is *Tuscan Road*, an amateurish unsigned oil on cardboard, presumably from 1898. This painting is reproduced in several art histories, including those of Alfred Werner and Schmalenbach.[5, 6] It also appears in a catalogue from a show at the Musée d'Art Moderne de Paris in 1981.[7]

Even before he turned sixteen, Modigliani spoke of establishing his independence. He was still an avid reader who devoured works by Giacomo Leopardi (1798-1837), Petrarche (1304-1374), and Dante Alighiere (1265-1321). Perhaps he shared readings with his mother. Regardless, similar to countless generations of young people, he must have submerged himself in these authors' classic works, whose lyrical poetry about love, loss, and desire inspired thousands: *Vita nuova*, Dante's ode to Béatrice; Petrarch's sonnets about his unrequited love for Laura in *Canzoniere*, and Leopardi's *Canti*, which contains *All' Italia*, a famous poem about patriotism and love of country.[8]

Amedeo's mother was working on her own novel. She had recently translated poems by the Italian novelist Gabriele D'Annunzio (1863-1938), a romantic philanderer and social climber who embraced excess in all of his undertakings. Biographer John Woodhouse summarized D'Annunzio's approach to life as one of self-indulgence: "to make his life as interesting and preferably as joyful as possible for himself, whatever the consequences for others."[9] The soon-to-be proto-fascist megalomaniac became famous for having a voracious sexual appetite; one day he would claim to be Italy's greatest poet since Dante, who, in addition to *Vita nuova* authored the *Divine Comedy*, reputably among the greatest literary works of Medieval Europe. "Italian poetry begins with 200 verses of Dante," D'Annunzio wrote, "and after a long interval, continues with me."[10]

Young Modigliani likely read D'Annunzio's *Laudi del cielo del mare della terra e degli eroi* (In Praise of Sky, Sea, Earth, and Heroes, 1899). While in his twenties, Amedeo was known to recite verses by D'Annunzio and Dante, sometimes inferring them as his own. Perhaps Amedeo, an introvert with artistic sensibilities coupled with intellectualism was impressed by D'Annunzio's ability to build a legend around

himself comprised of arrogant and ostentatious behaviors. "You must create your life, as you'd create a work of art," D'Annunzio wrote in his autobiographical first novel, *Il Piacere* (The Child of Pleasure, 1889). The book introduces readers to the first of his Nietzschean Übermensche-like heroes, the promiscuous aristocrat/poet Andrea Sperelli. Much of D'Annunzio's writing was considered decadent and replete with explicit sex and self-indulgence. Critics said it was a glorification of beauty at all costs. The similarities between D'Annunzio's characterizations and Modigliani's subsequent behaviors, particularly in his relationships with women, could be subjected to psychoanalytic studies.

The works of Friedrich Nietzsche (1844-1900) were also essential readings for young men like Amedeo, who could relate to the German philosopher's existential angst and metaphorical lyricism. "God is dead, and we have killed him," Nietzsche wrote in perhaps his most reader-friendly book, *Thus Spake Zarathustra,* published in 1885. The story is about a Persian sage who after ten years in the mountains, descends from his cave in order to teach that man can master his own destiny, as well as find both meaning and fulfillment in the face of his knowledge of impending death. The philosopher despised mediocrity and conformism and championed moral nihilism. The notion of 'duty' was a suffocating prejudice, Nietzsche declared, and the time had come for the 'Übermensch,' the creative artist and superman who would define their individual purpose and value through action. This message would have resonated with young Modigliani, who was barely past his life-threatening bout of typhoid fever. Perhaps it is not a coincidence that his teacher, Guglielmo Micheli, often called Amedeo "Superman," not because the young man sketched unceasingly in the artist's studio, but because he avidly read philosophy and committed himself to modern aesthetic ideals.

Along with Nietzsche, Dante, and D'Annunzio, Dedo read French philosopher Henri Bergson's work under the careful eye of his Aunt Laure. Like Modigliani, Bergson (1859-1941) was Jewish. Born from an English mother and a Polish father, he was a star pupil at Paris's École Normale before obtaining his diploma and the prestigious Agrégation de Philosophie. He was awarded the Nobel Prize for literature

in 1928. The only works Dedo may have had access to were in French, however. These included Bergson's doctoral thesis, *Essai sur les données immédiates de la conscience* (Time and Free will, 1886), and Bergson's second book, *Matière et Mémoire* (Matter and Memory, 1896) published when the philosopher was elected to the Collège de France ten years later.[11] Both works develop complex concepts not easily relatable for a young man without a high school education or advanced studies in philosophy. In the first, Bergson describes how our memories and attitudes influence our experience of time, proposing that our consciousness of lived time – *la durée* (*trans.* duration) is separate and apart from objective time.[12] In the second, he addresses problems of body and mind, suggesting the brain has a practical, material function that is separate from memory, which allows contemplation of the present by being lodged in the past.[13] A teenager like Modigliani could easily have become haunted with the idea of living in the present. Amedeo was already being called 'poor Dedo" by his family. Having lost his grandfather a few years earlier, he lacked a masculine/paternal role model, and became increasingly self-centered and difficult to get along with. To his mother's dismay, he also neglected his health. Perhaps Modigliani already felt that his days were counted.

When Eugénie arranged a meeting in Florence with prospective publishers of her translations, she brought her youngest son with her. Modigliani's time in the city would have differed from his days spent meandering between his home and the decrepit waterfront taverns that occupied Livorno's old port. Florence was a mainstay of modernist and Renaissance culture despite its rapidly growing population. Its streets were famous for inspiring Dante and the political philosopher Niccolo Machiavelli, who crafted his book, *The Prince*, a justification of the coequal exertion of authority and power in disregard of morals, during his exile outside the city in 1513. Florence was also the birthplace of *Pinocchio* and its creator, the author of children's stories, Carlo Collodi. Writers such as Rainer Maria Rilke, Thomas Mann, and Oscar Wilde had also made the city come alive in the imaginations of readers everywhere. For artistically-inclined Modigliani, however, Florence represented the world of Michelangelo, Boccaccio, Botticelli, and Leonardo

Da Vinci. Amedeo visited the Pitti Palace, and while it was not yet a museum, he would have seen paintings there and marveled at the overwhelming series of seven arch-headed stone apertures resembling a Roman aqueduct in the Boboli gardens. The budding young artist wandered through the city's art galleries to study reproductions of Sienese painters and to see firsthand more recent works by Fattori and the much-admired Austrian-Italian painter Giovanni Segantini (1858-1899), known for his pastoral and alpine landscapes.

There is little indication of Amedeo's activities after his return to Livorno. He grew close to Oscar Ghiglia, a significantly older friend who had become an artist, and Amedeo wanted to live apart from his family. Perhaps his way of thinking was encouraged by his aunt Laure, who filled his head with writings by the Russian, Pëtr Alekseyevich Kropotkin. Considering how Modigliani's older brother and fervent socialist, Giuseppe Emanuele, had been jailed for six months in 1898, the family probably discussed Kropotkin's ideas about morality, justice, and ethics. They must also have read articles from Kropotkin's magazine, *Nineteenth Century*. Aunt Laure gave Amedeo a copy of Kropotkin's *Memoirs of a Revolutionist* (1899), which describes the socialist philosopher-scientist turned anarchist's journey through all walks of society and life – from the aristocracy to prison, and from Russian peasantry to workers' communes in Western Europe. Amedeo and Laure would have had access to the revolutionary thinker's book, *La Conquête du Pain* – The Conquest of Bread, published in French in 1892. Kropotkin believed conditions of colonialism, capitalism, and industrialization were destroying society. Optimistically providing a new, utopian vision of anarcho-communism, he wrote, "In working to put an end to the division between master and slave, we work for the happiness of both, for the happiness of humanity."[14] Therein, perhaps, lie the roots of Modigliani's ultimately rebellious and antibourgeois sentiments.

Little is known of Amedeo's artistic output either before or after his trip to Florence in the last years of the nineteenth century. In addition to a few poorly executed landscapes attributed to him, albeit without certainty, there is a small *Self-Portrait* – a charcoal on paper signed 'a.

27

Modigliani'. This finely detailed drawing is of a handsome child with a pensive look. The boy is noticeably younger than fifteen, with shortly cropped hair and dark eyes. It is probably from 1899, and biographer Jeffrey Meyers describes the drawing as Modigliani's earliest surviving piece.[15] The drawing was sold at Christie's auction house for more than 900,000 British pounds in 2018.[16] A photograph of the piece was first published in *Tout l'oeuvre peint de Modigliani* (1972),[17] a catalogue compiled by Ambrogio Ceroni and art historian Françoise Cachin.[*]

§

[*] In *Becoming Modigliani,* paintings are referred to by catalogue numbers in Piccioni, L., & Ceroni, A., from *I dipinti di Modigliani*[18] and crosschecked at https://www.secretmodigliani.com

CHAPTER 4

THE SWORD OF DAMOCLES

"The doctors pronounced his case hopeless."

Margherita Garsin[1]

S hortly after Dedo joined Micheli's art studio, two of his fellow students contracted the infectious respiratory disease called tuberculosis, also known as *consumption*. The students' deaths within a year surely marked every one of Micheli's young artists. Then, that summer, 'poor Dedo' had a recurrent bout of pleurisy. He must have been gravely ill because, in September 1900, his sister wrote that "he suffered a violent hemorrhage followed by a fever, and the doctor's diagnosis held out no hope."[2] Amedeo's doctors would have known that unless the teenager had bronchitis, a bleeding ulcer, or a severe nosebleed, coughing up blood was an ominous sign of advanced lung or airway disease. Considering Amedeo's prior bouts of pleurisy, his recent exposure to friends who died of consumption, and the frequency of infectious lung diseases in the general population at the time, physicians likely told the young man's family that he too had consumption – the contagious, incurable, and ultimately fatal disease officially called tuberculosis. Should Amedeo survive, his convalescence would require rest, a healthy diet, and a change in climate.[3]

Tuberculosis was originally called *Phthisis*, which is Latin, from the Greek word *phthinein*, meaning dwindling or wasting away. It was

also called consumption, because contrary to rapidly fatal epidemic infectious diseases such as smallpox or the Bubonic plague, tuberculosis slowly consumed its victims. Responsible for what has been referred to as the "White Plague," the highly infectious respiratory disease affected large segments of the population and may have been responsible for up to twenty-five percent of all deaths in Europe during the seventeenth and eighteenth centuries.

Known to be caused by *Mycobacterium tuberculosis* (Mtb),[4] consumption has been with humanity since early civilization. Years ago, before the advent of effective treatments, everyone knew that its victims, referred to as consumptives, lived with dire expectations. At first, tuberculosis was considered a random killer only of individuals in the flower of their youth. It has since been shown to affect anyone regardless of social class, gender, age group, race, ethnicity, or profession.[5] Pathologist and medical historian Thomas Dormandy said that unlike other plagues, tuberculosis "transformed the lives as well as caused the deaths of its victims."[6] Writers and poets frequently romanticized and even attributed sexual undertones to victims of the illness. They described consumptives as having a gaunt, ghost-like appearance with rosy cheeks, a feverish glitter in their eyes, and a pale, almost transparent color to their skin. Hemoptysis, or the spitting of blood which might have unexpectedly appeared on a handkerchief, often signaled imminent death. In her essay *Illness as Metaphor* (1978), Susan Sontag wrote that "As once tuberculosis was thought to come from too much passion, afflicting the reckless and sensual...it was also regarded as a disease of repression [of one's sexual nature]."[7] Carolyn Day submits that physical signs of consumption, including having a pale complexion, flushed cheeks, bodily frailty, and a thin silhouette (later exaggerated by corsets), contributed to a new definition of female beauty in the first half of the nineteenth century.[8] Even Florence Nightingale succumbed to Romantic ideology in her mid-nineteenth century treatise *Notes on Nursing* (1859) when she wrote, "Patients who die of consumption very frequently die in a state of seraphic joy and peace: the countenance almost expresses rapture."[9]

There is nothing in the least romantic, however, about this life-threatening, highly contagious disease that spreads so easily through

the air. Joseph Severn's description of his friend, John Keats, less than two months before the poet's death from tuberculosis on February 23, 1821, is telling: "I had seen him wake on the morning of his attack, and to all appearance he was going on merrily and had unusually good spirits when in an instant a Cough seized upon him, and he vomited near two Cup-fuls of blood..."[10] Studies show that patients with untreated pulmonary tuberculosis have an expected death rate as high as seventy percent, and the duration of acute illness from disease onset to either self-cure or death is approximately three years.[11] No effective pharmaceutical treatments existed until the introduction of antituberculous medications in the late 1940s. Persons with consumption were therefore shamed, shunned, and often sequestered from society. They suffered from weight loss, a nagging cough, and unrelenting clinical deterioration. Patients were desperately cared for by their loved ones, courageous friends, family members, and charity workers who risked their own lives to be at the consumptive's bedside. This was and still is, particularly true for healthcare professionals who are at increased risk of acquiring tuberculosis compared to the general population because of their frequent exposure to Mtb through shared air or space with infectious patients.[12]

When young Modigliani, coughing and probably complaining of chest pain when he breathed, also became bedridden and feverish, his family and other caregivers would have been concerned for his health. When he coughed up blood, however, they were understandably frantic.

§

CHAPTER 5

<center>⎯⎯⎯⎯ ⚜ ⎯⎯⎯⎯</center>

IT'S ALL GREEK TO ME

"Learning many things does not teach understanding."

Heraclitus, c. 500 BCE[1]

Amedeo was barely sixteen when he became severely ill with pleurisy a second time. In those days, the leading causes of death were not unintentional injuries or cancer as they are to-day, but pneumonia, intestinal infections (enteritis), and tuberculosis. We now know the pleurae are one of the most frequent sites of extrapulmonary tuberculosis – disease that occurs in an organ system other than the lungs.[2]

Diseases of the pleura include inflammatory, malignant, and infectious processes. These cause thickening of pleural tissues and the accumulation of air (pneumothorax) or fluid (a pleural effusion) in the pleural space. Pleurisy, which usually makes breathing painful and difficult, may or may not be accompanied by fever, other signs of infection, or an accumulation of fluid that can compress the heart, lungs, and diaphragm. On physical examination, breath sounds may be decreased, or a dry sandpaper-like sound indicative of inflamed pleural tissues rubbing against one another – a pleural rub, may be audible.

Pleurisy associated with a large effusion causes even greater problems with respiration, including exercise intolerance and low blood oxygen

levels (hypoxemia). According to Caelius Aurelianus, a Greek-Roman physician who lived sometime between the second and fifth centuries CE, and who translated works of the famous Greek physician, Soranus of Ephesus, pleurisy was characterized by a severe pain in the side, a short dry cough, high fever, and a fluid collection that varied in size and nature from one person to another. He also described insomnia, restlessness, and loss of appetite that worsened as the disease progressed. "*Mentis alienation, gutturis stridor, et sonitus interius resonans aut sibilans in ea parte quae patitur*" (*trans.* altered mental status, stridor, and resonant hissing on the side of the person suffering), wrote Caelius, suggesting that ancient Greek physicians were listening to their patients' chests long before Laënnec's invention of the stethoscope in the early nineteenth century.[3]

When modern physicians speak of pleurisy, we speak of an inflammation of the pleural lining, which is a smooth, glistening, and semitransparent membrane made of mesothelial cells, loose connective tissues with blood vessels, adipose tissues, nerves, lymphatics, and fibroelastic tissues. The membrane folds back on itself to cover the outside of each lung and the inside of the ribcage. There are actually two pleurae, one for each lung. These membranes are essential to respiration as well as to help prevent infection from spreading to and from the lungs to other parts of the body.[4]

Between a visceral pleura that covers the lung and a parietal pleura (from the Latin, *pariēs* –wall) that covers the inside of the rib cage and diaphragm (a striated muscle that separates the inside of the chest from the abdomen), is the pleural space. This nearly virtual area contains a small amount of serous fluid, usually less than 12 ml and measuring 10 μm in thickness.[5] The fluid serves as a lubricant that allows the lungs to slip along the inside of the chest wall during inspiration and expiration. It also creates a surface tension that pulls the visceral and parietal pleura close to each other to help keep the air-filled lungs expanded against the inside of the chest.

Using medical terminology originating from Hippocrates and the ancient Greeks, an abnormal accumulation of fluid within the pleural space is called a *pleural effusion*.[6] An abnormal accumulation of air

within the pleural space is called a *pneumothorax*, and an accumulation of pus in the pleural space is called an *empyema* (from the ancient Greek, *empýēma* –abscess, akin to *pýos* – pus).[7] The Greeks believed that in addition to collecting in the chest, an empyema could form when excess phlegm flowed from the brain to the lungs, causing *phthisis* – a wasting away or slow consumption of body organs and functions if symptoms lasted more than forty-five days.[8] The word is actually Latin, from the Greek word *phthinein*, meaning dwindling.

Contrary to common belief, *phthisis* was ascribed to several serious disorders, some of which were the subject of clinical vignettes in *Internal affections*, a volume of the *Hippocratic corpus* (a group of early medicinal writings dating from the Greek physician Hippocrates and his followers in the fifth century BCE). During the second century CE, however, Aretaeus of Cappadocia made some distinctions. "If from an abscess in the lung or a settled cough or spitting of blood, pus should develop within and the patient should spit it out, the disease is called *pyë* and *phthisis*. But if the chest or a rib suppurates and pus comes out through the lungs it is called *empyë*. If after this, the lung consumed by the passage of pus, has an abscess, it is called *phthoë*."[9] Claudius Galen of Pergamum (129-216 CE), a Greek physician to the Roman Emperor Marcus Aurelius, described phthisis more precisely as a disease associated with fever, cough, and blood-stained sputum. Among other words used are – *Tabes* (emaciation or wasting, as in Tabes dorsalis, the degenerative nerve disorder that signals late-stage syphilis), *Marasmus* (withering), and *Hectic Fever* (intermittent fevers).

The cause of dwindling (wasting) was unclear. An inscription from the Babylonian Hammurabi Code (1948-1905 BCE) engraved in cuneiform script on a stone pillar, now at the Musée du Louvre in Paris, describes an illness consistent with tuberculosis. Documents in the biblical books of Deuteronomy (around 1400 BCE) and Leviticus used the Hebrew word *schachepheth* to describe a wasting that may also represent the disorder. Written records of a disease called "consumption" date to at least the Assyrian empire in 600 BCE, and by the fifth century CE, the Latin word *consumtio* was used to describe an illness that most likely represented the disease.[10]

The ancient Greeks learned of a "grievous consumption which took the soul from the body" when archaic Greek *aoidoi* (bards and poets) sang Homer's *The Odyssey* from the eighth century BCE.[11] PreSocratic (fifth and sixth centuries BCE) and Socratic (fourth century BCE) philosophers were unable to explain its origins. Societal and religious taboos prevented Greek physicians from examining the open human body.[12] Sacred laws prohibited exploration for anatomical purposes, and corpses were considered a source of pollution for all who came in contact with them. The skin also was considered inviolable, a symbol of wholeness so important that the skins of sacrificial animals were neither burnt nor eaten by human participants at sacrificial ceremonies.[13] For many years, therefore, physicians in their quest for causality did not or could not apply their powers of observation and analysis to directly study disease-related changes within the human body.

From a clinical perspective, Hippocrates (460-375 BCE) and his followers on the island of Cos distinguished between (1) a consumption of the lungs with suppuration, ulceration, and blood-filled phlegm; (2) mucus dropping down from the head into the lungs; (3) venous bleeding; (4) the collection of blood, pus and mucus accumulating in the pleural cavity; and (5) abscesses in the lungs. From their observations, they recognized how the prognosis varied depending on the progression, stabilization, or improvement of symptoms as well as the number of days their patients were ill.

They spoke of a disease caused by noxious humors that flowed from the head to the throat and lungs, affecting people between the ages of eighteen and thirty-five. The illness was associated with wasting. Patients were described as having smooth, pale, whitish skin and eyes that appeared exceptionally bright and hollow.[14] In *Diseases*, book 2 of the Hippocratic Corpus, they surmised that some individuals were predisposed to the illness. Their general appearance was that of a *habitus phthisicus*. They were tall and thin, with long necks, sloping shoulders, and poorly developed chests.[15] The description is eerily similar to that of some sitters in Modigliani's paintings.

The idea of a hereditary predisposition to the wasting illness was shared by medical professionals for centuries to come. It seemed

justified because victims of phthisis also had parents, grandparents, or siblings with the disease. Seen through today's lens, however, this was due to airborne transmission of Mtb between individuals living in close proximity. Unable to account for extensive person-to-person transmission and the rapid spreading of disease, some ancient Greeks proposed that air and water were probably contaminated by *miasmas*, from the ancient Greek word meaning pollution.[16] According to *The Nature of Man*, "Whenever many men are attacked by one disease at the same time, the cause should be assigned to that which is most common, and which we all use most. This it is which we breathe in."[17]

The physician Empedocles of Acragas formulated a four-part theory of "roots" constituting all forms of matter; the four elements fire, air, water, and earth, along with the principles of Love and Strife to explain the structure of the physical world and everything in it.[18] Empedocles could not have guessed his theory would be incorrectly connected to a humoral theory of disease based on four "humours" of blood, phlegm, yellow bile, and black bile one hundred years later, and elaborated upon by Hippocrates' student and son-in-law, Polybus in 400 BCE. In *The Nature of Man*, writers also said the properties dominating each of the four humours were based on an "interchangeability of forms." Disease resulted from imbalances in their various combinations: blood, hot and wet in spring; phlegm, cold and wet in winter; yellow bile, hot and dry in summer; and black bile, cold and dry in autumn.[19] Ultimately, the humoral theory would be opposed by views of the human body based on studies of anatomy in Alexandria during the Hellenistic period, spanning from the death of Alexander the Great in 323 BCE to the start of the reign of the first Roman emperor Caesar Augustus, also known as Octavian, in 27 BCE. Both teachings would dominate medical thought until the age of empiricism almost two thousand years later.[20]

*

Amedeo Modigliani would be a lifelong victim of the infectious disease once called phthisis and consumption, now called tuberculosis,

and he probably died as a result. This is why we must now leave Modigliani's narrative to turn our attention in the next five chapters to understanding the disease that in 2021, killed about 1.6 million humans around the world, including 187,000 people with Human Immunodeficiency Virus (HIV).[21]

According to the World Health Organization, eighty percent of tuberculosis cases today are in low- and middle-income countries, but tuberculosis occurs everywhere, and about half (50%) of those with untreated tuberculosis disease die.[22] Thanks to science, technology, public health education, better living conditions, and pharmaceuticals, tuberculosis is readily diagnosable, curable, and preventable. Yet today, more than one hundred years since Modigliani's death, tuberculosis causes illness in more than ten million people worldwide, including 1.2 million children, often with drastic consequences on a person's physical, psychological, financial, and sociological well-being.

I hope that a deeper understanding of this illness that has plagued humanity for thousands of years will help readers not only relate to all those affected by this disease, but also appreciate the individual burdens faced by our protagonist, Amedeo Modigliani, a young man who, in the early twentieth century, harbored what was still an incurable and fearsome infection.

§

PART II

THE DISEASE

CHAPTER 6

CONTAGION

"...I am ill. Spitting of blood and weakness."

Dr. Anton Chekhov[1]

Despite increasing scientific evidence that phthisis was a contagious disease, it was many years before its cause, Mycobacterium Tuberculosis (Mtb), was discovered (author's note: for the most part, I refer to "disease" as a pathological process affecting body organs and function, distinct from the word "illness," which is characterized by the experience of ill health and its various effects on the physical, mental, emotional, psychological, physiological, and social well-being of the affected individual).

The inventor of the stethoscope and illustrious French medical opinion leader, Professor René Théophile-Hyacinthe Laënnec (1781-1826), wrongly believed, at least for a time, that pthisis arose from having a constitutional predisposition to the illness, which included sorrowful passions and occasional causes – 'causes occasionelles' such as unhealthy sexual activity. In the second edition of his book, *Traité de l'auscultation mediate* (1819), published shortly before his own death from consumption, Laënnec wrote that "phthisis has long been thought contagious, and it is still thought to be so by the common people, by magistrates, and by some doctors in certain countries, especially in the southern parts of Europe...in France, at least, it does not seem

to be contagious."[2] Despite this error of judgment, Laënnec's research of phthisis remains remarkable because of how he described clinical findings, particularly lung sounds by auscultation and the many extrapulmonary manifestations of the disease, stating, "There is perhaps no organ free from the attack of tubercles."[3, 4]

Expanding on the concept of careful clinical observation, epidemiologists in the 1800s began a systematized study of persons exposed to infectious diseases.[5] Their work would change the medical lens and our perception of the origins of disease forever. Peter Parnum (1820-1885) reported observations of a measles epidemic on the Faroe Islands in 1846. Edwin Chadwick (1800-1890) used health statistics in his 1842 report, "To the Poor Law Commission," which detailed the vital relationship between hygiene and health. In 1847, Ignatz Semmelweiss (1818-1865) demonstrated how the origins of puerperal fever in a Viennese hospital were related to poor hygiene and an absence of handwashing. Puerperal fever is usually caused by bacterial infections of the female reproductive tract following childbirth or abortion. It was also called childbed fever. Today it is known as postpartum infection. During Semmelweiss's time, it was a frequent cause of postpartum death. John Snow (1813-1858), who studied the transmission of cholera in the mid-1850s, was among the first medical scientists to suggest cholera was caused by contaminated water (the toxin-producing gram-negative bacteria *Vibrio cholerae* would be discovered in 1883).[6] The idea that microorganisms could be responsible for causing disease became a reality when more than two hundred years after Anton van Leeuwenhoek (1632-1723) invented the microscope, Louis Pasteur (1822-1895) proved their existence in 1857. Twenty years later, Robert Koch (1843-1910) proved causality and furthered what became known as the germ theory of disease when he finally linked a specific rod-shaped bacterium to a specific disease (anthrax). He was able to first transmit anthrax to mice by inoculating them with blood from sick cattle. Recovering the rod-shaped bacteria, he was then able to transmit the disease to other mice.[7]

Numerous medical scientists and physicians had focused their efforts on the study of patients with other diseases. In 1834, Johann

Lukas Schoenlein (1793-1864) used the term *tuberkulose* in his lectures to describe diseases with "tubercles" (i.e., small lumps, from the Latin *tuber*).[8, 9] It seems that the name *tuberculosis* as it relates to phthisis, however, was first used in 1854 by a German physician, Herman Brehmer, in his doctoral thesis, *On the laws concerning the beginning and progress of tuberculosis of the lungs*.[10] Brehmer would also propose treating consumptives by packaging an open-air mountain cure, special diet, and supervised exercise program together in what he called "a place for healing" – a sanatorium in the peaceful alpine village of Göbersdorf, where his sister-in-law owned a spa on the border between Poland and the Czech Republic.

In 1865, the French army surgeon, Jean-Antoine Villemin (1827-1892), grew interested in consumption.[11] Based on his experience with an equine disease named glanders, eventually shown to be caused by the bacterium *Burkholderia mallei* – which Villemin knew was highly transmissible among horses, donkeys, and mules, he demonstrated the transmissibility of what he called *tuberculose* from animal to animal, and also from man to animal, by injecting rabbits with caseous material and fluid from a man who had died from the disease.[12] In 1865, Villemin thus proved without a doubt that tuberculosis was a transmissible, infectious disease. He published his results in a volume titled *Etude sur la Tuberculose* in 1868, but the etiology of the disease remained a mystery.[13]

By the late 1850s, the French chemist Louis Pasteur (1822-1895), already famous for his work on fermentation, had convinced the scientific community of the validity of his germ theory of disease. More than two decades later, on the evening of March 24, 1882, a German physician and future Nobel Prize winner named Robert Koch (1843-1910) enthusiastically announced to the Berlin Physiological Society that he had identified the slow-growing human tuberkelbazillus – the tubercle bacillus that caused tuberculosis.[14] In an article published three weeks later, he formulated what became known as Koch's postulates, a foundation for the study of all infectious diseases; (1) the observation of a bacillus in all cases of the disease; (2) growing the bacillus outside the host's body; and (3) reproducing the disease in a susceptible host using

material obtained from culture of the isolated organism.[15] A microbiologic diagnosis was made possible shortly thereafter when another future Nobel Prize winner, and a future employee of the Koch Institute, German physician Paul Erlich (1854-1915), discovered the acid-fast staining properties of the tubercle bacillus. The bacillus retains certain dyes but is not visible on other types of chemical stains. Using the Ziehl-Neelsen stain, for example, acid-fast organisms appear bright red or pink while the background stains blue.* These scientific discoveries made laboratory diagnosis of the tuberculosis illness possible, and in 1893, the tubercle bacillus was officially named *Mycobacterium Tuberculosis (Mtb)* (Appendix A – It's All About Mtb).

But, the journey of scientific discovery from tubercles to mycobacterium tuberculosis was long and fraught with obstacles.

§

*Thus identifying Mycobacterium tuberculosis. The lipoid capsule of the bacillus which is waxy at room temperature, stains with carbol-fuschsin and resists decolorization after a dilute acid rinse. Another stain used to detect mycobacterium species on clinical specimens is the auramine stain, originally developed in the 1960s. The dye binds with mycolic acids within the bacterial cell wall, causing acid-fast organisms to emit a bright green-yellow fluorescence when exposed to ultraviolet light.

CHAPTER 7

—◦◦◦•◦◦◦—

TUBERCLES

"There is perhaps no organ free from their attack."

Doctor René Théophile Laënnec[1]

In the second century CE, the Greek physician and philosopher Claudius Galenus, anglicized as Galen of Pergamon, was famous for performing animal dissections and vivisections in ostentatious ceremonial fashion. In Western Europe, his influence was particularly marked during the Renaissance, when medical students studied his latinized translations (a collection of his work in the original Greek, the Aldine edition, only became available in 1525).[2] Galen described the roles of several organs and demonstrated how nerves functioned, sometimes by severing sections of the spinal cord in front of an enthusiastic audience. Although many of his proclamations were wrong, he provided numerous anatomical insights and corrected many errors and presuppositions from earlier times.[3]

One important discovery was his description of *tubercles* in the lungs; from the Latin – *tuber*, a small swelling. Considering them to be tumors of a certain sort, he called them *phûmas*. Almost one hundred years earlier, the Roman encyclopedist A. Cornelius Celsus (25 BCE-50 CE) described bleeding from tubercles in the airways and lungs in Book 4 of *De Medicina*, also noting that, "When blood is spat up there is more cause for alarm, although that presents at one time less, at

another time more of danger."[4] Sadly, *De Medicina* was a voluminous work that was largely ignored by the encyclopedist's contemporaries. It was finally published only after the introduction of the printing press in 1478.

Galen also noticed swelling ulcerations, now called *scrofula*, synonymous with *struma*, although he was not the first. Aristotle (384 – 322 BCE) had described similar swellings of a cold and mucus nature on the skin of domesticated pigs, oxen, and wild boars – *scrofa* is Latin for "breeding sow," evoking the image of a row of suckling baby pigs. He described how swellings could spread from one animal to another. Translating from the original Greek, Aristotle may actually have been referring to small lumps around their necks. Hippocrates had declared these were caused by noxious humours and called them *choirades* (Χοιράδες – Xiráδes).[5] He proposed that ill health was caused by an imbalance in the distribution of cardinal fluids inside the human body: blood (red), black bile (from the Greek *melas*-black, and *khole*-bile), yellow bile (jaundice), and phlegm (white). The red, painful tissue swelling of inflammation, for example, was presumed to be caused by an overabundance of blood. Today, we know scrofula is a form of extrapulmonary tuberculosis. The usually painless inflammation of lymph glands in the neck region is called *cervical lymphadenitis*. Many patients with scrofula also have active pulmonary tuberculosis and may thus be contagious.

Despite Galen's discovery and description of *tubercles* in the lungs, he continued to propagate the idea that the seeds for disease occur outside the body and spread through the air, entering the body by inhalation and causing putrefaction when the "land" is favorable. This theory, which dates back to Hippocrates, is called the '*miasmas*' theory of disease – derived from the Greek verb *miaino*, which means to "stain, defile or pollute."[6]

After Galen, practical anatomy was virtually forbidden in Western Europe. This was due, in part, to the practice by several anatomists of vivisections in both animals and humans. Christian dogma prohibited dissection and paralyzed original scientific thinking for almost a thousand years. Saint Augustine (354-430 CE) said dissection was "an

inhumane interference in human flesh" that could not contribute to man's understanding of God-ordained harmony. Some studies of physiology and pharmacology continued, but after the destruction of books and papyri held in Alexandrian libraries in the fourth century CE, and despite numerous translations and retranslations of Galen's work, including significant alterations of his writings, almost a thousand years passed before interest in the anatomical sciences resurged.[7, 8]

In the fourteenth century CE, Mondino De Liuzzi (1275-1326) performed human dissections on executed criminals as part of regular teaching sessions once or twice a year at the University of Bologna. For the next two hundred years, dissections were performed in an effort to better understand anatomical illustrations, many of which were found in Galen's texts, but not to gain new knowledge. During the Renaissance, anatomical theaters were opened to the public, permitting artists such as Leonardo da Vinci to witness dissections firsthand in order to extend their knowledge of human anatomy. Grave-robbing too became popular, and, as dissection sessions became increasingly theatrical, the great Flemish physician and anatomist Andreas Vesalius (1514-1564) corrected many of Galen's errors, even while being accused of infamously exposing the still beating heart of a presumably deceased Spanish aristocrat.

In 1546, the Italian physician Girolamo Fracastoro (1483-1553) was one of the most distinguished intellectuals of his day. He was also a professor of logic and anatomy at the University of Padova – one of his contemporaries was a medical student named Copernicus (1473-1543), who would help initiate a scientific revolution by placing the sun rather than the earth at the center of the universe (in *De revolutionbus orbium*, published the year of Copernicus's death in 1543). Fracastoro declared that phthisis was contagious. He argued against the notion of a hereditary predisposition for the illness and said that patients warranted isolation measures similar to those recommended for victims of the plague. Having described typhus and named syphilis a "French Disease" in his poignant poem *Syphylis sive Morbus Galicus*,[9] Fracastoro wrote *De Contagione*. In this book, he claimed infections were caused by 'seminaria contagiorum', which were invisible, tiny spores that were

unique to each disease and spread by direct contact such as shaking hands, indirect contact through clothing, or even dispersed through the air.[10] This novel, comprehensive theory of contagion was different from Galen's theory of miasmas – disease propagated through bad air – that had dominated scientific thought for centuries. Fracastoro's theory was ignored, however, because he could never prove the existence of his imperceptible seed-like entities. These remained invisible until they were one day seen under a microscope fashioned after a three-powered telescope device called a "perspicullum," designed by astronomer Galileo Galilei in 1609.[11]

Another professor at the University of Padua, Doctor Giovanni Battista Montanus (1498-1551), wrote that for contagion to occur, some sort of contact was necessary. He lobbied to prevent consumptives from spitting on walls and said that walking in bare feet onto the spittle of a consumptive was enough to contract the disease.[12] This was around the time that British physician, William Harvey (1578-1657), formulated his theory about the circulation of blood based on observations made during cadaveric dissections, including those of his father and sister.

A few years later, the German anatomist François de le Böe, known by his Latin name, Franciscus Sylvius (1614-1672), advanced the ideas of both Hippocrates and Galen when he described how small, inflammatory hard-swellings he called "glandulous tubercles," could become soft and form destructive cavities in the lungs. He wrote, "From these tubercles I hold that not infrequently phthisis has its origin. Only the wasting caused by ulcers in the lungs is to be called phthisis, particularly when it is associated with cough, sputum, and hectic fever." Comparing them to scrofulas, Sylvius generated the idea of a relationship between Scrofulosis and consumption.[13]

In 1679, Theophilus Bonetus (1620-1689) observed a lung "seeded with minute tubercles" and in 1700, Jean-Jacques Manget (1652-1742) compared the minute tubercles to millet seeds (magnitudine seminum milii). The rapidly spreading form of consumption thus described would become known as *miliary tuberculosis*.[14]

Shortly after Sylvius's death, discoveries were made by an English physician named Richard Morton (1637-1698) in the court of King

James II. Morton compared the roundish, glandulous swellings he found in the lungs of patients with consumption to tissue changes he discovered in the swollen glands of patients with scrofula. First, however, he needed to distinguish these from changes due to other inflammatory illnesses of the neck, such as goiter and mastoiditis. Morton described the lung tubercles as being filled with a white, semi-solid, cheese-looking – caseating collection of dead material called *caseous necrosis*. In patients with consumption, Morton said, lung ulcerations and decay were associated with fever and a characteristic wasting away of the entire body. He proposed, but could not prove, that tubercles were contagious and the disease could run either an acute (which in medical terms means sudden and short-lasting) or chronic course.[15] "This distemper-as I have observed by frequent experience-like a contagious fever, does infect those that lie with the sick person with a certain taint," he wrote. He also observed that one of his patients "lived almost from his youth in a consumptive state, and from the age of sixty began to go downhill...his wife also contracted the disease but recovered."[16] Against great resistance from his colleagues, Morton suggested that consumption was a single disease derived from tubercles rather than from miasmas, inflammation, or ulcerations, as Hippocrates and Galen had suggested. Although Morton's ideas influenced later medical scientists, they did not go over well with many already established medical leaders of his time, such as Thomas Sydenham (1624-1689), Friedrich Hoffmann (1660-1742), or Herman Boerhaave (1668-1738) who stubbornly supported older theories.

In 1720, Benjamin Marten suggested illness was caused by "a specific animalicule"[17] and that "habitual lying in the same bed with a consumptive patient, constantly eating and drinking with him, or by very frequently conversing so nearly as to draw in part of the breath he emits from the Lungs, a consumption may be caught by a sound person."[18] After that, Scottish anatomic-pathologist Mathew Baillie (1761-1823) showed in his illustrated pathological works such as *Morbid Anatomy*, published in 1797, that tubercles also formed in organs other than the lungs.[19] For example, tubercles in the liver associated with the abuse of alcoholic beverages could be distinguished from scrofulous ones based

on differences in color and texture.[20] He was perhaps the first to differentiate tubercles from glands, describing the firm white, or softer thick curd, pus-like substance within.[21] Not surprising for the times, Baillie died from consumption.

Another anatomist, Aloys Vetter (1765-1806), working solely from autopsy material at The Algemeines Krankenhaus in Vienna and Crakow, distinguished between various lesions found in phthisis of the lungs and tubercles that were inherited or caused by other diseases (the word autopsy comes from the Greek *autopsia*,"a seeing with one's own eyes"). Yes…Vetter also died from tuberculosis. Indeed, for more than two hundred years many anatomists in Europe refused to dissect victims of pulmonary tuberculosis for fear of infecting themselves while those patients who were alive and suffering from the illness were ostracized and considered to harbor "the greatest human misfortune".[22]

In 1810, Gaspard-Laurent Bayle de Vernet (1774-1816) stressed that tubercles were the essential features of pulmonary phthisis in his *Recherches sur le phthisie pulmonaire*.[23] "Haemoptysis (author's note: the couging up of blood) is a frequent symptom of consumption, and is sometimes mistaken for its cause; but it often happens that when haemoptysis has been fatal, the lungs are found full of tubercles."[24] This French physician had studied under Napoleon's doctor, the famous Jean-Nicholas Corvisart. Bayle de Vernet performed more than nine hundred autopsies before finally describing six different types of consumption. In a sense, he confirmed the findings of the first-century Roman encyclopedist and surgeon Aulus Cornelius Celsus (25 BCE – 50 CE), who had described bleeding from tubercles in his patients' airways seventeen hundred years earlier.[25]

You guessed it…Bayle de Vernet was only forty-two years old when he too, died from consumption.

§

CHAPTER 8

LET IT BLEED

"I make phthisis very rare."

Dr. Francois Jean-Victor Broussais[1]

With so many deaths attributed to the "white plague," also known as phtisis and consumption, it was natural that healers, first known in ancient Rome under the generic term *medicus*, occupied themselves with the diagnosis, treatment, and sometimes cure of suffering patients.[2] Teachings were initially of an experiential nature as practitioners ventured into the realms of dietetics, pharmacotherapy, surgery, and medical science. The exercise of the profession was usually unregulated, however, giving rise to low standards and frequent abuse of trust, though not necessarily intentional.

"If walks are beneficial to the patient, let him take them; if they are not, he must keep his body as quiet as possible."[3] After this sage advice from *Internal Affections*, a book of the Hippocratic Corpus in the fourth and fifth century BCE, many learned men of medicine, most of them followers of the cult of Asclepius, offered questionable remedies for patients with phtisis or "wasting disease." Warm gruels, vapor baths, enemas and cathartic mixtures made of medicinal concoctions of herbs such as *Daphne gnidium*, *Cuscuta epithymis*, and *Euphorbia peoples* were commonly prescribed.[4] Lest we forget, these fine doctors also offered suppositories made of honey, *Thapsia garnica*, flour, eggs,

51

salt, and *sesamum orientale* to people with troubled breathing. For those who coughed and had trouble raising phlegm, they prescribed Mead, an alcohol made of fermented honey and water, referred to as the "drink of the gods," which served as an expectorant.

But it didn't stop there.

Hundreds of years later, Aretaeus of Cappadocia told Romans in the 1st century CE that "living on the sea will be beneficial" and "to have a good diet of porridge, pastry, spelt, and edibles prepared with milk. . ."[5, 6] Inspired by Hippocratic environmentalism and a need for physicians to master "the effect of each of the seasons of the year, and …winds, the hot and the cold common to every country,"[7] the Augustan medical writer Celsus (25 BCE-50 CE), recommended a change of air and a long sea voyage in addition to prescriptions of turpentine mixed with butter and honey, a proper diet of gruel, rice, grilled brains, and light wine.

Not to be outdone, a few years later, Pliny (23-79 CE) jumped in to treat some patients with inhalations of dried cow dung.[8]

When conservative methods like emetics, purgatives, and herbal remedies failed, the great Hippocrates proposed *temnein* – cutting, also known as blood-letting, or venesection and phlebotomy (from the Greek *phleb* – vein and *tomia* – cutting) as a means to support the healing work of Nature.[9] The procedure was presumed to rid the body of its impurities while restoring harmony between the four humours – black bile, yellow bile, phlegm, and blood, whose material constitution was affected by the four elements (also called contraries) – cold, hot, dry, and moist that comprised what became known as the Empedoclean elements of earth, air, fire, and water.[10] This 'humoral theory' of health and disease dominated Western medicine for almost two thousand years. It was based on the idea that illness results from an imbalance of the humors or changes in so-called "naturals," which are the environment and climate outside human control.

The pre-Socratic philosopher Diogenes of Apollonia, from the fifth century BCE, had postulated that air was the basic substance of all things and that humans acquired "vital air" (*pneuma*) through breath, which fueled the soul and made people capable of thinking, reason,

and sensation.[11] According to Hippocratic works, the heart, however, was considered the seat of "innate heat," and the role of respiration was to cool this heat. At first, blood vessels particularly noted around the heart and the liver, were grouped under the name *phleps* (φλεβες). Presuming that each anatomic structure had to have a precise role, Praxagoras of Cos, born in 340 BCE, distinguished that by their structure, veins were different from arteries. After observing that arteries were emptied in animals killed by strangulation for dissection, he proposed they carried *pneuma*.[12] Veins, on the other hand, carried blood that provided nourishment (*trophe*) to the body before being used up by the tissues, not unlike the way farmland is irrigated by a water canal.

Galen of Pergamon (129-216 CE) was the official physician for gladiators before becoming famous under the Roman Emperor Marcus Aurelius. He proposed that innate heat was necessary to the generation of the four humors, noting that "children grow of it" and that in the elderly, "the innate heat withers away and is finally extinguished, which is death."[13] Expounding further on the Hippocratic theory of the four humors, Galen taught that all the humors were collected in vessels that were readily assessed by taking a patient's pulse. He wrote perhaps eighteen books on the art of taking the pulse – *ars sphygmology* – in which he described how the arterial pulse, conveniently taken at the wrist, was synchronous with the heart. He additionally described the pulse's variations in illness and in health.[14] Air, he said, which is cool and dry, entered the lungs before being transferred to the blood vessels and delivered to tissues through the vascular system. In several of his writings of the 2nd century CE, including in his treatise, *De temperamentis* and *On the Doctrines of Hippocrates and Plato*, Galen argued that inflammation was caused by a flux of humors, with different mixtures occurring in response to stimuli such as fever or over-exertion of a particular body part.[15, 16, 17] He agreed with Hippocrates that humoral imbalance resulted in illness.[18] Rebalancing would restore health, and bloodletting, in particular, could discharge bad or noxious humours.

Extolling the benefits of menstruation for women and the relief patients obtained from bleeding in cases of hemorrhoids, including a flawed observation that people with hemorrhoids did not succumb

to pleurisy or pneumonia, Galen, like many Hippocratic physicians before him, thought he would imitate nature by bloodletting both curatively and to prevent disease.[19] Despite the remonstrations of another famous physician, Erasistratis,[20] Galen added bloodletting to his treatment regimen for phthisis, which also included using opium to diminish cough, fresh air. . . and, believe it or not, placing glowing hot irons on a patient's breasts to "direct any pus into the outer parts." To help his patients feel better, Galen also prescribed milk from a female ass and drinks of Hyssop and fleawort boiled in sour wine. If that didn't do, he recommended wrapping his patients' feet with cataplasms made of "myrrh-oil steeped in a potion of lupines, wiped off and smeared with butter" three times a day.[21]

A belief that disease could be cured by bloodletting was so strong it became a standard of care well into the Middle Ages, a time when Saint Bernard de Clairvaux wrote, "Man should be bled for two reasons; he either has too much blood, or he has bad blood."[22] Bleeding was necessary to maintain good health as well as to combat any and all "dis-ease" or subjective discomfort.[23, 24] Day-to-day procedures were performed by barber-surgeons, not all necessarily trained medical doctors. Red and white poles were placed in front of their places of practice; the pole represented the staff held by the patient at the time of the blood draw, the red signaled blood, and the white represented the bandages used to stop the bleeding.[25]

Léonardo Botallo (1530-1587), a physician at the French court, practiced liberal bloodletting rather than clystères (enemas) and other procedures to cure all remedies, a belief also supported by French Jansenist physician Philippe Hecquet in the nineteenth century.[26] In the years ahead, bloodletting for supposed phthisis would withstand attacks by Paracelsus (1493-1541), who preferred a prescription of mercury, zinc, and opium he called laudanum,[27] and Jean Baptiste van Helmont (1580-1644), who said the results of bloodletting, if studied, would be inferior to a chemical cure and that by draining blood, the phlebotomist drained the patient's soul.[28, 29]

Other than bloodletting and numerous ineffective remedies, medical care for patients with consumption was dominated by astrology,

myths, charms, and prayers based on hope and anecdote.[30] John Comrie, a medical historian from Edinburgh, for example, described the success of the "Royal touch," a tradition dating to Clovis (465-511 CE) and practiced by French and English monarchs who thought they could heal scrofulous individuals by simply touching them.[31, 32, 33] The common folk probably thought less of this tradition, considering the popular saying, "the king touches you, God cures you," persisted in Europe for more than a thousand years.[34]

Also crucial to healing were the *non-naturals* of air, diet, exercise, sleep, evacuation, and passions – those environmental and dietary factors not controlled by our human nature.[35] In a highly religious society, it was natural that recovery from disease was notably linked to God, Nature, and only sometimes, physicians. This was all the more so in the absence of effective pharmaceuticals and before the advent of modern scientific methods.

Throughout the seventeenth century, bloodletting was still recommended in addition to open-air cures by Richard Morton, who additionally warned patients "to avoid sleeping too long in the morning, because much sleep is wont to retain and heap up a great load of Humours in the Habit of the Body." Thomas Sydenham (1624-1689), nicknamed "the English Hippocrates,"[36] was avidly against bloodletting, but he was among the first to suggest consumptives go for long rides on a horse.[37]

By the early eighteenth century, physicians debated the generally accepted Humoral theory of disease against that of *Solidism*, a now obsolete mechanistic approach whereby only solids and fiber were presumed to be the source of disease, and in which the body was equated with a hydraulic machine circulating fluids through hollow vessels.[38] Bloodletting by phlebotomy was supplemented by a technique known as blistering – caused by applying a caustic agent such as potassium hydroxide onto the skin, and cupping – leaving a hot glass on the skin to create a suction vacuum and drawing blood to the surface.[39, 40] Emetics such as ipecac and tonics like Peruvian bark (cinchona) were used to induce vomiting and treat tubercular fever. To stimulate the intestines, doctors prescribed cathartics such as castor oil Calomel, which

is loaded with mercury. In 1785, the Scottish physician, William Cullen, said dressing consumptives in warm clothes and keeping them in closed rooms would combat inflammation. While this ran counter to those who still believed in the therapeutic value of horseback riding, it may have been a helpful addition to other presumably antiphlogistic (anti-inflammation) therapies in damp, cold-weather Scotland. Early nineteenth-century British physicians, including the eminent James Clark (who would become Queen Victoria's doctor), told twenty-five-year-old John Keats, who had studied medicine for a year at Guy's College in London and became a certified Apothecary before abandoning the medical profession to become a poet, that starving himself, being bled, and lying still in a dark room with closed windows would slow the progression of his illness while on cure in Rome.[41] Of course, this did nothing to prevent the young man's death a few months later, in 1821.[42] Nor had similar recommendations prevented the deaths of his mother and brother, who also succumbed to consumption.

Contemporaneously, patient discomfort was relieved using concoctions containing Opium, which would also reduce cough and the "nervosity" that might predispose to the deadly disease. Maintaining a tradition begun by the ancient Greeks and Romans, the benefits of a long voyage at sea were again expounded, this time by the well-known British physician Scot Ebenezer Gilchrist, in 1769. Many still believed purgatives had the power to discharge or attract an appropriate humor.[43] Even the famous French physician, Théophile Laënnec, suggested using a tartar emetic to produce vomiting and mercury to combat inflammation. For others, and for people with consumption who had the money and the energy, horseback riding remained in vogue for more than one hundred years. Ironically, the rapid deterioration of patients with tuberculosis was often referred to in the nineteenth century as "galloping" consumption.

In addition to these ineffective therapies still practiced during the first half of the nineteenth century, bloodletting was prescribed for virtually everything. Removal of 400-800 ml (at least 1.5 cups or 13-27 fluid ounces) of blood at a time was possible by incising a vein in the arm, foot, or neck – the jugular vein was often used in children.[44] Topological

bloodletting – cutting on a site predetermined to affect a specific target organ – was still recommended by some. We should remember that *Vampirism* was a fad, even before Bramstoker's famous novel, *Dracula*, in 1897. Lancets were spring-loaded or double-edged blades.[45] For patients with pleurisy, Laënnec wrote, "It is necessary to cut the inner vein at the elbow and not shrink from withdrawing a large quantity, until it flows redder or yellower, or becomes livid instead of clear and red."[46] The inventor of the stethoscope was against bloodletting his patients with phthisis "except to remove inflammation,"[47] which means he probably bled people more often than he let on. He can be applauded, however, for saying that "bleeding can neither prevent the formation of tubercles nor cure them when formed." Thankfully, he advised against cautery and quickly abandoned this dastardly yet commonly practiced procedure whereby a red-hot iron was applied to the chest, back, and underarms as many as twelve to fifteen times. Laënnec, who must have done this a few times without therapeutic effect, acknowledged that "only a small number of patients will submit to a mode of treatment so horribly painful."[48]

For bloodletting, he thought cupping, after scraping the skin with a small knife, was better than using medicinal leeches – named *Hirudo medicinalis*.[49] The animal is found in certain swamps and marshes. It has three jaws and releases an anticoagulant, Hirudin, that keeps blood flowing for several hours after the leech has been satiated.[50] Parisian physician and a contemporary of Laënnec, Professor Francois Broussais (1772-1838), championed the erroneous idea that most diseases, including phtisis, were due to chronic tissue inflammation that could be stopped through bloodletting. He became known as the French vampire of medicine because he used up to fifty leeches at a time per patient.[51] Broussais said he could control the quantity of blood removed and avoid the fatigue, fainting, oh…, and sometimes death that occurred after phlebotomy. The bloodsucking animals were usually applied onto the body surface corresponding to the inflamed organ – which, for consumptives, was usually the chest. In the 1830s, more than six million leeches per year were used in Paris alone,[52] and in 1833, France imported more than forty-two million leeches for medical use.[53]

History offers two particular examples of death from bloodletting. In the United States, former President George Washington was probably bled to death in 1799 after having forty percent of his blood removed while his doctors treated a throat infection. In Italy, a few days before British Lord Byron's death in 1824, Byron's physician, Dr. Bruno, offered to bleed him. "Have you no other remedy than bleeding?" Byron asked. The famous poet, who probably suffered from malaria, declined the doctor's offer. "There are many more who die of the lancet than the lance," he said. But, in the end, he was bled twice anyways, fainting each time…and then he died.[54]

In addition to bleeding, consumptives were treated depending on the context, physician biases, training, and geographic location. In Northern Europe, Cod liver oil, pills of copper sulfate, morphine, and astringent inhalations of Tar, iodine, turpentine, and hemlock tannic acid vapors were administered, especially in case of hemoptysis. To fortify the skin before and after bathing, frictions with croton oil, sulfate of copper, oxide, and sulphate of zinc, as well as spirits of turpentine and other substances, were also used. In Southern Europe, consumptives drank infusions made of belladonna and opium, swallowed seeds of Hemlock water dropwort – *Oenanthe crocata*, the most poisonous indigenous plant in Great Britain, and spread corrosive ointments made of emetic tartar – antimony potassium tartrate (called *revulsives*) on their skin. In a puzzling twist on the chicken or egg metaphor, some physicians believed the formation of pus fought inflammation caused by the disease.

Emetic tartar was also known as Autenreith's ointment. It was traditionally reserved for children with whooping cough, but in consumptives, it was continued until pustules formed on the skin, which soon became ulcers, signifying the body was sufficiently saturated and would begin healing. In another astounding example of medical practitioners remaining blind to the obvious, any untoward reactions to the ointment were attributed to underlying disease rather than the treatment itself. Finally, an Italian physician, Giovani Rasori, demonstrated the damaging rash could be avoided if patients took pills instead.[55] Unfortunately, Rasori also used pills of Tartar Emetic as a sedative to treat

pneumonia, believing it served as a counter-irritant. He never realized the pills' effects were toxic, if not lethal.[56]

By the 1840s, bloodletting was still the standard of care for treating most forms of inflammation, which was considered both a symptom and a disease by then. The procedure, with the addition of purging, came to be known as "heroic therapy."[57] It was indicated for all forms of fever or congestion, including consumption. Oblivious to the harm they caused, most physicians stubbornly supported the erroneous concepts that justified this centuries-old practice. Yet, as far back as the sixteenth century, Fracastoro wrote that "In fevers, I do not approve of phlebotomy, because they [the contagious seminaria or seeds] very seldom have their origin in the body, they come from without, either from fomes (what we call today fomites) or the air, or they are conveyed from one person to another."[58]

Doubt in the efficacy of bloodletting procedures arose despite French physician and early statistician Pierre Louis's (1787-1872) ambivalence about the procedure. Louis wrote that "bloodletting, notwithstanding its influence is limited, should not be neglected in inflammations which are severe and are seated in an important organ."[59, 60, 61, 62, 63] In a retrospective study, John Hughes Bennett (1812-1875) showed that bloodletting did not improve survival in patients with pneumonia. By the 1850s, therefore, doctors who kept up with the scientific literature – not all of them did – were aware of the procedure's shortcomings.[64]

During the second half of the nineteenth century, advances in technology, the rise of laboratory medicine, and the practice of pathological anatomy changed how physicians thought about a variety of medical issues.[65] The study of morbid anatomy steadily replaced the ancient humoral theory to explain disease processes. This was accompanied by a new awareness regarding the origins of infection, classifications of diseases, and the interrelatedness of both with empirical clinical findings. Physicians were increasingly mindful and accepting of the concept of causality… they learned that lesions explained symptoms. Modern notions of epidemiology and contagion soon altered the physician's place in society, expanding their role to help assure public health and safety. Medical professionals supported antisepsis and asepsis, accepted

germ theory, and enthusiastically embraced a budding pharmaceutical industry. Further scientific discoveries, preventive medicine, and the chemical manufacture of drugs and medications would change the face of medicine forever.[66]

§

CHAPTER 9

BEWARE (OF KISSING)

"Spittle is the enemy."

Lionel Amodru[1]

B y the end of the nineteenth century, physicians were increasingly discouraged by their ineffective and often dangerous therapies for tuberculosis. The process by which scientific methods replaced historic empiricism to help guide patient care was frustratingly slow. Bloodletting was mostly abandoned, but in 1892, even the famous Canadian physician and Professor of Medicine, Sir William Osler (1849-1919), still advocated for the procedure in patients with pneumonia. In his textbook, *Principles and Practice of Medicine* (1892), he wrote, "Pneumonia is one of the diseases in which a timely venesection may save a life. To be of service it should be done early."[2, 3]

Effective antibiotics such as streptomycin and isoniazid would not be discovered for another forty years. In Europe and abroad, therefore, the primary focus was on protecting healthy populations and preventing the spread of disease. Authorities decreed that consumptives were a danger to society. In the United States, tubercular patients were ostracized and disparagingly called "lungers." Discrimination against consumptives became rampant as thousands of thin, pale-skinned, coughing, and sometimes feverish patients with known or suspected illness were isolated in their homes, where they had to be cared for

61

by family members and friends. Others, particularly those poor and otherwise marginalized from society, were crowded into multibed insalubrious hospital wards to await their inevitable demise, an end that authors of the romantic period would refer to as a meeting with the grim, white ghost of death.[4]

Throughout much of the nineteenth century, the general public was seized by fear of the disease. Fines were levied against anyone, including physicians, who broke isolation policies. Loved ones and friends caring for the sick contracted the illness – many of them died. People with signs of tuberculosis were refused lodging or asked to vacate properties.[5] Tavern keepers could not rent out rooms if they were suspected of harboring a consumptive; ceilings and walls needed to be whitewashed, and sometimes, doors, window settings, and personal belongings were burned.

Examples of the emotional, physical, and psychological strains caused by such practices were described by nineteenth-century travelers such as consumptive poets John Keats (1795-1821) and Percy Shelley, as well as by Alphonse de Lamartine, whose wife died from tuberculosis, and in George Sand's letters about her partner, the composer Frederic Chopin (1810-1849), whose pulmonary symptoms were suggestive of the disease.[6] The community where they lived, in Majorca, Spain, shunned him and forced him to leave. In one letter, Chopin wrote, "These two weeks, I was sick as a dog, I got a chill despite the temperature of 70, amidst roses, oranges, palms and fig trees. Of the three most famous doctors on the island, one sniffed at what I spewed up, the other tapped at the place from where I spewed it, the third poked and listened while I spewed. The first said that I was dead, the second that I was dying and the third that I would die."

At the time, tuberculosis was thought to have killed one in seven of all people who ever lived.[7]

It was considered a duty for caregivers, usually women, to care for the sick. Hospitals dedicated to consumptives were common, and a few private facilities emerged for those who wanted to avoid the stigma of charity. Admission was determined both by social and economic status. The working poor, however, were a particular problem for most

governments because a family's resources were quickly depleted by disease. Increased urbanization had depopulated rural areas and over-populated cities, where sanitation and personal hygiene left much to be desired.

Except for Germany, where tuberculosis was being fought by new social security legislation and health insurance, patients suffered miserably. Without health insurance, workman's compensation, or disability insurance, anyone with a communicable disease like tuberculosis could not find gainful employment for weeks, if not months, and sometimes forever. Yet, in France, there was no public declaration of the dangers of contagion. Laënnec's longstanding opinion that tuberculosis was neither curable *nor preventable* had to be abandoned by medical authorities. Joseph Grancher, an immunologist and practicing pathologist at the Pasteur Institute, argued to the French Academy of Medicine that drastic legislative changes were urgently needed to protect the populations from contagion. "We know…that the *tuberculeux* who spits or secretes his bacilli is dangerous and that we must be protected from him…" he wrote in 1898.[8] By 1900, at least 100,000 deaths were attributable to tuberculosis – that is, almost two thousand people died from the disease each week.[9]

In Paris, tuberculosis was responsible for twenty-five percent of all deaths, a mortality rate twice that of London.[10] Meantime, thousands of patients entered public hospitals sustained by charitable or religious organizations. Previously working individuals mingled with beggars, prostitutes, and the homeless in an attempt to benefit from free care, diagnosis, and treatment in exchange for providing their doctors and medical students with human material, in other words, their bodies, from which medical professionals learned the art of diagnosis and treatment. Debates raged regarding legislation that could mandate physicians to reveal a patient's diagnosis of tuberculosis, accompanied by laws for mandatory disinfection of homes, schools, the workplace, and institutions harboring persons suffering from the disease or who had died from Mtb.

The extreme contagiousness of the disease had to be the focus of preventive efforts. While patients bore the burden of medical education

[handwritten margin note: Roots of containing contagion]

and procedural training, attempts to improve institutional hygiene led to architectural changes such as smaller hospital wards, larger hallways, high ceilings and windows, and better ventilation in hospitals and other healthcare facilities. In Paris, leaders of the *Assistance Publique* (French University Hospital Trust) had studied the problem of isolating tuberculosis patients since 1896, but it would take many years to implement their policies. Separate specialty-focused hospital pavilions were built in order to help isolate potentially contagious patients, their caregivers, and hospital personnel from other hospitalized patients and their healthcare workers.[11] The filth of earlier hospitals and almshouses where the poor received free care was partially remedied thanks to a growing focus on sanitation, although common wards (*trans.* salles communes) with only curtains separating patients' beds would continue to be used until the late twentieth century.

[handwritten margin note: why if not?]

Describing how the disease reflected inherited or acquired degeneracy in the United States, historian Katherine Ott writes that consumption was an illness, "not just of the body, but also of the mind and of spirit."[12, 13] In France, where the peak of tuberculosis-related mortality occurred around 1890, people were taught how to combat dirt, disgust, disease, and death.[14] Cleanliness became a valuable and safe therapeutic tool that fit well within the restraints of *miasmas* – the dangerous vapors and humoral theories of disease that remained anchored in the brains of many patients and their healthcare providers. Many Parisian hospitals financed through religious groups also added programs

[handwritten margin note: How?]

to help ensure their patients' spiritual salvation. In-hospital mortality, however, remained high, sometimes more than twenty-five percent on medical wards that specifically cared for tuberculous patients.

The risk of contracting tuberculosis was especially high for caregivers. A survey by Professor Louis Landouzy of the Paris Faculty of Medicine showed a death rate of 134 per 1,000 hospital employees per year between 1886 and 1895.[15] This meant that many doctors, nurses, and orderlies were probably infected or sick with the tubercle bacillus and potentially infectious. Even before this news became public, people seeking medical attention thought it was safer to be cared for outside the hospital rather than risk contracting tuberculosis while inside…

something those who experienced the recent SARS-CoV-2 pandemic
can relate to today. Aware of these statistics and the dismal outcomes
awaiting patients hospitalized with tuberculosis, the public naturally
blamed healthcare professionals. People became fixed in their opin-
ions that hospitals were a place to die rather than a place for cure. In
Germany, for example, hospitals were called *Krankenhaus* – the suffer
house. In Italy, the word *Ospedale* came from the Latin *hospitālis* –
hospice, which spoke little for an establishment's role as a beneficial
place for diagnosis, treatment, and cure.

*changed
now or
still
the
same?*

In an attempt to reverse the public's poor perceptions, French
politicians began referring to hospitals as *maisons de santé* – houses
of health.[16] Acknowledging that the infectious nature and cause of
tuberculosis were scientifically proven, advances in diagnosis laid the
foundation for new therapeutic measures and preventive strategies. Ex-
perts and political authorities alike knew the illness increased a person's
propensity to cough and expectorate. Hence, spitting, sneezing, and
coughing became the enemy – "Le crachat, c'est donc lui l'ennemi"
(*trans.* "spittle, there is the enemy"), wrote French Deputy and mem-
ber of the National Assembly, Lionel Amodru, quoting Professor Louis
Landouzy.[17]

Because sputum was proven to contain the bacillus, any and all
measures to limit and eliminate exposures were now justified. House-
hold workers, wives, and shopkeepers were told to use wet mops rather
than dry-sweep their homes and storefronts to avoid aerosolizing re-
spiratory secretions. Spittoons became commonplace, but like the
COVID-19 prevention strategy of mask-wearing in 2022, they were
subjects of debate. Some said the presence of spittoons in public build-
ings and theaters produced a stench of "profound disgust" and encour-
aged more spitting than usual.[18] Men, it seemed, liked using spittoons
for target practice.

An army of hygienists was sent to explore insalubrious hous-
ing where poor ventilation, overcrowding, and darkness exacerbated
the spread of disease. It is "above all, unsanitary housing, lacking air
and sunlight that is the great auxiliary of tuberculosis," Deputy Lio-
nel Amodru declared during parliamentary debates in 1901.[19] French

authorities focused their attention on the streets, where poor hygiene and slums were almost everywhere except around the city's grand boulevards and most affluent neighborhoods. However, it would not be long before the illness's victims also became the targets of political and public scrutiny. In 1903, with an estimated 700,000 cases of tuberculosis in France responsible for significant budgetary and public health concerns, hygienist Edouard Fuster emphasized the effects of tuberculosis on all of society. He told the Societé de Médecine Publique et de Génie Sanitaire that victims of the most severe forms of disease were menaced since their childhoods by perhaps heredity and contact with parents who had tuberculosis, certainly lived in poorly ventilated and crowded lodgings and suffered from poor nutrition that did not permit them to resist contagion. Prophylaxis, he said, would require "all measures destined to remove recognized vectors of contagion from still healthy environments; consequently, to *search* them out in all human communities, and then to *isolate* them as soon as they are a threat..." He further insisted, "It is not a question of throwing them to the ghetto, but to destroy the bacillus by *disinfection* everywhere its presence is suspected."[20]

But another problem raised its nasty head. Absinthe production had increased so much that it was less expensive than wine. Between 1876 and 1900, the nation's consumption of the "fairies' drink" soared from 1,000,000 liters to 21,000,000 liters per year, reaching 239,492 hectoliters in 1913.[21] With little regulation, alcoholic beverages of all kinds were sold in drink stands known as *buvettes* on street corners, in vegetable shops and tobacco stores, as well as in restaurants, cafés, and cabarets. If tuberculosis was a national peril, it was accompanied by another blight on France's Third Republic – alcoholism.[22] The War on Tuberculosis, therefore, would need to include battles against all that surrounded drinking, not to mention the unmentionable scourge of venereal disease. Drastic social reforms and new legislation were urgently needed to increase the capacity and obligations of municipal health departments so they could address the adverse consequences of alcoholism for individuals and families, as well as the harmful effects of increased population density and lack of effective preventive measures on the rapid spread of infectious diseases.

In 1903, Professor Louis Landouzy insisted that tuberculosis was both a medical and a social disease, emphasizing the need for prevention by teaching public hygiene in schools, at home, and in the armed services. "*Mieux vaut prevenir que guerir*" – Better to prevent than to cure, he wrote in his inspirational book, La *Tuberculose Maladie Sociale*.[23] In the meantime, every spittle or cough-related behavior in both public and private settings was considered a risk for contagion. "Méfiez-vous des baisers en général," – "Beware of kissing in general" – warned Dr. Paul Cuq in 1904 when he described how young married couples spread tuberculosis to each other and their children.[24]

Yes, by the time an enthusiastic and sexually active twenty-two-year-old Amedeo Modigliani would make his way to Paris, and a new life in early twentieth-century France, even kissing was to be avoided.

§

CHAPTER 10

WAKE UP

"Taking the lives of 4300 people each day."

Former CDC Director Rochelle Walensky[1]

"The history of tuberculosis is a story of medical failure," wrote Zumla and Gandy in the epilogue of their book, *The Return of the White Plague: Global poverty and the "new" Tuberculosis.*[2] In 2020, The World Health Organization (WHO) reported tuberculosis was the second leading cause of death by an infectious agent – after COVID-19.[3] In fact, the COVID-19 pandemic reversed whatever global progress had been made in reducing the number of people who died from tuberculosis in years past. A year earlier, in 2019, Mtb killed 1.5 million people, making it the top cause of death worldwide from a single infectious agent.[4, 5] In other words, almost three people in the world died from Mtb every minute.

Mycobacterium tuberculosis preferentially hitches a ride on respiratory droplets spread through the air when infected individuals cough, laugh, sneeze, sing, breathe, or talk. When the bacilli are inhaled, they pass through the mouth and nose to usually settle in the airways' smallest parts. There, in small airways called the bronchioles and in air sacks called the alveoli, the bacilli are attacked by the immune system. Special cells called macrophages swallow the bacilli, and the body's immune defenses sequester infected areas into small foci of

inflammation called granulomas. Only a tiny number of tuberculous bacilli need to be inhaled for a person to become infected, but not everyone who is infected will develop tuberculosis disease.[6] The bad news is that some bacilli can evade the immune system, persist without causing symptomatic disease even in the face of an adaptive immune response, and provoke a significant inflammatory reaction and diverse tissue pathologies that facilitate transmission.[7]

Almost a third of the world's population, about two billion people, are currently infected with Mtb. More than ten million people develop Mtb disease each year,[8] and at least three million people believed to have tuberculosis currently are either not diagnosed or not receiving treatment.[9] Left untreated, about fifty percent of people with the disease die.[10]

With good reason, tuberculosis was and still is a feared and often deadly disease that needs to be taken seriously.

Primary tuberculosis is the first encounter with Mtb. Controlled by the victim's immune system, the disease is mild and self-limited in ninety percent of cases. The lungs are usually affected. At the onset, the primary infection may cause coughing, weight loss, fever, and night sweats, but any organ system may be affected. Primary pleural infection is one of many possible causes of pleurisy, for example, which occurs less frequently than lung infections but is one of the most frequent sites of extrapulmonary tuberculosis.[11] Sometimes, associated pleural effusions go unnoticed, especially when they result from cell-mediated immunity and a hypersensitivity response caused after seeding the pleural space with microorganisms.[12]

In up to ten percent of infected individuals, cell-mediated immunity and other body defenses are unable to contain Mtb infection. The risk for progression to *active tuberculosis* is greatest soon after the initial infection and in persons with compromised immune systems. Patients who are immunocompromised by HIV/AIDS, for example, are at least ten times more likely to develop active tuberculosis than people with uncompromised immune systems.[13] Over time, chronic inflammation and a necrosis of the initial lesions – a process of *caseation* (caseum = cheese) – result in the formation of a collection of dead proteinaceous

tissues with a soft, white, cheese-like appearance (caseous necrosis). The softening of the caseum can be accompanied by the progression of Mtb disease, which in the lung can be associated with the formation of cavities, further growth of the bacteria in an oxygen-rich environment, extension into the airways, and a high risk of contagion when the bacilli are expectorated.[14]

At the end of Puccini's opera *La Bohème*, which was first performed in Italy in 1896, the young seamstress and grisette, Mimi, is surrounded by a philosopher, a musician, a singer, a painter, and her poet-lover Rodolfo. She dies "beautiful as the dawn." (*trans*. Bella come un'aurora).[15] Neither medical science nor the arts could save her. From a clinical perspective, patients with active pulmonary tuberculosis typically have a worsening cough, weight loss, fever (sometimes intermittent and thus described as 'hectic'), facial flushing (from low-grade fever), chest pain, loss of appetite, and night sweats. Over time, increased emaciation is accompanied by muscle wasting evidenced by prominent cheekbones and a wing-backed appearance of the shoulder blades, sunken eyes, and skin pallor. The pulse may become rapid and irregular, and cognitive decline may occur. Without treatment using appropriate antibiotics, the lung infection can be fatal, usually in less than thirty-six months.[16]

As mentioned previously, tuberculous bacilli are (probably almost) never eliminated. Infection with Mtb consists of a spectrum of disease states between active disease with symptoms of varying severity, including clinically significant illness, asymptomatic (without symptoms) latent infection, and reactivation disease.[17] During latent tuberculosis infection (LTBI), individuals are infected with the bacillus but are not infectious (i.e., contagious). This *latent phase* is usually without symptoms. It may last decades or even an entire lifetime.[18] Many people may not even know they are infected. Persons with latent tuberculous infection are not infectious and cannot spread the infection to others. From a scientific perspective, latency probably reflects a spectrum of reactions to tuberculosis infection, involving phenotypically distinct bacterial subpopulations and spanning various degrees of bacterial burden and associated host immune responses.[19, 20, 21]

In a few persons – about five to ten percent of infected individuals over a lifetime, the disease may enter a *reactivation* phase, causing re-activation disease or *post-primary tuberculosis.*[22] The dormant bacteria reactivate, causing disease even decades after the initial infection.[23] The risk for reactivation is highest when age, alcoholism, drugs, malnutri-tion, and illness weaken the immune status. It usually occurs as a result of waning immunity either from having an immature immune system (as in younger children), aging, undernutrition, smoking, or immune suppression from drugs, kidney dialysis, chemotherapy, chronic alco-holism, and diseases such as HIV/AIDS, diabetes, hemophilia, and can-cer. Progression of the disease can be rapid but is commonly slow-going. Hence it might also be considered historically as *consumption.*

Reactivation always causes symptoms. In patients with lung dis-ease, symptoms such as weight loss, fever, cough, and night sweats can begin insidiously. Sometimes, even early on, a person's sputum might be blood-tinged. As the disease progresses, damaged tissues can erode into the airways and blood vessels. Airway bleeding of any sort is called *hemoptysis.* Studies from the 1950s declared tuberculosis the most fre-quent cause of such bleeding.[24] Even today, about eight percent of pa-tients with tuberculosis will expectorate blood at some time during their illness.[25] Tuberculosis can additionally affect the airways directly, causing them to be coated with inflamed and necrotic tissues that give rise to coughing, airway narrowing, and difficulty breathing. Persons with active disease in the lungs or airways can be contagious. The degree of their infectiousness is directly related to the number of tubercular bacteria they expel into the air. In fifteen percent of cases, reactivation is outside the lungs, reactivation pleural tuberculosis and tuberculous meningitis being the most common, but infection can spread to any organ, usually through the bloodstream. Most patients with extrapul-monary reactivation tuberculosis are not contagious.

Let's reiterate. Tuberculosis is an infectious disease. Like other in-fectious diseases, anyone can be infected if exposed to the causative organism. Therefore, Mtb can attack persons of any social class, gen-der, age group, race, or profession.[26] It is neither hereditary nor caused by emotional misery, the environment, or an overly excited nervous

system, as was once thought.[27, 28] People with waning or compromised immunity, however, are particularly susceptible. Outside of the latent phase, those with tuberculosis disease are potentially infectious, and because Mtb is a slow-killing infection, exposure and transmission to others are common. Chances for airborne transmission from person to person are significantly increased in people living close to one another and in those suffering from malnutrition or from other causes of diminished host defenses. This contributes to disease severity and probably explains the high prevalence of the disease among marginalized and impoverished populations. Patients are most infectious when they are in what experts call a state of "open tuberculosis," when bacteria are visible on sputum smears rather than only after growing in culture media.

Tuberculosis has been consistently designated a global emergency by the World Health Organization (WHO) since 1993. Although case detection rates and the number of successfully treated persons have increased, progress has stalled in many parts of the world, mainly because of disruptions caused by the COVID-19 pandemic.[29] In the United States, Dr. Rochelle Walensky, former Director of the Center for Disease Control (CDC), wrote that "up to 13 million people in the U.S. have latent tuberculosis infection, and without treatment, risk developing active tuberculosis disease in the future."[30]

In addition to the financial and logistical burdens created by the need to prevent the spread of tuberculosis globally, as well as to detect, diagnose, and treat the disease in patients with active, latent, and reactive infection, there is great concern about the emergence of multiple drug resistance, especially in low-income countries. Modern medical treatment typically includes a combination of oral medications as part of a 'Directly Observed Therapy Short-course program' (referred to as DOTS). Specially trained healthcare professionals can thus ensure that (usually) free medicines are taken by infected persons. Caregivers can also inquire about potential side effects from therapy. Medical treatment is generally successful in controlling tuberculosis and preventing active disease in patients with latent infection. Still, prolonged treatment regimens, as well as surgical or minimally invasive surgical interventions are sometimes needed to treat tuberculosis-related

complications such as broncholithiasis, airway strictures, chronically trapped lung, arteriovenous aneurysms, and benign tumoral obstruction. These complications usually result from the effects of inflammation, opportunistic infections, scar tissue formation, or evolving lesions in affected organs.[31] Physicians are increasingly vigilant for chronic lung diseases such as bronchiectasis and chronic obstructive lung disease, including chronic bronchitis and emphysema.

Modern-day healthcare workers and public health officials everywhere are apprehensive about growing mycobacterial resistance to any or all currently available antituberculosis medications.[32] The threat of multidrug resistance ignites fears of a return to the catastrophic era before antibiotics when death rates soared, and vast percentages of the population were affected by tuberculosis.[33] Despite the efforts of the WHO and other international agencies, growing poverty, social injustice, the politics of exclusion, discrimination, poor access to health care, overcrowding, other healthcare-related inequities, and usually unjustified policy constraints or gross indifference present real obstacles to finally ridding us of a disease that *should* have been eliminated long ago.

§

PART III

FIRST ITALY, THEN PARIS (1900-1914)

CHAPTER 11

<center>✦</center>

SURVIVING TUBERCULOSIS

"The experience was more traumatic than I ever allowed myself to admit."

Tamaryn Green (Miss South Africa, 2018)[1]

Modigliani's life changed forever when he was infected with Mycobacterium tuberculosis. From his childhood onward, he had to fight against a disease that would haunt him for the rest of his life. The sixteen-year-old was likely bedridden, feverish, pale, and fatigued. He complained of pain when he breathed and had little appetite. He probably had a fever and suffered from a nagging cough. The doctors would have suspected tuberculosis at their first visit because they would have been told about his first bout with pleurisy five years earlier. Now, it seemed, he had pleurisy again. They would have noticed decreased chest expansion each time Dedo took a breath. On physical examination, they would have found dullness to percussion, diminished breath sounds on the affected side, and a pleural rub consistent with the disease. Fever is often high and persists for weeks. We know today that pleurisy, an inflammation of the pleural lining with or without an associated collection of fluid inside the chest cavity, can occur at any time during the course of pulmonary tuberculosis but usually happens within a year after primary infection. Chest pain and fever can precede the fluid collection by several weeks. While the

disease is often self-limiting, it can be followed by pulmonary tuberculosis in about sixty-five percent of cases, usually within five years of the pleural disease.

In the sixteenth century, the French philosopher and essayist Michel de Montaigne wrote, "How many ways has death to surprise us!"[2] When Modigliani became ill, there were no effective pharmacologic treatments against respiratory infections, including tuberculosis. The disease, therefore, was a killer, and the death of its unfortunate victims usually came as no surprise. Even today, when most people in the world have access to effective medical treatment, tuberculosis is often fatal. In 2019, 1.4 million of the 10 million people who fell ill with Mtb died from the disease![3] Studies have also shown higher subsequent mortality in Mtb survivors compared with the general population.[4, 5] Many survivors have ongoing chronic medical problems and significant psychological distress, as well as an increased risk for recurrent episodes of tuberculosis.[6] Results from one recent study show that up to fifty percent of microbiologically cured tuberculosis patients may be left with permanent moderate or severe pulmonary function impairment (a loss in breathing capacity).[7] The WHO estimates that 18-80% of the 54 million people who have survived tuberculosis since the year 2000 have residual lung damage,[8] making tuberculosis one of the most important causes of chronic lung disease globally.[9]

When Amedeo coughed up blood, the doctors became confident of their diagnosis and feared for the young man's life. They must have shared their concerns with Modigliani's family, which is why Dedo's sister recalled, "the doctor's diagnosis held no hope."[10]

While some biographers suggest Modigliani caught the disease while partying with fellow art students in the streets of Livorno or flirting with chambermaids during his youthful initiations to sex, he could have become infected while working in the confined space of an artist's studio left to Micheli's students by a fellow painter who died from the disease.[11] It is also possible that Dedo's bouts of pleurisy when he was a child signaled his original tuberculous infection. Primary pleural infection, also known as tuberculous pleuritis, occurs less frequently than pulmonary infection, but the pleura is the most frequent site of extrapulmonary

disease. It presents as an acute illness in two-thirds of cases but evolves more insidiously in a third. Pleural tuberculosis is accompanied by co-existing lung parenchymal disease in more than eighty percent of patients.[12] Both pleurisy and pulmonary tuberculosis can be accompanied by scar tissue formation and a retraction of part of the lung, as well as by the formation of adhesions that prevent or inhibit lung expansion – this is called trapped lung syndrome.[13] Any form of tuberculosis-related pleural or lung disease can leave patients with chronic symptoms such as cough, shortness of breath (especially with exercise), or a persistent, albeit slight chest deformity and mildly reduced chest expansion.

The tuberculous etiology of Modigliani's pleurisy might have been confirmed by the presence of a lymphocyte-predominant exudate or bacteria in the pleural fluid after a procedure called thoracentesis. This procedure entails the removal of fluid by inserting a small needle into the chest cavity by first going through the skin and muscles in the space between two ribs. Thoracentesis was first introduced in 1852 by the American physician Henry Bowditch (1808-1892), but there is no mention of procedures of any sort in the Modigliani family memories. This is pertinent because since 1882, Carlo Forlanini, a professor at the University of Pavia three hundred kilometers north of Livorno, was considering a technique called "induced" or "artificial pneumothorax" to treat patients with tuberculosis.[14] He was impressed by reports of improved survival in patients with a spontaneously collapsed lung – a pneumothorax, and surmised that perhaps tuberculous lesions healed more quickly when the lung was deprived of air and oxygen in its collapsed state rather than when fully aerated and inflated inside the chest. He began by allowing a fixed amount of air to enter the pleural cavity through a needle placed into his patient's chest. Subsequently, the pressure inside the chest became less negative, causing the lung to recoil (collapse) due to its elastic properties. This, Forlanini believed, improved his patient's symptoms. The pneumothorax could be maintained, if necessary, by repeatedly introducing air (using positive pressure) into the pleural cavity. Based on some initial success, Forlanini proposed that artificial pneumothorax, ultimately called *collapse therapy*, put the diseased lung at rest, helped close any cavities created

by the infection, promoted healing, improved blood oxygenation, and helped improve cardiopulmonary function.

Normally, there are no free gases in the virtual space between the visceral pleura-lined lung and the parietal pleura-lined chest wall. As previously mentioned, the pressure inside the closed chest cavity is negative in relation to atmospheric pressure because the elastic properties of the lungs favor their collapse. Forlanini collaborated with his younger brother Enrico, an engineer and inventor of the hydrofoil, in order to build a "pneumo-device" which included a hollow needle, a hydraulic pump, and a pressure gauge to reliably control and measure the amount of positive pressure compressed air he could inject into the hemithorax to artificially collapse the tuberculous lung. The doctor subsequently used nitrogen (which he believed would be resorbed more slowly than air due to the physical properties of gases) to keep the lung collapsed for more extended periods of time. He called his treatment *aerotherapy*, but the procedure became known as collapse therapy or therapeutic and *artificial pneumothorax*.[15] The procedure was described in Thomas Mann's famous novel, *The Magic Mountain* (1924).[16] "It's a surgical operation, they often perform it up here. Behrens [the chief physician of the sanatorium] is a regular dab at it. When one of the lungs is very much affected, you understand, and the other one fairly healthy, they make the bad one stop functioning for a while, to give it a rest. That is to say, they make an incision here, somewhere on the side, I don't know the precise place, but [Dr.] Behrens has it down fine. Then they fill you up with gas—nitrogen, you know—and that puts the cheesy part of the lung out of operation."

Forlanini's first case using his apparatus was performed in 1888, but he did not report his results until seven years later, in the Italian journal *Gazzetta Medica di Torino*, and he waited until 1906 to report a series of 25 cases in the German journal *Deutsche Medizinische Wochenschrift*.[17, 18] The medical community did not like his ideas, however, so Italian physicians did not readily adopt the practice of artificial pneumothorax.[19] Dedo, therefore, probably never underwent such a procedure. A statement by his older brother Emanuele many years later – that Dedo had only "one and a half lungs" becomes all the more

interesting. Hypothetically, the artist could have developed scar tissue or adhesions inside his chest that hampered good lung expansion, had a bronchial stricture with subsequent partial lung collapse from lack of air, or had a part of his lung that was no longer aerated subsequent to his earlier tuberculosis and pleurisy – physicians call this *atelectasis*, which is a well-recognized and usually well-tolerated finding in many patients with a history of lung disease such as tuberculosis. Each of these sequelae might have contributed to the chronicity of some of Modigliani's symptoms, including his cough.

Without recourse to therapeutic surgical interventions or effective medical therapies, yet faced with a patient suffering from potentially fatal consumption, Amedeo's doctors would have initially recommended prolonged rest and opium or other narcotics for pain relief, cough suppression, and sedation. Coming from the poppy plant, opium was believed to help combat inflammation and render patients more apt to heal since the mid-nineteenth century. It could be purchased in any pharmacy without a doctor's prescription and was commonly used to enhance comfort and prevent cough.[20]

Laudanum, made of 10% powdered opium in alcohol (the equivalent of 1% Morphine) and Paregoric (the alcoholic and camphorated tincture of opium), were used to treat everything from stomach cramps to fever.[21, 22] Both were readily available. Even in the United States, Paregoric could be purchased without a medical prescription until 1970. Eubispasme was a concoction of black pills made from codethyline, an alkaloid extracted from opium. It was commonly used for treating colds and the flu. It was among many drugs still available in France without a prescription until 1957.

More potent drugs were also available. The German pharmacist Friedrich Sertürner had isolated morphine from opium in 1804. Its discovery was heralded as a milestone by the medical community because of morphine's reliability and long-lasting effects, particularly for pain relief and sedation. An alkaloid constituent of opium, called codeine, was isolated by French chemist Pierre Robiquet in 1832. The name "codeine" comes from the Greek word *kōdeia*, which refers to the head of the poppy plant. Therapeutic trials performed in 1834 showed

its efficacy against tubercular cough, and many subsequent studies confirmed its effectiveness against pain.[23]

Cocaine was also popular, touted by no other than Sigmund Freud. *Le Vin Mariani*, produced in 1863 by French chemist Angelo Mariani (1838-1914), was made of Bordeaux wine and coca leaves from Peru. It contained 7 mg of cocaine per bottle. The wine was legal and authorized in France until 1910. In 1898, Heinrich Dreser of the Bayer Pharmaceutical Company advocated using a new cough suppressant manufactured by adding two acetyl groups to the morphine molecule. This "heroic" drug called Heroin® was four times stronger than morphine and presumably safer than codeine. The company sent flyers and free samples to physicians throughout Europe and the United States. By 1899, Bayer produced more than a ton of Heroin® per year and exported it to twenty-three countries. In one early study, G. Strube of the Medical University Clinic of Berlin gave oral doses of 5 and 10 mg of Heroin® to fifty phthisis patients, effectively relieving their coughs and producing sleep. He noted no unpleasant reactions, except his patients wanted the drug long after he stopped prescribing it.[24]

In Italy and elsewhere in Europe, tuberculosis treatment was part of a competitive, poorly regulated medical marketplace.[25] Standard of practice remedies were ineffective and rapidly discarded, including "Igazol" (a compound of formaldehyde, trioxymethylene, and iodine derivatives administered through a vaporizer), tuberculin (for a time advocated by bacteriologist Robert Koch himself), immune sera (sometimes known as Maragliano's serum, named after Genoese physician Edoardo Maragliano), and gold compounds. Dangerous traditional remedies, including opioids and even Atropa belladonna (deadly nightshade), were also used to relieve symptoms, although with risks and usually without significant benefit.[26, 27, 28] This gave conventional doctors a terrible reputation.

Sadly, while the germ theory for disease and the discovery of the infectious organism responsible for tuberculosis were scientific breakthroughs, they were not yet universally accepted, nor had they resulted in the discovery of new and effective treatments. Many desperate patients were thus lured into therapy by quacks and unscrupulous medical entrepreneurs who clung to the concepts of hereditary predisposition

or miasmas – the adverse effects of environmental factors, especially 'bad air.' They proposed curative vapors using carbolic acid, enemas of sulfuretted hydrogen, hot air (the tubercle bacillus cannot live at temperatures between 31 °C and 41 °C), and a host of other ineffective and sometimes unsafe treatments.[29, 30] Healers without a medical license flourished. They practiced an alternative medicine that avoided the costs and loss of income associated with hospitalization and the potentially discriminatory consequences resulting from the disclosure of tubercular infection to friends, lovers, schoolteachers, coworkers, or the authorities. Their reliance on a healthy diet, exercise, fresh air, and vitamins, however, reinforced public pressure so that conventionally licensed medical practitioners also focused on healing the whole body rather than solely treating symptoms with often painful and usually ineffective or debilitating remedies. Although turn-of-the-century doctors were unlikely to propose useless bloodletting, long ocean voyages, purging, or uncomfortably long rides on the back of a horse, they erroneously advocated therapies such as Tuberculin in the 1890s and BCG vaccine or Sanocrysin in the 1920s, that were destined to fail.[31, 32]

A critical physicians' meeting on tuberculosis was held in Naples on April 25, 1900, only a few months before Dedo became ill. More than one thousand physicians attended the meeting, including doctors from Northern and Central Italy. Attendees learned that Italy seemed to have fewer tuberculosis cases than other European countries. This lower incidence of disease was presumably due to Italy's more temperate climate. Provisions were being made to build luxurious sanatoriums for the wealthy – medical tourism was on the rise, but also to provide monies for poor people and to support their families. A government-funded competition was held to construct other sanatoriums in suitable places.[33]

Amedeo's symptoms gradually improved, and it was clear the young man would survive his first encounters with this potentially fatal disease. Still, poets, novelists, and opera librettists throughout Europe had highly romanticized the illness. Surely Modigliani and his family knew the destinies of famous operatic heroines who succumbed to tuberculosis: Violetta in Verdi's opera *La Traviata* (1853), Antonia in Jacques Offenbach's *Les Contes d'Hoffmann* (1881), and of course,

Mimi in Giacomo Puccini's opera, *La Bohème* (1896). "Amo Mimi, ma ho paura," sings Mimi's young lover, Rodolfo, before he abandons her. "I love Mimi, but I am afraid."

Modigliani would have also known that tuberculosis took the lives of many literary stars. The American writers Henry David Thoreau (1817-1862), Ralph Waldo Emerson (1803-1882), and Edgar Allen Poe (1809-1849) succumbed to the disease. Percy Shelley (1792-1822), the Emily and Charlotte Bronte sisters (1818-1848 and 1816-1855, respectively), and Robert Louis Stevenson (1850-1894) were also killed by Mtb. Nor could the well-read Garsin-Modigliani family have ignored the tragedy of the already famous and well-loved twenty-five-year-old English poet, Mr. John Keats (1795-1821). Having first manifested symptoms two years before his death, Keats died from consumption in a small hotel near the Spanish Steps in Rome. In 1819, he had already lost his uncle, mother, and brother to the deadly disease, and shared his thoughts about his own inevitable demise in the first verses of *La Belle Dame Sans Merci*, a poem about an ailing, errant knight discovered by an unnamed passerby along the banks of a lake.

> "I see a lily on thy brow,
> With anguish moist and fever-dew,
> And on thy cheeks a fading rose
> Fast withereth too."[34]

Amedeo Modigliani was lucky, for not everyone with tuberculosis deteriorated as rapidly as did Keats. Dedo's doctors knew that some patients recovered from the initially morbid effects of the disease. Many patients who survived, however, had their futures marked by chronic illness and often debilitating symptoms that could include a recurrence of hemoptysis and even death many years after their initial disease. Thankful that the boy survived, the best his doctors could recommend now was attentive follow-up care and a long, supervised convalescence in a sanatorium.

§

CHAPTER 12

Rx: SANATORIUMS

"Never despair…follow the rules and play the game out to the end."

Dr. Norman Bethune[1]

Amedeo survived his fearful bouts of hemoptysis, and in spite of the doctors' early prognostications, he was alive. For many patients with tuberculosis, it takes months to recover from symptomatic primary infection. Even if Amedeo's pulmonary symptoms signaled reactivation disease, only time would tell if his health would deteriorate further. Regardless, the young man's convalescence would be lengthy.

In the early twentieth century, many hospitals resisted admitting patients with active tuberculosis because they did not want to be known as places where patients died. Instead, physicians encouraged home care, which was both more practical and less expensive. There is no evidence that sixteen-year-old Amedeo spent time in a medical facility in Livorno. Considering doctors had only a few pharmaceutical remedies available to provide symptomatic relief, they would have wanted to recommend something more – like a sanatorium.

Travel to warmer climates was believed to be beneficial for consumptives. This practice dates at least as far back as the ancient Greeks.[2] As a result, throughout much of the nineteenth century, people suffering from tuberculosis and other ailments traveled to the southern

parts of Italy, Spain, or France to breathe in "some good air" and exercise near the regions' clear and warm coastal waters. Many physicians urged their wealthier patients to sojourn in Southern French coastal towns such as Nice and Hyéres, known for their soft marine breezes and sunny weather. In Italy, special laws caused a problem for families because anyone who died from tuberculosis in their hotel room was responsible for a £100 fine.[3]

British physician, George Bodington, argued that conventional methods for treating disease harmed rather than cured patients. He resisted prescribing emetics and dark, sun-deprived isolation. He shunned potentially toxic treatments, including mercury. Instead, he proposed fresh air and a glass of sherry or Madeira in the forenoon, along with a nutritious diet, rest, and carefully supervised exercise in a healthy open-air environment.[4] Others favored mountainous regions where they thought spas, clean air, and a healthy combination of rest and exercise far from the miasmas of crowded cities promoted healing. Caregivers had opportunities to teach their potentially contagious clients all they needed to know about good health and hygiene before patients resumed their economically productive roles in society. At first such "cures" were accessible only to wealthy individuals. Over time, European governments realized they had to assume at least part of the financial burden associated with (hopefully) temporary loss of work and income for patients suffering from tuberculosis, who, above all, posed a risk of contagion to healthy functioning members of society.

As open-air cures grew in popularity, the first sanatorium or "place of healing" (from the Latin *sanare* – to heal) was established in 1859 by a German physician, Hermann Brehmer (1826-1889).[5] The site was a pristine Bavarian alpine village named Göbersdorf, Silesia, then part of Germany, in the mountains between Poland and the Czech Republic. Coincidently, Brehmer's sister-in-law had opened a hydropathic spa in Göbersdorf ten years earlier. Brehmer based his recommendations for sanatorium-based treatment on his doctoral thesis, *tuberculosis primis in stadiis semper curibalibus,* and relied on autopsy findings reported by Carl van Rokitansky to help justify his therapeutic regimen. The Viennese pathologist found healed tubercles in conjunction with atrophic

hearts in patients not killed by tuberculosis. Brehmer proposed that a heart and body strengthened by exercise and good nutrition would heal the lungs of anyone already ill or predisposed to harboring Mtb.

Sanatorium-based care provided symptom control for tuberculous patients and had the benefit of isolating those already infected and potentially infectious from society for weeks, months, and even years. While this protected the general public from disease, it also objectified patients, many of whom were coerced into receiving whichever treatments were in vogue. Sanatoriums mirrored political, financial, and social pressures resulting from changes in societal values, physician biases, and general philosophies regarding public health. Desperate to control the spread of tuberculosis, physicians were tempted to rely on unproven therapies that could be instituted within these establishments with little or no oversight.

Despite statistical evidence demonstrating that patients with tuberculosis could not be permanently cured as a result of treatment, sanatoriums were advocated because they represented a nation's united efforts to combat an epidemic that had become a major economic burden and a menace to workforce productivity.[6] Initially, they mainly served financially prosperous families who could afford to send their loved ones away for at least several months and often longer. Insurance companies eventually covered patient-related expenses so patients could return to work more quickly.

It is a general rule that infectious diseases affect all social classes, regardless of age, affluence, gender, race, or sexual orientation. They also damage a nation's economy when they strike in epidemic or pandemic proportions. By the time Doctor Peter Dettweiler (1848-1915), who had contracted tuberculosis himself and recovered at Göbersdorf, founded his own sanatorium near Frankfurt in 1876, efforts were being made to open sanatoriums around the world.[7, 8] In Italy, Edoardo Maragliano founded the first dispensary and hospital ward for consumptives at the University of Genoa in 1896. A national movement to fight the disease prompted dispensaries to treat every aspect of the illness in Siena, Padua, and Pisa. In 1898, a 100-bed specialty hospital opened in Budrio, near Bologna. In Valtellina, the Lombardy region

of Italy, a large sanatorium was made affordable to the working class, but the building was only completed in 1903. In France, the first institutions for needy children and wealthier adults were built along the coast at Berck-sur-Mer (Pas-de-Calais region) in 1861.[9] Doctor Edward Livingston Trudeau (1848-1915) was instrumental in building the first sanatorium in the United States, on Saranac Lake, in New York's northern Adirondacks mountains. In Davos, Switzerland, the site of Thomas Mann's novel, *The Magic Mountain*, tuberculosis survivor Doctor Karl Turban strictly managed what became the first closed, high-altitude facility in 1889. Patients who did not comply with Turban's rigorous treatment regimen were immediately released from the institution and were unlikely to be admitted elsewhere.[10]

The rush to build more sanatoriums continued well into the twentieth century.[11] Full room and board, relaxing walks with plenty of fresh air along tree-lined paths and in manicured gardens, and sunbathing on recliners placed across large covered terraces – subsequently referred to as *heliotherapie* were commonplace. Intermittent periods of prescribed rest and exercise were also the norm. The Italians used the aphorism *Lana, letto, latté* – wool, bed, and milk, to describe the treatment regimen.[12] Therapy was accompanied by a "hygiene of the mind" and the "avoidance of frivolity" enforced through discipline and strict obedience to rules and regulations designed by paternalistic and often patriarchal physicians.[13] Some institutions contained two classes of patients; those with hopefully curable disease and those with advanced and probably incurable, ultimately fatal conditions. Radiology suites were installed, and offices for dentists. Operating theaters provided access to procedures such as collapse therapy and other surgeries. Patients were discharged only after follow-up sputum tests demonstrated an absence of tuberculous bacilli on sputum smear and culture (referred to as a transition from open to closed tuberculosis). Even after discharge from the sanatorium, prolonged monitoring of a patient's health and symptoms was necessary because of the risk of renewed contagion in case of relapse or reactivation disease.

Sanatorium-based treatment was advocated even after research presented at the Berlin International Congress on Tuberculosis in 1899

showed that death rates for patients treated in sanatoriums were similar to those treated at home.[14] Such failures were not unique to Europe. In 1903, a study of 1000 traceable patients from Doctor Trudeau's sanatorium in Saranac Lake showed that more than half of the patients presumably healed and discharged were dead. Only a third were well, although with nascent disease.[15] The good doctor himself contracted what he presumed would be hopeless and fatal tuberculosis when he was twenty-six years old (his brother, whom he nursed, had recently died from the disease). To Trudeau's surprise, he lived another forty years, dedicating his life and legacy to the fight against tuberculosis in the United States.

Amedeo Modigliani would not be so fortunate.

§

CHAPTER 13

INFLUENCERS

"This astounds me. . . I had thought to be more than this!"

Comte de Lautréamont[1]

E ugénie did not listen to her son's doctors and refused to send Amedeo to a sanatorium. Instead, she took him south so he could rest while visiting Italy's most famous museums. Her brother, Amédée Garsin, covered the expenses. Eugénie and her beloved Dedo went to Naples, Torre del Greco, Rome, Florence, Venice, the Amalfi coast, and Capri for over six months. She nursed Amedeo throughout his convalescence, read to him, and slept in his room until he fully recovered.

Throughout much of 1901, the teenager sketched endlessly and prowled through countless museums, monuments, and churches. His correspondence is replete with juvenile exuberance. From Capri, "a delicious place to take the cure," he wrote his friend and fellow artist from Livorno, Oscar Ghiglia. "I am studying English, but the moment will also come for organizing myself, probably in Florence, and work... but in the good sense of the word, that is to say to dedicate myself with faith (body and soul) to organizing and developing all the impressions, all the germs of ideas, that I have harvested in this peace, as in a mystic garden."[2] Of Rome, the seventeen-year-old wrote, "Its feverish delights, its tragic landscape, its beautiful and harmonious forms—all

these things are mine through my thought and my work."[3] In another letter from Capri, he exclaimed, "Imagine that yesterday I went walking in the country under the moon alone with a Norwegian girl… erotic enough in truth, but also tender."[4]

Modigliani's sensibilities allowed him to appreciate beauty in all its forms. In the five surviving letters from his correspondence with Oscar Ghiglia, little explicitly suggests he was haunted by a life-threatening illness or had a premonition of his destiny.[5, 6] There is sometimes a joyful, almost juvenile sense of excitement in Amedeo's revelations and no evidence of uncontrolled depression or anxiety.[7] Yet, there is a sense of urgency in his words, and the expression of his burning need to consume himself in his art; "I am writing to let myself go, and to see myself as I am," he said. "I am myself prey to the awakening and dissolution of powerful energies. I wish instead that my life were a richly abundant river running joyfully over the earth. You [Oscar] are now the one to whom I can tell everything. I am rich and fertile now, and I need work."[8]

After a short stay back in Livorno, Dedo went to Florence, freshly accustomed to his independence and living outside the confines of his family. Soon thereafter, however, life-threatening disease struck again. He contracted scarlet fever, a pandemic bacterial infection caused by a spherical, gram-positive bacillus, *Streptococcus pyogenes*, also known as *A streptococcus*.[*] Once feared and a leading cause of death among children,[9] symptoms include a violent fever, pharyngitis (Strept throat), swelling of the parotid glands, a 'strawberry' tongue, and a fiery red rash that often covers the whole body except the palms and soles (it is commonly called a sandpaper rash because it looks like sunburn and feels gritty like sandpaper).[10] Also called scarlatina, the illness usually affects young children and teenagers but can occur at any age. Symptoms resolve within ten days. Before antibiotics, infectiousness could last up to several weeks, and the disease often had life-long consequences because

[*] Gram stains (discovered by Danish physician Hans Gram in 1884) classify bacteria based on their cell-wall constituents that stain positive or negative. The cause of scarlet fever was discovered by American bacteriologists Gladys and George Dick in 1924.

of the effects of toxins on the heart (rheumatic heart disease with the destruction of one or more heart valves), kidneys (glomerulonephritis), and liver. Until the introduction of antibiotics in the 1940s, mortality rates were as high as twenty percent.[11]

In Florence, Eugénie rushed to Dedo's side, and once more, the young man cheated death. He spent some weeks convalescing in Cortina d'Ampezzo, which then was part of the Austro-Hungarian empire in the Dolomite mountains, before returning to the city with Oscar Ghiglia, who was eight years his senior and studying with Giovanni Fattori at Florence's *Scuola Libera del Nudo* in 1902. The old man had become bitter and resentful about life, art, and politics. Modigliani may have thought he had little to learn from him, so he went his own way and eventually reached Pietrasanta, the medieval Tuscan village known since the Renaissance for its proximity to the calcite-rich marble quarries of Carrara. The marble quarries were famous for having been used by Michelangelo four centuries earlier. Here Amedeo likely fell in love with what he yearned to make his life's work. He attacked sculpture assiduously, learned to use a hammer and chisel, and carved at least three statues, two of which presumably were heads. For reasons that are still unknown, however, he stopped sculpting. Perhaps discouraged, he felt incapable of reaching the artistic heights of a Michelangelo, Donatello, or Tino di Camaino whose works in marble he would have seen in Florence.[12] Regardless, the dust and debris from working on stone would have worsened his cough, and the physical strain of carving directly on limestone or marble was probably too much for the still-ailing teenager.

Modigliani moved to Venice in 1903. In March, he enrolled in the *Scuola Libera del Nudo*, known at the time as the *Regio Istituto di Belle Arti di Venezia*. During the following years (from 1903 to the autumn of 1905), Amedeo would befriend painters such as Guido Cadorin, Umberto Brunelleschi, and Fabio Mauroner; in 1905, Modigliani's studio was adjacent to his in a small building opposite the Church of San Sébastiano. He saw paintings and portraits by Giacomo Balla (1871-1958), many regional works, portraits by Italian artists such as Alessandro Milisi (1856-1945) and Giovani Baldini (1842-1931), as well as

paintings by a blend of international artists at the *Biennali* of 1903 and 1905.[13] Surrounded by twisting canals, famous squares, and historic buildings, Modigliani painted and wrote poetry. He admired Giosuè Carducci, the poet and literary critic who, in 1906, would be the first Italian to receive the Nobel Prize in Literature. He was likely familiar with poems by Guido Gorrazaon (1883-1916) and Sergio Corazzini (1886-1907), members of what became known as the *Crepuscolarismo* (*trans.* The Twilight School). These works are characterized by nostalgic descriptions of monotonous lives drowned in the melancholic shadow of death.[14] Both poets were Modigliani's age and, like him, died in their youth from tuberculosis.

Amedeo was no longer a young teenager. He had witnessed the tragic ends of other consumptives, and several now-dead artists or their family members had been among his friends. Tuberculosis was still what the English writer and puritan preacher, Mr. John Bunyan had called the "captain of death,"[15] and any sign of blood on Modigliani's lips would not have gone unnoticed. After all, people with symptoms suggesting the disease were shunned and ostracized throughout Europe. Surely, Amedeo lived in fear of a recurrence. "Une vie brève mais intense," he repeatedly said to the sculptor Jacques Lipchitz when he lived in Paris only a few years later. "A brief but intense life" – Modigliani had to be aware of his death sentence.[16] His advice to Oscar Ghiglia provides insight into the direction of Amedeo's philosophy of life.[17] "The man that cannot leave behind everything that is old and rotten is not a man," he wrote, "but a bourgeois ... can't suffering serve to find yourself and to make your dream stronger than your desire. Always let your aesthetic needs prevail over your social obligations." Despite the sense of invulnerability that characterizes youth, Dedo must have sensed his life would be short. Now, he was struggling to find his own way in the world. Searching for authenticity, he clearly was having an identity crisis.

From what is known, Amedeo's father, Flaminio, would have been of little help because he was, for the most part absent. The young man's grandfather Isacco, who had nurtured Amedeo's sense of the aesthetic, had died while Modigliani was still a child. Without a father figure

93

and freed from the protective halo of his mother, he began spending more of his time conversing with friends about art, spiritualism, philosophy, and literature. He spent less time studying at the academy. He lingered whole afternoons in cafés, started drinking, and began using hashish, although probably not abundantly. While he may have been like other young people looking for new experiences, it is also possible that an unspeakable sense of impending doom contributed to forging his personality. Perhaps unwittingly, he felt the benefit of self-medication with drugs or alcohol to soothe a cough that could signal to others he was ill. He also began exhibiting a nocturnal restlessness that would plague him for the rest of his life. In *Acquaforte*, a book by fellow artist Fabio Mauroner (1884-1948) published posthumously in 1955, Mauroner writes, "Towards evening Modigliani would disappear: he spent his evenings through to the early hours in the most remote brothels where, he maintained, he was able to learn much more than in any Academy, and where he became friend and confidant to all those ladies of pleasure, and especially of concierges, in whose conversation he found an experience of life that was particularly interesting."[18] In a letter to Oscar Ghiglia, of which only part remains, Modigliani wrote, "From Venice I have received the most precious lessons of my life; from Venice these lessons now seem to be coming out of me, giving me feeling of growth like that which comes after a piece of work."[19]

Amedeo Modigliani was not a tall man, but he was handsome. He measured less than 5 ft 5 inches (1.65 cm), had dark eyes, a prominent chin, a large forehead, and a short mass of tangled black hair. While in Venice, his wardrobe did not yet include the immediately recognizable plain brown corduroy jacket, red scarf, sometimes blue-checkered shirt, and dark broad-brimmed hat he was known to wear in Paris. Instead, an allowance from his family allowed him to buy elegant clothes, including white collared shirts and jackets that helped reinforce his good looks and seductive charm. Naturally charismatic, Modigliani cast an image of what became the proverbial artist-playboy. He could recite Dante in Italian, quote Lautréamont, Baudelaire, and Rimbaud in French, and excitedly referenced the utopian theories of Russian anarchist Peter Kropotkin, whose works he had read in Livorno. His

favorite philosopher was Frederich Nietzsche. Already a cult figure in many circles, Nietzsche pronounced that art was sacred and that suffering, like life itself, was a noble sacrifice on the altar of creativity. In the *Birth of Tragedy*, the German philosopher whose work is also identified with nihilism wrote what must have resonated with a young Modigliani living with the tuberculous sword of Damocles over his head: "Dionysian art ...," Nietzsche said, "wishes to convince us of the eternal joy of existence: only we are to seek this joy not in phenomena, but behind them." Nietzsche distinguished as Dionysian (ectasies) and Apollonian (dreams) artistic energies which burst forth from nature herself. He wrote; "We are to recognize that all that comes into being must be ready for a sorrowful end; we are forced to look into the terrors of the individual existence – yet we are not to become rigid with fear."[20]

§

CHAPTER 14

<p style="text-align:center">❧❦❧</p>

AMONG FUTURE GREATS

"Nothing grows in the shade of tall trees."

Constantin Brancusi[1]

I ncreasing poverty, population displacement from rural settings to larger cities, unemployment, and compulsory military service during the first years of the twentieth century prompted many Italians to emigrate to the United States and other countries. Modigliani was exempted from service by the Italian draft board because of his fragile health. In 1906, he was twenty-two years old, unemployed, and without a university degree. After his uncle's unexpected death in Marseille, his means of financial support were vanishing. He had no work history, no desire to take on a conventional job, and was barely interested even in selling his paintings.

Manuel Ortiz de Zárate was a frequent companion who often extolled the wonders of Paris. Slightly younger than Amedeo but physically impressive and towering over the young Italian, the broad-shouldered and witty Chilean stowed aboard a ship to Europe when he was a teenager (his maternal grandfather had been president of Chile). He subsequently studied art in Rome before moving to Venice. His work focused on painting still life and landscapes, although his portraits, and especially his self-portraits, show a mature confidence, solid features, and firm lines. Ortiz de Zárate became Pablo Picasso's assistant in 1916. He stayed in

Paris until The Great War but died in Los Angeles in 1946, having never recorded his memories of friendship with Modigliani.

According to Charles Douglas, the author of *Artist Quarter*, whose name is a blend of British adventure writer Charles Beadle (1881-194?) and journalist Douglas Goldring (1887-1960), one story in particular is anchored in legend. When they first met in Italy, Modigliani told Ortiz de Zárate of his burning desire to be a sculptor, stating that he was painting only for "a lack of something better to do."[2] We know today that Amedeo had tried his hand at sculpting in the first years of the twentieth century but was quick to abandon working with stone. As a sculptor, therefore, he had failed. Turning again to painting, he rounded out his culturally-rich upbringing by training with the Macchiaioli, studying the works of Italian Renaissance and Sienese masters, and seeing first-hand what was considered some of the finest art in Italy's best museums. Despite everything he did, however, the ambitious, idealistic young artist who had already survived three potentially fatal infectious diseases was getting nowhere.

It was time for a change.

With dreams of Paris dancing in his head, many of them placed there by Ortiz de Zárate,[3] Amedeo went to Florence, where he could board a train to France. His mother met him there to say goodbye and to give him money. Always supportive of her son's endeavors, she gifted him a fine edition of Oscar Wilde's *The Ballad of Reading Gaol* for his travels. Wilde wrote the book while self-exiled in Normandy in 1898. He had served a two-year sentence of hard labor in a British prison in Reading, Berkshire, about fifty miles from London. The forty-six-year-old creative genius, essayist, and *provocateur par excellence* had defied the homophobic and exclusionary culture of his times. He died in Paris, a broken man, from meningitis that was possibly of syphilitic origin in November 1900. Perhaps, Eugénie had a premonition her son Dedo might have a troubled, self-destructive life reminiscent of that of the Irish playwright.

Amedeo arrived in the French capital sometime in autumn of 1906. At first, he lived in the upper-class neighborhood of La Madeleine, near where the Rue Royal connects the Church of the Madeleine to the

Place de la Concorde.[4] Fluent in French, comfortable with French culture, and with money from his mother in his pocket, it is unlikely the twenty-two-year-old Italian-Jewish immigrant felt the shock of being an outsider. His goal, of course, was not to find a steady desk job that would pay his rent or make his fortune, but to explore the limits of his artistic talents and to excel in his creative endeavors.

Like many young people embarking on a new life in a new city, and, like almost everyone who visits Paris even for a short while, Modigliani must have perused *à pied* – on foot – the many shops, cafés, and affordable eateries lining the city's sidewalks and boulevards. In the background, there would have been a roar of steam, and soon, gasoline-powered motorcars moving up to thirty miles per hour on avenues that also served electric trams and horse-drawn vehicles.

The French capital was crowded with people walking or on their bicycles. Considering there were almost 100,000 horses in Paris in those days, pedestrians had to be careful to avoid the many horse-drawn carts and carriages that still filled the city's streets: In April, only three kilometers from La Madeleine, on the Rue Dauphine opposite the Pont Neuf and only months before Modigliani's arrival, a one-horse carriage accidentally killed Pierre Curie, the discoverer of radium and co-winner with his wife, Marie Curie, of the Nobel prize in physics.

In conversation with men and women of the working class, with merchants, as well with any bourgeois living in his neighborhood, Amedeo would have learned the end of the Dreyfus affair had not entirely laid to rest the latent antisemitism reigning in Paris or healed the many political differences that divided the nation. Most people welcomed the victory of the Republic over a reflexive authoritarian state unduly influenced by clerics and the military, however. They hoped that a new government under the radical Prime Minister, George Clemenceau, would cement a separation of church and state that would conclusively take religion out of politics. Still, there were sporadic waves of turmoil and social discontent as many planned reforms were postponed. Amidst it all was an ongoing public health crisis that warranted a crusade against the triple scourge of the times; alcoholism, venereal diseases, and tuberculosis.

98

Despite its filth and insalubrious housing, much of the city had maintained its *fin de siècle* splendor. Paris, therefore, was hailed as a jewel of modern Europe, and The Eiffel Tower was the French capital's emblem. It was the tallest building in the world, constructed for the 1899 World Exposition, across the Seine River from the newly built Musée de Ethnographie du Trocadero. In its shadow, 2.7 million inhabitants roamed through one thousand kilometers of small streets, alleys, and boulevards lined with ten thousand lampposts, half a million electric lights, and dozens of Art Nouveau subway entrances. With an increasing number of foreign artists, writers, and intellectuals streaming into a city already famous for its history and physical beauty, Paris was still considered the cultural center of the Western world.

Modigliani quickly befriended other Jewish artists, such as Ludwig Meidner (1884-1966), the future German expressionist painter who studied art at the Académie Julian in Montmartre. The school was an alternative to the École des Beaux Arts, helping students prepare for their entrance exams there as well as giving them a chance to exhibit in various official Salons. Amedeo however, enrolled in the Académie Colarossi, at 10 Rue de la Grande Chaumière, adjacent to another art school named the Académie de la Grande Chaumière at no. 14. The school Amedeo chose was primarily attended by foreigners who had not been accepted to the Beaux Arts. The reasons for his decision are unclear, especially as the school was in Montparnasse, an hour's walk from the neighborhood of Montmartre, where Amedeo chose to settle due to his dwindling economies.

At first, he lived in the Hotel du Poirier, then in another café-hotel near the Place du Tertre, surrounded by small streets tangled with shops, shanties, and dozens of artists harboring antibourgeois sentiments. According to Meidner, Amedeo did not drink heavily but already had financial troubles. He ran up tabs at local eateries and needed to avoid various landlords when he ran late with the rent. Meidner and Modigliani sketched endlessly in the street, at the cafés, and in art school, but already the budding artist had a habit of giving away his drawings.

Meidner accompanied Amedeo to the Salon d'Automne, an exhibit that had become famous for having launched the Fauvism art movement

in 1905. The 1906 show included what was probably the first sizeable posthumous retrospective of Paul Gauguin's work; the controversial artist died in 1903 after spending the last ten years of his life on the French Polynesian islands of Tahiti and the Marquises. Amedeo was less intrigued with Gauguin (1848-1903) than with Cezanne (1839-1906), whom he revered. He also admired James Abbot McNeill Whistler (1834-1903), the American-born artist who had once studied in the Latin Quarter and painted the famous portrait *Whistler's Mother*, acquired by the French state in 1891.

Meidner shared his recollections of Modigliani in an article published in 1943.[5] "Never before had I heard a painter speak of beauty with such fire," he wrote. When the twenty-two-year-old Meidner left Paris and returned to Berlin for military service in 1907 (he failed the physical examination), he carried with him several small portraits Amedeo made for him to sell, sadly without success. Like most of Amedeo's early work, none of these have ever surfaced, and Amedeo kept no written records of his paintings.

In December, Modigliani met fellow Italian painter Gino Severini (1883-1966), who recalled seeing "small figures or still-lives on pieces of cardboard with very delicate colors and a refinement of taste that surprised me" in a studio Amedeo rented at 7, Place Jean-Baptiste Clement, on the corner of the Rue Lepic. The studio was at the top of the stairs near a dilapidated building at 13 Rue Ravignan called the Bateau-Lavoir (*trans.* the Washboat), where Picasso and other artists lived.[6] At the Bateau Lavoir and a club nearby called the Lapin Agile, as well as other hangouts, Amedeo met fellow Jewish painters Chaim Soutine and Moise Kisling, as well as Maurice Utrillo and Utrillo's mother, the post-impressionist painter and former model, Suzanne Valadon, who became lifelong friends.

He also met Max Jacob, the writer-painter, poet-critic, and self-proclaimed Kabbalist who was a close friend of Picasso. In the years to come, Modigliani lived among a multitude of innovative artists, writers, musicians, and art dealers who defined the avant-garde. Modigliani, whom Werner Schmalenbach described as a chronicler of the times, did portraits of them all, except for Marc Chagall and Jules Pascin. In

Why?

[handwritten: How did the Dreyfus Affair affect M.'s sense of self-identity? Was there any impact on him?]

addition to those already mentioned, he did portraits of Paul Guillaume, Léopold Zborowski, Constantin Brancusi, Apollinaire, Jean Cocteau, Diego Rivera, Roger Dutilleul, Frank Haviland, Henri Laurens, Blaise Cendrars, Manuel Humbert, Juan Gris, Léopold Survage, Léon Bakst, and countless others who lived and worked in close proximity. This made at least some cross-pollination with the influences of other artists virtually inevitable, yet Modigliani stayed true to his own visions of what his art needed to be. *[handwritten: → Can you tell more about his vision?]*

While there is no evidence Amedeo spent time at the Louvre or other museums copying paintings by masters, he still must have been at least somewhat affected by his contemporaries. This was a unique period in recent art history, a time when many future "greats" worked and played together in the same neighborhoods. They could not help but be inspired, and perhaps sometimes intimidated, by each other as they elbowed their way onto the French art scene. Meidner wrote that Modigliani admired Gauguin (1848-1903) and Henri de Toulouse Lautrec (1864-1901). He was fascinated by the Norwegian painter Edvard Munch (1863-1944) and interested in Whistler's delicate tones.[7] One early watercolor by Modigliani, *Woman with a hat* (Ceroni n° 6, 1907), is reminiscent of a Toulouse-Lautrec. The gaunt female figure of his *Sorrowful Nude* (Ceroni n° 8, 1908) recalls *Madonna* by Munch. There is a sense of loss and mourning similar to that conveyed in Picasso's Blue Period portraits in Modigliani's *La petite Jeanne* (Ceroni n° 10, 1908) and in *The Jewess* (Ceroni n° 9, 1908), a canvas Amedeo exhibited along with five other works at the Salon des Indépendants. Later, similar to works by Picasso and Brancusi, Modigliani's long-faced sculptures and caryatids would be influenced by his study of African masks, Khmer heads, and ancient Greek, Egyptian, and Cycladic art in Paris's museums.

In 1907, the year Modigliani became a member of the Societé des Indépendants, Henri Matisse (1869-1954) showed his *The Blue Nude*, and George Braque (1882-1963) exhibited paintings inspired by Fauvism. The Salon had been created more than twenty years earlier so that artists could show their works to the general public with total freedom and without subjecting themselves to the potentially injurious remarks

of academic juries. This was also the year of a posthumous retrospective for Paul Cezanne at the Salon d'Automne. The painter from Aix-en-Provence had long been hailed as an illustrious post-impressionist. Although the details of his technique varied during his lifetime, he was known for using large patches of color that could overflow into and onto each other to fill the planar space of his canvas. Modigliani, who carried a copy of Cezanne's painting, *Boy in a Red Waistcoat* (1888-1890), in his pocket, must have been inspired by the artist's search for structural simplicity and use of color.

Gradually perfecting the content of his palette and his use of texture, underdrawings, and line, Amedeo painted portraits with a style that had its roots deep within Italian classicism. Despite external influences and the commercial and critical success of other artist groups, he kept himself at the margins of all that was modernism and was determined to follow his own path. In his search for a unique style, he was neither entirely modern nor excitedly innovative, but he was not traditionally classical, conventional, or academic either. Like Cezanne, Modigliani believed that artists must find their own way according to their own sensibilities.[8] "What I am searching for is neither the real nor the unreal, but the Subconscious, the mystery of what is Instinctive in the human race," he wrote in one of his sketchbooks in 1907.[9] Clearly, Modigliani heard in his heart what Cezanne said about painters to writer and poet Joachim Gasguet; "Another person's advice and methods should never make you change the way you feel."[10]

§

[handwritten margin note: How does the search for the subconscious manifest in his portraits?]

CHAPTER 15

<div align="center">⌒◦•◦⌒</div>

MODI'S 'CURSED' QUEST

"What is true in a man's life is not what he does, but the legend which grows around him...."

<div align="right">Oscar Wilde [1]</div>

Canvas and paints were expensive. It seems Modigliani preferred to sketch and had thus become a veritable street artist. According to legend, but not unlike many artists passing through the cafés and cabarets of Montmartre, he also drank Absinthe. The name stems from the Greek word *Apsinthion*, meaning undrinkable. Traditionally, the green-colored drink is ceremoniously poured into a glass of cracked ice, over which a lump of sugar is suspended on a flat, perforated spoon. Cold water is dripped from a dispenser over the sugar into the glass containing the absinthe until the sugar dissolves and the drink takes on a pleasant milky color due to the precipitation of essential oils. Absinthe was inexpensive but strong, and its anise-like fragrance was so exquisite the drink was enjoyed by men and women alike.

Alcoholism, especially acute absinthism, was a major health concern in turn of the century France. Advertisements extolled the qualities of the intoxicating drink with an alcohol content as high as ninety percent. The sweet-tasting emerald green liquor was also known as *la fée verte* – the green fairy, because of its ability to cause euphoria without drunkenness. It was first produced in 1792 with a recipe

by a French physician, Pierre Ordinaire, and made widely public as an all-purpose treatment for medical ills. Entrepreneur Henri-Louis Pernod bought the recipe and opened a large distillery in Portarlier, France.[2] The drink's popularity spread in the 1870s when literary giants such as Baudelaire, Rimbaud, and Guy de Maupassant shouted Absinthe's virtues.[3] It quickly became inspirational for many artists; Toulouse-Lautrec, Vincent van Gogh, Albert Maignan, and even Picasso indulged in its use, making absinthe drinkers the subjects of several of their paintings. Examples include Toulouse-Lautrec's *At the Moulin Rouge* (1892-1895), Edgar Degas' *In a Café* (1876), Albert Maignan's *The Green Muse* (1895), Edouard Manet's *The Absinthe Drinker* (1859), and Picasso's *Woman drinking absinthe* (1901).

Absinthe's effects were caused by mixing alcohol with wormwood, a medicinal plant used to treat intestinal worms and stomach cramps in ancient Greek and Egyptian cultures. The oil extracted from wormwood contains the narcotic thujone (*Artemisia absinthium*), which is known to cause neurological problems and even insanity. Because the amount of thujone in absinthe was never enough to significantly alter brain chemistry, however, it is more likely its effects were related to the drink's high alcohol content (up to 75% per volume as opposed to 4-6% alcohol contained in wine or beer).

Modigliani, who was already known to barter sketches for drinks at the local bistros, had quickly built a reputation for excellent draftsmanship. His friend and fellow Italian painter, Gino Severini, had settled in Paris around the same time as Amedeo. Severini introduced Modigliani to the dominating and forceful characters of Pablo Picasso and George Braque, who had begun their ventures into Cubism. Amedeo spent many days and sometimes nights in the decrepit collection of artist studios that formed Picasso's headquarters at the Bateau Lavoir near what is now the Place Émile-Godeau, but he never joined the Picasso clan, nor did he adopt particular styles such as Fauvism or Cubism.[4] Although Modgliani could not avoid even the subconscious influence of many great artists around him, he set out to establish his own voice and develop his own artistic style. Embarking on such a quest despite the external constraints of poverty, a lingering threat of hunger, and

the risk of being underappreciated for his work was bound to lead him into trouble.

In late 1907, the painter Henri Doucet brought Modigliani to 7 Rue du Delta, a house with twelve rooms facing an open meadow fenced off from the street in the working district of Montmartre. Doucet had met Modigliani at the Lapin Agile, a hangout for impoverished artists. Amedeo was being evicted from his studio on the Place Jean-Baptist Clement and had nowhere to go. The house was rented by Dr. Paul Alexandre, twenty-six years old and a well-to-do dermatologist who had interned at Lariboisiere Hospital and had a medical practice nearby.[5]

The doctor was an avid art enthusiast as well as a generous friend and patron. Modigliani, who had settled not far from the Rue Delta, lived alone and had few possessions. At times he left what belongings he had at the house, as well as several paintings. The good doctor began collecting Modigliani's work and was soon among the only people who bought his paintings. During the next six years, Alexandre amassed more than four hundred drawings, twenty-five paintings, and several stone sculptures.[6, 7] He enthusiastically hoarded many of the artist's sketches that might otherwise have been discarded or lost. Always Amedeo's biggest fan, Paul Alexandre exhibited his young friend's paintings on the Delta home's walls and commissioned him for a series of family portraits.

This is where Modigliani's story has a twist, for it is during these years between 1907 and 1910 that, according to his friend, André Salmon, Amedeo was already drinking heavily and indulging in drugs, especially hashish and opium.[8] Paul Alexander, however, makes no mention of this in his writings. The Russian poetesse Anna Akhmatova (1889-1966), who knew Modigliani from 1910-1911 and was his muse for a series of caryatids and many other drawings, did not report behaviors consistent with these addictions. She described his personality as "shining, sparkling, effervescent" when she first met him in 1910. A year later, however, she found "his spirit seemed to have darkened somehow, and he had let himself go."[9] According to Salmon, Modigliani by this time was consistently drunk, drugged out, and carousing

about Montmartre with his friend and fellow painter, Maurice Utrillo, nicknamed *Litrillo* because of the amount of alcohol he could ingest at one sitting. Yet, there is no hard evidence Modigliani spent his days in a drunken and drugged stupor. Although she did not see him often, Akhmatova never claimed he drank, nor did Amedeo's other friends describe findings such as slurred speech, vomiting, muscle incoordination, or loss of consciousness usually associated with acute alcoholism (also known as alcohol poisoning). There is no suggestion during those early years of his having shiny eyes and trembling hands indicative of delirium tremens caused by sudden alcohol withdrawal, and even Salmon's suggestion that Amedeo's behaviors were such that his friends called him *Modi* because it was a twist on the French word *maudit*, which means accursed, is likely a stretch of the imagination. Family members said people close to Amedeo called him Dedo, while for others, "Modi" was a shortcut that probably represented nothing more than a youthful play with nicknames.

In addition to providing artists like Amedeo with a place to stay, Alexandre and his twenty-one-year-old brother Jean hosted lively parties they called theatricals, where the young people could dress up and act out different scenarios. They held hashish sessions where friends, including Modigliani, experimented with the dynamics of drug intoxication. Hashish, made from oils extracted from the cannabis plant, was smoked or stylishly served as edible pellets from porcelain dishes. The drug is composed of trichomes; compressed resin glands from the flowers of the cannabis plant. Its active ingredient is tetrahydrocannabinol. Scientific interest in hashish resulted from the work of Dr. Jacques-Joseph Moreau in the 1840s at the Hôpital de Bicêtre in Paris. His book, *On Hashish and Mental Derangement,* flew in the face of conventional wisdom by suggesting that mental illness resulted from a malfunctioning brain, not from brain damage per se.[10]

One particular evening, Modigliani introduced Dr. Alexandre to his companion, an elegant woman named Maud Abrantès, whose portrait Modi painted and sketched on several occasions. According to historian Alessandro De Stefani, Maud was a twenty-two-year-old married American woman, a "morphinomane" (addicted to morphine)

whose real name was Leontine Phipps.[11] Maud became pregnant a year later and left for the United States (Modi's role in this is unknown). One of the paintings, *Maud Abrantès* (Ceroni n° 7B, 1908/1909), is at the Hecht Museum in Israel. It shows a beautiful albeit sullen woman with a chiseled jawline, luscious lips, and dark, sunken eyes. Examining *Maud* upside down, there are at least two other painted faces, one of which is visible to the naked eye. On the painting's reverse side, another painting was discovered; *Nude with a hat* (Ceroni n° 7A, 1907/1908), which represents a woman in garish pale-yellow tones with hollow cheeks, dark hair, and eyebrows, and large, glossy red lips. Since 2010, X-radiographic analyses discovered the portrait of a man beneath it, perhaps painted by another artist or by Modi himself, as well as a third image, perhaps in the shape of a head with hair. Neither *Maud* nor *Nude with a hat* is signed.[12] Several other paintings may have been done around the same time but have never surfaced. At the time, one of Modi's friends, the sculptor Diogo de Macedo, described them; "Portraits and sketches with gangrenous tones and broken expressions. Strange lecherous masks, prostitutes, and the demented. Those excessive paintings full of anguish hypnotized us."[13]

With his distinctive charm, good looks, and ability to converse knowingly about all things art and literature, Amedeo was a likable character who never ceased to exude his Italian passions. Ludwig Meidner said, "Modi had the gift of making friends everywhere. He knew everybody, and wherever he went he was welcome."[14] Perhaps this is why he appealed to many women and how he began to rely on them to help him survive as his consumption of alcohol and drugs supposedly increased. His legend, partially enrobed in fact, includes countless ill-tempered outbursts, the arrogance of artistic creativity, a series of in-your-face confrontations with strangers over nothing, removing his clothes in public for no particular reason, giving away or selling his work for nothing (although often unsigned), a collection of bistro brawls, stumbling drunkenness, and the suave seduction of countless women, many of whom he is presumed to have taken to bed. Whether the young man was simply acting out, exhibiting the troubled behaviors associated with an overuse of drugs and alcohol, or intentionally

exploring the boundaries of his creative nature through the use of mood-altering substances and sex is still unclear.

He certainly shared many of the environmental, personality, and educational characteristics found in other victims of substance abuse. He was alone, away from family supervision or positive influences, young, unemployed, and sensitive. He had a pronounced sense of introspection and a desire to stimulate and explore his creativity. His literary role models also had histories of drug use and alcoholism. For example, he was enamored with the French poet Charles Baudelaire, who embarked on a voyage of self-destruction that provided him greater intimacy with all that was beauty, truth, and the divine. Modi's other literary heroes were Rimbaud and Verlaine, Nietzsche, D'Annunzio, and Lautréamont. He often quoted from the Italian novelist and author of *Il piacere*, Gabriele D'Annunzio (1863-1938), whose protagonist, Andrea Sperelli exemplified a lifestyle that included sexual promiscuity, a love for aesthetics and a decadence representative of late nineteenth-century Italy. A copy of *Les Chants de Maldoror*, by Uruguayan turned Parisian writer, Isidore Ducasse using the pen name Le Comte de Lautréamont (1846-1870), was a hard-to-find cult classic Amedeo carried in his pocket. "The charm of death exists only for the brave," wrote Ducasse before dying in a Parisian hotel room in 1870, miserably alone and probably from tuberculosis.[15]

Maldoror celebrates evil through the story of a man who abandons God and humankind. The word "Maldoror" comes from the French words for sickness or evil (mal), gold (or), and horror (horreur). First published in 1869, the book was unnoticed for many years until the surrealists published a new edition in 1924. There had been no new editions since 1890, which more than likely was the version carried by Modigliani.

Entirely on his own and still in his early twenties, Amedeo seems to have floundered during his first years in Montmartre. His biographers have not uncovered or released correspondence he might have had with his mother. One must wonder how or why their close and mutually loving contact was temporarily lost, but it seems that without someone to be accountable to, and in the absence of a constant, stable,

financially secure, and healthy environment, except for that occasionally offered by his hard-working physician friend, Paul Alexandre, Modi's wild side became unbridled.

"Guard the sacred cult for everything that can exaggerate and excite your intelligence," he wrote Oscar Ghiglia a few years earlier.[16] Perhaps Modi needed to investigate new sources of artistic inspiration. If so, he would not have been different from many artists, musicians, actors, and business professionals today who turn to alcohol and drugs as a way forward. The pressures to be original amidst the group of extremely talented artists living in Montmartre in the early 1900s must have been tremendous. Or, perhaps depression, discouragement, and other emotional or psychological pains led him to substance abuse and alcohol to ward off inner demons. We know Modi's grandfather, Isacco Garsin, suffered from neurosis and that his uncle Amédée had probably committed suicide. Ten years hence, Modi's aunt Gabrielle would also take her own life, and Laure Garsin would be committed to an insane asylum.

Another possibility is that like many artists and imaginative personalities, particularly those with unnerving apprehensions, Modi succumbed to the lure of mind-bending substances. While this may help explore creative fantasies initially, addiction looms perilously ahead. The dramatist Jean Cocteau wrote about his own battle with addiction: "Everything one does in life, even love, occurs in an express train racing toward death. To smoke opium is to get out of the train while it is still moving. It is to concern oneself with something other than life or death."[17] Taking opium in some form or another to diminish symptoms caused by his illness, Modi also would have felt its comforting effects on his psyche.

Besides, taking opium was somewhat of a fad in the early twentieth century. Until the death by overdose and hanging of their friend, the German painter Karl-Heinz Wiegels in 1908, even Picasso and his lover Fernande Olivier indulged occasionally in drugs at their studio in the Bateau Lavoir.[18, 19] Opium-containing products were sold in pharmacies and on the street, and opium was casually smoked in homes and coffee houses. As a result of the opium trade with China, it was

readily available almost everywhere, and going to opium dens was a fashionable pastime for men and women of all ages and social classes. The drug was legal until the 1912 Hague Opium Convention, which established international restrictions limiting its use to legitimate medical purposes. Laws against the sale and general use of opium were not implemented on a global scale until the Treaty of Versailles in 1919.

Hashish pills were also inexpensive; Modi's friends André Salmon and Apollinaire readily indulged. Prescribed as analgesics and cough suppressants, narcotics had been available in Parisian pharmacies since the 1840s. Even in the United States, pharmaceutical companies were only required to provide details regarding the amount of opium, cocaine, or cannabis in their products after implementation of The Pure Food and Drug Act of 1906. Today, opium and opium alkaloids such as codeine and hydrocodone are used legally for their antispasmodic, antitussive, sedative, and analgesic properties, as well as recreationally, albeit with many restrictions. Despite increased awareness, health care regulations, and the combined work of judiciary and regulatory drug enforcement agencies, drug use and misuse remains a significant social problem with many health care challenges.

In early twentieth century France, authorities vigorously debated many of the judicial and moral issues connected with a possible "war on drugs" (drugs were referred to as 'stupéfiants' and encompassed everything from cigarettes to alcohol, morphine, heroin, and opium). By 1916, laws were both in place and implemented to protect the general public, regulate medical prescriptions of narcotics, and punish drug traffickers and illegal users.[20] However, these generally were not attached to public health policies or designed to address the diverse healthcare issues related to various states of drug addiction.[21]

Alcohol, too, was readily available, inexpensive, and socially acceptable at the turn of the century. In addition to its mood-altering qualities, alcohol raises the stimulus level at the brain's cough center to diminish the cough reflex (a dangerous side-effect of this is the increased risk of aspiration). As an antitussive, therefore, it can be quite effective, albeit with possible psychoactive activity. The commonly-used cough, cold and flu medicine Nyquil, for example, contains as much as 25% alcohol,

and even over-the-counter preparations such as dextromethorphan and diphenhydramine cause euphoria, feelings of increased awareness, and sedation.

An adjunct and frequently less expensive alternative to alcohol at the time was ether, a colorless and highly volatile clear liquid that could be ingested or inhaled. Rapidly absorbed and distributed to the nervous system, ether causes excitation, euphoria, visual hallucinations, and lethargy. These effects were known in the eighteenth century,[22] but it was in 1847 that French academic physicians accepted ether for use as an anesthetic after its effectiveness was described to the Academy of Medicine by the surgeon J.F. Montaigne. Five years earlier, American physician Crawford Long had administered ether to a young boy before removing two small tumors painlessly from the boy's neck.[23] Journalist, Decadent writer, and self-proclaimed chronicler of *fin de siecle* Paris, Jean Lorrain (1855-1906) was a known éthéromane who lived in Montmartre at the turn of the century,[24] as was poet Max Jacob, whose home and person often reeked of ether according to writers Rosanna Warren and Charles Douglas.[25, 26]

With the renewed presence of symptoms such as lack of energy, nagging cough, or chest discomfort, twenty-three-year-old Amedeo may have discovered that drugs and alcohol helped him function. These physical ills, associated with his added burden of knowing he harbored a potentially fatal illness and self-imposed anxiety caused by his solitary inward search to discover and express himself initially through art, could easily have formed a mental environment in which existential malaise, depression, and a decreased sense of self-worth were readily cultivated. With this understanding, Modi's story is not one of self-sacrifice central to an avant-garde concept of art as a religion[27] but that of coexisting addictions in a highly functional, intelligent, chronically ill, and creative young person. Today's news is full of examples showing the social behavioral havoc and dysfunctional interpersonal relationships that result from such pathology. In sum, Modigliani's overindulgence in drugs and alcohol might have helped him control and camouflage his signs of tuberculosis[28] and alleviated pressures created by his sense of purpose. With what appears to be an urgency, he wrote of his desire

shortly after his second near-death experience in 1901, "to create my own truth on life, on beauty, and on art."[29]

Perhaps too, Modi's turn toward mind and mood-altering substances came from a not-infrequent need to transcend the banality and pain of everyday life. Any psychological malaise Modi felt may have stemmed from his ambivalent nature, and his obviously incoherent behaviors may have been overt manifestations of contradictory feelings. On many fronts, he was heir to a dual Mediterranean condition. As much as he was comfortable with Hebraic symbolism, he was equally at ease with the Christian religious art of the Sienese School and the Renaissance. From a belief perspective, however, and despite being raised in a non-religious household, he was proud of his Jewish origins, had a Bar mitzvah, and surrounded himself with other Jews. Secondly, from an artist's perspective, he was a sculptor at heart; we know he sometimes received letters addressed to Amedeo Modigliani, *Sculptor*, but the man had at least temporarily abandoned working with stone and found himself painting. Thirdly, in regard to his place in the Garsin-Modigliani clan, Modi was the youngest child from a middle-class family of intellectuals – his oldest brother was a successful politician, and his other brother was an engineer. Amedeo, however, was without a university degree. Feeling like an outsider and as one who sensed that people without the courage to pursue their dreams had nothing more than mediocre bourgeois lives, his rejection of social norms was natural. In this sense, he fell victim to a climate of speculation, neglect, and exploitation that reigned in Paris at the time, which in addition to what Douglas Hall called Modi's "immature self-deception about the role of artists" contributed to his psychological and emotional unrest.[30] Amedeo's urge to fight social constraints was dampened, however, by conflicts caused by the contradictions between his lack of money, bourgeois upbringing, and desires to project the aura and appearance of a well-to-do gentleman. Modi who carried himself well, quoted Bergson and Nietzsche, and recited verses from Dante Alighieri's *Divine Comedy* with all of its rhetorical splendor. Age would eventually mellow him in this regard, because in later years, his friend Léopold Survage said that Modi "accepted his legendary poverty without a fight and

with no sadness because for him earthly goods, which he considered chains, held no importance."[31] Inner conflict, however, often precedes acceptance. Jean Cocteau described Amedeo's personality at the time, saying that "he frequented the haunt of the intelligent, and animated it with his magnificent, drunken presence – that was enough for us."[32]

Amedeo strove to project an image of the upper-class playboy artist for whom money meant little and art meant everything. Feeling entitled to live according to his own moral code, yet without financial security and responsible mentorship, Modi probably failed to design a robust moral compass or resolve his inner contradictions. "With one eye you look at the world, with the other you look in at yourself," he told Survage by way of explanation for the manner with which he painted his sitters' gaze.[33] Perhaps, when Modi looked inward, he did not always like what he saw, thereby fostering an inner rage that would have tormented him in ways he could not understand. In an attempt to remedy existential angst and emotional pain, it is only natural he would turn to palliatives such as drugs, alcohol, or sex for even temporary relief.

There is also another reason for the young artist's behaviors, many of them exaggerated in the manufacture of a larger-than-life Modigliani legend built on the premise of suffering, failure, and self-sacrifice in the name of art, accompanied by a lack of external validation during the artist's lifetime that represents a form of martyrdom.[34] Modi was a lunger – a *tuberculeux* – at a time when having tuberculosis had significant social consequences. Even the hint of disease was shameful and subjected its victims to considerable discrimination. Similar to what was experienced during the recent SARS-CoV-2 pandemic, people who cough are naturally avoided and ostracized by those who fear they harbor an infectious disease, making the desire to hide one's illness natural, especially if disease is of an infectious and contagious nature or linked to socially frowned upon behaviors. The social environment of Paris in the early twentieth century was similar to ours in this regard. Jobs were lost, reputations destroyed, and communities were divided when family members became ill. With the additionally implied association of tuberculosis with alcoholism, poor living conditions, and venereal

diseases, there was even more cause for shame and discretion. Often, this is still the case for people suffering from tuberculosis, infected with sexually-transmitted diseases, or publicly declared to be degenerates because of unacceptable alcohol-related poor behavior. Modigliani, with his history of tuberculosis disease, and likely suffering from chronic symptoms, lived with the constant threat of reactivation and in fear of its often-fatal consequences. This is not something victims of illness usually speak of. Instead, like having syphilis in the 1900s or HIV/AIDS in the 1980s, it is a secret carried deep within one's heart. It is a secret that affects the soul and virtually every interpersonal and social interaction.

§

CHAPTER 16

———— ⚜ ————

STONES

"In pectore * *I feel that one day or another I shall find my way."*

Amedeo Modigliani[1]

In late 1908 or early 1909, Paul Alexandre introduced Modi to another friend with whom Modi soon developed a close relationship, the Romanian sculptor Constantin Brancusi (1867-1957). Curiously, it seems Amedeo painted only one portrait of Brancusi, and it is on the reverse side of his painting, *The Cellist* (Ceroni n° 22a, 1909), that he sold to Paul Alexandre. Brancusi found Modigliani a studio close to his own at 14 Cité Falguière, on a small cul-de-sac, Impasse Frémin, between the large artist residence La Ruche and the Boulevard Raspail in Montparnasse. Amedeo occupied this studio for a couple of years. The influence these men had on each other is most apparent when comparing some of Modi's carvings with Brancusi's long series of exquisite ovoid heads inspired by the contemplative pose and fine features of Baroness Renée-Irana Frachon; works such as *Sleeping Muse*, a bronze sculpture of a sleeping head lying on its side with its eyes closed, initially done in marble in 1909, or Brancusi's photograph of his stone sculpture *La Baronne R.F. (Tête de Femme), pierre* (1909), also from 1909.[2]

* Latin formula for saying "deep inside," or "in my heart."

Inspired by Cycladic, Egyptian, Khmer, and African tribal art viewed during his trips to the Louvre and Trocadéro Museums, Modi embarked on an obsessive search for an architectural reduction of space. Leaving aside his drawings of theater scenes and circus performers, as well as many sketches of female nudes, Amedeo began drawing women, as well as hermaphrodites and figures with androgynous features in various austere and often geometric positions. Many of the faces have elegant, elongated forms, expressionless or absent eyes, and long narrow noses. Some wear necklaces, earrings, or headdresses. Others are done in profile, resembling figures found in the hieroglyphics of ancient Egypt or portrayed in African tribal art, including Baule masks from the Ivory Coast. Almost all are nude. These drawings dominated Modigliani's creative output for several years. While many have a sculptural character that exudes mystery and sensuality, those with an exaggerated verticality and elongated necks foretell the stone sculptures he would title "*Têtes*" – "*Heads*," and the signature style he would apply to many portraits done in oil.

This was also the start of his work with caryatids inspired by Greek archaic art of the Cycladic period from 2800-2300 BCE. From his first drawings in 1908 to at least the beginning of 1914, he constantly improved the precision of his line and the simplicity of his compositions, usually using graphite, crayon, ink, pencil, and watercolor. The word "caryatid" derives from the Greek word for a woman of Caryae, partly draped figures usually crouching or standing that were carved into marble on ancient Greek monuments or holding up roofs of ancient Greek temples. The sculptor Ossip Zadkine recalled seeing some of Modi's later pieces; "I was going to see these large drawings of caryatids, in which shapes, children's bodies were barely supporting the weight of a heavy blue Italian sky."[3]

Amedeo's work was architectural and spatially unique in that many drawings of these figures are seen frontally or in profile. Their oval faces and drooping heads, rounded hips, and faintly curved thighs amidst vertical and horizontal lines suggest a subtle movement. At the same time, viewers cannot help but sense how these figures could easily support invisible structures that lie beyond the edge of the drawing paper.

Laure — did she make any impact on Modi? Is her kind?

Met with Laure's work

In the early twentieth century, artists' drawings were not viewed by most collectors as definitive works but rather as preliminary pieces for more substantial endeavors. Some of Modi's works on paper are obviously studies for his work in stone. Still, regardless of Modi's intent, many of his drawings are not mere preparatory sketches but definitive artworks themselves. These, too, dominated much of his creative output for several years.

In many of his drawings and subsequent stone carvings, Modigliani incorporated the archaic smile used by Greek sculptors of the 6th century BCE to display a sense of repose and gentle well-being. Others show a full upper and lower lip smile reminiscent of the Khmer smile of hundreds of stone apsaras – celestial dancer statues of the Angkor dynasty in Cambodia, particularly in Angkor Wat, between the 9th and fifteenth century CE. Recalling his visits to the Cité Falguière, the cluster of artist studios and apartments where Modi stayed between 1909 and 1912, Portuguese sculptor Diogo de Macedo (1889-1959) described Modi's carvings as being "reminiscent of savage idols, the taste influenced by the East – small, slanting almond-shaped eyes…" and when Modi bathed his limestone heads in candlelight, "…his sculptures really looked like exotic Jain divinities, mysterious and sophisticated."[4]

Poor health may have prompted a return to Livorno in the summer of 1909, where Amedeo helped his forty-six-year-old aunt Laure work on philosophy. Her future would be dark. After developing paranoia and isolating herself from human contact, she was interned in an insane asylum. In a note dated November 9, 1915, after telling his mother he is "painting again, and selling, which is a lot," Modi expressed his concern for his aunt; "if she retains her intelligence – her marvelous intelligence – it is a great deal. I am very moved that she remembers and takes an interest in me even in the state of forgetfulness of human things in which she finds herself. It seems to me impossible that such a person can't be led back to life, to a normal life."[5]

While in Livorno, Modi also painted *The Beggar Woman* (Ceroni n° 20), a canvas eventually gifted to Paul's younger brother, Jean Alexandre, and *The Beggar of Livorno* (Ceroni n° 24), a piece he brought back

117

to Paris and sold to Paul Alexandre before showing it along with five other paintings at the Salon des Independents in 1910. Although he spent time with his childhood friend, the painter Gino Romiti (1881-1967), there is no evidence he sculpted while there. Modi's mother, Eugénie, who until then kept a diary, made no mention of her son's illness or his profession as an artist.

Back in Paris, Amedeo did a 92 x 75 cm oil on canvas portrait of Alexandre's father, *Jean-Baptiste Alexandre au crucifix* (Ceroni n° 12, 1909).[6] It was his first official order. The painting was analyzed as part of the Modigliani and His Secrets research project conducted by the Centre de Recherche et de Restauration des Musées de France (C2RMF) in collaboration with eleven French museums, including the Musée des Beaux-Arts de Rouen.[7] Using multi-analytical techniques that included macro X-ray fluorescence, infrared imaging, and scanning electron microscopy, researchers affirmed Modigliani's use of lead white to outline facial features and a larger than-assumed number of pigments making up the subject's black suit jacket. Tests also revealed the presence of two other portraits of Alexandre beneath the final one. These findings and other analytical studies of Modigliani's paintings help extinguish notions that Modigliani was a rudimentary or unrefined portraitist. In fact, several paintings made of Paul Alexandre and his family, technical analyses of his work, as well as dozens of drawings from the Alexandre collection show that early in his career, Modi was not only a highly skilled and intentional draftsman with a firm line but a painter of increasingly refined elegance who used a complex color palette and a variety of pigments.[8]

Modigliani had neither the desire nor the ambition to earn a decent living by making dull, though visually accurate portraits for people's living rooms. While he would accept commissions throughout his career, his work would entail the use of a subtle palette of colors with many nuances, careful preparation, meticulous surface work, frequently superimposed layering, a rich combination of colors, shapes, and rugged textures, intentional brushwork, and harmonious background organization. There is something uniquely attractive in both the figurative and non-figurative components of Modigliani's compositions.

According to results from studies of viewers' visual attention, these "help people infer and imagine the context in which Modigliani portrays his characters."[9]

Biographers and art historians often point to his portrait, *The Amazon* (Ceroni n° 21, 1909), as a notable early work. The famous painting is of his friend Jean Alexandre's girlfriend, Baroness Marguerite de Hasse de Villiers. The subject has a slender yet shapely figure with sharp outlines. She is wearing gloves and a rich yellow/ochre riding suit. Her chiseled face, thinly plucked arched eyebrows, and the sideward glance of her well-demarcated eyes with dark pupils project an arrogance that exudes wealth and entitlement. Modi completed at least twelve preparatory drawings for the commission and definitely took his time before delivering the final product, which apparently annoyed his model. Sketches from Paul Alexandre's collection show how Modigliani altered his subject's pose and facial angles to capture the woman's haughtiness without making her appear to be mean. The subject's painted eyes, thin eyebrows, and slightly tilted head make her look imperious yet coy, although some might find her contemptuous. Modi took many weeks to paint the portrait, starting at his decrepit studio in the Cité Falguière but finishing in the more comfortable rooms of the house on the rue Delta. Jean Alexandre told his brother, "The portrait seems to be coming along well, but I'm afraid it will probably change ten times again before it's finished," adding that Modi had no money and was hardly eating.[10] Ultimately, the Baroness did not like the painting and refused to buy it.

In regards to Modigliani's sculptures, few survive. As of this writing, his corpus includes only twenty-eight pieces (referred to as "C" followed by a Roman numeral for twenty-five works included in Ambrogio Ceroni's catalogue from 1965 and as Heads A, B, and C for those in Flavio Fergonzi's treatise published in 2013).[11, 12] Almost all were carved directly in sandstone or limestone, which is softer and more forgiving than marble. Technical analyses confirm that some of Modi's pieces are crinoidal limestone, historically quarried near a small town in the eastern Lorraine region of France named Euville.[13] The stone was used to build metro lines, bridges, and buildings during the

reconstruction of Paris in the second half of the nineteenth century.[14] Modi probably excavated stones from nearby construction sites or took ready-to-use blocks from local stonemasons and construction work-ers.[15] He often worked in his courtyard, finding the studio itself too small. He had, in fact, left his former apartment to the Hungarian artist Rezsö Balint; "My studio is available, now I'm sculpting, and for this I moved to the ground floor," he told him.[16]

Modi's sculptures range in size from 60 to 160 centimeters.[17] While they share many characteristics, each is aesthetically distinct, though some seem more finished than others. Pieces with large smooth planar surfaces were probably masons' blocks originally destined for use in a building.[18] Except for a standing nude currently at the National Gal-lery of Australia in Canberra (CXI, 1913), a few spherical works (CI, CII, CIII, CVIII, and CX, 1911), and a crouching caryatid (CXXV, 1912-1914) chiseled roughly in limestone and exhibited at New York's Museum of Modern Art, Modi's pieces are elongated "Heads" with androgynous features and minimal facial structures.[19] Their long necks and oval-shaped faces have rounded chins and usually straight, ar-row-like noses that exaggerate their verticality and occupy a central balancing position in the carvings. Some have closed lips as in a puck-ered kiss (such as CXIX, 1911-12, CXX, 1912 and CXXII, 1912); others smile faintly (such as CXII, 1909) or seem almost expressionless (such as CXXIII, 1915?). There is also a uniquely oval shield-shaped sculpture from white Carrara marble (CVI, 1913) that was formerly in the Jean Masurel collection and is now in the Musée d'Art Mod-ern-Centre Pompidou and on loan to the LaM.[20] The viewer's gaze is captured by the sculpture's sharp-edged long, cylindrical nose and deep-set, almond-shaped eyes beneath a prominent forehead and mass of wavy hair carved into the unfinished rectangular block.

In many pieces, Modi's treatment of the hair with its engravings, curlicues, and unpolished surface is reminiscent of Archaic Greek Art.[21] The backs of the carvings are almost always less finished than the fronts and sides. Modi's signature is almost always in cursive but was chiseled irregularly in full into the back of the neck on *Head* (CXIX, 1911-12), which is part of the Barnes collection. Near the back edge

of another *Head* (CXXIII, 1915?), owned by the Museum of Modern Art, the name MODIG/LIANI is chiseled in block letters, similar to block-lettered writings on some of Modi's portraits such as *Léon Indenbaum* (Ceroni n° 191, 1916) and *Paul Guillaume* (Ceroni n° 102, 1916) from a later period.

The first exhibit of sculptured works was presumably in March 1911, in a joint show with Modi's friend, the Portuguese artist Amadeo De Sousa-Cardoso (1887-1918). De Sousa-Cardoso died from the Spanish flu when he was thirty, but several photographs from the De Sousa-Cardosa archives show Modi's sculpted heads as a work in progress. This has allowed experts to compare some pieces to Modi's finished products exhibited later or sold to collectors.[22] While there is some stylistic repetition during the six years at most during which Modi worked in stone (1909-1915?), and there are several seemingly unfinished pieces, Amedeo kept no records of his carvings, so it is difficult to establish an exact timeline for his sculptures. The trajectory he took in his execution of carvings and his search to express his artistic ambitions, therefore, remains ripe for exploration.[23, 24]

§

CHAPTER 17

ANNA

"All that was divine in Modigliani only sparkled through a sort of gloom."

Anna Akhmatova (1889-1966)[1]

Anna Andreyevna Akhmatova was born on June 23, 1889 in a small cottage along the seashore near Odessa, in the Ukraine. Her mother's family, offspring of the Stogovs, were wealthy landowners. Her womanizing father's family name was Gorenko, which Anna abandoned to assume the pseudonym Akhmatova. The name derived from a maternal ancestor of Khan Akhmat, the Tatar leader of the Great Horde killed in 1481, and thus she claimed to be a descendant of Genghis Khan.[2] "Only a crazy 17-year-old girl would choose a Tatar surname for a Russian poetess. That's the surname of the last Tatar princess of the Horde. Taking a pseudonym occurred to me because, having found out about my poems, my father told me: 'Don't bring shame upon my name.' – 'I can do without your name then!' I said."[3]

Anna was raised in Tsarskoye Selo ("Tsar's village," renamed Pushkin in 1937), a small town south of Saint Petersburg and the former residence of the Russian imperial family. Her parents separated in 1905. The following year, Anna's older sister Inna von Shtein died from tuberculosis. Her sister Iya would also succumb to the disease when she reached her twenties. Anna herself was an asthmatic who probably

contracted tuberculosis disease while in the Crimea during The Great War. Speaking of the illness to her assistant and secretary, Lydia Chukovskaia, in 1940, Anna said, "I would have died too, of course, but I was saved by my thyroid disorder which destroys tuberculosis. * We had terrible TB in the family, though my father and mother were absolutely healthy."[4]

Anna graduated from the gymnasium (a name used for schools that preserved the right to send their students to university) in Kiev in 1907, and on April 25, 1910, she married her childhood sweetheart, albeit reluctantly. The Russian poet and adventurer Nikolai Stepanovich Gumilyov (1886-1921) had studied literature at the Sorbonne in Paris. Anna turned down his proposals for marriage several times in past years, ignored his love-sick suicide attempts, and told him she was no longer a virgin, until she finally wrote her widowed brother-in-law that "I am going to marry my childhood friend…He has loved me for three years now, and I believe that it is my fate to be his wife. Whether or not I love him, I do not know, but it seems to me that I do." A year earlier however, when Gumilyov asked her if she loved him, she answered, "I don't love you, but I consider you an outstanding individual."[5]

In May, 1910, the newlyweds honeymooned in Paris. Anna was highly cultured, spoke French almost fluently, and wrote poetry since she was eleven. It was her first trip outside Russia, and she was in the French capital for only a month. Of course, she spent most of her time attending cultural events, seeing Russian friends, and frequenting literary circles with her Symbolist, and philandering poet/adventurer husband. She had barely commenced her own literary career, one that would span the next sixty years and place her along with Osip Mandelstam, Boris Pasternak, and Marina Tsvetaeva as one of the most important poets in Russian history.[6]

The twenty-year-old had an imposing presence. The Russian journalist and feminist writer, Ariadna Tyrkova-Williams (1869-1962)

*Although thyroid hormones help modulate several immune system functions, there is no scientific evidence that thyroid disease protects against Mycobacterium tuberculosis infection.

described her; "Lithe, tall, svelte, her head wrapped in a floral shawl. The acquiline nose, her dark hair with the short bangs in front and held in place in back with a large Spanish comb. The small, slender mouth that seldom laughed. Dark, stern eyes. It was impossible not to notice her. You couldn't walk past her without admiring her. The young people went crazy when Akhmatova appeared on stage at literary readings. She was a good and skillful reader, who was fully aware of her feminine charm, and she possessed the regal self-assurance of an artist who knew her worth."[7]

Anna met Modigliani sometime during her stay. She recalled him telling her he was twenty-four, though he was already twenty-six. She saw him only a few times, noting his surprise at her ability to guess other people's thoughts: "On communique," he said to her repeatedly, "Il n'y a que vous pour réaliser cela." (*trans.* "We communicate. Only you could understand that.").[8]

It is impossible to know whether anything more than conversation transpired between the Russian poetesse and the Italian artist, and in June, Anna returned with Gumilyov to Tsarskoe Selo where the newlyweds stayed with Gumilyov's mother. In September, Gumilyov embarked on a six-month adventure to Africa. Anna moved to Saint Petersburg where she studied history and literature at the Higher Women's Institute. She was already writing some of the poems that would later be included in her first book.[9] The art critic Sergei Makovsky, who also edited *Appolon*, a Saint Petersburg magazine that published works by Akhmatova, Gumilyov, and Mandelstam remembered that "Everything about the appearance of the Akhmatova of that time – tall, thin, quiet, very pale, with a sorrowful crease to her mouth and satiny bangs on her forehead (the fashion in Paris) – was attractive and evoked a feeling half of touched curiosity, half of pity."[10, 11]

Modigliani wrote Anna frequently throughout the winter. "Vous êtes en moi comme une hantise," she recalled reading in one of his letters – *You are obsessively part of me.*[12] The words could signify an unhealthy obsession, a haunting presence, the unpleasantness of harboring feelings against one's will.

Was this love, or perhaps something else?

The self-described dark-haired, slender and graceful woman with a Bourbon profile saw Modigliani again in May 1911, when she rented an apartment near the church of St. Sulpice in the 6ᵗʰ arrondissement near the Rue Bonaparte and Luxembourg Gardens. This time, Anna stayed in the French capital without her husband until mid-July. In a short memoire published in the August 1964 issue of *The London Magazine*, she recalled watching Modigliani – she never refers to him in her writing as Amedeo, Dedo, or Modi – "working on a sculpture in a small yard next to his studio." At his request, she visited his exhibit at the Salon des Indépendants, but he did not come over to speak with her because she was with friends. Although Anna remembered Modigliani telling her he had been very ill all winter, she eloquently described him as having "the head of an Antinous and eyes with sparks of gold – in appearance he was absolutely unlike anyone else." She added, "I don't recall that he exchanged greetings with anyone in the Luxembourg Gardens or the Latin Quarter, where everyone more or less knew one another. I didn't hear him mention the name of any acquaintance, friend, or artist, nor did I hear him tell a single joke. I never saw him drunk, and he never smelled of wine. He evidently started drinking later, but hashish already figured somewhat in his stories…With me he never spoke of anything mundane." *Published where?*

She recalled his taking her to the Louvre to visit the Egyptian rooms, assuring her that "*tout le rest* – everything else, wasn't worth looking at." Authors of the catalogue from the exhibit *Amedeo Modigliani, l'oeil interieur* at Lille's Museum of Modern Art (LaM) describe beautifully how Modigliani used lines and proportions inspired by those of Egyptian sculptures – he drew Anna "bedecked with the jewelry of Egyptian queens and dancers," – eventually transposing this vision of his muse to his caryatids and stone carvings.[13]

Several drawings, probably made from memory, were preserved by Modi's friend, Dr. Paul Alexandre. Strangely, there is no evidence Modi ever introduced Akhmatova to him. Anna's characteristic features in the drawings identify her without doubt as Modi's subject. In one sketch, she is lying naked on her stomach, her elongated and slender body partially prone across the bed. Her legs and feet extend

unseen to the floor beyond the limits of the paper while towering over her from behind is the silhouette of a muscular man with a tapered waist, his head and neck are cut off at the shoulders (*Female Nude Lying on Her Stomach, with Partial Standing Figure*, black crayon on paper, c. 1911). In another drawing, Anna is seated with one arm draped over the back of a large chair. Her other hand is tucked behind the back of her head. Her thick dark hair is tied up in a bun and her chin rests on her shoulder. Three candles are seen burning on a shelf in the upper corner of the sketch. Again, her slender body is unnaturally elongated. Her high bosum is simply outlined using a series of dashes, also used to demarcate her narrow waist and pelvis (*Seated Female Nude*, black crayon on paper, c. 1911). These and other drawings are reproduced in Noël Alexandre's *The Unknown Modigliani* and presented in *Unmasking Modigliani*, the catalogue of an exhibition held in New York's Jewish Museum in 2004.[14, 15]

Modigliani did many sketches of Anna but there are no paintings of her, and she never posed for him. "He did them at home and gave them to me later," she recalled.[16, 17] Of the sixteen or so drawings she carried back with her to Russia, only one survived. She displayed it prominently on the walls of every apartment she lived in until her death in 1966. She also placed its reproduction on the dust jacket of the first edition of *Beg Vremeni* (The Flight of Time), which in 1965 was the most complete collection of her poetry published during her lifetime.

Anna, who subsequently gained some of her notoriety from her multiple sexual and sometimes simultaneous relationships with different men, neither refuted nor admitted to being romantically involved with Modigliani, but there is no direct evidence they were sexually active. Regardless of whether their relationship was a loving one, a symbiosis of two artistically and creatively-minded intellects, or a simple fling, however, they certainly spent much time together. They often walked through the Gardens of Luxembourg, as close friends and lovers still do today. They sat on benches rather than rented chairs in the park, and huddled under a black umbrella Modi carried when it rained. They shared the joys of reciting poetry they both knew by heart; poems written by France's Prince of Poets, Paul Verlaine, who died

in 1896. Sometimes, Amedeo led his new-found muse through the maze of narrow cobblestoned streets behind the Panthéon, originally among the city's most ancient archeological structures. It was transformed in the mid-eighteenth century into a church and a mausoleum, now housing the tombs of some of France's most illustrious figures. The neighborhood, which is part of the 5th arrondissement, is located across from the University of La Sorbonne and extends between the Gardens of Luxembourg and Île de la Cité, the small island formerly known as Lutécia, on the Seine, which is also home for the Cathedral of Nôtre Dame.

"At night, by the moonlight…" Akhmatova remembered… "It was [Modigliani] who showed me the *real* Paris." Reciting Verlaine, perhaps their two voices echoed in the night:

All sing in a minor key
Of victorious love and the opportune life,
They do not seem to believe in their happiness
And their song mingles with the moonlight,
Moonlight (2nd stanza) by Paul Verlaine[18]

Anna returned to her native Russia after Bastille Day (July 14). She joined her husband at his family's country estate of Slephyovo, north of Moscow, an area Anna described in her memoires as "fields ploughed in even squares on a hilly spot, mills, bogs, dried-out swamps, wheat."[19] There, she resumed her writing, all the while longing for Saint Petersburg and a return to the literary life. She recalled, "I did not go horseback riding and did not play tennis, but just gathered mushrooms in both of the Slephyovo gardens, while Paris still glowed behind me in a sort of final sunset."[20]

Soon, she and Gumilyov traveled to Moscow, Kiev, and finally returned to Tsarkoye Selo where they lived until 1916. Anna stood out among literary figures, became close friends with poet Osip Mandelstam, and in 1912 published a collection of forty-six poems in her first book, *Vecher* (Evening). She was critical of her own work, saying later; "These are the poor poems of a very vapid little girl which for

some reason were reprinted thirteen times."[21] The book brought Anna instant fame, and the first three hundred copies of the collection were quickly sold out. The poems embodied many timeless themes of love, but the experiences and feelings she shared were from a female poet's perspective. A cruel fate, accompanied by remorse and the memories of an ephemeral happiness that can only end in suffering when love ceases, obviously appealed to new generations of readers.

Akhmatova was destined to become one of Russia's most significant literary figures, a tragic love-poetesse and heartfelt voice for the oppressed. Despite intense personal hardship and loss, she remained in the country throughout the Soviet revolution and endured Stalin's murderous regime and years of subsequent repression. Her husband, from whom she was by then separated, was unjustly imprisoned and executed by the Soviet secret police in 1921. Her son, Lev Gumilev, who was born in September 1912, spent almost twenty years in Soviet prison camps beginning in 1936. Although Anna herself was too well known and too popular to be disappeared by Stalin, the country's cultural minister, Andrey Zhdanov spoke out against her in 1946. Referring to her many sexual relationships, he said Anna was "half nun, half whore, or rather both nun and whore with her petty, narrow private life and her trivial experiences."[22] Although much of Akhmatova's work was banned by the soviet regime for many years, nothing stopped Anna from writing. She famously authored parts of her masterful elegy *Rekviem* (Requiem) in 1963, and *Poema bez geroia* (Poem without a Hero) in 1965.[23] The full version of *Requiem*, however, was not published in the Soviet Union until 1987.

Anna never revealed much publically about her relationship with Modigliani, and no letters between the two of them, if an exchange of letters ever existed, have survived. It certainly appears that by the time Anna returned to Russia in the summer of 1911, all communication with Modigliani for some reason ceased. We may never know, therefore, the extent of the young man's feelings toward her, or whether his infatuation or love for her was reciprocated. One of Anna's biographers, Roberta Reeder, suggests that Anna's poem *"Mne s toboiu p'ianym veselo"* (When you're drunk it's so much fun) relates to her

(*possibly adulterous*...my words) moments with Modi in Paris.[24] It was published in *Vecher* (Evening, 1912), and may even have been written during Anna's stay in the French capital in 1911. Reeder's translation of the poem is somewhat different from the version that follows, but the sense of the writing is the same. Akhmatova's use of metaphor and sudden change in perspective, from the coyly playful to a description of changing colors in Autumn and the biting torment of a forbidden love that must come to an end is characteristic:

When you're drunk, you're so much fun –
Your rambling tales make no sense.
The early fall arrived and hung
Bright yellow flags upon the elms.

In the land of fraud and guile,
we have strayed, and now repent,
But what are these fictitious smiles,
On our lips, so strangely bent?

Not happiness or peace of mind
A biting torment – we pursued…
I will not leave my friend behind, –
So tender and so dissolute.

<div align="right">

When you're drunk, you're so much fun
by Anna Akhmatova[25]

</div>

Almost fifty years would pass between the days when young Anna Akhmatova and Amedeo strolled along the boulevards of Montparnasse to when the few pages of Anna's memories of him were translated from the Russian and published (1958-1964). By then the Modigliani myth had become a well-anchored *fait accompli*, and the Jacques Becker film, *Montparnasse 19,* in which a handsome French actor named Gérard Philip portrayed a decrepit and drunken Modigliani played regularly in European movie theaters since 1958.[26] Akhmatova disparaged the film, calling it vulgar.

She was not one to shrink from melodramatic discourse,[27] yet, Anna's account of her times with Modigliani reads both like a declaration of facts and a series of melancholic recollections in which the role of love feels unclear. "He seemed to be encircled by a girdle of loneliness," she declared, adding that he never complained of his poverty or apparent lack of recognition. When she returned to Paris in 1911, she found that Modigliani had changed immensely; "He had become in some way dimmer and slighter." she said.[28, 29] "He was not at all like anyone in the world…Somehow, I have always remembered his voice."[30]

If we believe the legend, Modi seduced the twenty-year-old newly married Russian while she was on her honeymoon, or perhaps it was he who fell under her spell. To explain their liaison, Anna said afterwards that it was likely neither of them understood one essential thing: "Everything that happened to us then belonged to the prehistory of our lives – his life being very short, and mine very long. The breath of art had not yet burnt up or transformed our two existences; it was a luminous, weightless moment, the hour before dawn."[31]

In 1912, shortly after the publication of *Vecher*, Anna Akhmatova traveled overland with her husband to Italy, which she described as being "like a dream you remember for the rest of your life."[32] Perhaps, in that dream she had a little bit of Modigliani with her.

§

CHAPTER 18

POSTCARDS FROM HOME

"Happiness is an angel with a grave face."

Amedeo Modigliani[1]

In his book, *Primitivism and Modern Art*, Robert Goldwater likens Modi's work to a combination of Baule masks from the Ivory Coast and Archaic Greek art, writing that, "Baule sculpture is the most refined and linear, the most aesthetic and the least daemonic of African work: it could be easily integrated with the other styles Modigliani assimilated, and with the graceful, sentimental direction of his art, best seen in the paintings that follow the sculpture."[2]

From 1911 to 1913, however, Modi concentrated on sketches, sculptures, and caryatids. In addition to carving, he worked on paper using mostly graphite, crayon, pastels, watercolors, and ink. For the most part, he ceased painting, except for some commissioned works from Paul Alexandre's family and a few standing caryatids whose bodily shapes and rigid poses are reminiscent of ancient Egyptian statues (Ceroni n°32-34).

In March 1911, Modi exhibited his sculptures in his friend Amadeo De Sousa-Cardoso's large studio on nr. 3 Rue du Colonel Lombes, near what is today the Quai d'Orsay Learning Commons in the 7th arrondissement. In the summer of 1911, his ill health and poor financial situation prompted a visit from his aunt Laure. She rented a small

house in Yport, a small village on the Alabaster coast in Normandy, intent on spending a few weeks there with Amedeo. She sent him travel money on several occasions so he could join her there, but Modi spent it on paints and settling minor debts. He finally appeared at Laure's door in September, but he was soaking wet after wandering to a nearby beach in the rain. Fearing his already poor health would deteriorate further, Laure promptly returned to Paris, bringing her nephew with her.[3]

During the following year, Modi's financial situation did not improve, although he sold sketches and received monies from his older brothers. Modi rarely dated his drawings, so a concise timeline of his work is difficult to establish. Works from Paul Alexandre's collection show a clear influence of Kmer art. Figures, whether caryatides, female nudes, or hermaphrodites, are usually shown standing or kneeling. Later, some sit cross-legged. Their geometric shapes are concise and drawn unhesitatingly. Sometimes, breasts are outlined using a series of dots, waists are tapered, and hips are slender, curved, rounded, or straight. Discreet adornments are drawn as a series of dots that may represent a string of pearls in a necklace or a hip belt.[4] For the most part, each drawing exudes sensuality and grace.

In October, seven of Modi's sculptures were exhibited in the 1912 Salon d'Automne (CXVI, CXVII, Head A, CXXII, CXV, Head B, and CXXI).[5] Four of them (CXXII, CXV, Head B, and CXXI) are visible in a photograph in the October 12 issue of the journal *L'Illustration*, placed together and listed as "*Têtes formant un ensemble décoratif* – a decorative ensemble" in Salle XI, entitled The Cubist Room, alongside paintings by Jean Metzinger, František Kupka, Francis Picabia, and Henri le Fauconnier.[6] A week later, photographs of two of his sculptures were featured by Claude-Roger in the October 20 issue of *La Comedie Artistique* entitled *Maîtres Cubes* – Cubist Masters.[7] Another two had been featured in the October 5 issue of *La Vie Parisienne*.[8] He had described his sculptures as "things" (*trans.* choses) to Anna Akhmatova and as "columns of tenderness" to art dealer Paul Guillaume.[9] Perhaps Modi thought of them as decorative architecture, not unlike the statues and frescos of ancient Greece, Egypt, or Angkor Wat, rather than as objects to be put on display. Sculptor Jacques Lipchitz recalled

132

seeing Modi stooped over a "few heads of stone – maybe five – standing on the cement floor of the court in front of the studio [at 14 Cité Falguière]. He adjusted them one to the other." Amedeo told Lipchitz that he conceived of them as an ensemble.[10] According to art dealer Paul Guillaume, "Modi dreamed of leaving to humanity a temple he had built from his own plans. He was not thinking of a temple to honor God, but of one to honor Humanity."[11]

Jacob Epstein was an American-born Jewish sculptor who lived in Great Britain. Only twenty-eight years old and already a well-known sculptor, he was frequently in Paris working on his monument for Oscar Wilde's tomb at the Père Lachaise cemetery, where Wilde was interred in 1909. After visiting Modi at his studio, Epstein recalled it was "filled with nine or ten of those long heads which were suggested by African masks, and one figure. They were carved in stone; at night he would place candles on the top of each one and the effect was that of a primitive temple."[12] Contrary to prior findings, recent technical analyses confirmed the presence of wax on at least two of Modi's sculptures; the Barnes head (CXIX, 1911-12) and *Head of a Woman* (Philadelphia Museum of Art CXX, 1912). There are also remnants of paint on others (CXIX, CXX, and also CXIII, owned by the Museum of Modern Art in New York).[13, 14] Amedeo, it seems, was more interested in the forms and feelings he created than in the properties of the materials. Lipchitz says Modi thought "the stone itself made very little difference; the important thing was to give the carved stone the feeling of hardness, and that came from within the sculptor himself: regardless of what stone they use, some sculptors make their work look soft, but others can use even the softest of stones and give their sculpture hardness."[15]

Poor finances may have brought Modi's time at the Cité Falguière to a close. Letters show that Modi's brother, Emanuel, often paid Modi's rent there.[16] In March, Amedeo had a studio back in Montmartre, at 39 passage de l'Elysée des Beaux-Arts, near what is today the back of the brick church of Saint-Jean de Montmartre, on the cobblestone street now named Rue André Antoine. Later that autumn (1912), he moved to an insalubrious partially glass-walled space on the ground floor at 216 Boulevard Raspail in Montparnasse. It was close to

what is now the Metro Vavin and only a minute's walk to where artists who had abandoned crowded intellectual hotspots such as the Closerie des Lilas, now gathered on the terraced cafés of La Coupole and La Rotonde. The route leading from there to the art schools and studios on Rue la Grande Chaumière was nicknamed *The Via Sacré* – the sacred way (perhaps a take on the Via Sacra, a major pedestrian thoroughfare of ancient Rome that traversed the Forum from the Capitoline Hill to the Colosseum), because neighborhood artists could walk from their lodgings and the academies to the cafés no matter how much they drank after painting.

Little is factually known of Modi's life in 1912 and 1913. Biographers repeat stories of numerous casual love affairs, changes of address, and increasing episodes of public drunkenness. However, it is unlikely that bar and restaurant owners were any more prone to trade free meals and booze for insignificant pencil sketches by an unknown artist than they would be today. Some stories are more than likely, though not necessarily intentional, exaggerations that are inconsistent with the refined sensitivities, elegance, and unhesitating lines of Modi's drawings at the time. For example, the artist Anselmo Bucci (1887-1955) said, "We found Modigliani at the Café de la Rotonde, where he practically lived: he was dead drunk as usual….He came forward, dirty, with a foul breath, and glazed eyes. He was laughing, with a sardonic monotonous simper. He was laughing, running his hands through his battered curls and showing his black teeth."[17]

If one believes there is no smoke without fire, something must have led Modigliani into a downward spiral. Perhaps it was the stress of poverty, a perceived lack of appreciation for his paintings, a struggle with inspiration, or other disappointments, none of which are mentioned by his friends Paul and Jean Alexandre. Perhaps Modi had begun to feel lonely or unloved, an outsider who refused to embrace the various art movements in vogue at the time. Like many of his peers, Amedeo was a foreigner, but he should have had little reason to feel like a stranger. Paris was, after all, full of foreign visitors and immigrants. Modi was cosmopolitan, but it was still unclear whether he had talents equal to those displayed by the giants around him. Perhaps he lacked that "spark

of originality" he desired, or perhaps he felt insecure about pursuing an artistic vision that seemed so contrary to the art movements of his time. Regardless, with his background and knowledge of the French language and French culture, Amedeo should have readily conformed to city life in Paris. Perhaps, if he had feelings of disenfranchisement, they had nothing to do with his art. Perhaps, like many young people finding their way, he was quite simply depressed and unhappy.

The particularity of Modi's situation, and a likely contributor to an existential crisis that otherwise is not uncommon for many people, was his history of tuberculosis. Never described as weak-looking or sickly by his peers, Modi still may have been subjected to chronic bouts of fatigue, pain, or a nagging cough he would have strived to conceal because any signs of tuberculosis, a shameful, still misunderstood, and feared disease, would have engendered feelings of disquiet and put him at increased risk of alienation from others. It may have been easier for Amedeo to use alcohol to forget and divert attention away from his symptoms, rather than be perceived disparagingly as "a lunger" (un tuberculeux). *I repeated before a # of times so many 'perhaps', hypothetical*

Modigliani was again an example of opposites; a multidimensional character who had not yet found his place. He was independent yet sociable, an introvert who masqueraded as an extrovert and occasionally used drugs or drinks to enhance his disinhibitions, which he displayed perhaps too frequently in public. He also harbored an infectious disease, although he would not have known that in the absence of reactivation, he was probably not contagious. He was a painter, but also a sculptor at heart. He was a romantic, but unable to maintain a lengthy, stable, relationship with women. He was also a secular Jew with more than a passing interest in literature, philosophy, and the spiritual world. These interests sometimes showed in his work, and on occasion, he added symbols or texts presenting a personal reflection or line of poetry in his pieces. One example is his drawing, *L'Artiste*, from the Paul Guillaume collection and sold at Christie's to a private collector in 2001. In this rapid sketch of three faces, Amedeo included a star of David and the cryptic text, "Ce qui est en bas est comme ce qui est en haut, et ce qui est en haut est comme ce qui est en bas" (*trans.* What

What must be some example of his spirituality - interwoven through his art.

L'Artiste and the inscription - what had he possible meant?

Can it be self-reflexive?

What

is on the bottom is also on top, and what is on top is like that which is on the bottom,), from *La Table d'Emeraude,* also known as the Smaragdine Tablet. The Tablet is considered one of the most important pieces of alchemic literature. It is attributed to alchemy's founder, the mythic Hermès Trismégiste. This natural philosophy originated in ancient Greece before having lasting effects on the development of chemistry, medicine, literature, and the arts throughout the Christian, Muslim, Chinese, and Medieval European worlds. Modigliani was ostensibly a man with diverse interests.

During the winter of 1913, Amedeo may have been seriously ill and had to be hospitalized. Biographers have not discovered medical records from that time, and the nature of his disease is unknown. By January 1913, he had abandoned the limestone carving of a *crouching caryatide* (CXXV) he had left at Cité Falguière, but he sold two sculptures to the British painter Augustus John (presumably for 200 francs each, including transport). Sometime in March or April, he left what was left of his sculptures and other belongings with Paul Alexandre. Of these sculptures, Alexandre wrote, "Almost all of them are in effect the same statue started over and over again, as he tried to achieve the definitive form – which I believe he never attained."[18]

Using the money from his sales or a financial gift from his mother, Amedeo returned to Livorno for what would be the last time.[19] According to Charles Douglas, Modi was in Livorno for eight months, but we know little of what he did there.[20] Witnesses said that when he arrived in Italy, "His head was shaven like that of an escaped convict."[21] A more likely explanation is that hospital personnel had cut Modi's hair for hygienic reasons, to prevent lice and the spread of typhus. It is just as possible that he invested in a good haircut before visiting his mother.

Modi wrote his friend Paul Alexandre frequently, sending him at least eight postcards, mostly of the city and its port, and others from nearby Vallechia in Pietrasanta, the marble capital fifteen miles south of Carrara. He does not mention his illness or a recent hospitalization in his letters. In April, he asked Paul to keep an eye on one of his sculptures and thanked him for sending him what was probably his copy of *Les Chants de Maldoror* by Lautréamont. "Fulfillment is on

its way," (*trans.* La plenitude approche), he told him, informing Paul that his future sculptures would be in marble. Contrary to the lengthy and self-reflective letters of his adolescence, Modi's notes were concise and to the point. On a card mailed from Pietrasanta on May 6, 1913, Modi wrote, "Flatterer and friend, happiness is an angel with a grave face. no sonnet needed." and signed it "the resuscitated one." He added in blue pencil, "I write soon."[22] Without incontestable evidence the twenty-eight-year-old Modi was ill during his stay in Italy, it is possible that Modi's signing "the resuscitated one" was actually an exclamation of whatever joy he felt working again on marble.

A month later, Amedeo sent Paul another note, dated June 13, 1913, in which he announced his imminent return to Paris. He said he would send Paul two small pieces of marble 'as scouts,' which the doctor never received.[23] Demonstrating his customary kindness, caring, and compassion for Modigliani, Dr. Alexandre refrained from telling him that twenty-six-year-old pharmacy student Jean Alexandre, Paul's younger brother who had contracted tuberculosis two years earlier, died from his disease on June 8th, only days before Amedeo's scheduled arrival.

§

Hermes Trismegiste —

PART IV

THE PLEASURES OF PAINTING (1914-1918)

CHAPTER 19

WAR

"All is war now and art is under worse than lock and key."

Alice Morning [1]

A recent illness that was severe enough to warrant hospitalization and the news of Jean Alexandre's death from the same disease Modi harbored since he was a child were devastating reminders of Amedeo's own mortality. This probably fueled his desire to paint again, and he did so voraciously. Returning to Paris, he first visited with the twenty-seven-year-old Mexican painter and muralist Diego Rivera and his first wife, the Russian-born artist Angelina Beloff. They lived in a studio complex at 26 Rue du Depart in Montparnasse, the same building as Dutch abstractionist Piet Mondrian, who lived on the second floor. Modi did several sketches of the rambunctious Rivera, who was enamored with Cubism at the time, as well as at least one portrait (Ceroni n° 42). The painting includes letters of Rivera's name etched onto the canvas in a way that is reminiscent of graffiti by street artists today. Notes from Rivera state that Modi actually did more than one portrait and that his paintings were done in 1916.[2]

Modi also saw much of Max Jacob, who came to visit when Modi was going back and forth between his studio on 13 Rue Ravignan and the home of Beatrice Hastings (1879-1943), a British poetess and writer originally from South Africa, who lived on the Rue Norvins

in Montmartre. Jacob was a poet, natural connector, and close friend of Pablo Picasso. He introduced Modi to twenty-three-year-old Paul Guillaume (1891-1934), who became Modi's unofficial manager (Guillaume probably began representing Modigliani officially in 1915).[3] Amedeo celebrated the new relationship by doing a portrait of the art dealer (Ceroni n° 100), on which he wrote the words "Novo Pilota Stella Maris (*trans.* New Pilot North Star). The painting hangs at the Musée de L'Orangerie, in Paris. According to the sculptor Ossip Zadkine; "Sittings took place in a cellar lit by a strong electric lamp and where there was a bottle of wine on the table."[4] Guillaume was already known for his important collection of African tribal art and for representing Picasso and Brancusi. He helped arrange an exhibit of at least one of Modigliani's drawings and a limestone sculpture (*Head*, now part of the Tate, Liverpool collection) at London's Whitechapel Art Gallery during their summer exhibition, *Twentieth Century Art: A Review of Modern Movements,* held from May 8 to June 20, 1914. Modi already had connections with buyers in Great Britain because he sold sculptures to the South African painter Edward Roworth and a well-known Welsh painter named Augustus John during their earlier visits to Paris (John's fame would increase after his portrait of Lawrence of Arabia in 1919, now owned by the Tate Modern in London). Foreign interest in Modigliani already indicated that Amedeo was neither ignored nor considered a minor artist in his time. In fact, during the Whitechapel exhibit, the modernist sculptor Henri Gaudier-Brzeska, also a close friend of Jacob Epstein, listed Amedeo among the other "moderns" – Epstein, Brancusi, Archipenko, Dunikowski, and himself in an article for *Blast*, a new journal of art and literature founded by writers Wyndham Lewis and Ezra Pound, both of whom were friends and writer-colleagues of Modi's not yet but soon-to-be lover, Beatrice Hastings.[5]

In the meantime, Amedeo rekindled his friendship with a twenty-four-year-old Welsh painter named Nina Hamnett (1890-1956). Nina was somewhat of a celebrity groupie and a portraitist who partied at the café de la Rotonde.[6] Writing of her experiences in her name-dropping memoir, *Laughing Torso*, she describes Modi's tendency to undress in public and become boisterous and easily irritated when drunk.[7]

Maldoror – rened – signipicance

Sometime during the war – Nina speaks of German guns firing shells onto Paris – Amedeo offered her to choose from among several gouache drawings of caryatids hanging on the walls of his apartment on the Rue du Saint Gothard; "They were very beautiful and he said, 'choose one for yourself.' The bed was unmade and had a copy of *Les Liaisons Dangereuses* and *Les Chants de Maldoror* upon it. Modigliani said that this book was the one that had ruined or made his life."[8] "He was also a gentle man with flair," she writes, "a man with the endearing habit of rolling his Rs and saying 'Admi*rr*able' when he saw something that pleased him."[9]

Strangely for Nina and many young artists living at the margins of society before the war, the rumblings of an international conflict seemed of little concern. Her descriptions of nights out with Modi and friends are void of reports of any conversations about politics, science, ethics, or France's growing colonization of North Africa. Nor does she voice concerns about French president Raymond Poincare's unwavering support of Russia's position toward France and their country's increasingly threatening and saber-rattling German neighbor. Perhaps artists surrounding Amedeo shared the optimism of many French nationalists. Maybe they believed that war with Germany would be short and inconsequential. They were too young to have experienced firsthand the suffering, loss of life, and humiliation of Germany's occupation of Paris during the Franco-Prussian War in 1870. Besides, they probably thought France had the strength of a prosperous and almost equally mixed rural and urban society. Propagandists reveled that France was the fourth-largest industrial power in the world.

The events leading to the deadly conflict that summer had not yet occurred when Modi began a stormy, sometimes abusive, and likely dysfunctional two-year relationship with Beatrice, who was also a friend of Nina's. Béa's real name was Emily Alice Haigh, and she became Modigliani's lover and second muse. The 'poetesse sud-africaine', as she was known in Paris since her arrival there in May 1914, was actually born in England. A modernist before her time, the thirty-five-year-old authored essays, articles, and books under at least seventeen pen names. During her two-year stay in the French capital, she used the

pseudonym 'Alice Morning' to write sixty-eight articles in a section titled 'Impressions of Paris', for a British magazine called *The New Age*.[10] Her revenues essentially helped pay for most of Modigliani's expenses.

Although she rarely mentioned him in her articles, shortly after meeting Amedeo, Hastings wrote in the July 9, 1914 issue of *The New Age*, "He is a very beautiful person to look at, when he is shaven, about twenty-eight, I should think, always either laughing or quarreling à la Rotonde."[11] During their time together, Modi would paint at least fourteen portraits of "B.H." (a play on words and shortening of Beatrice to Béa) and dozens of drawings. The couple socialized in the cafés of the Boulevard Raspail and attended parties hosted by artists and friends. They often ate at a modest cremèrie-restaurant at 3 Rue Campagne-Premier, only blocks from the Café du Dôme. Amidst a few marble tables surrounded by wooden stools and backless benches, they were hosted by Madame Rosalie Tobia, a woman in her forties who had modeled once for William-Adolphe Bouguereau (1825-1905).[12] Bouguereau, who taught at the French Academy des Beaux Arts, was a traditionalist; an academic painter whose work was highly regarded before the Impressionists and avant-garde movements changed the public's perceptions of art. Mme. Tobia, commonly known as Mme. Rosalie graciously served local workers wine with sausage or pasta and sometimes soup. She put up with the raucous behaviors of impoverished artists and even traded meals for their drawings. She called Modi's drawings "gribouillis" (*trans.* scribbles) that usually wound up as toilet paper or for starting a fire in the stove.[13] Other artists who sat at Mme. Rosalie's tables were the modernist poet and painter Max Jacob (1876-1944), Maurice Utrillo (1883-1955), who became known for his paintings of Montmartre, Moïse Kisling (1891-1953), soon to be famous for his portraits and landscapes, and Chaim Soutine (1893-1943), whose still life paintings of slaughtered carcasses portrayed his visions of death.

Their world changed drastically on August 3, 1914, when France declared war on Germany. Many businesses closed, the public was thrilled with the fervor of war, and art exhibits became few and far between. Then, there were curfews, food shortages, and rationing. Hashish and

other drugs became illegal. Compulsory military service was extended from two to three years, and the Triple Entente, France's defensive pact with Britain and Russia, was enforced. France had imposed mandatory conscription for all single men beginning at age twenty; this was now changed to ages eighteen to forty-one and passed into law in 1916. A general income tax was enacted in 1914 to help defray expenses, but only five percent of households had to pay anything during the first years of the system, even as the financial cost of fighting for France escalated rapidly. Subsequent devaluations of the French Franc set the country's economic production back over a decade.

While war caused financial hardship, deprivation, emotional strain, and undue human suffering, it above all represented the pitifully unnecessary loss of life and limb. During the first months of fighting, heavy casualties on the Western Front forced French authorities to increase the conscription age to forty-five. Between 1914 and 1918, more than 8.4 million French citizens served in the military, mostly in the artillery and infantry. The vast majority were on the front lines, where soldiers rotated in and out of the trenches for periods of four to six days at a time. More than eighteen percent of those enlisted in the French armed forces, some 1.5 million men, died in uniform, and overall, there were 4.2 million casualties.

Modi's brother Emanuele, who was over forty years old, was elected to the Italian parliament in 1913. Together with his wife Vera, he joined other European intellectuals to speak out against the war. Italy was a member of the German-Austro-Hungary Alliance but declared its neutrality even before the fighting began. Eight thousand Italians living in France asked to join the French army; five thousand were accepted, mainly in the Foreign Legion. In May 1915, however, Italy resigned from the Triple Alliance. The country joined Great Britain and France in their fight on the secret condition they would help Italy annex frontier territories after the war. By the end of the fighting in November 1918, more than five million Italians had served in the country's military, and almost 500,000 men had been killed.[14]

Surrounded by such enthusiastic patriotism, Amedeo may have volunteered for military service and been turned down for health reasons.

We know he did not serve in any capacity but chose to remain in Paris. Many artists who were not French citizens were allowed to sit out the war or went abroad. For those of military age who stayed in France and did not wear a military uniform, the social pressures and feelings of isolation must have been tremendous, even if there were good reasons for exempting them from service.

Forty-four-year-old Henri Matisse, who, along with André Derain, was already well-known as a leader of Fauvism, was rejected by French military authorities because of a weak heart. By 1917 he was in Nice, on the French Riviera, where he painted many lyrical and colorful masterpieces. Maurice Utrillo was exempted from military service because of emotional instability. Max Jacob, born in 1876, was almost too old to serve, and Picasso, being from neutral Spain did not need to. Braque and Juan Gris were also from Spain and were thus not obliged to become soldiers; they too went to Southern France. Modi's friend, the sculptor Jacob Epstein, filed for exemption in Great Britain but was called up in 1917 after his friends, the sculptor Henri Gaudier-Brzeska and philosopher/poet/art critic Thomas Ernest Hulme were killed in battle. Another friend, sculptor Léopold Survage was already thirty-four. He did not enlist because of health problems.

Many artists in Modi's network of friends did serve in the military, sometimes at a great personal sacrifice. Jean Cocteau became an ambulance driver with the Red Cross, and André Salmon fought in the trenches until he was wounded and discharged. Twenty-three-year-old Polish-born Moïse Kisling received a monthly stipend from his dealer, Adolfe Basler, in exchange for paintings but chose to join the French Foreign Legion. He was seriously wounded in the same battle as another friend, the Swiss writer Blaise Cendrars (1887-1961), who had also enlisted in the Legion as a foreign volunteer. Cendrars survived the war but was among the 145,000 French casualties of the Champagne offensive in 1915, where he lost his right arm.

Ossip Zadkine was not yet a French citizen but became a stretcher bearer and was wounded in action. Chaïm Soutine was eventually discharged because of poor health. Modi's old German friend from 1906, Ludwig Meidner, was drafted into the German army where he served as

a translator. The twenty-eight-year-old novelist, Francis Carco, became an aviator. He came out from the war unscathed. Guillaume Apollinaire joined the artillery and volunteered to fight in the infantry. The poet and enthusiastic supporter of artists in Montmartre and Montparnasse sustained a life-threatening shrapnel injury to the head in 1916. He was thirty-eight when he died of the Spanish flu on November 8, 1918, only three days before the armistice. Modi's friend and enthusiastic collector, Dr. Paul Alexandre, was mobilized in August 1914. Serving in the medical corps from the onset of the conflict to his release from military duty at general demobilization six years later, he never saw Modigliani again.

§

CHAPTER 20

AFFIRMATION

"Modigliani's drawing is supremely elegant. He was our aristocrat."

Jean Cocteau[1]

In September 1914, France's victory at the First Battle of the Marne stopped the German army only thirty miles from Paris. For a while at least, the city seemed to have been saved. However, throughout the autumn and then again in March 1915, Paris was devasted by several tons of bombs dropped from German Zeppelin airships. This not only changed the cityscape but also wreaked havoc on the population and killed hundreds. Some observers saw bombs dropped by hand from German planes marked with iron crosses, speeding across the skies at less than six thousand feet. Refugees fleeing the Front and nearby occupied territories, as well as thousands of injured soldiers soon filled the city's streets. Shelter was sought along barricades, and in concrete buildings, in health dispensaries, and in a growing number of hostels and makeshift tent cities.

Wounded soldiers, including amputees and those disfigured from facial wounds – *les geules cassées* – were everywhere. The American Hospital in Neuilly became an emblem of volunteerism and charity, treating more than sixteen hundred soldiers per day and running sorely needed ambulance services between the front lines and Paris. Armies from both sides now built and sustained their double line of trenches

from the coast of Belgium southward through France to Alsace and the Swiss border. Between them, barbed-wire-covered flats became killing grounds for millions of young soldiers. Every day, contaminated water, poor sanitation, and crowded quarters made the trenches and the lines behind them breeding grounds for poor health and infectious diseases, which soon took their toll on civilian populations. Death rates from tuberculosis, already high before the war, grew significantly even as military review boards did all they could to exempt or promptly discharge anyone with symptoms or signs of disease. By the end of the fighting, more than two hundred thousand people died from tuberculosis alone in seventy-seven of the eighty-nine French territorial departments.[2] Thankfully, the deadly impact of another infectious disease, typhoid fever, decreased due to widespread vaccination campaigns. Influenza, of course, affected thousands, and this was well before the global pandemic caused by the H1N1 influenza virus that killed millions during the last year of the war.

In Paris, prices for goods and services soared. A black market for virtually everything flourished. With food becoming scarce, the painter Marie Wassilieff, one of the first Russian artists to arrive in the city ten years earlier, converted her atelier on 21 Avenue du Maine into a canteen for artists. It was February 1915, and on its walls were paintings by Chagall and Modigliani, drawings by Picasso and Leger, and a wooden sculpture by Zadkine. Because it was considered a private club rather than a restaurant, the business was exempt from curfew laws. Many people were actually relatively well-off because the French government provided unemployed artists with small stipends, and monetary allowances went to the families of enlisted men.

With her eatery filled almost every night by a cosmopolitan group of artists, their companions, and hangers-on of all sorts, Wassilieff had her hands full. Her clients were a veritable contact list of avant-garde painters, sculptors, well-reputed writers, poets, and musicians, many of whom became famous. There were also prostitutes and people looking for love but not for long-term relationships. The scene was reminiscent of clubs in Hollywood or New York today, although these are without the backdrop and desolation of war. At Wassilieff's, drinks, dance, and

conversation flowed freely, almost as if there were no war. Parties often began at venues such as La Rotonde, where non-bohemian intellectuals also gathered. The Russian Marxist Leon Trotsky liked to play chess there. He was the second cousin of famous Russian Chess Grandmaster David Bronstein, so not surprisingly, he was quite a good player.[3]

Amidst the deprivations, uncertainty, and loss of income to which many artists were accustomed, and despite the multiplying horrors of war at the Front, Modigliani and others who remained in Paris went on with their routines; work in the morning and lunch in nearby eateries such as Chez Rosalie, followed by coffee or drinks in the afternoon (the coffee trade did not collapse until the growth of submarine warfare in 1917).[4] Sometimes they met at Chez Baty, Apollinaire's favorite restaurant in Montparnasse.[5] The place was described as a "well-maintained grotto" below the Hôtel de la Haute Loire. The owner had an unexploded shell from the War of 1871 stuck in its dining room walls.[6] Meals there were followed by witty conversation, mingling with girlfriends, and evening drinks at La Rotonde or Le Dôme. In nearby parks and other eateries, friends gathered around a stove, dogs were walked, and young couples kissed, sadly sometimes for the last time. Life appeared to go on as before, although men were mostly absent. The city became what existentialist philosopher Jean-Paul Sartre, who was ten years old at the time, later described as a place that was "devirilisé" (*trans.* devirilized).

Millions of women went to work, spontaneously and without the incentives of governmental reward, to ensure that crops were harvested, shops stayed open, and manpower shortages everywhere except on the battlefield were palliated. Their activities extended to salaried jobs, post-office work, and many factories. Thousands of women, nicknamed "war godmothers," offered to care for soldiers whether or not men were orphaned or separated from their families. More than seven million letters per day were thus exchanged between combatants and "their women" at the home front, thus maintaining the troops' morale and providing emotional, spiritual, and sometimes more intimate comforts.[7] For a time, military authorities tolerated prostitution because they realized they could not repress their young male combatants' sexuality. The incidence of gonorrhea and syphilis, however, reached

epidemic proportions, not only among sex workers and soldiers but also in the civilian population back home. Healthcare statistics may be exaggerated, but almost 800,000 new cases of syphilis were reported in France during the war years.[8]

To help prevent the further spread of venereal diseases, whose debilitating symptoms kept fighting men off the front lines for weeks at a time and threatened the health of women and children, as well as that of future generations of offspring, dispensaries offered free and discrete medical consultations. *Les services annexes* (*trans*. auxiliary services) began operating under the auspices of the Council for Welfare and Public Hygiene in 1916. That same year, the French government asked the newly enfranchised Rockefeller Foundation to help address the growing spread of tuberculosis in the French armed forces. During the first months of the war, 86,000 French recruits were exempted or discharged from military service because of presumed but not verified Mtb infection. Despite such precautionary measures, the number of soldiers with suspected tuberculosis disease released back to civilian life increased to 150,000 by 1917.[9]

The euphoria of war and hopes for an early victory were quickly dashed by stories of death and disease at the Front. The public despaired seeing thousands of walking wounded seeking refuge and medical care in France's cities. Modi's friend, Moïse Kisling, was shot in the chest, but Victor Chapman, who would soon be the first American pilot to be killed in the war, was a friend of Kisling's. He gifted the artist five thousand dollars, providing Kisling with enough money to continue working independently. Georges Braque was temporarily put out of commission with a head wound. Blaise Cendrars, whose real name was Frédéric Sauser, returned from the Front without his right arm. In 1916, after watching his children play in the Gardens of Luxembourg, Cendrars wrote *La Guerre au Luxembourg* (The War in the Luxembourg, 1916), a powerful narrative poem with illustrations by Kisling. The work blends children's voices with those of anonymous combatants in order to contrast the realities of war with the innocence of childhood. *"On ne peut rien oublier, il n'y a que les petits enfants qui jouent à la guerre,"* Cendrars wrote (*trans*. We can forget nothing, only small children play at war).[10]

In December 1916, the nine-month battle of Verdun ended. The murderous confrontation caused more than 400,000 French casualties, but Germany's attempt to destroy the French army failed. Yet, the war was barely half over. On the home front, artists not serving in the military were far from being children, and they did not "play" at war. Instead, they went about their business and continued to indulge in their customary pastimes; gathering with friends, partying as they could in cafés and eateries, and working at their art. As a result of government interventions, however, alcohol was harder to come by, and even absinthe was prohibited. Pressures from a wine-making industry still reeling from the destruction of European vineyards by the phylloxera infestation, coupled with increased public awareness of absinthe's destructive hallucinatory properties led to wine being preferentially sent to the front lines. A government ban was finally implemented on the substance in 1915.

Despite these constraints, Amedeo was drinking more heavily, although witnesses agree that he had a low tolerance to alcohol and was drunk after only a few glasses. His productivity had feverishly accelerated since 1914, but his drinking habit was not helped by his new girlfriend, Beatrice Hastings, who consistently indulged in excessively consuming alcoholic beverages. After meeting her, Picasso's friend, the poet Max Jacob wrote Apollinaire; "I have discovered an English poetess who gets drunk (on) whisky alone,"[11] he said by way of introduction. Jacob visited Béa frequently at her home in Montmartre, where she translated many of his poems into English, subsequently publishing them in the British magazine *The New Age* for which she was an editor. "I've met a truly great English poet," Jacob wrote his friend, the novelist Jean-Richard Bloch. "Miss Hastings, a drunk, a pianist, elegant, bohemian, dressed in the fashion of the Transvaal and surrounded by bandits who dabble in art and dancing."[12]

Beatrice said Modigliani was the spoiled child of the neighborhood; "Enfant sometimes-terrible but always forgiven – half Paris is in morally illegal possession of his designs." Eventually, she owned one of Modi's limestone "heads," probably a carving from 1911 (CVIII), now in Harvard's Fogg Museum in Cambridge, Massachusetts.[13] Modi did

not live with Béa in Montmartre, but they were often together. They picnicked near Baudelaire's tomb in the cemetery of Montparnasse and bar-hopped between neighborhoods like party animals. It is challenging to know which stories about their troubled, grossly dysfunctional relationship are true and which are exaggerations, but undoubtedly there were fireworks, and not always of the best kind. We know with certainty that while Modi was with "B.H." (a play on words with her name, but also one of many pseudonyms she used in her writings for *The New Age*), he worked less in stone and dedicated himself again to painting. Whether this was because he was disappointed trying to transpose his two-dimensional artistic visions into sculptures or because he was drawn more to his concept of forms, already perfectly exhibited in preparatory drawings, than to the material appearances of his finished stone pieces is unclear. Also, he probably realized he was not healthy enough to handle the laborious physical efforts required for carving. He could not inhale limestone and marble dust without coughing nor use chisels and other carving instruments expertly for extended periods. Although, like Rodin and others, he could have found carvers to do the heavy work, this would probably have been against his somewhat righteous and rigorous work ethic. Perhaps too, he thought paintings were financially more viable, or quite simply he lost interest in sculpting.

André Malraux wrote, "All art is the expression, slowly come by, of the artist's deepest emotions *vis-à-vis* the universe of which he is part."[14] Modi did numerous portraits and drawings of Beatrice, each of which exhibits a unique aesthetic sensibility and engenders different feelings. His drawing of her nude feels serene and almost admirative. His portrait titled *Beatrix with a hat* (Ceroni n° 46, 1914) is contemplative, whereas *Madam Pompadour* (Ceroni n° 57, 1915) and *Beatrice at the theater* (Ceroni n°110, 1916) seem tongue-in-cheek. In *Beatrice in Front of the fireplace* (Ceroni n° 58, 1915), he paints her rounded and with many curves, giving the impression she is patiently tolerating the viewer's lingering gaze but would prefer to get on with her day. In *Beatrice with a checkered shirt* (Ceroni n° 109, 1916), however, her soft curves and rounded features are replaced with a series of straight lines,

angles, and shadows that give her the chiseled appearance of a stern schoolmaster. Other than Béa, Modi's sitters were friends, fellow artists, and a few models. He painted many more than once, presenting them differently, intentionally changing something from one painting to the next. He also did many pencil studies, either on-site or from photographs of his subjects that he sometimes followed with renditions in oil. He took enormous risks by anchoring himself into a uniquely stylistic and single-minded approach to painting, creating a body of work that could be considered monotonous, repetitive, and unoriginal, the product of an uninspired and uninspiring artist who did little more than reproduce his subjects' features on a canvas, albeit via the gadget of puckered lips, abnormally long flat noses, orange-colored skin tones, soft-rounded shoulders, swan-like necks, and eyes that appear mask-like and devoid of emotion.[15] This explains why Modi's paintings are sometimes viewed condescendingly in academic circles.[16] By focusing nearly always on the human face in both his paintings and his sculptures, however, he developed a highly distinctive, singularly personal approach to portraiture that resisted the influences of artistic trends and personalities, including those of cubism and artists such as Picasso.

Similarly risky was that in Modigliani's day, portraiture as a genre was on shaky ground. Photography was rapidly replacing paintings, sketches, or drawings to document moments in time or place. Modi distinguished himself, however, from photographers and traditional portraitists. His paintings were anything but reproductions. He also refused to join existing art movements such as Fauvism, Cubism, Modernism, Futurism, or Expressionism. Instead, Modi tasked himself with altering an art form rooted in the classics. While he succumbed to influences that can be deemed Cézannesque, he endeavored to make them his own.

With all of his hardships, Modigliani lived during a vibrant period in art history. Times were dominated by an international conflict that killed more men than any war had previously, but Paris provided a unique artistic and intellectual environment. Both before and after the fighting, countless creative personalities congregated almost daily to vigorously debate or exchange novel ideas. In this sense, Modi was at

least at times better off than artists elsewhere, and after an initial dwindling of exhibitions and art shows as a result of the war, Europe was replete with renewed opportunities to display one's artistic activities.

He first showed the results of his wartime productivity in the 1916 avant-garde art exhibit of fashion designer Germaine Bongard on the stylish Rue de Penthièvre. Bongard was the sister of master couturier Paul Poiret (1879-1944), nicknamed "the king of French Haute Couture." Germaine sponsored musicians such as Erik Satie and several artists, also owning a painting by Amedeo's old friend, the Italian Futurist Gino Severini. This was not Modi's last exhibit. Two of his sculptures were displayed alongside Brancusi's work in an *Exhibition of Sculpture* held at the Modern Gallery in New York City. Before the exhibit, Amedeo's work was applauded by a leading art publication, *Magazine 291*. Later, photographs of his sculptures were included with Brancusi's in *African Negro Art: Its influence on modern art*, a book focused on the themes of the Modern Gallery exhibit. Shortly thereafter, two of Modi's drawings, *Portrait of Hans Arp I* and *Portrait of Hans Arp II*, were shown alongside work by Kisling, Picasso, and the already-recognized Dadaists Jean (Hans) Arp and Wassily Kandinsky at the Cabaret Voltaire in Zurich.

Modigliani's international stature was further affirmed when three of his portraits were shown alongside paintings by Raoul Dufy, André Derain, Fernand Leger, Henri Matisse, Van Dongen, de Chirico, Marie Wassilieff, and Pablo Picasso in what became known as the most important art exhibition of the war years; The Salon d'Antin's *L'Art Moderne en France*, in July 1916.[17] Thanks to scientist and curator Billy Klüver's astute study of twenty-four photographs taken by Jean Cocteau, there is evidence of Modigliani, Picasso, Ortiz de Zárate, Max Jacob, Kisling, and others posing together near La Rotonde that summer. Klüver points out that one of the photographs, plate No. 20, may be the only historical document showing Amedeo laughing.[18]

In November 1916, five of Modi's paintings were exhibited at the Lyre and Palette Gallery on the Rue Huyghens. *Madam Pompadour, Les Epoux Heureux, Portrait of P.G., La Jolie Ménagère*, and *Portrait of Kisling* were shown along with twenty-five African masks from Paul Guillaume,

poems by Jean Cocteau and Blaise Cendrars, music by Satie, and works of only four other painters: Picasso, Ortiz de Zárate, Kisling, and Matisse. Around the same time, Norwegian dealer Walther Halvorsen, who represented André Derain, organized a large exhibit of more than 160 artworks by a selection of French artists at the *Kunstnerforbundet* (Norwegian Artists Association) in Kristiania. Sitting at the Rotonde with Picasso and Modigliani, the dealer asked Modi to draw Picasso's portrait for the exhibition and paid him ten francs for it. He later commissioned a portrait of Matisse to match the Picasso portrait. Reproductions of both sketches appeared in the November 5, 1916, issue of the Norwegian daily newspaper *Dagbladet* and in the December issue of the journal *Aftenposten*.[18]

With that kind of recognition, Modi had to be high-fiving everyone in town.

§

How did he deal w/ recognition? How did it affect his behavior?

CHAPTER 21

PORTRAITS (OF BÉA)

"Madam Pompadour"

A. Modigliani (Oil on canvas, 1915)[1]

Beatrice Hastings's surrealistic novella, *Minnie Pinnikin,* provides a glimpse into the lives of artists such as Amedeo and others living in Paris during the early years of the First World War.[2] "I am in a fairyland now playing (that is doing only what I like) all day long with now and again a sudden ghastly glimpse of a world going mad." This extract from the nonlinear narrative, much of it written in a stream-of-consciousness style, tells the story of Minnie (Beatrice herself), a character named Pâtreador (presumably Modigliani), and their friend Bombas (probably the poet Max Jacob). Hastings was invited to read part of the manuscript at the Lyre and Palette Gallery, where Modi exhibited his works in November 1916.

As Amedeo's lover, muse, and financial turn-to, Beatrice was surely more than a pretty face and inspiring model. She was a well-cultured, self-dependent, strong-willed, financially and otherwise independent intellectual who could easily hold her own in any conversation. Using her literary voice and more than a dozen different pen names, Béa wrote poetry, parodies, political essays, and contemporary works of experimental fiction she would self-designate as modernism. She authored commentaries on issues such as feminism and women's suffragism. Sometimes,

and unbeknownst to her readers, she debated with herself under the guise of different pen names. After her relationship with Modi crumbled, she stayed in Paris but became ill and traveled to Southern France and Switzerland to recover before returning definitively to England. Apparently, she never owned a painting by Modigliani.

In the 1930s, Béa published a defense of the founder of the Theosophical Society, Helena Blavatsky, and tried, albeit unsuccessfully, to reestablish her own literary career. She spent part of the Second World War at her home in the south of England, alone, fragile, and painfully suffering for many years from cancer. On October 30, 1943, she turned on the gas and committed suicide, also killing the pet mouse she had cradled in the palm of her hand.[3] Béa's work is now being (re)discovered by contemporary feminist and modernist scholars. As for the text of *Minnie Pinnikin*, it was lost for more than fifty years until curator and Modigliani expert, Kenneth Wayne, found it in the archives of New York's Museum of Modern Art.[4]

Hastings and Modigliani had a troubled two-year relationship plagued by physical violence and frequently heated arguments. They threatened each other with knives and guns at least once between 1914 and 1916. Another time, showers of *Mea culpa* followed after Modi pushed Béa through a living room window, or when he slapped her for looking insistently at other men. When Hastings was going to pose for Modi's friend, the painter Moïse Kisling, Modi forbade it, saying, "When a woman poses for a painter, she gives herself to him."[5]

Whatever their reasons, the couple's public and private remonstrations fed the rumor mill and sparked countless stories by many of their friends and acquaintances.[6] Beatrice, who was six years older than Modi, was smart, learned, and original. According to her former friend and lover, the writer Katherine Mansfield, she was also absolutely reckless. "In some way I fear her." Mansfield wrote in her journal. "…There was a peculiar recklessness in her manner and in her tones which made me feel she would recognize no barriers at all. At the same time, of course, one is fascinated."[7]

Hastings was also physically violent, especially when she drank. According to sculptor Jacques Lipchitz, she bit Modi in the crotch after he threw her to the ground during a brawl in her backyard. From the onset, however, Modi must have been lovestruck and sketched her constantly. Béa described him as being… "inspired every day with something about me – 'voila, encore une' or 'encore un', he would say – I never knew what he meant and was too arrogant to ask. I never posed, just let him 'do' me, as he pleased, going about the house."[8]

While Beatrice was definitely Modi's second muse, appearing several years on the heels of Russian poet Anna Akhmatova, it is less evident whether his love for her was reciprocated. Despite prolific writings and weekly magazine columns, Béa kept details of their relationship mostly private and rarely mentioned him. From existing anecdotes and reminiscences, it seems that she understood him, and for a while at least, tolerated his presumably multiple affairs, sour moods, and public displays of anger, perhaps brought on by his excessive drinking or highs on hashish.[9] Modi's friend, the painter Carlo Carlá provides a glimpse of Modi's behaviors in 1914, after "two years spent in privations and drink had consumed him to the marrow…Strange character, airy and opaque. In conversation he often boiled over in excesses of rage which might have seemed artificial to those who did not know him well."[10]

How much Béa appreciated Modi's art is also not clear. Her nomadic life in the years after her sojourns in Paris must have prohibited her from keeping any pieces. A glimpse of her influence on Modi is provided when early in their relationship, using the pen name of April Morning, Beatrice wrote articles for a British weekly magazine called *The New Age*. In one, she described how Modi ran after her taxi when she left for a brief trip to England:[11]

"Modigliani was gasping, "Oh, Madame, don't go!"
I said, "Modigliani, someone says you've been three years fiddling about with one type of head, and you'll be another three on the new design."

He came round. "Cretin!" he glared at me as though I had said it. "Mais, ma-a-a-is, ma petite, he is right! I might have grown asparagus in the time."***

Hastings also provides a glimpse of Modi's self-critical attitudes and quest for perfection in another piece she wrote for her series *Impressions of Paris* (February, 1915):[12]

"I possess a stone head by Modigliani which I would not part with for a hundred pounds even at this crisis: and I rooted out this head from a corner sacred to the rubbish of centuries, and was called stupid for my pains in taking it away. Nothing human, save the mean, is missing from the stone. It has a fearful chip above the right eye, but it can stand a few chips. I am told that it was never finished, that it never will be finished, that it is not worth finishing. There is nothing that matters to finish! The whole head equally smiles in contemplation of knowledge, of madness, of grace and sensibility, of stupidity, of sensuality, of illusions and disillusions--all locked away as matter of perpetual meditation." Where is it mentioned? → the art of unfinished?

In all likelihood, Béa was describing a limestone sculpture that is now in Harvard's Fogg Museums in Cambridge, Massachusetts (CVII). Completed in 1911, the piece represents Modi's desire to sometimes work *non finito*, an Italian term meaning unfinished, intentionally or not by the artist. Sculptors say, "Non finito reveals the process. It lets the viewer into the work, into the vision of the artist."[13] Important classic examples include Donatello's sculpture, *Vierge à L'enfant*, Michelangelo's later works such as *Awakening Slave*, and Rodin's *La Pensée*.[14]

Modi's heads, or *Têtes d'un ensemble décoratif*, for example, were often described as unfinished. Their aesthetic roughness appears to represent but an incomplete translation of his artistic ideals shared once

* *Translation of cretin.* "Numbskull,"or as a convention of modern speech, "What the Hell."
** "Growing asparagus" is an old French expression for doing something that takes time (asparagus can take three years to grow from seed to harvest).

with his friend Oscar Ghiglia several years earlier; "Every great work of art must be considered as one considers any other work of nature. First of all in its esthetic reality and then as to the sources of its development and mystery of its creation, as they have agitated and disturbed its creator."[15]

Modigliani threw himself into the actions of his work. His method of direct carving, whereby the sculptor works directly on the finished wood, stone, or marble materials rather than on making a clay or plaster model that is subsequently carved into a final material by the sculptor or hired experts, distinguished Amedeo from many other artists. Lipchitz said, "Modigliani, like some others at this time, was very taken with the notion that sculpture was sick, that it had become very sick with Rodin and his influence. There was much too much modeling in clay, 'too much mud.' The only way to save sculpture was to start carving again, direct carving in stone."[16]

There is no doubt Modigliani essentially abandoned sculpture soon after his love affair with Béa began. Whether this was because he feared the physical labor and dust were bad for his health, thought paintings would sell more easily, felt burdened by the cost of materials (unlikely because limestone could be easily removed from around Paris's many construction sites), or simply became bored with the process remains a mystery. As mentioned previously, perhaps he felt, learned, and experienced that marble or limestone was not an ideal means by which he could express his visions of form, shape, and individual sensibilities. Sadly, he left few written explanations about the workings of his creative spirit or the reasons for his choices.

Nine years after her relationship with Modi ended, Beatrice was forty-six years old and somewhat more revealing about the nature of their love affair. In a series of notebooks titled *Madame Six,* she said anyone close to Amedeo called him Dedo, not Modi.[17] Secondly, she said that hashish turned him into a "craving, violent, bad boy, overturning tables, never paying his score, and insulting his best friends, including me." She also claimed that Modi frequently used cocaine, which "made him brilliant in an almost incomprehensible way…but that he rarely did anything good when drugged," and provided a common, albeit

weak excuse for Modi's turn to alcohol that is commonly offered to explain or justify a person's proclivity for substance abuse still today, mainly that, "Like many artists, he needed alcohol; it fed him: but he ruined the effect by adding drugs, the effect of which seemed just the opposite, they starved, vampirised him."[18] Another friend, Ukrainian sculptor Chana Orloff said "that in Modigliani the subconscious had taken the place of the conscious. To work well he had to have two or three glasses of wine. After the first, it didn't work; after the second, things were a little better; after the third his hand worked on its own... He threw away sketches when he was sober. He drew with incredible facility when intoxicated."[19]

Yet, Modigliani's productivity was astounding.

He did dozens of drawings of Béa and painted her portrait at least fourteen times. She sits royally in front of a door (Ceroni n° 81, 1915), on a wicker chair (Ceroni n° 79, 1915), or in front of a fireplace (Ceroni n° 58, 1915). In a theatre, she wears an extravagant black hat and high-collared jacket (Ceroni n° 110, 1916) – with a wink to Cubism, a rectangle of newsprint is incorporated onto the painted surface. The painting was altered and restored since its initial purchase by Albert C. Barnes in 1923. Strangely, as compared with an archival photograph, the painting now shows what appears to be an upside down and backward newspaper collage from 1953.[20]

An earlier painting emphasizes Béa's long, slender neck and uncovered head of dark hair parted in the middle. She is painted on a background of blue-green wallpaper visible on the right, against the canvas's lower edge (Ceroni n° 76, 1915). In *Madam Pompadour* (Ceroni n° 57, 1915), the *e* from "Madame" and "de" are left out of the incised inscription next to her cheek, which is perhaps a nod to her Britishness. In 1916, he paints her as a blond with a checkered shirt (Ceroni n° 109, 1916), or as conservators at the Tate Gallery, London discovered, painted over by *Portrait of a Girl/Victoria* (Ceroni n°118, 1917?) probably done after they parted ways.[21] Analyses suggest this is a version of Beatrice sitting in front of the fireplace.[22]

In addition to portraits of Beatrice, Modi worked on others almost constantly, and his output is impressive. There are paintings of some

fifty artists, writers, and colleagues, including *Pablo Picasso* (Ceroni n° 86), *Léon Indenbaum* (Ceroni n° 191), *Jacques and Berth Lipchitz* (Ceroni n° 161), and *Jean Cocteau* (Ceroni n° 106), not to mention his art dealer, *Paul Guillaume* (Ceroni n°100, n° 102, and n° 108) and several friends, *Moïse Kisling* (Ceroni n° 98, n° 107, and n° 154), *Max Jacob* (Ceroni n° 104 and n° 105) and *Chaïm Soutine* (Ceroni n° 97).

Among dozens of female portraits, some have names. There is *Lola de Valence* (Ceroni n° 48), *Antonia* (Ceroni n° 59), *Rosalia* (Ceroni n° 72), *Louise* (Ceroni n° 94), *La Faantesca* (Ceroni n° 91), *Lolotte* (Ceroni n° 139), and *Little Lucienne* (Ceroni n° 126). Other paintings were given names by art dealers, gallery owners, and museum curators: *Mme Dorival with a hat* (Ceroni n° 121), *La Petite Servante* (Ceroni n° 124), and *Girl with a Sailor Blouse* (Ceroni n° 125), not to mention a dozen or so signed pieces Modi did while dabbling in a Fauve-like Pointillism, such as the oil on crayon *Portrait of Rosa Porprina* (Ceroni n° 84, 1915).

By 1916, Modi's display of his subjects' postures, sometimes formal attitudes, extended necks, and soft facial curves became more consistent. This was often combined with a sharp intersection of planes and straight lines in his portraits, particularly of women. Perhaps Modi was inspired by Béa herself; a photograph shows her long slender neck to be not dissimilar from that of the Hollywood actress Audrey Hepburn in the 1950s. On the other hand, Amedeo had already extended the necks in many of his sculptures. During his time with Beatrice, therefore, it seems Amedeo became a portraitist who thought like a sculptor.

The likeness of Modi's portraits to real persons was precise yet very different from a photograph or traditionally painted portrait-like reproduction. The way Modi handled his sitter's eyes is equally original and mysterious. Sometimes he painted them asymmetrically; other times closed, slit-like, hatched-over, blackened, with or without pupils, or uniformly colored a soft shade of blue in a way that truly objectifies them. Then, in others, there is no "gaze" at all, and at first glance, there is no way to sense the sitter's mood or feelings – what the French call *état d'âme*. Deprived of seeing the sitter's eyes as a window into their soul, viewers are surprised, and sometimes, spellbound. The consequent aura of the sitter's remoteness strangely draws us closer, much

in the way sculpture is approached – with curiosity and longing to discover an object's projected sensitivity. We are thus inclined to engage with the "look" of Modigliani's subject and all that emanates from it rather than the look of the sitter itself.

§

painty vs. sculpture → where do we see more of a convention? Or is convention determined by the audience?

If art is a form of gesticulation, then it is also a form of art [to/art] convention w/out [speak]

conversation is gesticulation

Expressy rueself thru the movement of your hands or arm

When the author lets his work to enter the world, he no longer control is → all forms of art

CHAPTER 22

IT'S ALL IN THE DETAILS

"It's for you."

Amedo Modigliani[1]

Painting was a truly physical and psychological endeavor for Modigliani, but less so than working on stone, when dust and wielding heavy tools affected his breathing. Before starting on his canvas, Modi queried his sitters and engaged with them conversationally. He then relied on his natural intelligence and sensibilities to design his preparatory lines. As Léopold Survage said in 1947: "His psychological instinct first led him to carry out a study into the character of his model in the form of a conversation – something which took more or less time but once the decision was made, the portrait conceived, he worked impetuously."[2] Foujita said, "When Modigliani was painting, he went through all sorts of gesticulations."[3]

Modi's sense of the aesthetic and his propensity for intellectualization were carefully nurtured during his childhood under the care of his thoughtful and self-reliant mother. His portraits, although stylistically similar, are not the equivalent of photographic look-alikes. Their geometry and underlying structure look and feel different in their combinations of ovals, curves, angles, and straight lines, even when a collection of arabesques is almost universally superimposed on large planar surfaces serving as a matrix. Through his purposeful choices of

color, form, posture, and background, some of his best portraits project a sense of repose. In others, there is a restlessness, as if his sitters wanted to rise to their feet and leave the frame like movie actors brusquely departing their mark when their director yells, "CUT!".

Legend has it that Modi seduced his models by reciting poetry and spent many nights stumbling drunkenly about between watering holes from Montmartre to Montparnasse. Considering how typhoid fever had almost killed him when he was a child[*] and that inoculation against the disease was not yet compulsory, Amedeo, like many others, probably feared drinking unsafe water – in Paris, its chlorination had only begun in 1911. Besides, even French temperance groups advised that one liter of wine a day was not dangerous for the working man – a recommendation that helped the medical community and the government in their battle against the far too affordable and recently banned absinthe.[4, 5] Consumption of the emerald-green drink had increased fifteen-fold between 1875 and 1913.[6] By the start of the war in 1914, the average yearly consumption of pure alcohol, including wine, beer, cider, and distilled alcohol was more than sixty liters per adult inhabitant, making France the leading consumer of alcohol in the world.[7]

No such extravagances are mentioned by sculptor Léon Indenbaum. In a story told to Jeanine Warnod, he described how a splendid, gentle-faced Modigliani with an intelligent air about him offered to do his portrait (Ceroni n° 191, 1916). "It's for you," he said, signing it.[8] When I met Ms. Warnod in 2023, she told me that in earlier years, according to her father André Warnod, a gentle and well-behaved Modigliani stood by the door handing drugs to other young people coming to a party at Warnod's apartment.[9] Modi could not avoid living among marginalized, sometimes hard-drinking, hard-partying artists. He was an occasional user of intoxicating substances and opioids that would have helped to relieve his pulmonary symptoms. His private life was frequently in turmoil, yet he spent hours alone sketching, painting,

[*] Like many bacterial diseases, an attack of typhoid fever does not prompt long-lasting immunity or protect against future infection.

** Why there is no agreement as to whether he was or was not a drinker?*

discarding, and revising drawings or painting over older works. If his drinking sometimes got out of hand, and it is possible he was an occasional heavy drinker or an evolving high-functioning alcoholic – well, he could alternatively have been a binge drinker with lengthy periods of sobriety.[10] How else could he have consistently and with such rapid precision sketched preliminary drawings and covered his canvases with the unhesitatingly sharp preparatory lines that formed the matrix for the complex color compositions modern science has now revealed in his paintings.[11]

Hanka, the partner/wife of his soon-to-be art dealer, Léopold Zborowski, declared, "Contrary to what is said, he never came once drunk to our hotel to paint. Waking late, he would lunch at Rue Campagne-Première at Rosalie's, then come to our rooms and put himself immediately to work."[12] Sculptor and friend Jacques Lipchitz described a mellow Modigliani when Amedeo came to their home with an old canvas and a box of painting materials before painting a portrait of the Russian sculptor and his new wife, the poet Berthe Kitrosser (*Jacques and Berthe Lipchitz*, Ceroni n° 161, 1916). Modi charged "ten francs per sitting and a little alcohol." Lipchitz wrote. "I see him so clearly even now – sitting in front of his canvas which he had put on a chair, working quietly, interrupting only now and then to take a gulp of alcohol from the bottle standing nearby."[13] Although Modigliani finished the double portrait within a few sittings, Lipchitz felt guilty about its low price, so he asked for something more substantial. Modi worked on it for two more weeks. The technical analysis of the painting, which is in the Chicago Art Institute, shows that Modi's additions left Lipchitz's face untouched but significantly altered Berthe's features, also making them softer and shifting the tilt of her now much rounder head.[14]

Finnish artist Léopold Survage (Ceroni n° 211, 1917/1918) said that Amedeo sketched quickly; "I have sometimes seen him stop like a runner out of breath. It was then that he felt the need for a crack of the whip and the remedy was there within his grasp, a glass of red wine or a shot of *marc*, after which he would immediately get back to work."[15] Paulette Jourdain (Ceroni n° 333, 1919), who was fifteen years old in November 1919 and one of Modigliani's last sitters, told biographer

William Fifield that "He [Modi] would drink off tiny glasses, drink off one, then another, as he worked."[16]

Another one of Modi's curious habits was to write his sitter's name on his canvases as if to mark both his and his sitter's places into the annals of an art history he knew he would not live long enough to know. Their names are a lesson in diversity and multiculturalism. As art historian Emily Braun points out, there are Poles, Russians, Lithuanians, Catalans, Spaniards, Mexicans, South Africans, Algerians, Swedes, Italians, French, and Greeks representing a melting pot of Modernist artist-émigrés in Paris before, during, and after the war. Some were Jews, and others were not. Some were rich, and others were poor. There were homosexuals, heterosexuals, bisexuals, and many who reveled in promiscuity. Several were already well-known or soon to be famous. Others were his lovers or friends, and sometimes children, but many were common working-class people he did not know personally yet ennobled through his paintings.[17] Hence, Modigliani was not only a chronicler of the Montparnassian avant-garde, writes curator Kenneth Wayne, but "the first portraitist of his time to paint total strangers."[18]

Modi usually signed his name in the corner of his paintings in lowercase cursive script. He used black, or sometimes color, to make the signature stand out somewhat against the painting's background. He also liked to turn paysage-format and marine-format canvas strainers – a rigid frame with fixed corners, made of wood and used by artists to mount their canvases – on their shorter edges to give the portraits greater height. Contemporary art conservation scientists show that he often painted over previous and abandoned compositions, sometimes using whichever colors pre-existed in the painted-over works to reinforce components of his new painting. Current knowledge that Modi continued this practice even when he had money and free materials has altered prior beliefs that he reused canvases only because of a lack of funds. Beneath *Antonia* (Ceroni n° 59, 1915), for example, a combination of X-radiography, infrared imaging, and X-ray fluorescence spectroscopy shows five different compositions.[19] Most of the paintings that researchers have examined show carefully executed preparatory drawings using clean graphite lines or thin brushes beneath the

[handwritten margin note at top: Modigliani seemed to put his physicality & emotions into his work, but does it have to be marketed upon his self destructive talent (if there were such)?]

completed works. Modi's habit was to paint around rather than over these lines.[20]

Regardless of whether and how much he drank, Modi's productivity during the first years of the war (and later) was remarkable. There are no signs he lacked confidence in the way he implemented his artistic vision. Although he was a loner, he had many friends and a history of female companionships. Financially, he was not necessarily in greater need than many struggling artists at the time, and even with a war raging only miles away, he had more exhibits and greater recognition in 1916 and 1917 than he had yet known in his entire life.

Amedeo was not usually a docile, carefully calculating artist who stood contemplating his canvas while he worked. Instead, his acts of creation were all-encompassing and physical. Painting rapidly, he pushed through the constraints of form defined by his respect and admiration for the Italian masters without allowing his work to be polluted by the public's (or would-be collectors) appeal for modernism. Modigliani fidgeted, he smoked, and he drank while he worked. His shoulders heaved, and he grimaced as he spoke out with joy or frustration. Singing sometimes, or reciting verses of poetry he learned as a child, Modigliani drew his subjects with incredible ease and precision. His friend, Lunia Czechowska, whose portrait he first did in pencil in 1916, said, "he painted with such violence it scared her."[21, 22]

§

[handwritten note at bottom: The discussion about Modigliani's drinking seems to go in circles, why is there is so much focus on it? How does it illustrate his paintings?]

169

CHAPTER 23

<div align="center">━━◦◦❖◦◦━━</div>

TURNING THE PAGE

"To everything there is a season."

Ecclesiastes 3:1-8[1]

By early 1917, Modi had made what probably was one of his last drawings of his muse, Beatrice Hastings. It is a standing nude, as if Amedeo "did" Beatrice while she was just going about her business. In the sketch, she is tall, thin, and with small breasts.[2] There is a hint of hair on her pubis, which is partially covered with what resembles a towel held in both hands as if she had just finished drying herself after a bath. Her downward gaze is pensive. The sketch is far more detailed than those nudes Modi did of his first muse, the Russian poet Anna Akhmatova, and possibly foretelling of the nude sketched for the catalogue cover of his exhibit at the Gallerie Berthe Weill, near the famous auction house, The Hôtel Drouôt, later that year. [3]

As Beatrice left him for new adventures, Amedeo struck up a liaison with one of her friends, a twenty-four-year-old student named Simone Thiroux (1893-1920). Simone had inherited some money from her Canadian father and begun her medical studies in Paris. She became caught up in the bohemian lifestyle and quickly depleted her savings. A victim of unrequited love, she accompanied Modi to a few of the sittings with Jacques and Berthe Lipchitz, to whom Modi described Simone as a *poule mouillée*, a derogatory term that literally means a wet

chick, but is slang for wimp or someone who is incapable of holding her own.

Simone, who was called La Canadienne by Modi's friends, was described by author Charles Douglas as "a good-looking blonde; a tallish, elegant figure, very attractive."[4] It is unknown whether Modi made sketches of her, but there is at least one pencil drawing that is considered authentic. There is no definitive evidence he painted her portrait or used her as a model for one of his nudes. A possible resemblance to Simone is found in an oil-on-canvas titled *Girl in a Green Blouse* (Ceroni n° 114, 1917), bought by the American collector Chester Dale in 1927 and currently at the National Gallery in Washington D.C. A similar painting (although the sitter's hair is a light brown), *Jeune femme à la guimpe blanche*, was recognized as authentic by Modigliani experts, Arthur Pfannstiel and Jeanne Modigliani. It was reportedly sold by the French auction house Hôtel Drouôt in 1939.[5] Based on a tip from the broker, the piece was declared in all probability to be a fake (although not yet proven and despite its presumed authentication in Paris in the 1950s, 1960s, and in a letter from Angelo Ceroni dated 1996).[6] It was seized by Italian authorities in 2019.[7] Two other paintings from around that time are of a blond woman, although there is no evidence they are Simone; *Standing Blond Nude with Lowered Chemise* (Ceroni n° 193, 1917), whose photo is the frontispiece of Francis Carco's 1924 book *Le Nu Dans La Peinture Moderne*[8] (it was exhibited at the Tate London in 2017), and *Seated Nude with Folded Hands* (Ceroni n° 267, 1918?). Both have what appear to be the same blond, blue-eyed sitter; both are painted on a greenish-blue background washed out by overcleaning during restoration.

Eight years younger than Modigliani, Simone dated Amedeo for a very short while and possibly bore him a son he refused to acknowledge (Serge Gerard Thiroux-Villette was born September 15, 1917. He was later adopted, became a monk, and died in France on October 30, 2004.). Abandoned ruthlessly by Modigliani, Simone later made ends meet by teaching English and working as a nurse at a charity hospital. She died miserably and alone from tuberculosis in a common ward at the Hôpital Cochin on October 6, 1920.[9] She was twenty-seven years old.

These were obviously troubled times for thirty-year-old Amedeo Modigliani. His break up with Béa and the romp with Simone occurred while he was being subjected to the pressures of one art exhibit after another. On November 16, 1916, however, he had written his mother:[10]

"Darling Mother.

I have let too much time go by without writing, but I haven't forgotten you. Don't worry about me. Everything is going well. I am working and if I am sometimes worried, at least I am not as short of money as I was before. I wanted to send you some photographs, but they didn't turn out too well. Send me your news.

A big hug from Dedo."

For reasons that are unclear, Modi broke from his dealer, Paul Guillaume, whom he obviously admired and respected; he had made four portraits of the man and sketched him frequently. It was also more than two years since he had news from his friend, patron, and supporting figure, Dr. Paul Alexandre, who was knee-deep in the blood and guts of World War I. And Modi was not keeping the best of company. His friend Utrillo was a mentally ill alcoholic who spent time in the asylum, and his buddy, the temperamental and depressive Chaïm Soutine, whose paintings Modi admired, was slumming it between hole-in-the-ground lodgings and low-rent neighborhood bars where he indulged in violent rages against anyone and everything. Even his friend, Moïse Kisling, was a heavy drinker, though he had returned from a lengthy convalescence in Spain after his war injury and married a woman named Renée – Modi sketched her in 1916 and painted her portrait on cardboard shortly thereafter (Ceroni n° 163, 1917).

By January 1917, winter was already cold in Paris. According to the novelization of Modi's life, Amedeo was drinking more, taking drugs, and coughing up blood.[11, 12, 13] This is certainly possible, as the drugs and the booze would have helped suppress the artist's embarrassing and disabling cough. Perhaps he had developed bronchiectasis, an abnormal

dilation of the peripheral airways called the bronchi, which causes a chronic cough that may or may not produce phlegm. Cough by itself is irritating and can cause blood vessels to break in the lungs and airways, which produces blood-tinged sputum or frank hemoptysis, the dark-red or bright-red splotch of blood on a handkerchief that is famously depicted in Hollywood movies. It is also possible that Modi had reactivation pulmonary tuberculosis and may even have been infectious. There is no evidence of his being severely ill or hospitalized, however, and none of his friends mention his visiting doctors or a dispensary. Biographer Pierre Sichel writes that "During the winter – probably 1916-1917 – Modi disappeared for several days…He reappeared as mysteriously as he had gone, staggering into the Zborowski's room* … penniless as usual and in a deplorable state, unable to give any account of where he had been…hungry and filthy."[14]

The death rate from tuberculosis in Paris had increased to 358 per 100,000 population in 1917, which was more than fifty percent higher than before the war (comparatively, in New York City, it was 188 per 100,000 and dropping).[15] France had already mobilized more than eight million men in their war effort, and many combatants returning from the Front, either permanently or on temporary leave, were either ill or had become carriers of the disease (in other words, they had latent mycobacterium infection). With the scourge of alcoholism ongoing, the social environment was ripe for a public health crisis.[16]

Modi's health was dwindling. He lost some of his teeth, ate badly, and for whatever reason, was drinking more. Carlos Carrà writes that "at times, he spoke in gelid, halting tones, jumping from one word to another, with intervals of indecipherable silences."[17] There were times he disappeared for days, reappearing haggard and seemingly exhausted to his friends. Other times, like many who are disinhibited by their use of alcohol, he took off his clothes, danced in the streets, or became boisterous, recalcitrant, and argumentative. Descriptions of his drunken escapades, getting kicked out of parties, or needing to be

* Léopold Zborowski was Modi's new art dealer and manager.

accompanied home by friends bolster the legend of Modi's being an out-of-control, self-indulgent yet charismatic brat who squandered his time between paintings by plunging himself into unjustified despair, booze, and babes. An immune status weakened by malnutrition, living (and partying) in overpopulated quarters where not everyone was versed in the habits of good hygiene, harboring chronically poor health from the sequela of childhood infection with Mtb, and alcoholism provided a bedrock of risk factors for the reactivation of mycobacterial tuberculosis. It was only a matter of time before the deadly disease raised its ugly head again.

On the upside, however, Modi had some money in his pocket, several nice reviews to boost his ego, and the good fortune to meet Léopold Zborowski (1889-1932). Born in Zaleschiski, in the Austro-Hungarian empire, the twenty-three-year-old Pole had come to Paris by train, enamored with art but aspiring to become a poet. After being interned at the start of the war because of his Polish-Austrian origins, he was released in the winter of 1915, when he resumed a relationship with his partner and future wife Hanka. Zborowski soon abandoned poetry and became an art dealer. Like today, dealers served as intermediaries between artists and collectors. They built relationships with other dealers, gallerists, art traders, auction houses, and anyone who might help them market the particular artist or art form they represent. Not unlike already famous merchant collectors such as Paul Durand-Ruel (who supported the Impressionists) and Daniel-Henry Kahnweiler (Picasso's exclusive dealer from 1912-1914 and a promoter of many unknown modernists), Zborowski's ambitions were both ideological and entrepreneurial. He loved Modigliani's work, but he was not wealthy. Nonetheless, he gave Amedeo a daily allowance, perhaps up to sixteen francs a day. This was quite a sum considering the French government provided formerly tuberculous war veterans only three francs a day for three months to help with their rehabilitation.[18]

Zborowski and Hanka invited the artist to work in their downtown apartment, then offered him a room at their home on 3 Rue Joseph-Bara in Montparnasse, only a four-minute walk from the Académie Colarossi on Rue de la Grande Chaumiére. Modigliani painted prolifically there,

but not surprisingly, Léo had trouble making ends meet, let alone selling Modi's paintings for a profit. Not everyone wanted someone's portrait hanging on their walls, especially if it was painted by a commercially unproven artist, even when a low(er) sales price made it a good deal. However, the art dealer Georges Chéron had a persisting interest in his work (Ceroni nº 67, 1915), as had the collector Jonas Netter, who purchased Modigliani's portrait of *Chaïm Soutine Seated at a Table* (Ceroni nº 155). Contrary to Paul Guillaume's declarations that he was the only one who bought Modi's paintings, there were many sales to reputable dealers and collectors both in France and from abroad, including to the Egyptian antique dealer Joseph Altounian, who owned several drawings (*Madame Minouche*) and a portrait.[19] Again, Léopold Survage provides insight as to Amedeo's technique, describing a behavior entirely different from that described by Carrá: "He never cleaned his palette, which grew thicker and thicker, heavier and heavier. Often, once the work was finished, he would sing – Hebrew songs and mantras full of sadness and nostalgia. In the evening, he would go out with a friend and, walking very slowly, discuss music, painting, or literature. He did not, in fact, like walking and would often stop to elaborate on his discussion, well-chosen and well-composed, just like his painting."[20]

Among Modi's many paintings from the period is a new portrait of *Jean Cocteau* (Ceroni nº 106, dated 1917) painted over a canvas of Kisling's. The poet, whose face is seemingly chiseled into a pointed chin, sits on a chair immersed in blues. Cocteau bought the painting directly from Modigliani in 1917, paying only five francs for it. Amedeo also made the first of many portraits of his new dealer, Léopold Zborowski, and experimented more with the exaggerated, swan-like necks and tilted heads that would characterize his work, even though such extreme exaggerations are in very few pieces. One famous example is his painting of Hanka's friend, Lunia Czechowska - *Woman with a white collar* (Ceroni nº 169, 1917). The painting became the first of Modigliani's paintings to be owned by a state museum – it was acquired by the Museum of Grenoble in 1923. The sitter's dark clothes and apricot-colored skin on a dark background contrast with her white V-shaped low collar. She has a slender, exaggerated neck and tilted head, but her

face is soft with lightly blue-filled eyes and delicately closed lips that make it appear as if she is looking at you with patient consternation. Structurally, it is as if the entire head ensemble could be detached *en bloc* from the pedestal-like neck. In her memoirs, Lunia described how Amedeo worked with such intensity he knocked the piece off his easel. When the portrait fell to the ground, a cigarette butt became stuck in the fresh paint. Its trace is still visible.[21]

Modi also did many portraits of Zborowski's wife, Hanka (aka. Anna) Zboroswka. One is the dark-haired *Hanka Zborowska with white collar* (Ceroni n° 160), where the slight curvature of the sitter's extended neck flows gently into her soft-looking oval face with its terra-cotta perplexion. The name ANNA is written in bold black letters in the upper corner of the canvas. In another, she is seated in a large, dark-flowing dress, *Hanka Zborowska Seated* (Ceroni n° 177). Her neck is very straight, and her long, tapering oval face is prolonged by her jet-black hair pulled up high onto her head, which is barely tilted. It stands out against an orange-red, flame-like swirling background. Her eyebrows are narrow lines, and her eyes, which are characteristically asymmetric, resemble a pair of dark almonds. The piece is unsigned, but experts consider it to be an original. It is currently at the Museum of Modern Art in New York. Contrary to most of Modi's paintings, recent radiographic analysis shows no under-drawing in this painting. Researchers suggest that Modigliani's familiarity with his subject allowed him to forego this habitual preparatory step.[22]

Then, in March 1917, Modigliani met Jeanne.

She was eighteen years old to Modi's thirty-three.

Her family name was Hébuterne, and it's said they met through the graces of Ukrainian- Jewish sculptor Chana Orloff, possibly at La Rotonde or perhaps across the street at the Académie Colarossi where Jeanne took art classes.[23]

Modigliani's friend, the Japanese painter Tsuguharu Foujita, described her as *vicieuse et sensuelle*.[24] He also said she was no longer a virgin.

§

CHAPTER 24

1917

"There is no hell, no inferno except the frenzy of living"

Henri Barbusse[1]

As the war entered its fourth year, Parisians had become accustomed to many hardships. Unemployment was low, and workers' wages had increased, supplemented by living allowances for families of men who were mobilized. Food shortages and lack of coal, however, made the winter of 1917 difficult. Workers' strikes broke out in revolt against high profits made by the war industry and a surge in prices for ordinary goods. Parisian streets and public places were filled with foreign workers, refugees, and an increasing number of soldiers, still affectionately called *poilus – hairy ones,* a nickname dating from a time when long-haired fighting men with mud and grit on their faces wore fierce mustaches to accentuate their masculinity. Now, many *poilus* wandered the streets. Thousands were dazed, sick, or wounded. They huddled in makeshift lodgings and gathered in the courtyards of neighborhood hospitals. Many combatants who had survived gunfire, bayonet charges, chemical inhalations, and death from the skies suffered from shell shock – what is currently known as post-traumatic stress disorder.[2]

Despite their resilience, Parisians felt the effects of war. People were horrified by news of French military leaders executing their own soldiers

for presumed cowardice. There were rumors the troops would soon refuse to fight. Behind the lines, in cities and in rural areas throughout France, women performed jobs previously done by men. In many places, they constituted a majority of the workforce, in spite of being subjected to horrendous and unfair working conditions that set their appeals for equal rights back many years. The authorities had their hands full to maintain the public's enthusiasm for conflict. In an attempt to prolong their citizens' patriotic fervor, therefore, pro-war propaganda was everywhere; in film, songs, posters, newspapers, and oral indoctrination.[3] Young children pretended to kill make-believe *boches*, a word probably derived from the slang word 'caboche', meaning a rascal or a squarehead and used to contemptuously describe German soldiers.[4] Servicemen, wives, widows, mothers, and others looked disparagingly at anyone, including artists, who shirked from their duty to advance the war effort.

Stalemate on the Western Front, after almost a million casualties overall at the battle of Verdun alone, and the failure of Nivelle's offensive in Champagne, led to a change in military leadership. In May, General Philippe Pétain, the hero of Verdun, was named Commander-in-Chief of the French armed forces. With the coming of Spring, Parisians were also filled with hope at the prospect of American soldiers entering the conflict. The United States had joined the Allied forces in April 1917, insistent on maintaining their own agenda and refusing to allow their troops to be controlled by foreign leaders. The first soldiers from the American Expeditionary Force arrived in June with their commander, General "Black Jack" Pershing. On the Fourth of July, thousands of Parisians marched with two hundred newly arrived American soldiers to the historic Picpus Cemetery, about two miles from the Place de la Bastille. Standing on a small platform framed by the red, white, and blue flags of France and the United States, General Pershing, American Ambassador William Sharp, France's former military leader Le Maréchal Joffre, Prime Minister Ribot, and other officials reverently faced the tomb of the Marquis de Lafayette. The Marquis had served both France and the American colonies gallantly during America's War of Independence before personally designing the French flag in the early days of the French Revolution. General Pershing's representative,

Colonel Charles Stanton, spoke words that drew thunderous applause; "Lafayette," he said, "We are here."[5]

It's about time, people thought. France had already lost almost a million men. Morale at the Front was dismal, individual desertions were widespread, and entire infantry units hesitated to leave the trenches. War, they said, was futile, and they were unwilling to participate in attacks that resulted in nothing but useless casualties.[6] Meanwhile, in Paris, the cost of living had increased one hundred percent since the year before. Train stations and public squares seemed permanently transformed into triage zones and resting centers for the wounded and the traumatized, and the number of refugees, many of whom transited through Paris and other large cities, reached at least 1.25 million by December 1917.[7] Subjected to more stringent controls and even hostility from local civilian populations, they were considered unfair competition for an already exploited and significantly diminished labor force. Since the first signs of the Russian revolution in February, even more people streamed in from the East, often preceded by wealthy aristocrats also fleeing the Bolsheviks.

In order to address civilian needs and serve this new influx of potential patients while still providing medical care to soldiers, the American Hospital of Paris in Neuilly increased its capacity to two thousand beds. Like other hospitals, it used an adjacent high school, the Lycée Pasteur, to house its ambulance service. The American expatriate, Edith Wharton, helped civilian populations by starting the American Hostels for Refugees. Her work and that of a British nurse named Edith Cavell inspired tens of thousands of female volunteers, many of whom served in the Red Cross. Representing virtuous and patriotic femininity, they were also nicknamed "white Angels" because of their white aprons, bonnets, occasional veils, and connotations of the divine.[8] Their care and compassion while tending to the wounded and the dying in hospitals and on the battlefield reset the nurse-caregiver model for the entire profession.

Although the carnage of war would include greater bodily mutilation than ever seen before (in part from increased use of machine guns and heavy artillery), as well as horrendous physical and emotional

damages from chemical warfare, many soldiers' lives were saved. Progress made in wound care, surgical techniques, the medical treatment of hemorrhagic shock, and rapid access to mobile radiographic imaging vehicles contributed to increased survival. Huge changes occurred in hospitals' operating theaters, where anesthesiologists had fewer complications and deaths as a result of using nitrous oxide gas and oxygen instead of chloroform and spinal anesthesia for many patients.[9, 10] In newly formed Casualty Clearing Stations close to the Front, the number of amputations and deaths by gas gangrene, a foul-smelling bacterial infection of soft tissues caused by *Clostridium perfringens*, decreased significantly because surgeons debrided wounds and bathed them in a new antiseptic solution invented by American chemist Henry Dakin and French surgeon Alexis Carrel.[11]

The Assistance Publique des Hôpitaux de Paris (government-run public university hospitals of Paris) also increased their bed load by the thousands, but not solely for the wounded.[12] Authorities were troubled by issues of public morality. At the turn of the century, some experts estimated that thirteen to fifteen percent of the male population was syphilitic,[13] and the triad of venereal disease, tuberculosis, and alcoholism was a public health threat that required immediate attention. Hospitals expanded the size of their wards and opened free evening clinics for patients with known or suspected communicable diseases. Public Health services extended their sphere of influence, creating more than one hundred *services annexes* – auxiliary services for anyone with "suspicious lesions."

Since the start of the fighting, syphilis and other sexually transmitted illnesses (STIs) such as gonorrhea spread like wildfire. Both had a considerable impact on fighting men because they incapacitated soldiers for weeks, forcing their removal from the front lines. When soldiers returned to their families, went on leave, or resumed civilian life, these sexually transmitted diseases also endangered their partners. The entanglements of promiscuity, religion, and morality dictated how both the Allies and Central Powers implemented preventive measures.[14] In France, temperance was encouraged, condoms were freely distributed to the troops, and medical treatment was administered by intraurethral

injections (for gonorrhea),[15] mercurial compounds,[16] and arsenic-based salvarsan (available since 1910) for syphilis.[17] Public education about the dangers of STIs became a priority.

Nationwide advertising campaigns were launched to teach about the dangers of transmission. Women were quickly made into scapegoats. In thousands of banners, posters, and leaflets, females were blamed for spreading disease while men were warned to resist a woman's temptations. American troops, for example, were strictly forbidden from visiting brothels. Dominion troops from Canada, New Zealand, and Australia were taught that women were either "ladies or loose."[18] Infected persons were shamed and segregated. When necessary, they were placed in specialized Venereal Disease wards. Posters, pamphlets, and periodicals warned about the dangers of sex, while in the cities and rural areas, prostitution, which flourished since the beginning of the war, came under greater government control.[19]

Authorities imposed but not always enforced strict regulations on brothels, also known as *maisons de rendez-vous* (*trans.* homes for meetings). The police and a cadre of social hygiene workers kept watch on women working in dance halls, cinemas, theatres, and cafés where covert, overt, and clandestine prostitution reigned.[20] Ironically, mandating closing times as early as nine p.m. for restaurants, bars, and brasseries or forbidding businesses from serving drinks to soldiers and women backfired. Initially, many public health interventions were ignored. There was a rise in disease frequency and growth in the number of registered and unregulated sex workers. French soldiers were ordered to go only to *licensed* brothels, including the soon-to-be officially called *Bordels Militaires de Compagne* (*trans.* Military Field Brothels). Using the acronym BMC, this was a clever substitution for the military designation of Batallion Médicale de Compagne (*trans.* Medical Field Battalion). Soldiers were also advised to avoid young and "apparently healthy" single women who "deprived of good counsel" rounded off their monthly salaries with earnings from promiscuous friendships.[21] By October 1917, however, even registered prostitutes were forbidden by law to enter bars and cafés.[22]

Exemplifying one of the great absurdities of the war, government agencies turned their attention to remedying the long-term effects of

losing so many men to both battle and disease. Rather than voice resistance against the war in order to force their government to resolve conflict through negotiation and peace, many French officials implemented a perverse sort of patriotism. Venereal diseases, they said, placed the future of France in jeopardy. In addition to causing an enormous financial burden, their numerous ill effects were felt in the workplace, on fighting forces, on children, and on future generations. Gonorrhea threatened male and female fertility, caused miscarriages, preterm births, and neonatal blindness, among other adverse birth outcomes. Syphilis, because it was transmitted from pregnant mother to fetus, threatened France's future because of higher infant mortality and the effects of congenital disease. Spontaneous abortion or late-term stillbirth occurred in thirty to forty percent of cases. Still today, an untreated woman with syphilis has a nearly seventy percent chance of fetal infection during the first four years of the disease.[23] About one in three infected fetuses are born alive with congenital syphilis, which may cause bone damage, skin rashes, severe anemia, enlarged liver and spleen, jaundice, and brain and nerve problems resulting in blindness, deafness or meningitis.[24]

The war had already caused birth rates to fall up to fifty percent.[25] Despite the dangers of uncontrolled venereal disease, however, soldiers on leave were urged to do their duty to repopulate the country. It seems the government feared that further reduction of the population would result in an insufficient number of available men of fighting age in case of future conflicts. The esteemed French Academy of Medicine, which had been tasked since 1820 to "respond to government requests to respond to all matters relating to public health," were now asked to protect the health and wellness of new mothers and children.[26] In addition to voicing concerns about STIs, the Academy said that rising infant mortality and neglect were linked to how women worked in the fields and factories rather than staying at home. The Academy, therefore, recommended that breastfeeding and infant children be allowed in the workplace.[27] Medical leaders ignored the fact that women's salaries and quality of life were significantly less than those of men in similar positions. Only a few industrialists were as forward-thinking as

André Citroen, who made his female workers' well-being a priority in his armaments factories, assuring them in-house medical care, healthy meals, factory-based child care, and ample time for physical exercise.

The moral landscape throughout France also needed to change. People were asked to refrain from promiscuous behaviors in order to help counter the wave of prostitution and greater sexual freedom that marked the earlier years of the war, and extramarital sex was frowned upon. Women who spent the war years unmarried were encouraged to wed and have children with younger men who, as teenagers, had not been called to serve in the armed forces. With more than 600,000 widows and a million fatherless children or orphans by the war's end,[28] there was a newfound respect for single mothers. French authorities also provided financial and institutional support to assure that children (designated as "pupilles de la nation"), with a parent who had been killed or severely wounded while defending France would be cared for by the state.[29]

Overall, almost seventy million men and women fought in what was now being referred to as The Great War. Many spent years surrounded by mud, gore, and guts in anticipation of their next rush from their trenches. From what Jean Cocteau had called "an incredible labyrinth of corridors, roads, and underground galleries," they courageously stepped into a vast expanse of land filled with barbed wire and shell craters from which many never returned.[30] Luckier men (and women) spent the war far from the front lines. They cooked for the troops, managed logistics, transported and cared for the wounded, or buried their comrades and loved ones. By the end of the war, military and civilian casualties from both sides numbered twenty million dead and at least twenty-one million wounded.[31]

During the last months of 1917, many Parisians yearned to live with an illusion of normalcy even though an end to the fighting was not in sight. Amidst a bustle of automobiles, military vehicles, ambulances, and horse-drawn carriages, civilians zigzagged between barricades made of wood and dirt-filled barrels. They strode past monuments and churches protected by sandbags. Men in suits and walking canes mingled with women wearing long skirts and hats on city streets and along the grand

boulevards. People feared German air raids, but they were accustomed to electrical blackouts. They stood patiently in line for produce at neighborhood markets and used their government-issued cards to obtain bread, meat, and the coal they needed to heat their apartments.[32] The city was also dominated by a black market for goods and services through which many made their fortunes. Even a few starving artists were no longer starving because their art dealers found wealthy clients eager to make what could turn out to be a good investment. Artists who had not fled Paris and been spared from military service, either by nationality or because of medical exemptions like Modigliani, went on with renewed hope in their daily business.

However, tired of enduring hardships, the people's patriotic spirit faltered. The industrial needs of the war prevailed over mass conscription, causing fewer men to be sent to the Front and sending more male workers to the factories.[33] Musical compositions, such as *Germanophile* by Camille de Saint-Saens, failed as propaganda to help maintain the war effort.[34] The horrific realism of a French soldier's life described in Henri Barbusse's award-winning novel, *Le Feu – Under Fire*, finally hit home and did little to boost morale.[35]

§

CHAPTER 25

TIME TICKS

"Life is a gift, from the few to the many, from those who know and have to those who do not know and do not have."

Amedeo Modigliani[1]

Modi's star shined throughout the rainy spring of 1917. Contrary to Beatrice, his newfound muse, Jeanne Hébuterne, was a quiet type who was unconditionally devoted to him. Everyone from Japanese artist Tsuguharu Foujita's wife, Fernande Barrey, to the writer André Salmon said there was an almost angelic gentleness about her. Sculptor Jacques Lipchitz described her as "a strange girl, slender, with a long oval face which was so white, it hardly recalled the idea of skin."[2] Biographer June Rose said she had "a milky complexion set off by chestnut hair,"[3] which perhaps is why some of her friends had nicknamed her *coconut*. Hanka Zborowska said she never heard her truly laugh.[4] Léon Indenbaum (1890-1981), the Russian émigré sculptor whose portrait Modi did in 1916 (Ceroni n° 191),[5] said he heard Jeanne talk so seldom that he could not remember what her voice was like.[6] She was also an artist, studying at the Académie Colarossi and preparing her entrance exams for the École des Beaux Arts.

Jeanne came from a strict home environment that reinforced her tendency to be an introvert. Her bourgeois mother, Eudoxie, and father, Achille, were ardent Roman Catholics who swore they did not suspect

185

their daughter's liaison with Modi until July 1917.[7] By early summer, however, Jeanne and Amedeo had moved into a small apartment on 8 Rue de la Grande Chaumière, only steps from the Académie Colarossi and minutes from Zborowski's apartment on 3 Rue Joseph-Bara, where Amedeo zealously worked every day.

With production flowing and having almost finished negotiations with his new dealer, Léo Zborowski, Modi exhibited paintings at the Galerie Chéron et Cie, at 56 Rue La Boëtie, an old avenue lined with art galleries from the Place de la Concorde to the Champs-Élysées. Also, thanks to some goodwill that resulted from Modi's contribution of artwork to the Dadaist magazine *Cabaret Voltaire* earlier that year, Amedeo was asked to exhibit paintings alongside works by Hans Arp, Paul Klee, Giorgio De Chirico, and others at the Gallery Dada, in Zurich. Interviewed ten years later, De Chirico would say, "There is no modern art movement in Italy. Neither dealers nor galleries. Modern Italian painting does not exist. There's Modigliani and myself, but we are practically French."[8] Clearly, Modi was recognized abroad, and he was among the few younger artists with an international presence.

Amedeo was a painter of portraits. In 1917 alone, he did more than a hundred. He had refused to sign The Futurists' Manifesto endorsed by the likes of Giacomo Balla and Gino Severini because he could not support their coalition "against the nude in painting, as nauseous and as tedious as adultery in literature,"[9] nor agree with their declaration to "Finish them off... The Portraitists, The Genre painters...to sweep away from the ideal field of art all themes, all subjects that have been already used."[10] Also, despite his technical skills, Modi had no interest in becoming an academic portraitist, hired to provide history with exact images of his subjects. He refrained from creating a false aestheticism to please the needs of art critics, speculators, or even bourgeois collectors who were gradually replacing wealthy aristocrats and millionaires as arbiters of modern art. When he was at the top of his game, Modi's paintings resembled the people he portrayed, but more importantly, they reflected his spiritual interpretation of his sitters. Perhaps he felt uncomfortable thus robbing them of their souls. Perhaps, that is why he preferred to give away his paintings or accepted only token payment

In what way did his paintings reflected his spiritual interpretation of people?

[handwritten annotation at top: How did M. curate meaning of his sitters, people he painted — did he always paint people he knew well?]

and a bottle of wine for his efforts. His friend and early collector, Dr. Paul Alexandre wrote, "Each portrait is the result of deep meditation in front of the sitter…Modigliani never painted without meaning."[11]

[handwritten annotation in right margin: more about it?]

Some of Amedeo's works, of course, were the product of private commissions. There is *Monsieur Lepoutre* in his orange-yellow jacket (Ceroni n° 156), for example, and *Mme George van Muyden* (Ceroni n° 216) with her décolleté, bare shoulders, and rosy cheeks. The discovery of fiber inclusions embedded in the flesh tones of other paintings done during the same period suggests that Modi used a cloth to buff the painted surface, making it almost shine. Presumably, Modi sometimes made more than one version of his subjects. There are, for example, two very similar portraits of *Doctor Devaraigne* (Ceroni n° 182 and Ceroni n° 183, 1917), also called "the handsome commander" in full uniform (the doctor was a gynecologist), in addition to an oil sketch. The second of these, which has two signatures, was later owned by American composer George Gershwin. There are also two virtually identical portraits of *Elena Povolozky* (both catalogued as Ceroni n° 167, 1917) – her real name was Hélène. The authenticity of each has never been questioned. Married to a Ukrainian book editor in Saint Germain-des-Prés, Povolozsky presumably entertained Modigliani and his friends on several occasions.[12] The two paintings are very similar, but the name ELENA is inscribed in a different place on each (one portrait is now in a private collection, and the other is in the Phillips Collection in Washington D.C.).[13]

Modigliani also painted several portraits of his dealer, Léopold Zborowski, and of Léo's partner Hanka, whom Modi painted more than a dozen times. He used many other sitters more than once as well. For example, the Algerian woman *Almaisa,* whose portrait he did at least twice, provides an example of how he first produced an incomplete oil of the sitter's head and shoulders (Ceroni n° 133, 1917) before attacking his larger and more finished work that includes the sitter's name, "Almaisa" written in block letters in the upper right-hand corner of the canvas (Ceroni n° 132). A third painting is *Almaisa nude on a divan* (Ceroni n° 131, 1917). He still painted over older canvases too, although in at least one instance, this may have been to dispel

memories of a prior romance. Technical analyses reveal that beneath Modi's painting, *Portrait of a Girl/Victoria* (Ceroni n° 118) displayed at the Tate London in 2017, is a portrait of Beatrice Hastings which probably dates from 1915.[14]

Amedeo almost always painted on traditional materials; canvas, cardboard, and paper. At least once, however, he unintentionally engaged in the habit of future twenty-first century graffiti artists who paint on whatever surfaces become available. At some point, for example, he sketched his younger friend Chaim Soutine's full-length portrait on the wood panels of Zborowski's living room door. Modi believed in Soutine and persuaded the art dealer to represent the twenty-one-year-old artist.[15] He had befriended the poor, eccentric Jewish-Lithuanian émigré sometime between 1913 and 1915, and the two men occasionally shared workspace in the Zborowski's apartment. The upper panel of the door eventually found its way to Nashville, Tennessee (Ceroni n° 217). It was donated in 2016 to the Musée d'Orsay by its owners, the Marlene and Spencer Hayes Foundation. The lower panel has never surfaced.[16]

In 1966, the controversial, yet talented and self-destructive American author-founder of Gonzo journalism, Hunter S. Thompson wrote, "The Edge... There is no honest way to explain it because the only people who really know where it is are the ones who have gone over."[17] A half-century earlier, Modigliani's drive to paint had become an obsession. Naturally, he wanted to earn a living, obtain notoriety during his lifetime, and leave a legacy for future generations. But something else motivated him beyond his needs for money, fame, and recognition. He knew his time was limited and attacked what he could of life before being consumed by disease. In so doing, he became entangled in the self-destructive web of overwork, alcoholism, and drugs. Describing Modigliani's health at the time, Ilya Ehrenburg, a Russian novelist who had known Amedeo since 1912, said: "Modi was always coughing, always felt cold."[18] By the time the sculptor Ossip Zadkine returned from the Front in October 1917, Amedeo was "thin and emaciated and could no longer take much alcohol – one glass was enough to make him drunk."[19]

Like many artists living within their self-indulgent bubbles of Montmartre, Montparnasse, and the intellectual centers of the nearby neighborhood of Saint Germain, Modigliani's life would have consisted mostly of a series of trips between his poorly heated apartment, his working space at Zborowski's, and the cafés of a war-torn city where Zadkine said Amedeo continued to sit with friends at the table and draw. "Occasionally he sang in a hoarse voice; he could hardly get his breath."[20] Zadkine said, adding, "To hide his cough, he invented for himself an almost hysterical laugh."[21]

Modi's extraordinary productivity during this period likely contributed to his deteriorating health. Chronic pulmonary symptoms and declining health would have rendered Amedeo less able to tolerate an overabundance of work, drink, or physical activity. Recurrent symptoms would have forced him to take opium-filled laudanum for pains and discomfort, as well as codeine or even heroin hydrochloride – available until 1914 – to calm his nagging cough. Cocaine too was available and still prescribed by physicians for catarrh, a buildup of mucus in the nose, throat, or lungs.[22] Soldiers used it to alleviate fatigue in the trenches and, in addition to drinking cheap wine called *Pinard,* to boost their morale and gather courage. In 1915, Beatrice Hastings wrote "Montparnasse, a foreign quarter, is entirely mad...the illicit sale of cocaine and hashisch must be something enormous...I know a charming girl who is going to pieces with hashisch, which is sold for twopence the pill!"[23]

When stories circulated that German sympathizers smuggled drugs into French cities to subvert the country's war effort, stricter prohibition laws were enacted to make cocaine and other substances less accessible to fighting men and civilians without a medical prescription.[24] French authorities cracked down hard on illegal drug use and in an effort to protect current and future generations from the shame of degeneracy, also policed public intoxication. Considering the social context during the war years, therefore, and Modigliani's considerable productivity, it is difficult to accept without question the allegations that he was a compulsive drug addict and drinker who spent his days and nights being inebriated. No public records have been produced to

So he was not?

suggest he was hospitalized in an asylum for alcohol abusers or even arrested for disturbing the peace. In this regard, the suggestion that many accounts of Modi's life, including those provided by family members and friends, were deformed as part of a Modigliani myth-making process after the artist's death is likely accurate.[25, 26] Further fictionalization and romanticization of Modi's life focused on accentuating the virtues of male virility, self-sacrifice, and the heroic arrogance of the starving artist who resists the lures of commercial success and widespread public recognition to remain faithful to the personal vision of his art. Such portrayals are particularly noted in Michel Georges-Michel's 1924 novel *Les Montparnos* and Charles Douglas's *Artist Quarter*.[27] These, in turn, inspired French cinematographer Jacques Becker's 1958 film *Les Amants de Montparnasse* (1958) and subsequently, Dennis McIntyre's play *Modigliani* (1968), which show a poor, unappreciated yet brilliant and vulnerable hard-drinking Modigliani on an inevitable path toward self-destruction.[28, 29]

While there are stories of Modi's rowdy behavior, his penchant for undressing in public after having a drink too many, and stumbling about at night between watering holes, there are no corroborated descriptions of excessive drug use as a cause for unexplained agitation, trembling, hallucinations, lying, stealing, or desperately seeking money for a fix. Other than some entertaining tales in *Artist Quarter*, none of Amedeo's fellow artists described him injecting morphine or heroin, snorting cocaine, drinking and sniffing ether, or lazing about in an excessively drugged-out hashish and opium-induced stupor. Nor have they disparagingly called him a *toxicomane* – a term used since the early 1900s to describe those who overindulged in drugs.

This is not to deny the Italian artist did not enjoy hard liquor and wine. After all, Modi once told his friend, Léopold Survage, that "Alcohol is for the middle-class evil. It is a vice. It is the Devil's beckon. But for us [artists], it is necessary."[30] Except for reports from the last weeks before his death, Modi's friends did not describe an excess of signs of alcohol poisoning such as consistently slurred speech, vomiting, seizures, or loss of consciousness.[31] "*De mortuis nil nisi bonum dicendum est* – Of the dead nothing but good is to be said." Some might even

argue that Modi's nocturnal behaviors, including possibly binge drinking and perhaps his daily collations while working were not very different from those of many young people today who don't need to clock in at their jobs in the morning.

Survage amusingly said that Modi painted his subjects with tilted heads and slender, extended necks because he had a habit of drunkenly gazing at people through the curved glass of a bottle of absinthe. So, Amedeo Modigliani drank, and he probably took drugs. With no end to the war in sight and cognizant of his deteriorating health and an ultimately premature death, Modi would have known he was a ticking time bomb, and that in all probability his time was running out.

§

CHAPTER 26

SEX SELLS, BUT DOES NUDITY?

"Maybe all the nude paintings in the history of art are actually pornography."

Mochtar Apin[1]

Naked figures probably inspired sculpture and pictorial art even before the 110 mm high Venus of Willendorf was sculpted by a Paleolithic artist 30,000 years ago.[2] The limestone figure represents a faceless female (is she naked or is she nude?) with pronounced genitalia, haunches, and heavy breasts. With her protruding belly, the figure is presumed to represent fertility, and hence is an example of early man's ability to use symbolism to reflect human behavior.[3]

Except for representations in academic and religious paintings, few Western artists built their careers exhibiting nude males in their paintings. Rubens, Renoir, Corot, Giorgioni, Titian, Botticelli, Albrecht Dürer, Matisse, Maillol, Ingres, Gaston Lachaise, Lucian Freud, and Cezanne however, are but a handful of artists among dozens of European masters who excelled in their representations of naked women. Art historians and critics, however, harbor a certain intellectualism to differentiate nakedness from nudity; for many, these differences represent more than an exercise in semantics. For art critic and British television celebrity John Berger, to be naked is to be seen by others for who you are. To be nude, however, is to hide oneself and be seen by others

as an object, possibly for sexual fantasy. To be naked is to be without suggestion of exhibitionism or subject to voyeurism. The viewer of a naked person might even feel intrusive, surprising the subject who happens to be naked at a particular moment in their life. The nude, on the other hand, appeals to the viewer and is present for the purpose of being viewed. The nude subject is visibly aware of being seen. As Berger writes, "A naked body has to be seen as an object in order to become a nude."[4]

The debate pertains to what nudity and nakedness represent in Western European art. Even though the Louvre exhibited both naked and nude figures since the sixteenth century, for example, Edouard Manet's famous *Olympia* (1865) and *Luncheon on the Grass* (1863) were considered immoral and vulgar when they were exhibited in Parisian salons. Manet's model for both paintings was a woman named Victorine-Louis Meurent (1844-1927), nicknamed "la crevette" (*trans.* the shrimp) because of her small stature and red hair. She was a French model and painter who also posed for Edgar Degas. Fearing public disparagement and concerned he had insulted academic traditions; Manet kept the paintings hidden for years in his studio. In *Olympia*, Manet revealed a reclining nude who is brought flowers by her fully clothed female servant. Breaking the rules of the time, which consisted in painting only biblical, allegorical, or mythological figures unclothed, Manet caused a furor when he revealed a woman with overt sexuality and obviously the venerated object of the viewer's gaze, staring matter-of-factly back at the viewer.

In a different type of painting altogether, and even more daring for the time, Gustave Courbet (1819-1877) neglected the female body altogether to provide instead a close-up view of his model's *bas-ventre*; her torso, one breast, spread-legged thighs, and vagina in *The Origin of the World* (1866). The painting was commissioned by an Ottoman diplomat and was owned by noted French editor Edmond de Goncourt and French psychoanalyst Jacques Lacan.[5] Arguably the painting is pure porn, but it resides in the Musée d'Orsay, where it still astounds many viewers today. In one brochure, museum curators describe how Courbet went to "lengths of daring and frankness which gave his painting its peculiar fascination."[6]

In 2014, the performance artist, Deborah de Robertis, created an uproar when she sat almost naked in front of the painting at the museum. She recreated the image of Courbet's infamous work by exposing her vagina, adding afterward that Courbet "shows the open legs, but the vagina remains closed. He does not reveal the hole, that is to say, the eye. I am not showing my vagina, but I am revealing what we do not see in the painting, the eye of the vagina, the black hole, this concealed eye, this chasm, which, beyond the flesh, refers to infinity, to the origin of the origin."[7]

Society has historically alienated and censored artists' portrayals of naked and nude female bodies in various ways across civilizations, social conventions, and époques. In his comments about Modigliani's contemporary, the Austrian expressionist painter Egon Schiele (whose mentor was Gustave Klimt), art critic and poet Craig Raine wrote, "Nudity isn't necessarily pornographic, even if it is explicit…"[8] Schiele's nudes were confrontational in their sexuality and erotically charged with often awkward poses.[9] The twenty-one-year-old artist's work was so controversial that he was temporarily imprisoned in 1912 for allowing minors to be near his drawings (Schiele's girlfriend was seventeen).

In Europe, cultural sensitivities have never been so universal that similar principles governed definitions of pudicity and prudishness when it came to Western society's perceptions of nudes across time and place. Giorgioni and his student, Titian, in their paintings of a *Sleeping Venus* (c.1510) and *Venus of Urbino* (c.1534), invented the Classic Venetian nude by presenting the naked female body "with noble delicacy and no indication of rawness or lasciviousness."[10,11] Botticelli's paintings of naked women, including his famous *Birth of Venus*, are considered emblematic of female beauty. Yet, many of the artist's paintings were burned in protest by Savonarola's followers in 1497. Bernini's *The Rape of Proserpina* (1621), which, experts say, is a fabulous example of baroque sculpture, is perceived today as a representation of unacceptable male-imposed violence and sexual abuse. The statue shows the violent abduction and prelude to the rape of a naked and screaming Proserpina by the Greek God Hades. His strong hands forcibly grasp the woman's skin-like marble thighs to signal all resistance is futile.

On a different note, the Aragonese painter Francesco de Goya's representation of a voluptuous naked woman, *The Nude Maja*, was confiscated by Spanish authorities in 1815. Goya's model is completely naked and languorously reclining on lace-covered pillows over a green sofa, her eyes erotically beckoning the observer. The painting had purportedly been hidden by Goya's patron, the Prince Manual Godoy, in his private study for several years after the work was commissioned. A half-century later and despite being grossly indecent, Gustave Courbet's *Woman with a Parrot* (1866) was surprisingly accepted by the French Academy as a work consistent with classicism. The painting shows a naked woman provocatively lying on her back. Her hair is disheveled, and her legs are partially spread – only the upper half of her right thigh is covered by a bedsheet, exposing her blond pubic hair. Interestingly, the woman is a brunette.

Kenneth Clark, art historian and author of *The nude: a study of ideal art* (1956), distinguished nakedness as being without clothes, from nudes, as a form of art. He wrote that nudes by Renoir were similar to Titian's *Venus Rising from the Sea* (c. 1520) in the way "the female body, with all its sensuous weight, is offered in isolation, as an end in itself."[12] Yet, the lines distinguishing works accepted as art from those that might otherwise be considered inappropriate are not always clear. For example, although Picasso's famous *Les Demoiselles d'Avignon* (1907) shows five naked prostitutes explicitly offering themselves in a Spanish brothel, the painting was never considered inappropriate. It still is thought to be a groundbreaking masterpiece. The French artist known as Balthus, however, was banned in 1934 for his portrayal of a woman teacher forcibly exposing the vulva of her spread-legged naked young student in *The Guitar Lesson*; the painting has not been publicly displayed since 1977. Another painting by Balthus, *Therese Dreaming* (1938), shows a twelve-year-old girl sitting with her hands on the top of her head, her eyes closed as if lost in thought, with her leg and skirt raised just enough to see her underwear. In the foreground, a cat laps milk from a small white saucer. Even today, the painting might be judged crudely representative of voyeurism and the nascent sexual desires of a young girl entering her teenage years. In 2017, thousands

petitioned the Metropolitan Museum of Art of New York to acknowledge the painting was an eroticized depiction of a child by an adult (the museum refused).[13]

What one person considers sensuous, erotic, or beautiful, others see as salacious, obscene, or potentially insulting.[14] When we see nudes and nakedness in paintings, we are forced to examine, at least in part, our personal views and biases about what we consider to be acceptably sexual and erotic. At the same time, we can expand our horizons, learn to be more tolerant, and open ourselves to learning to appreciate beauty in all its forms. Society's tastes and preferences are fickle and everchanging, however, which is perhaps why some art forms are censored, and why experts believe it necessary to distinguish between nakedness and nudity. In the 1964 pornography case, *Jacobellis v. Ohio*, for example, United States Supreme Court Justice Potter Stewart (on the Court from 1958-1981) sparked controversy and a national debate regarding "reasoned" and "emotional" responses to pornography when he proceeded to "define what may be undefinable," saying of obscenity that "I know it when I see it."[15]

Even if most opinions about art are presumably gender-neutral, there is still something to be said about the objectivization of women. With few exceptions, historically, it has been mostly male artists who depicted the female body in all its shapes, forms, and positions. In 1975, the British film theorist, Laura Mulvey, introduced the term "male gaze." In her essay, *Visual Pleasure and Narrative Cinema*, she analyzed the interweaving of erotic pleasure in film, focusing on meaning and the central role of the female image in Hollywood cinema. She described what is known as scopophilia, where both sexuality-driven "looking" and its ego-driven narcissistic opposite of "being looked at" are a source of pleasure. Fueled by sexual instincts, the viewer, who in most cases is a heterosexual male, is an active, controlling "voyeur (looker)" whose gaze objectifies the usually passive female other who is the "observed." Ignoring, for the most part, the non-straight male spectator and female viewers, Mulvey writes, "What counts is what the heroine provokes, not what she represents...In herself, the woman has not the slightest importance."[16]

Another visual arts example of the male gaze is when painters and art historians justify female nudes as a means to honor the beauty and aesthetics of the female body. This can be interpreted as suggesting females are moral, spiritual creatures who must be protected against animalistic, carnal men.[17] The nineteenth century English painter of historical nudes, William Etty, described nude females in classical painting as "God's most glorious work," a point he illustrated with *Pandora* (1824), *The Sirens and Ulysses* (1837), and in his paintings of a naked *Andromeda* (1830) wrapped in chains or secured to a rock while awaiting rescue by the hero Perseus – paintings that could readily be considered lessons in bondage for men of the Victorian era.

Realist artists such as Manet and Courbet shocked their viewers by placing naked females outside of a historical or biblical context and by painting naked women, presumably prostitutes and courtesans, or perhaps lovers, "nude" with purposefully alluring dispositions. Yet, in 1863, the French painter Alexandre Carbanel also shocked members of the Academy in Paris as well as art aficionados of every social class when he revealed his masterpiece, *Birth of Venus*. The painting shows a recumbent, fully exposed naked female – minus Sandro Botticelli's seashell and prudish hand gestures modestly covering her private parts. The nude woman reclines lasciviously on a bed of gentle sea foam below a group of mischievous naked cupids. French writer Emile Zola (1840-1902), a friend of Cezanne's and author of *Thérèse Raquin*, a novel about a young woman who kills her husband to be with her lover, provided an example of the male gaze combined with a taste for gastronomy when he described the painting; "the goddess, drowned in a river of milk, resembles a delicious courtesan, not made of flesh and bone - that would be indecent - but of a sort of pink and white marzipan."[18]

Modern psychology suggests that males and females perceive, receive and interact with the world differently. In *Ways of seeing*, John Berger summed up the male gaze when he wrote, "The female nude is subservient to the male 'spectator-owner' ... men act and women appear".[19, 20] It is likely, therefore, that nudes are sometimes painted by males in order to satisfy their natural and perhaps primitive or

genetically-derived inclination to objectify women. This position has been sometimes displayed and also mocked in poetry and literature, as in these lines from Lord Alfred Tennyson's poem, *The Princess* (1847).[21]

"Man is the hunter; woman is his game:
The sleek and shining creatures of the chase,
We hunt them for the beauty of their skins;
They love us for it, and we ride them down."*

Undoubtedly, the male gaze is a well-anchored socio-cultural representation of gender. This does not mean, however, that male artists are self-indulgently thinking "tits and asses" when they ask their models to pose a certain way (author's note: by artist, I extend the discussion to photographers, filmmakers, and other professionals called upon to 'manipulate' the female image). Neither intellectual discourse nor emotions-based arguments can reliably translate what always goes on inside the creative mind. Just as some males are aware of how they might objectify females (thankfully, not all men do so reactively or intentionally), others are not inclined toward exerting such patriarchal control.

"Sex lies at the root of life, and we can never learn to reverence life until we know how to understand sex," wrote the popular physician-writer Havelock Ellis in *Studies in the Psychology of Sex.*[22] Circumstances change, special situations arise, and working relationships evolve. For example, today's art viewers are increasingly gender diverse, which alters the subjective interpretations of any sexual undertones represented by nakedness and nudity in paintings. Like all humans, artists and their models are prone, of course, to their individual and often unique expressions of the allures of lust, love, passion, and desire. While this does not condone the objectivization of any person, even by way of idealization and romanticism, it helps explain how *gaze* is experienced, albeit sometimes differently, depending on one's gender and sexual proclivities.[23] Recognizing

*In the rest of this beautiful and somewhat comedic poem, Tennyson totally rejects a primitive male conception of power and mastery over women.

its existence in day-to-day interactions means learning to accept, deny, or revolt against one's position as an object and to negotiate one's place within or alongside the gaze accordingly. For females, this usually means exuding their sexuality regardless of male demonstrations of power and patriarchy in order to avoid becoming what John Berger called a surveyed female or passive objects for male pleasure.[24]

§

CHAPTER 27

MODI'S GAZE

"Each of his paintings triggered the beating of my heart."

Léopold Zborowski[1]

Three of the four most expensive works of art ever auctioned are portraits of nude women, fetching between 132 million and 160 million Euros, in 2015 and 2018 respectively. Two of them are by Amedeo Modigliani.[2]

We do not know what prompted Modi's dealer, Léonard Zborowski, to relinquish his private drawing room so that Amedeo, probably sometime in 1917 and at the height of his artistic productivity, could abruptly switch gears from portraits to painting more than twenty large-scale nudes. These canvases are usually more than sixty by ninety centimeters with the largest being 73 x 116.7 cm. Of course, like many visual artists with a strong foundation in the classics, Modi was no stranger to the form. He had probably spent hundreds of hours sketching nudes at art academies. He grew up studying and probably copying many Sienese and Renaissance paintings, and as a sculptor, he studied the female form with great intensity.

The author, Malcolm Gladwell, claims it takes ten thousand hours of intensive practice to master a set of complex skills and materials.[3] We cannot imagine the number of drawings Modi made of friends, lovers, sitters, and strangers as he perfected his skills over the years. Just

as musicians constantly practice and writers constantly write, Amedeo would endlessly sketch. Whether sitting at a brothel in Venice, drinking at La Rotonde, having coffee at La Closerie des Lilas, partying chez Rosalie, or dining with a girlfriend at Wassilieff's canteen, Modi observed and sketched people around him, sometimes trading his work for food, drink and whatever else he might receive in exchange for a drawing. Acquiring the vocabulary sufficient to transform his vision into a palpable reality demanded thousands of hours of deliberate practice.[4] In one sketchbook filled mostly with nude drawings, he scrawled, "What I am searching for is neither the real nor the unreal, but the Subconscious, the mystery of what is Instinctive in the human Race."[5]

The nature of this quest represents the essence of Modigliani's obsession, like film director Michael Powell, "to create at any cost."[6] Of course, talent alone is never enough to become a Master. As much as he sketched in public, Amedeo probably spent even more time in the relative seclusion of his living quarters and artist's studio, where he filled hundreds of books with one sketch after another, exploring, experimenting, and discarding what he did not like. Similar to composers who weave harmonies into a tune, Modi searched for just the right combination of lines, angles, and shadows to transpose his feelings into the design. As French novelist Francis Carco wrote in the art journal *L'Éventail* in July 1919, "I have watched Modigliani draw…his keen sense of nuance leads him to shape the attachment of an arm, the innocent curve of a young breast. It contains in a barely perceptible stroke an entire architecture, supports the slight bulge of a belly, extends into the heart of the soul a movement, the will to live."[7]

As demonstrated by works in the Paul Alexandre collection, Modi had sketched nudes early in his career and continued doing so even as he developed his recognizable style with portraits. Despite perhaps hundreds of drawings of naked women and nude studies, however, there is no record of erotic drawings or examples of vulgarity and porn in Modi's early work. From 1908, there is a signed *Nude study* (Ceroni n° 8) also visible in a photograph of Paul Alexandre's friends moving from his home at the Rue Delta in 1913, and presumably from 1909, on the verso side of an unsigned *Portrait of Jean Alexandre* (Ceroni n° 16) is an

unsigned *Seated nude* in oil that was exhibited at both the Villeneuve d'Ascq Museum of Modern Art and Tate London museums (LaM 2016 and 2017 respectively).[8] Among these early works, there are also at least three nude drawings and two portraits in oil of *La Petite Jeanne* (Ceroni n° 10 and Ceroni n° 11) in the Alexandre collection. She was a female friend Modi brought to Alexandre's home at the Rue Delta in Montmartre. Modi visited her when she was hospitalized in Broca Hospital under the care of Dr. Darier, a specialist in venereal diseases and more specifically, syphilis.[9, 10] Modi sketched her sitting naked on her hospital bed, and probably completed his work in oils later at his studio. The paintings were shown at the Salon des Indépendants in 1910.[11] According to a letter from Jean Alexandre to his brother Paul, the young woman was hospitalized with German measles (rubella) and feared she would be disfigured. Noël Alexandre notes she was Modi's girlfriend and was treated for venereal disease.[12] Jeanne Modigliani stated she was a prostitute. Why Modi chose to paint the troubled girl naked rather than in her hospital gown remains a mystery.

That same year, and despite pressures from his friend Gino Severini, Modi refused to sign the Futurists' Manifesto calling for "the total suppression of the nude in painting for ten years." [13] He would go on to sketch at least some of his muses naked, although he never represented them nude in oil. First was the Russian poet Anna Akhmatova, who provided him with inspiration for many of his unclothed drawings of caryatids. Modi's only full-length stone sculpture, *Standing Nude* (CXI, 1913), which is currently in the Australian National Gallery, was made from preparatory drawings of Anna, inspired by Cycladic and ancient Egyptian art.[14] He also did nude sketches of other women, although only one seems to have survived of Modi's second muse, Beatrice Hastings, and none have been unquestionably identified to be of his one-time lover, Simone Thiroux. Nor do there appear to be nude drawings of Modi's muse number three and the mother of his children, the young Jeanne Hébuterne. Biographer Meryle Secrest states Jeanne is depicted on Modi's exhibition poster for his show at the Berthe Weill Gallery in 1917.[15] The drawing is of a naked woman standing. She has long hair, and her head is tilted to the right. She holds her hands

modestly between her breasts, and there is a noticeable dark tuft of pubic hair between her thighs. If we are to believe claims that Jeanne was quiet, even "incapable, disequilibrated, morbid…with no effect on Modigliani,"[16] it is unlikely that she willingly posed naked for Amedeo. It is possible he drew her from memory, of course, or perhaps he forced her to appear naked on paper for all to see, manifesting either his admiration or a form of patriarchal control and rakedness that seems contrary to his personality.

Reflecting on why the great masters all have nudes as subjects, Italian painter Giorgio de Chirico wrote, "Without doubt, artists were instinctively tempted by the difficulties drawing or modeling a beautiful naked figure presented and which constituted a test of their strengths, knowledge, and talent. . .For an artist, a painting representing a nude was the surest way of testing his progress and experimentation of a new technique."[17] We don't know why Modi chose to measure himself against the great masters in this way. Perhaps Zborowski convinced him it was good for business, or perhaps he was simply tired of painting portraits. He may have been searching for a gimmick, something to help assure his legacy, or perhaps he was just another thirty-one-year-old male thinking about sex (no lascivious maliciousness or female objectification intended). *Isn't naked body is the most beautiful object → Art*

Nakedness, after all, was not out of the ordinary in the bohemian artist community of early twentieth century Paris, when Jules Pascin, Per Krohg, Kees Van Dogen, Picasso, and other painters were stretching the boundaries of what was viewed to be acceptable nudity.[18] Utrillo's mother, Suzanne Valadon, who was the first self-taught female artist to join the Societé Nationale des Beaux-Arts in 1894, also did several paintings of naked girls, including that of a pubescent young woman standing naked with her fully exposed and hairless mons pubis, in *Nu au miroir* (1909). Matisse's friend, Charles Camoin (1879-1965), had exhibited spread-legged female nudes with pubic hair, such as *La Saltimbanque au repos* and *Nu à la chemise mauve* at the Salon des Indépendants in 1905 and the Salon d'Automne in 1909, respectively. Paris was also the center of a flourishing photography trade where mid-nineteenth century photographers such as August Belloc and

nakedness is not eroticism, it is Art in its pure form

Eugene Durieu showed nudes well before Alfred Stieglitz exhibited his intimate pictures of Georgia O'Keefe at the Anderson Gallery in New York in 1921. Photography had been a common pastime for Paul Alexandre and his friends in Montmartre, who often entertained themselves by performing "theatricals" that included naked women parading in front of fully clothed men.[19] Female nudity, even in public, was considered neither taboo nor of poor taste when Modi was a young man.

French academic and art historian, André Malraux, saw eroticism as rooted in human curiosity about the sexuality of the opposite sex. Indonesian painter Mochtar Apin half-jokingly said in an interview, "Who knows, maybe all the nude paintings in the history of art are actually pornography." Apin's own paintings of nude women are a medium of provocation.[20] During his younger years, Amedeo was reputed to have slept with several women, including female friends or prostitutes who posed for his paintings. Whether Modigliani was ever faithful to his later lovers is still in doubt, but when he painted his "great nudes," Amedeo was presumably monogamous and in love with Jeanne Hébuterne.

His dealer, Zborowski, paid for professional models and provided Modi with canvases, paints, and stretching equipment that allowed the artist a certain consistency in quality and materials. In 2019, four paintings from from the Courtauld Gallery in London, the Guggenheim and Metropolitan Museums in New York, and the Koninklijk Museum in Antwerp were loaned to the Tate Modern in London. Technical examinations showed the canvases were cut from the same rolls of commercially prepared materials. The paintings share Modi's "consistent and limited range of pigments," as well as how he applied his paints, used his brushes, designed borders, and occasionally blended paints on canvas. Researchers say the paintings have a "strong degree of stylization."[21] Analyses also suggest a stylistic progression. For example, the Courtauld nude (*Female nude*, Ceroni n° 127, 1916/17) represents a first stage in Modi's development, with characteristics similar to his earlier work on portraits. The sitter's head droops slightly onto her left shoulder, and her eyes are closed as if the artist caught her napping. She is leaning backward slightly, supporting herself with her arms, one

nudity => Beauty

of which disappears behind the body to suggest her vulnerability. Her pubic hair is curly, which is different from the neater, albeit asymmetric way he treated the pubic region in subsequent nudes in the series. Three other paintings, *Nude*, (Ceroni n° 186, 1917), *Reclining nude* (Ceroni n° 199, 1917), and *Sitting nude* (Ceroni n° 188, 1917), were also done with a limited palette and "a sequence of painting that is both systematic and idiosyncratic with a preference for surface finish."[22]

Perhaps, nudes are not dissimilar to how landscapes, still life, animal paintings, and even portraits can represent a "natural" reality. Regardless of how or where it is placed, there is the sensual curve of a shoulder and the sometimes-disturbing truth of nakedness. Art critic Giovanni Scheiwiller described how Modi's nudes possessed great beauty because in some, the female models were presented in "all their young splendor," thus eliciting spiritual emotions and carnal passions. In others, the artist could transmit his joy of the aesthetic, which served as witness to a perfect spiritual communion between the painter and his model.[23]

Modigliani rarely dated his paintings, but it appears he did a series of at least twenty-two nudes between the end of 1916 and 1919, most of them around the time of his first and only one-person show at the Berthe Weill Gallery in Paris. Each of his paintings is different, evoking a certain eroticism and voyeuristic sexual impropriety while simultaneously stirring our memories of Renaissance art and European Classicism. Art historian and curator Emily Braun writes, "The most startling aspect of a Modigliani nude, what makes it immediately identifiable, is the way in which the female body is literally in your face…Long before Helmut Newton, Amedeo Modigliani did big nudes, big in presence, sexuality, and historical ambition."[24] The French art critic and formerly one of August Rodin's secretaries, Gustave Coquiot, wrote; "Without doubt, many of these nudes are too uniformly of that apricot tone that was the fashion – and that made the faces of so many young women into warm and nostalgic fruit."[25]

According to biographer Jeffrey Meyers, there are "languorous undulations: breasts are full, waists narrow, hips ample. His nudes have a direct and immediate appeal."[26] Canadian realist painter Alex Colville

205

told Meyers it was the sexual power of Modigliani's portraits that stirred him.[27] "They are very much female animals..." he wrote, "but they have some of the qualities of ancient Egyptian sculpture (and painting) which give them a kind of simple power that much expressionist work lacks. So, the result might be called monumental sexuality."[28] Biographer Meryle Secrest wrote, "For a sensualist, Modigliani's nudes are naturalness personified, the opposite of vulgar or obscene. For a classicist, they are interpretations, not of ideal form, but naked human flesh."[29] Another biographer, June Rose, compared Modi's nudes to his other paintings; "The faces of the nudes are simpler, less tormented than those of his portraits, the nudes are not melancholy, but direct, open, sensuous in form and sumptuous in color... since his friends were intellectuals, artists and writers, intense, complex men and women, consumed by an inner reality, that is hardly surprising; the girls who posed for his nudes were healthy young women, models, maids, waitresses, milkmaids reveling in their bodies and their sexuality."[30]

The art historian and museum curator Werner Schmalenbach wrote that Modigliani "eternalizes what may be called the objective beauty of the female body."[31] Clearly, people find something in the "great nudes" appealing. So do investors. A study from the Association for Cultural Economics at Erasmus University in the Netherlands found that in Modi's case, nudity had a positive influence on the determination of hammer prices and estimated prices at auction.[32] Amedeo could not have guessed that one hundred years after painting his reclining nude, *Nu couché sur le côté gauche* (Ceroni n° 184, 1917), it would sell for $157.2 million, the highest auction result in Sotheby's 274-year history.[33] Probably completed in 1917, it was the largest work of his career. Modigliani's *Nu couché sur le côté gauche* measures nearly fifty-eight inches (147 cm) across and is the only one of his reclining nudes to be entirely contained within the canvas.

That none of Modi's nudes were immediately sold at his first and only one-person show at the Berthe Weill Gallery in December 1917 must have profoundly hurt Amedeo's ego. Weill (1865-1951) was a Jewish art dealer specializing in the avant-garde. Artists in her stable included Picasso, Matisse, Derain, and Gleizes, as well as female artists

such as Suzanne Valadon and Emily Charmy. In her memoirs, she tells of one of her earliest encounters with Modigliani, who came into her gallery asking her to look at his sculptures. This was several years before Amedeo worked with Zborowski. "He is in terrible shape, this one!" she writes. "He almost fell on me...non! non! impossible! I cannot... another must go...so sad! This fine and cultivated spirit! A magnificent head! Is he really a drunkard?"[34] In late 1917, Zborowski, now representing Modigliani, asked Weill to organize an exhibit of his paintings and drawings in her gallery. The opening was on Monday, December 3. Only four of Modi's nudes, each simply titled *Nude,* were actually included among the thirty-two works Ms. Weill showed.[35] One of them was placed on a wall directly across from the window of the neighborhood's police commissioner, who was sufficiently shocked by the paintings to call them trash. "*Je vous ordonne de m'enlever toutes ces ordures* – I order you to remove all this trash," he said after ordering Ms. Weill to his office. According to reports, an angry crowd and the commissioner were displeased with Modi's display of pubic hair on some of the nudes. Threatened with the official seizure of all the paintings, Weill closed her gallery for the rest of the evening and took the nudes down from the wall. Contrary to myth, however, this mild disturbance did not shut down the exhibit. Only two drawings were subsequently sold during the two-week gallery exhibit, prompting Weill herself to purchase five paintings from Zborowski so Modi's work would not be for naught.[36]

As Emily Braun vividly points out in her essay, *Carnal knowledge,* the sad irony is that while Modigliani painted his nudes with vivacious sensuality, the male gaze was being bandaged and obliterated by the horrors of war only miles away from Paris.[37] It is also ironic that while thousands of young men were being killed or mutilated daily by shrapnel and machine gun fire, a few fickle persons who found the pictorial display of a professional model's genital anatomy distasteful could censor and force the temporary closure of an art gallery. Perhaps they did not appreciate Modi's display of what American poet Gus Blaisdell described as "apricot thighs with offset twats"[38] – Amedeo characteristically painted the pubic triangle askew, directly on the canvas rather

than over a layer of fresh paint, as if a small, rectangular tuft of hair were waxed from the right side of his subject's mons pubis.[39]

Undoubtedly for some, staring at the unabashed and sometimes provocative textural embodiment of a naked woman flushed with desire or presumably subdued by a post-coital exuberance may simply have been too much to bear. The scandal at the opening of Modi's first one-person show, however, was not the consequence of a widespread act of public indignation. It was neither a news-making critique from an unenlightened bourgeoisie incapable of judging modern aesthetics nor a display of closed-minded academicians unable to stomach a pictorial sexual indiscretion. In fact, shortly after the exhibit at the Berth Weill Gallery, French poet and novelist Francis Carco purchased several of Modigliani's nudes from Zborowski, including *Nude with a coral necklace* (Ceroni n° 185, 1917), in which the model modestly covers her pubis with her left hand,[40] and *Standing nude - blond nude with dropped chemise* (Ceroni n° 193, 1917), where the model's blue eyes and pursed lips suggest a hint of resignation and amused annoyance. "I had these nudes in my home," Carco wrote in his 1920s memoir, "They were women I loved and I felt alive beside them. And they were alive: their presence excited me."[41]

While some might wonder whether Modi's paintings were emblematic of sexual provocation, others argue their historical resonance.[42, 43] The writer André Salmon declared shortly after the artist's death that "Modigliani is our only painter of nudes."[44] Thirty years later, writing for the New York Museum of Modern Art,[45] James Thrall Soby described Modi's paintings as the "nudest of nudes... One feels that Modigliani's models have flung off their clothes, eager for the artist's admiration and utterly unrestrained. These are (let us be candid) erotic nudes for the most part, though dignified by conviction of style."[46]

Modi's nudes take up the entire canvas. They are alone, self-assured, meditative, serene, and without the accoutrements of a narrative frame other than the occasional adornment of a string of pearls. Of course, the nature of subjectivity usually precludes judgment, and while critics, experts, collectors, and amateur enthusiasts might debate the technical aspects of an artist's work, it is the way the art speaks to

us – *L'art qui parle* – that makes each creative piece unique.[47] Eighteen months after Modi's exhibit, Francis Carco wrote in *L'Éventail*, "None before Modigliani attached a greater intensity of expression on the face of a woman."[48]

§

[handwritten: Art speaks to us by making each creative piece unique]

[handwritten: Quillette –]

PART V

MODI'S LAST YEARS
(1918-1920)

CHAPTER 28

———— ❧ ————

ADDICTION

"I think myself the fool of tragedy strutting upon the stage."

Iris Tree[1]

W hen the young British actress and model, Iris Tree (1897-1968), posed for Modigliani in his *Female nude* (Ceroni n° 127, 1916/17), now at the Courtauld Gallery in London, she would not have guessed the charismatic young Italian danced on the fringes of a downward spiral of self-destruction, debauchery, and disease that would lead to his death. Modi's alcohol consumption was likely limited; beer was plentiful, but government regulations banning absinthe had been enacted since 1915. From October 1917 onward, even wine, which was still viewed as a *boisson hygiénique* (*trans.* healthy drink) and France's national drink was targeted by the war on alcohol.[2] Martini Vermouth, made from aged wine marketed as a tonic for civilians, was favored by many over the cheap red wine known as *pinard*. The word 'pinard' stems from slang spoken around Bordeaux where *pinarder* means to get drunk. Usually from the Beaujolais region, this wine had less than 9% alcohol and was mostly reserved for the troops (a poilu's daily ration of wine increased from 0.25 liter to 0.75 liters per day from 1914 to 1917).[3] Laws prohibiting public drunkenness were also enforced, and drugs such as opium, morphine, and cocaine were harder to come by because they were needed for combatants.

General conditions in Paris were substantially better than any-where near the occupied regions to the north or in the severely dev-astated territories closer to the front lines.[4] Mobilization had created new industrial needs, however, and generated a workforce shortage.[5] By 1918, many soldiers were being recalled from the trenches to help in factories, where working conditions improved after a series of gen-eral strikes.[6] Meanwhile, enormous government debt and frequent de-valuations of the French franc had prompted significant price increases for goods and services. Growing inflation would continue inexorably for several years, even after the war.[7]

Food products were rationed intermittently, and the prices of coal, gas, and electricity were carefully controlled. Flour and sugar were also tightly rationed, and citizens were asked to eat potatoes to save on bread. Civilians carried individual alimentation cards with coupons they could exchange for foods based on a person's age, although fresh produce was always hard to come by. Salaries varied widely depending on the region and type of employment. In 1914, the average salary of a non-qualified laborer working a minimum of fifty hours per week was less than one-hundred-fifty francs per month,[8] and by the end of the war, a day laborer still made less than three hundred francs a month,[9] when a kilogram of bread cost at least a franc and a kilo of red meat about fifteen.[10] During the war, a budget of at least two francs per day was deemed necessary to feed a small family, but impoverished wives of mobilized men received only 1.25 francs per day as part of a separation allocation.[11] Soup kitchens everywhere thankfully provided meals for workers and those most in need.

Modigliani, however, was better off financially than he had been in years. His dealer, Léopold Zborowski, continued to provide him with an allowance of at least five hundred francs per month in addition to provisioning him with canvases and other materials.[12] Modi's paints, sketchbooks, and canvases were probably not inexpensive, which ex-plains, at least in part, the artist's habit to paint over previously used works earlier in his career. Considering that widows of common sol-diers had pensions of only eight hundred francs per year, to which three hundred francs were added in March, 1919, for each fatherless child,

Modi's guaranteed monthly revenue was not insignificant. Five months before his exhibit at the Berthe Weill Gallery in December 1917, Russian journalist Ilya Ehrenberg saw; "…Modigliani and Jeanne walking in the boulevard Vaugirard. They were holding hands and smiling. I thought: Modi has found his happiness at last."[13]

After the exhibit closed on December 30, 1917, and despite the initial lack of sales, Weill herself bought several pieces, and Francis Carco ultimately purchased several nudes. A few well-known collectors also acquired Modi's work from Zborowski. The sale of additional portraits, rather than disappointment caused by a lack of public acclaim for his nudes, probably fueled Modi's return to painting portraits. During the first months of 1918, therefore, Modi's life seemed anything but doomed. His paintings were recognized both nationally and internationally. He exhibited alongside some of the biggest names in modern art, and he had money. Probably reveling in his new connection with Jeanne Hébuterne, he painted voraciously and made the young woman his muse.

An alternate reality and an essential part of the Modigliani myth is that he was starving, discontent, neglected in the art world, living in poverty, and increasingly ill. It is difficult to explain how he could have engaged so drastically in self-destructive behaviors such as drinking abundantly and being high on opiates while producing some of his best work. History is replete, however, with writers, artists, entertainers, and others who are able to function successfully despite, and sometimes thanks to the effects of alcohol and other mood-altering substances. Which of the realities of Modi's life are true is subject to debate by his biographers and other Modigliani aficionados. Like success in almost every field, creative brilliance, talent, and originality often come with a price. Modi was neither the first nor would be the last to injure their body in the pursuit of a creative vision. In Amedeo's case, as for almost anyone suffering from ill health, the sense of a foreboding future was also a powerful catalyst for productivity.

Regardless of Modi's state of mind and despite his stipend, life in war-torn Paris had to be difficult. Contrary to common belief, he was not that close to other artists of his time. He rarely spoke about art or

of his work, and he did not have much, if any support system around him other than his art dealer and now, Jeanne. He was also far from his family, particularly his mother. His only real friends, wrote Lunia Czechowska, were Utrillo, Léopold Survage, Soutine, and Kisling.[14] Utrillo, however, was an alcoholic and probably mentally ill. British art critic Clive Bell described him as; "A strange artist…personal enough, just as Modigliani was handsome enough, to satisfy the exigencies of the most romantic melodrama."[15] Soutine suffered from depression, and Survage had moved to Southern France. Kisling, who was wounded in the war and also a heavy drinker, probably suffered from posttraumatic stress disorder. As for Modi's much younger girlfriend, Jeanne Hébuterne, there may actually have been little in common other than love and lust; she was, after all, the daughter of a bourgeois family that represented all that Modi had rebelled against. She was without financial means of her own, and he was nothing more than an artist, an Italian Jew at that, making their relationship something her parents could not condone.

To help make ends meet, Modi and Jeanne could have chosen to work, at least part-time. Of course, Amedeo had never had a job other than being an artist. He possessed no skills other than draftsmanship and was already more than a decade into living the self-indulgent and often irresponsible life of a bohemian. Jeanne Hébuterne could have worked because jobs were plentiful. She was by no means rich, but her parents were well-off and had traditional family values. Their being unsupportive of her relationship with Modi must have made her life more difficult. Perhaps, they expected her to "marry well" after art school rather than build a career or learn a trade that could provide an income. Financial times were difficult, however, and had the nineteen-year-old woman become an apprentice seamstress, for example, she would have worked ten hours a day earning only one franc, hardly enough to buy two boxes of eggs (in the factories, women earned twenty to thirty percent less than men).[16] Wages in female-dominant economic sectors, such as the textile industry or domestic services, were about three francs per day, which was considerably less than earnings for men in other sectors, although some salaries increased significantly during the

Why is Modigliani's life surrounded by myth? to do there no agreement among his biographers?

war.[17] Economic needs linked to national defense, for example, led to an increase in hiring, and wages for workers in military-related jobs (such as in munitions factories) were higher than in the textile industry or even agriculture, with its influx of foreign and immigrant workers.[18] The minimum wage act of 1915, which mainly applied to working women, provided a cost-of-living increase based on profession and the district where a person lived.[19]

If the Modigliani myth is even partially correct, another unanswered question is why Modi, during arguably one of the most prosperous, happy, and productive moments in his short career, would have continued to overindulge in mood-altering substances such as drugs and alcohol. While it is impossible to go back in time to watch Modigliani's life during that period, André Salmon and others consistently wrote that Modi drank desperately but owed none of his genius to alcohol.[20] *what does it mean?* We also know from Zadkine and Ehrenburg that Modi's health had taken a turn for the worse. Symptoms of tuberculosis include chest pain, fatigue, weight loss, decreased appetite, and cough. It was possible for Modi to obtain prescriptions for opioids and other cough suppressants from any of the free medical clinics. It was also possible that he relied on alcohol to help mask or control his symptoms (considering his small stature and fragile health, it would not have taken much to become drunk). Studies show that brief exposures to even mild blood concentrations of alcohol enhance mucociliary clearance and the ability to clear secretions, which might help diminish a person's cough. Studies also show, however, that heavy alcohol use exacerbates airway inflammation and harms the immune system.[21] Chronic alcohol use contributes to malnutrition, blunts mental function, and suppresses cough and gag reflexes, thereby increasing the risk for aspiration of respiratory secretions and pneumonia. Its damaging effects on the immune system increases a person's susceptibility to many bacterial, viral, and fungal pathogens, including tuberculosis.[22]

Modi's consumption of alcohol and opioids (including cannabis in the form of hashish) was a way to control his symptoms (similar to how many opioid addictions are caused today by an overuse of prescription narcotics). Frequent use since his teenage years would have

increased his risk for addiction to the synergistic or combined effects of these substances. In addition to helping to relieve symptoms such as a chronic cough, sleeplessness, and general malaise, alcohol's mood-altering properties can mask or help avoid negative feelings and enhance a person's positive sense of well-being. Hashish, too, is a mood-altering substance commonly used to reduce anxiety and cause euphoria.[23] It is a cannabinoid with a concentration of delta-9-tetrahydrocannabinol (THC) that may be up to four times greater than that of marijuana. Research shows there is more than a fifty percent concordance between cannabis use and alcohol abuse, and that alcohol increases the absorption of THC.[24, 25] The synergistic effect of combined alcohol and cannabis or opioid intoxication (being both drunk and high) is known as *crossfading* or "greening out."[26, 27] A popular expression is "Weed then beer, you're in the clear. Beer then grass, you're on your ass!" Users looking for the combined effects of mood enhancers prefer to smoke, then drink rather than risk the nausea, vomiting, and general malaise associated with doing it the other way around.[28]

Symptomatic disease is just one of several possible reasons Modigliani became a frequent user of drugs and alcohol. A second hypothesis is that like many artists, Amedeo's thirst for creativity kept him in a chronic state of dissatisfaction with his own work. Modi needed to master the medium to which he had devoted his life. At the same time, he wanted to be a sculptor, and this as yet unfulfilled desire may have contributed to the frustrations and longings of a thirty-year-old man who contemplated perhaps on building a family while furthering his reputation as a painter. While there is little evidence he yearned for external validation, the long list of his exhibits alongside key figures in the art world, both nationally and abroad, suggest a desire to play in the big leagues. Modi may have turned to alcohol or drugs to frantically fuel a creative genius he knew to be ephemeral. He may have wanted to fit in with other hard-drinking personalities, or on the contrary, build a persona that sufficiently distinguished him from them. Speaking of Amedeo's tendency to be overly theatrical, Picasso said, "It's curious, we never see Modigliani drunk on the boulevard Saint-Denis, but always at the corner of boulevards Montparnasse and Raspail..."[29] In

other words, where artists and other people sitting at the cafés nearby could see him. Such self-destructive actions are not different from how some artists and entertainers today use mood-altering substances before engaging in socially disruptive behaviors for marketing purposes or to build their reputations. Sadly, addiction frequently follows.

A third hypothesis is that Amedeo overly indulged because he was fully aware he harbored an ultimately fatal disease. After all, tuberculosis had taken the lives of several friends, and he had already lived for many years with the probability of an early death, compounded by the threat of physical and emotional harm from the war. Facing the inevitability of a premature demise is emotionally and psychologically taxing for anyone. Modigliani could have turned increasingly to drugs and alcohol to evade what he sensed was his ultimate reality.

A fourth hypothesis is simply linked to his becoming trapped and gradually more ill as a result of his addiction to mood-altering substances. We know today that addiction is a multifaceted biopsychosocial disorder.[30] It is also a treatable, chronic medical disorder involving complex interactions among and between brain circuits, genetics, a person's biological systems, the environment, and an individual's life experiences, coupled with using substances and engaging in behaviors that become compulsive or have a range of harmful consequences.[31] These include an increased susceptibility to disease and infections. Like many victims of drug and alcohol addiction, Modi's illness evolved gradually, and his end was sudden.

If we are to believe some of the anecdotes about Modigliani, he was increasingly prone to rowdiness, public displays of anger, refusals to seek help and apparent drunkenness. He was prone to mood swings even as a child, and may have been highly sensitive or vulnerable to deep emotions.[32] Unknowingly, he may have turned to mind-altering substances as a form of self-medication and only later began to suffer from their adverse consequences. Modern scientists debate the adverse effects of alcohol and cannabis on mental health and personality, including, for example, the potential for cannabis to increase the risk of early psychosis, especially if used by adolescents and young adults.[33, 34] Alcohol use disorder, with or without an evolving personality disorder

or mental illness, therefore, constitute a fifth hypothesis for Modigliani's changing behaviors. Many genes related to alcohol metabolism seem closely tied to an increased risk for problem drinking.[35] While biographers have not provided a history of alcohol use in his immediate family (parents, aunts, uncles), psychological or emotional disorders are described in Modi's grandfather, Isacco (neurosis and paranoia) who was a positive influence and surrogate father before dying when Modi was only nine years old, his maternal uncle Amédée (who died from tuberculosis or suicide), and his childless aunts, Gabrielle (who died by suicide in 1915), and Laure (eventually institutionalized because of emotional instability and a persecution complex). Amedeo's daughter Jeanne, would become an alcoholic who drank compulsively and died in 1984 when she was only sixty-six years old.[36]

Hence, the cause for Modi's downward spiral remains a mystery but is probably linked to a series of events that affected him both emotionally and physically, even if they did not adversely affect his artistic skills and productivity. The deleterious effects of an absent potentially influential figure such as his father and the loss of an attentive grandfather were exacerbated by the traumas of three life-threatening infectious diseases while Modi was still a child; typhoid fever, tuberculosis, and scarlet fever. Later, he lost the caregiving support of his uncle, and lived far from a loving mother as he strove to survive in the competitive environment of early twentieth-century Montmartre and Montparnasse. And, there was war, women (…but are reports of his picadillos true?), drugs, and alcohol, not necessarily in that order. His friend, Lunia Czechowska said, "I am convinced that alcohol was not necessary for his genius, but it was a refuge and a stimulant, no doubt, which enabled him to forget his difficulties. A sort of anesthetic but not a vice. He had picked up this habit when he was very young, when he had no one to help him."[37] During the next two years, including the fourteen months he would spend on the French Riviera, many of Modi's portraits would display with increasing frequency and precision the characteristics for which he would become famous. His figures would have warm skin tones, slender swan-like necks, an elongated nose, and often asymmetrical, closed, or cross-hatched eyes that force the examination

of their usually oval faces. In some paintings, the eyes are a soft, light blue-gray. In others, only one eye is darkened. *"With one eye you look out at the world,"* Modi told Léopold Survage in 1918, *"with the other you look in at yourself."*[38] We can only wonder whether Modi was fully aware of the negative turns his life could take as an adult, even as he became an increasingly accomplished visual artist.

→ how does the statement reflect on § of his paintings?

• true self-reflexivity

his downward spiral might have been affected by an absence of a father — there → speculation after speculation

"with one eye you look at the world, with the other you look in at yourself" — How does this self-reflexivity affected his that artistic choices? Self-awareness contradicted by self-destruction

CHAPTER 29

❦

BLUE SKIES AND SUNSHINE

"Modigliani was a great artist."

Maurice de Vlaminck[1]

At 7:18 am on March 23, 1918, the earth shook violently on the Quai de la Seine. Parisians everywhere heard the explosion and feared the worst. Twenty more German artillery shells fell from the stratosphere that day, each delivering fifteen pounds of trinitrotoluene, the yellow, odorless powder explosive commonly known as TNT. Unbeknownst to the French military, they were shot from the north side of a wooded hill at Coucy-le-Château-Auffrique, a small medieval village surrounded by forests about 120 kilometers Northeast of Paris. The Germans had also set up their "Paris Guns" at two other locations. The guns were the most powerful land-based artillery weapon since the beginning of the war. Each was 34 meters long and weighed 256 tons, and for the next five months, they would shower Paris with explosive shells that fell haphazardly on the city. Leaving four-meter wide by one-meter-deep craters, the bombardments destroyed hundreds of buildings, terrorized the entire population, and ultimately killed 250 people.[2]

Seventy-five innocent victims died on Good Friday of the following week when a shell that hit the Saint Gervais-Saint Protais church in the Marais district caused the church's roof to collapse. Fearing the

bombardments signaled a German Spring offensive, more than half a million people fled the city. Many headed West or South toward The French Riviera, also known as the Côte d'Azur. Léopold Zborowski decided to take his stable of artists to Nice. Hanka was recovering from a bout of ill health, food and goods were plentiful there, and Léo hoped he could sell paintings to wealthy refugees and vacationers at resorts along the warm Mediterranean Sea.

In April, a newly pregnant Jeanne Hébuterne, accompanied by her mother, took the train to Cagnes-sur-Mer, a small town along the coast, about fifteen kilometers from Nice. It is not far from the charming old village of Antibes, known for its sixteenth century fortifications and star-shaped Fort Carré, built under the reign of King Henri II and reinforced by the military architect Le Marquis de Vauban in the seventeenth century. Modigliani, Chaïm Soutine, Foujita with his wife Fernande Barrey, and Zborowski followed shortly thereafter. As the story goes, Modi feared there would be no alcoholic beverages on the train, so he wandered around the station in Paris looking for a few bottles of wine he could take with him on the journey.[3] It is impossible to know if Modi simply wanted to indulge in his favorite beverage, treat a nagging cough, or avoid the potential effects of alcohol withdrawal during the long train ride south.

At first, Modi and the group lived in Cagnes. Amedeo and Jeanne moved into a house in the hills, the "Pavillon des Trois Soeurs," according to Hanka Zborowska.[4] Léo soon returned to Paris to sell paintings, while Amedeo stayed on, living in various places, including at the Hôtel Tarelli, located in a bulding at 5 Rue de France, where a few prostitutes also had rooms. According to Francis Carco, some girls who knew Modi was ill with tuberculosis and too poor to pay for a model posed for free.[5] Jeanne settled in with her mother at 155 avenue de la Californie, sometimes joined by Modi, who often sought the company of his friend Léopold Survage who had also settled in Nice.[6] Later, Modigliani would live for a short while in an apartment at 13 Rue de France (the original building no longer exists), one block inland from the beach and six hundred meters from the heart of Nice and its central square known as Place Massena. He remained in the south of France

until May 1919, sometimes living with Jeanne, and often dining for free at a restaurant owned by Eugénie Baccalin on 3 rue de France.

In the early autumn of 1918, Modi may have contracted influenza, also called *The Spanish Flu*,[7] and for a short while, he stopped drinking.[8] The infectious respiratory disease had already ravaged military personnel on both sides of the conflict, and by the end of 1918, influenza would kill between 125,000 and 250,000 civilians in France alone.[9] Considering his weakened state from tuberculosis and alcohol use, it is a miracle Modi did not die if indeed he had the flu, which we now know was caused by the influenza H1N1 virus with genes of avian origin.[10] By late autumn, a second wave of the disease continued to cause deaths throughout Europe.[11] On November 9, 1918, only two days before the armistice, the thirty-eight-year-old writer and Modi's former supporter, combat veteran Guillaume Apollinaire succumbed to the disease. A month earlier, it had also taken the life of Modi's contemporary, the twenty-seven-year-old Austrian artist Egon Schiele (1890-1918). Known for his auto portraits and psychologically penetrating nudes, Schiele simplified and sometimes eliminated his models' hands and feet to focus his viewers' attention on bodily contortions and genitalia.[12] The rather conventional look of his famous standing nude, *Mädchen* – The young girl, painted in 1917,[13] with her mask-like face, symmetric breasts, pink nipples, not-so-perfect body, and prominent pubic hair prompts an emotional reaction that is quite different from that of Modigliani's *Standing nude - blond nude with dropped chemise* (Ceroni n° 193, 1917) painted the same year.

The end of the war marked the beginning of an era governed by hyperinflation, unemployment, and the arrival of vast numbers of Americans to help rebuild a war-devastated Europe. Modigliani and Jeanne, however, remained in their self-indulgent bubble far from the tumult and financial hardships of Paris. The Riviera was filled with wealthy people and refugees from France, Russia, and other parts of Europe who had fled the war or escaped their cities and rural areas while waiting for better times to return home. During their stay in Southern France, neither Modi nor Jeanne experienced firsthand what many photographers did in war-marked regions; the innumerable lines

of abandoned children, teenagers standing guard over their family's sparse belongings at a train station, the befuddled elderly searching for a safe place to sleep, or hundreds of walking wounded hungrily waiting in food lines.[14]

There are no stories of Jeanne spending her days on the Riviera mending socks or collecting food for refugees and orphans. There was some discord between Jeanne and her mother, and perhaps, even more between Jeanne's mother and Modigliani. When, on November 29, 1918, Jeanne gave birth to a daughter they named Giovanna (Jeanne) at the Hôpital St. Roch, Modi did not officially recognize the child. For reasons that are still unknown, he had not married his pregnant girlfriend, and his daughter was registered as Jeanne Hébuterne *de pére inconnu* – father unknown. Supposedly, Modi got drunk rather than walk a kilometer from the hospital to the city's administrative offices at the Hôtel de Ville to sign the paperwork needed to officially and legally be recognized as the girl's father. No members of Modi's family, nor Jeanne Hébuterne's father and older brother, traveled to Nice to be with the couple, and no photographs have surfaced that permanently recorded the event. Perhaps the Garsin-Modigliani family was disappointed Modi neither married nor had his child with a Jewish woman.

All the while, Modigliani was painting at an astounding pace. He did the *Portrait of Léopold Survage* (Ceroni n° 211, 1918) which he sent to Zborowski to help honor a business agreement of delivering four paintings a month. The piece was quickly sold to collector Roger Dutilleul. He also painted the portrait of stuntman *Gaston Modot* (Ceroni n° 279, 1918) and a blonde woman named Germaine Meyer who would marry Léopold Survage three years later (Ceroni n° 277 and Ceroni n° 276).[15] Modern analyses of Modi's canvases help define his organizational structure, complex layering, and consistent brush strokes. They shed light on his stylistic progression and also help detect forgeries.[16] Using a limited palette of rich colors reminiscent of Italian Renaissance masters, Modi's paintings from these times include large plaques of color that support his subjects placed sculpturally at the forefront of each canvas. Studies show that his fluid underdrawings, made in pencil or sometimes charcoal, were rarely erased or reworked, confirming the

accuracy of his draftsmanship and the speed with which he painted. In a rare revelation of his style, Modi told Survage, "What I see before my eyes is an explosion which forces me to take control and organize."[17] In part because of the way Amedeo outlined his subjects in black and applied golden ratios classically to establish beauty and balance, his sitters occupy virtually all of the viewer's attention.[18] Writer and art critic, André Warnod, described Modigliani's figures as "suffused with delicate but intense life: extraneous detail has been excluded…emaciated faces, very long bodies with small heads nodding like flowers too heavy for the stems they grow on. Disturbing reminders of the sensitivity and sensuality of the painter."[19]

In Paris, Zborowski was selling, and several aficionados already possessed Modi's paintings.[20] Now, important collectors such as Jonas Netter and Roger Dutilleul took an even greater interest in Modi's work. The week before Christmas, at Paul Guillaume's new gallery on the famous Faubourg de Saint Honoré, Amedeo's paintings were exhibited alongside those of Picasso, Derain, and Matisse in a show of major importance called *"Peintres d'Aujourd'hui"* (*trans.* Painters of today). The exhibition was reviewed or mentioned in over fifteen newspapers, firmly establishing Modigliani's reputation in France and internationally.[21]

With a percentage of proceeds from the sales and a monthly allowance from his dealer, who also sent blank canvases to Amedeo expecting completed paintings in return, Modi had more money and fame than ever before. Far from the war, he worked steadily, albeit with some difficulties finding sitters for his paintings. Many of his subjects during these months, therefore, were friends, acquaintances, children, and young people. His health perhaps improved for a time as well. After all, the weather along the sunny southern coast of France was always better than the overcast gray days of Paris in the winter. Of course, there was an occasional rain and the chilly Westerly Mediterranean wind, but skies in Nice were almost always blue. Strolling along the city's famous Promenade des Anglais, only steps away from the long pebble beach that stretched from Antibes to the tip of the Quai des États-Unis, Modi and his friends walked past the newly built Hotel Negresco,

the Westminster, and the Hotel Beau Rivage where Matisse had begun painting his masterful series *Interieur de Nice* in 1917. Amedeo Modigliani, Italian immigrant, painter, Jew, former sculptor, chronic lunger, and now the father of a baby girl, could honestly say he was a success.

§

CHAPTER 30

READY...SET...SELL

"You can never do too much drawing."

Tintoretto (1518-1594)[1]

odigliani was above all a draftsman who tuned his skills by making thousands of drawings. In this sense, his work during the last two years of his life was very different from most other modern artists, particularly as Modi's time in Southern France triggered style changes seemingly inspired by painters such as Simone Martini, Sandro Botticelli and Parmigianino from the late medieval and early Italian Renaissance.[2] The art critic Lionel Vitali described sustenance behind Modi's work when he wrote, "A painter's drawing is like the secret diary of a writer: in both the artist presents himself naked, without pretense and unadorned. [In Modigliani's drawings] often there is an even, fine line drawn in a single stroke, like a thin thread, of an extraordinary purity, which encloses forms in a rhythmical interplay of exquisitely elegant arabesques."[3]

Modi preceded his oils with fine pencil drawings, which he reinforced with dark outlines before adding colors between them.[4] Léopold Survage described how Modi incorporated his draftsmanship skills into his paintings: "He would begin by tracing his drawing with a very fine brush, in much the same way as he drew his famous pencil sketches, sometimes controlled or sensitive, sometimes violent and

harsh, depending on the character of the sitting model and the way he felt about him or her."[5] Recent technical analyses of Amedeo's paintings reveal how his palette took on a new luminosity while he lived in Southern France. He brought in lighter tones, used lean paints that dried more matte than glossy, and worked in multiple thin, translucent layers. Some of his background colors have tones reminiscent of those used on walls and window shutters of homes lining the winding streets of Nice's old village. On many paintings, Modi used short brushstrokes macchiaioli style, gave texture and thickness to his layered oils, and, as his daughter Jeanne later suggested, he "blotted his paints with a rag or a sheet of paper in order to obtain a better blending of the colours."[6]

Modi's frequent use of dominants like blue and golden orange were reminiscent of Cézanne, but he characteristically preserved his sitters' soft drooping shoulders and gentle postures. Often, but not always, he painted blue-grey or turquoise-filled eyes with black cross-hatchings. His signature, with a small "m" frequently moved to the upper right-hand corner of the canvas. Describing Modi's paintings from an earlier time, Russian journalist Ilya Ehrenburg wrote, "But what is extraordinary is that Modigliani's models resemble each other; it is not a matter of an assumed style or some superficial trick of painting, but of the artist's view of the world."[7]

In his introduction to the New York Museum of Modern Art's Modigliani Retrospective in 1951, art critic and patron James Thrall Soby expanded on this idea when he wrote, "...within his admittedly narrow range, he [Modigliani] showed a remarkable sensitivity to evocative detail. He conveyed much, for example, by placing a model's arms, heavy with embarrassment, or easy and forgotten, weak or bold, the hands often clasped in a foreground arc. In certain portraits the eyes are a dusty jade, open wide; in others, lidded and evasive; in others still, sharp as beads within a surrounding flaccidity. The small, pursed mouth was a favorite device, but he varied it to suggest changing shades of character and mood. It is chiefly because all the portraits look so forcefully his that we tend to think them all the same. They are not, as the careful observer will know."[8]

This is obvious in the portraits of children and young people Modi began painting while still in Paris a year earlier. One example is *Alice* (Ceroni n° 69), currently owned by the National Gallery in Copenhagen. It is listed as painting number fifteen at Modi's exhibit at the Berthe Weill Gallery in 1917. Done using heavy impasto (a sculptural construction) that also included making deep lines in the hair with the stick side of his paintbrush, this beautiful portrait exemplifies what Roger Fry wrote about Modi's paintings a year later; "What prevents his colour from being drab and monotonous is precisely what prevents his tone from being too mechanically exact, namely a strong feeling – again a sculptor's feeling – for surface quality. He hates any dead uniformity of surface."[9]

Modi's ability to alter his models' countenance and thus transpose his own sensibilities onto his viewers is evident in his magnificent series of three paintings of *Elvira* (Ceroni n° 269, n° 270, and n° 272), which also provides examples of how Amedeo could play with the positions of his subjects' hands after choosing to represent his sitters in three-quarter view rather than their heads and shoulders only. In the first, the sitter wears a black dress with an ornate lace collar. She appears relaxed, waiting, perhaps impatiently with her hands gently folded in her lap. In the second, Elvira's dress is plain, standing out against the pale blue-gray background. She appears to be melancholic and slightly annoyed. Her faintly blue-filled almond-shaped eyes without pupils are smaller than in the other paintings. Her left elbow is against the table, and the faint blush on her face is realistically the result of cradling her left cheek and chin in the palm of her left hand. Her right arm and hand hang limply on her thighs. The third painting of Elvira is perhaps one of Modi's finest nudes outside of his series of large paintings. His model stands naked, sculptural, with small, high breasts sitting well above her contoured waist and round hips. She looks irritated, as if the artist had said or done something distasteful to make her feel uncomfortable. Her eyes are darkly filled without a trace of blue. She is almost gothic, the obvious object of Modi's gaze rather than a subject of adoration, even as the harmonious curves of her face, shoulders, and arms lead the viewer's eyes to a pudically held white cloth, or perhaps it is a nightgown she is holding to hide her pubis.

The controversial Italian socialite/art patron and future mistress of Benito Mussolini, Margherita Sarfatti (1880-1961), said Modigliani was "a modern Botticelli, consumed by fire of the spirit, which refines, renders almost immaterial his creatures in order to better let their meditative spirit and gentle melancholy shine through…"[10] This spirit is never more clearly illustrated than in Modi's numerous portraits of children and young adults, many of which we now know, thanks to the astute work of biographer Alain Amiel, were done during the artist's stay on the Riviera:[11]

La petite fille en bleu (Ceroni n° 245), also known as *Girl standing*, is a full-length portrait of a young girl with asymmetrically painted light blue, almond-shaped eyes. Modi painted her in Hanka Zborowska's kitchen in Cagnes-sur-Mer.[12] The child's head is slightly tilted, like a flower weighing on its stem. She stands in what appears to be total innocence in the corner of a room. Her hands are crossed at the waist over a light blue dress that matches her eyes. Her shadow is cast against the wall behind her, and her left foot, covered in dark shoes and socks that stretch to mid-calf, is cocked inwards as if she were hesitating or waiting patiently for something to be said to her. She has an egg-shaped face, with a delicate, well-designed nose separated from her slightly puckered red lips by a narrow medial cleft, also called the philtrum – from the Greek word meaning love charm, and her dark hair is held up with a thin red ribbon tied at the top of her head. There is a moderate amount of blush on her cheeks, almost as if she had a malar rash, so named because the rash resembles a butterfly, which in medical terminology is suggestive of the autoimmune disease called Lupus Erythematosis.[13]

In *Marie, fille du peuple* (Ceroni n° 253), Modi uses warm facial tones and a light-colored hair ribbon to contrast with his sitter's dark hair and clothes, which make *Marie* stand out against a vibrant, fence-like colored background. She is naturally coquette, with an oval face, a slightly turned-up nose, and a few locks of tousled hair falling across her forehead. Her barely tilted head is turned slightly to the right, exposing a single earring. Her eyes are painted asymmetrically but without pupils. With one of her eyes painted a hazy gray and the other

closed, she appears to be wistful, almost as if she were annoyed and challenging the viewers to guess what she is thinking.

In *Seated girl with loose hair* (Ceroni n° 299) and *Garcon en culotte courte* (Ceroni n° 255), Modi delves into orange tones, contrasting with bright pastels of blue and lime-green in the first painting and small patches of black in the second. The eyes in each of the paintings are treated differently, filled in the same blue as the girl's dress in the first, but asymmetrical, small and slightly slanted in the second, as if the young boy were squinting. Amedeo also worked with red-orange colors in two paintings he did of a young girl wearing a turtle-neck sweater. Modi often made several paintings of the same model, changing their pose or the expression on their faces. In *Girl with pigtails* (Ceroni n° 243, 1918) and *Girl with a beret* (Ceroni n° 244, 1918), the subject's rounded chin, ultra-white teeth and soft but well-contoured red lips are prominent. Modi wants us to look into this subject's light blue eyes, which in the first painting are wide-open, as if the girl was looking straight into the lens of a camera. In the second, they are slightly asymmetrical, one painted slightly darker than the other, which gives at least this viewer the impression she is impatient, adorably longing to stop her pose and leave the scene.

A change of colors in Modi's palette, including dominant blues reminiscent of Cezanne, is accompanied by subtle alterations of his technique, as outlined in the analysis of *Le petit paysan* (Ceroni n° 257), that experts believe was completed in 1918. Researchers from the Modigliani Technical Research Study describe a thinness of the paint, a narrow range of pigments, and no varnish, concluding, "the bulk of the painting could well have been executed in such a medium – one which qualifies as tempera, as it contains both oil and water-based casein."[14] The webmaster of SecretModigliani.com shares a diary entry dated March 31, 1932 and a story from the painting's first owner and former curator of the Holbourne Menstrie Museum in Bath, Mr. Hugh Blaker. After learning of Léopold Zborowski's death, Blaker wrote: "I was a friend in 1919 when he [Zborowski] hawked Modigliani in vain in London. My purchase alone enabled him to pay his rent of the first-floor room. He brought over Modigliani stripped of stretchers and

frames. He rolled them in bundles to dodge freightage. He laid them on the floor. I bought four of them. So far as I know, I was the only man in London to care a tuppenny damn about 'em."[15]

Blaker was referring to Zborowski's visit to London in order to attend what would be Modigliani's final exhibit outside Paris during his lifetime: The *Exhibition of French Art 1914-1919* at the Mansard Gallery was held on the top floor of the Heal & Son department store building from August 9 to September 6, 1919. The show was organized by Osbert and Sacheverell Sitwell, two British aristocrats who were also members of the Bloomsbury group. Formed in 1905, the group included Virginia Woolf and her sister, the artist Vanessa Bell and her art critic husband Clive Bell, the writer E.M. Forster, painters Duncan Grant and Roger Fry, economist John Maynard Keynes, philosopher Henry Sidgwick, and occasionally, writers Aldous Huxley and T.S. Eliot.[16] The three painters probably knew of Modigliani's work because Bell, Fry, and Grant had each done portraits of British model and actress Iris Tree (1897-1968), who sat for Modigliani when he painted his *Female nude* (Ceroni n° 127) in 1916/17. She also sat for Modigliani's friend, sculptor Jacob Epstein in 1915. Iris was the daughter of famous actor Herbert Beerbohm and a cousin of Marie Beerbohm, a wealthy socialite who may have posed for a series of Modigliani portraits in 1917/1918: *Woman with red hair with necklace* (Ceroni n° 230), *Woman with red hair in evening dress* (Ceroni n° 231), and *Girl seated* (Ceroni n° 232).

Impressed by the works they saw in Paris, the Sitwells organized the exhibition in order to present contemporary French artists to the British public. More than three hundred paintings and almost one hundred-fifty drawings were exhibited, including works by Archipenko, Derain, Vlaminck, Fernand Léger, Kisling, Suzanne Valadon, Ossip Zadkine, Picasso, Matisse.[17] Inside the gallery, there was "an enormous wicker basket full of sheaves of Modigliani drawings, from which the visitor could choose a specimen for a shilling."[18] The exhibit had more than twenty-four thousand visitors.

"Why does he [Modigliani] paint people with necks like swans?" Osbert Sitwell heard someone say derisively at the opening. However, more than a dozen paintings were sold that day, including a Modigliani

nude. The painting's buyer, Arnold Bennet, wrote in the exhibit's catalogue that "Four figure subjects of Modigliani seem to me to have a suspicious resemblance to masterpieces."[19] Bennet also purchased Modigliani's portrait of Lunia Czechowska, for which he paid one thousand francs.[20]

As a reward for their organizational efforts, the Sitwells kept Modi's *Peasant Girl* for themselves: "Monumental, posed forever in a misty blue world…a wry-necked peasant girl of northern France, with her fair hair, sharp, slanting nose, and narrow eyes…hands clasped."[21] Art historian Kenneth Wayne believes Sitwell referred to a painting now titled *La Belle Epicière* (Ceroni n° 256), which is resplendent with its dominant orange-golds and blues. Considering how the trees in the background of the painting resemble those in one of Modi's rare landscapes done at the time, the canvas was most likely completed during Modi's stay in Cagnes-sur-Mer.[22]

Clive Bell gave Modi a backhanded compliment in his review of the Mansard Gallery exhibit when he said, "The collection of Modiglianis is the best that I have seen. Modigliani will never be a great painter, but he is a very good one. To begin with, he is not a painter at all; he is a draughtsman who colours his drawings. Indeed, it is in his pencil drawing that he is seen to the greatest advantage. Evidently, Modigliani is admirably aware of his own limitations. Never does he set himself a task beyond his powers. Unfortunately, that means that he never sets himself the sort of problem from which comes the greatest art. He exploits his slightly literary sensibility with infinite tact, and, as his sensibility is great, there is not much risk of becoming a bore. But, when one notices how much he has been influenced by Picasso and Derain one notices, too, how impossible it is that he should ever be a match for either of them."[23]

Not that money is a measure of quality or artistic value, but Picasso's *The Women of Algiers* (version "O" 1955), which sold for a world record $179,365 million at Christie's in 2015, barely surpassed Modigliani's *Reclining Nude Open Arms* (Ceroni n° 198, 1917), which sold for $170,405 million that same year.[24] André Derain, meanwhile, has yet to surpass $25 million at auction.

§

CHAPTER 31

<center>❧ ❧ ❧</center>

BECOMING MODIGLIANI

"Two enemies – the same man divided."

<div align="right">Emile Cioran[1]</div>

During his time on the French Riviera, Modigliani produced more than sixty paintings, several of which critics say are among his best. His palette now included lighter colors, with tones of blue, yellow-brown, reds, orange, and ochre reminiscent of homes along the narrow streets of Nice's old village. Art critic and biographer Alain Amiel said Modi's stay in Southern France was among the artist's happiest times.[2] At first, Amedeo settled at the Hotel des Colonies near the train station in Cagnes-sur-Mer. Then, he lived briefly with Jeanne in a charming little house in the hills. Between April and June, 1918, three months during which Modi and Jeanne lived blissfully together, he did perhaps six portraits of Jeanne and more than twenty paintings of children and teenagers.[3] Although adult models were difficult to find, parents readily allowed their children to earn some pocket change by posing a short while for the painter. Surrounded by eucalyptus trees and mimosas, Modi painted several well-known works in the kitchen of a small home Hanka Zborowska rented nearby.[4] It is also possible he stopped drinking for a short while, although Hanka tells how Modi became angry when the young girl who posed for his painting, *Marie, fille du peuple* (Ceroni

<center>235</center>

n° 253, 1918) bought grenadine syrup rather than red wine when she was sent to do errands.[5]

Despite these happy times it seems uncertainty filled Modi's life. His dealer, Léopold Zborowski was at first unable to sell any paintings, so he moved with his wife Hanka to the much larger and more affordable city of Nice a few miles away, then left for Marseille and returned to Paris where he had greater success. Modi also moved close to the center of town in Nice, where he transited between apartments and cheap hotels. He stayed for a while with his friend, fellow artist Léopold Survage. He also made several sorry attempts at continuing his domestic life with a pregnant Jeanne, who had settled far from the center of town at 155 Avenue de la Californie, perhaps with her mother.[6] One month after the birth of their daughter, who they named Giovanna Hébuterne, Modi celebrated New Year's Eve by dining with Survage at the club-restaurant Le Coq d'Or, at 14 Avenue de la Victoire – today L'Avenue Jean Medecin, in Nice.[7] With a healthy sense of humor, the two men wrote Zborowski, Modi's dealer in Paris:

"On the stroke of midnight.

Dear Friend; I embrace you as I would have done if I could the day you left. I am hitting it up with Survage at the Coq d'Or. I have sold all my pictures. Send me some money soon. Champagne is flowing like water. We send you and your dear wife our best wishes for the New Year. Hic incipit vita nova.

The New Year!
Modigliani."

Zborowski, it seems, did not take the joke lightly and assumed Modi was living it up even though money was tight. This prompted a follow-up letter from Amedeo in which Modi called his dealer "naïve" and declared he "hadn't sold a thing." Modigliani, who had promised to send Zborowski his completed works, had never tried to sell any paintings himself. Speaking with Modi's daughter almost fifty years

later, Survage affirmed they had pretended to drink champagne, but it was only red wine.[8]

Leaving Jeanne and the baby in Nice (by now, it seems Jeanne's mother had returned to Paris), Amedeo spent several days and perhaps a few weeks in the villa of the landscape painter Anders Österlind and his wife Rachel Bakra, both friends of the Zborowskis. Born in 1887, Anders was three years younger than Modigliani and the son of the Swedish artist Allan Österlind. Like Amedeo, Anders had suffered from severe pleurisy, probably tuberculous in origin, when he was younger. This caused his subsequent exemption from military service. In 1907 he met Rachel, with whom he had a son, named Anders-Allan – nicknamed Nanic in 1909. Rachel and Anders were married in 1914. Anders enlisted in the French Foreign Legion as a Swede in 1917, but was quickly discharged for medical reasons related to his pleural disease. He and Rachel had settled in the picturesque hills above Cagnes-sur-Mer.[9]

The Österlind's home was near the Chemin des Colettes, only a few hundred meters from the large and beautifully landscaped garden villa of August Renoir. Anders was a child when he first met the renowned painter in Paris. Now, he frequently visited Renoir, who, despite being elderly and afflicted with severe rheumatoid arthritis, was still able to paint. Modi accompanied Anders on his visit with Renoir but once. According to Charles Douglas, whose book *Artist Quarter* is full of anecdotes, of which a few are more or less true, Amedeo rebuffed Renoir when the old Master said he always "caressed buttocks for days before finishing a canvas" and advised Modi to "paint with the same joy that you would make love to a woman." With characteristic arrogance, Modigliani replied, "I, Monsieur, don't care for buttocks," before rudely storming out of Renoir's home.[10] In another story, this from biographer Pierre Sichel but also related by Anders Österlind to his gallerist Ernest Brummer, the Österlinds gave Modi the best room in their house, "all white and clean," only to find that Modi did not sleep much and that "coughing and thirsty, he spent his nights drinking by the jug and spitting on my walls as high as he could, looking on afterward at the course of the saliva."[11, 12]

Rachel Ôsterlind died from intestinal tuberculosis on July 30, 1920. Anders remarried in 1922 and continued to exhibit his paintings in galleries and museums. His son from Rachel, Nanic Ôsterlind, was ill for much of his life and spent some time in sanatoriums. He died age thirty-four in 1943, also from tuberculosis.[*]

Among the many portraits Modi painted during his stay on the Riviera, including *Girl in pigtails* (Ceroni n° 243), *Girl with a beret* (Ceroni n° 244), and *La petite fille en bleu* (Ceroni n° 245, 1918) mentioned previously, there is a small portrait of Rachel Ôsterlind. Her pupils are painted uncharacteristically inside her conventionally painted eyes, and her right hand is folded gently against her ear (*Rachel Ôsterlind*, Ceroni n° 284). The painting is clearly visible on a shelf in the background of a photograph taken of "la belle" Rachel, who was already a consumptive in her home at the time. The portrait is now in a private collection but was exhibited at the Tate London in 2017 and at the Nassau County Museum of Art in 2023.

Anders was a landscape painter, so it is not surprising that Modi also tried his hand at landscapes during the five weeks or so he lived there. Each of the four portrait-sized (61 by 46 cm) canvases he did in this style is similarly marked by a sparse number of trees in the foreground, behind which are a few homes (Ceroni n° 290-293). One of the paintings, *Landscape in the Midi* (Ceroni n° 293), was sold at auction at Christie's in New York in 2022. It strangely has two signatures; one in white, the other in black, in its lower left- and right-hand corners. Modi's landscape paintings appear ordinary, with colors and construct more likely to have been inspired by Ôsterlind or Cezanne rather than by the Macchiaioli with whom Modi trained when he was young.

Contrary to Cezanne, who reveled in Nature and said; "The landscape is reflected, becomes human, and becomes conscious in me. I objectify it, project it, fix it on my canvas,"[13] Modi thought his own landscape works were amateurish. He felt no pleasure in painting them. In a brief letter to Zborowski, he wrote, "I am trying to do some

[*]Anders Ôsterlind received the Legion d'Hônneur in 1951 and died in Paris on January 5, 1960.

landscapes. The first canvases might possibly look like a beginner's..."[14] Encouraged by Survage to simply paint what he saw, Modigliani said, "There is nothing to express in landscapes."[15]

In February 1919, Amedeo must have been pleased when he learned of an article by the British curator and art critic Roger Fry in the well-reputed The Burlington Magazine. In *Line as a Means of Expression in Modern Art*, Fry wrote, "The beautiful variety and play of his surfaces is one of the remarkable things about Modigliani's art and shows that his sculptor's sense of formal unity is crossed with a painter's feelings for surfaces."[16] The article included two reproductions of Modigliani's work: a watercolor and pastel color drawing of a caryatid, and a pencil drawing, *Portrait of Mlle. G.*[17]

Around this time, Modi wrote to Zborowski that he lacked money, having lost his wallet and his identity papers. In another note, he announced his move to an apartment at 13 Rue de France, in the city center, only a five-minute stroll from Nice's long pebble beach and the famous boardwalk called the Promenade des Anglais.[18] Modi told Zborowski, "All these changes, changes of circumstance and the change of the season, make me fear a change of rhythm and atmosphere. We must give things time to grow and flower." Providing what reads like an apology for a lull in his productivity, Modi also wrote, "I have been loafing a bit for the last few days. Fertile laziness is the only real work." He added, "Thanks to my brother, the business of the papers is almost finished. Now, as far as that goes, we can leave when we want to. I am tempted to stay here [on the Riviera] and to go back only in July."[19]

Only three months later, however, Modigliani returned to Paris. A "Safe Conduct" pass from French authorities was required to travel between regions during and for a time, after the war. Using one issued by the police in Cagnes-sur-Mer, Modi was permitted to leave the region on May 31, 1919. This hasty departure, leaving Jeanne and his six-month-old daughter behind on the Riviera is unexplained.[20] Perhaps he was bored, or perhaps he thought new commissions for portraits awaited him in the French capital. According to biographer William Fifield, Modi told Léopold Survage before leaving, "This is a good place to recuperate. But now back to the hell of Paris, that stimulates

my work."[21] Or, perhaps Jeanne's inability to satisfactorily care for her child forced Modi to search for another wet nurse before his family arrived in Paris. It is also possible he already knew his twenty-one-year-old girlfriend was pregnant again (although highly variable, the mean time to ovulation and fertility in lactating, breastfeeding mothers using no contraception is about 190 days and is less than three months if not breastfeeding).[22, 23] After all, Modi had a history of fleeing his responsibilities. More than a year earlier, several months after he had met Jeanne, his former lover, twenty-five-year-old Simone Thiroux, gave birth to a son she named Gérard, whom Modi never acknowledged.[24] Shortly after Simone's death from tuberculosis, the boy was temporarily cared for by two of Modigliani's female acquaintances; Foujita's wife Fernande Barrey and Swedish painter Anna Diriks before being given up for adoption. Gerard Villette-Thiroux became a Catholic priest.[25] He was "discovered" by the *Journal du Dimanche*, a French newspaper preparing for the June 1981 Modigliani exhibit at the Centre Pompidou in Paris.[26]

There is no documentary evidence that Modi was increasingly feeble during his last months on the Riviera, nor that his health was poor when he arrived in Paris in the Spring. Whether he was drinking intermittently is unknown. Back in Montparnasse, having neither married the mother of his child nor legally recognized the infant as his, he was comforted by another female friend, the beautiful Lunia Chechowska, who stayed with the Zborowskis at 3 Rue Joseph Bara after the disappearance of her husband who had joined the Red Army in Poland. Modi sketched her in pencil a few years earlier and painted her portrait at least four times (Ceroni n° 169-172). During the war, Lunia often stayed with the Zborowskis while her husband was at the Front. Now, Modigliani courted her with vigor, although Lunia never claimed they had an affair.

Lunia was born in Prague in 1894 – her maiden name was Ludwika Makowska, and she was ten years younger than Amedeo. Among her published recollections, she described a stroll to the Luxembourg Gardens, where Modigliani used to walk amorously with Anna Akhmatova a decade earlier. Lunia recalled, "We walked and walked,

often stopping by the little wall along the Luxembourg gardens. He [Modigliani] spoke of Italy, which he was never to see again, and of the baby he was never to see grow up, and he never breathed a word about art the whole time. He had so many things to talk about that we were never able to say goodnight."[27]

One can only guess their conversations because little is known of Modi's thoughts and opinions about anything at the time, including his feelings about a war that had caused almost two and a half million French casualties, half of which were killed on the Western Front. The country was in financial ruin, the working class was decimated, and France's total population, which had grown almost five percent per annum before the conflict, had fallen steadily during the fighting to only 38.7 million in 1919. Labor productivity dropped to less than half of its prewar levels. Roads and homes were destroyed, agriculture and trade suffered immensely, inflation soared, and the country's total debt grew from 33.5 billion francs before the war to 197.5 billion francs in 1920.[28] The country's entire social fabric was changing, and bohemia as it was known, had ended.[29]

Public sentiment about life, leisure, and luxury was drastically altered by the widespread devastation and carnage caused by what was referred to as The Great War or the War of 1914-1918 (the words First World War were used to distinguish it from World War II in 1939). Marxism took on a new meaning marked by the promises of the Russian revolution, while in art and literature, the Surrealists, soon led by André Breton, revolted against traditional standards. In their attempt to transcend postwar society's social, economic, and political constraints, artists and writers declared there was life beyond art. They strove for artistic expression by exploring their unconscious minds and imaginations. The United States benefitted economically from the destruction of France's Old-World order, so wealthy American ex-pats flocked to Paris, where they joined many artists, writers, and intellectuals who wanted to change the world. Together with a new French avant-garde, they would help characterize a new "bohemia," as well as alter the perception of art in the Western world and with it, foster a new breed of collectors.

[Handwritten margin note at top: "have been exhibited in his paintings? What does their absence tell us?"]

None of these worldly events seem to have affected Modi's artistic vision. Whereas themes of love, war, family, death, and disease have inspired artists since the dawn of time,[30] Amedeo, except for his series of nudes, remained faithful to his singular painting of portraits which Jean Cocteau said "are not the reflection of his external observation, but of his internal vision." Other painters, such as Toulouse-Lautrec facing the challenges of physical disability, Frida fighting her chronic pain, Renoir with arthritis, Munch with depression, Van Gogh with epilepsy, and Gauguin suffering from syphilis and malaria, displayed feelings and emotions that were both expressed and transformed by their art. Nowhere in Modigliani's paintings, however, is there a trace of disease-related malaise, alcohol-induced inner turmoil, or the haunting permanence of death. Still quoting Cocteau, "His drawing was a silent conversation."[31]

[Handwritten margin note at left: "How would disease-related malaise or alcohol-induced inner turmoil could"]

[Handwritten note: "In what way? About what?"]

Modi settled into an upper level studio apartment Zborowski found him at n° 8 Rue de la Grande Chaumière, adjacent to the Académie Colarossi (n°10), L'Académie de la Grande Chaumière (n°14), and l'Union des Artistes (n°15) on the small street between Notre-Dame-des-Champs and the Boulevard Montparnasse.[32] Lunia said he worked endlessly and only began drinking again after Jeanne joined him in Paris at the end of June.[33] Some of his portraits in the following months are almost parodies of his own style, reinforcing André Malraux's statement in *The Voices of Silence*, his six hundred-page treatise on the history of art: "The mistaken impression that artistic expression and visual experience necessarily concur was fostered by the most widespread form of art: the portrait."[34] In some paintings, the swan-like necks of Modi's sitters became more exaggerated; their faces were more oval and pointed, their blue-filled eyes made smaller, and their lips made tighter and more puckered. *Lunia Czechowska in Profile* (Ceroni n° 320) and *Lunia in black* (Ceroni n° 318) are illustrations of such exaggerations of a sitter's features. In the first, she is seen only partially in profile. The slope from her streaked red hair is tucked in a bun that extends past her high rounded forehead to an upturned nose behind which is a hint of the sitter's contralateral eyelid. Lunia's white, V-necked blouse prolongs the verticality of her neck and face to the bottom of the canvas. In the

second, Lunia's face is oval-shaped and characteristically askew, tilted as if about to fall from a pedestal. The plunging neckline extends the verticality of the painting almost to where the sitter's hands are peacefully clasped on her lap.

Modern technical analyses of Modi's later paintings show how his work retained its structural complexity; a thin (and sometimes thick) layering of paints over a preferably clean surface, the diligent use of complementary colors and a somewhat limited palette were consistent with his classical training. Studies also reveal his detailed preparatory drawings, textured backgrounds, deftly applied brushstrokes, and carefully placed but minimal highlights in the painted eyes of some of his subjects.[35]

These findings also apply to many paintings Modi completed during his fourteen months in Nice and in Cagnes, as well as to the many portraits he made of Jeanne Hébuterne, his girlfriend and now the mother of his daughter, Giovanna born November 29, 1918, less than two weeks after the armistice signed November 11, 1918, that finally ended The Great War. Amedeo probably first painted Jeanne's portrait in 1917, producing *Jeanne Hébuterne wearing a large hat* (Ceroni n° 180). Modi always searched more to bring out the sensitivities and spiritual essence of his sitters than to construct a replica of their facial features. Jeanne, however, with her sloping shoulders, gentle expression, and chestnut-colored hair is immediately recognizable. This portrait is additionally of interest because of Jeanne's fingers lightly touching her tilted head or chin. This is a sensory trick used by patients who suffer from torticollis, also called wryneck, Jeanne's head angulation, hand gestures, and hypertrophied sternocleidomastoid muscle are also visible in other paintings (Ceroni n° 173, n° 174, n° 218, n° 307, and n° 326) as well as photographs, prompting some medical experts to suggest she may have had resting cervical dystonia, also called spasmodic torticollis, a painful and involuntary contracture of neck muscles that causes the head or neck to twist or turn to one side.[36, 37]

Stylistically, Modi's paintings of Jeanne through the years have all the characteristics that contributed to making Amedeo's work famously unique; her asymmetric light blue-filled eyes, thin eyebrows and a

slightly tilted head perched on a slender and elongated neck. The way her long nose is sometimes painted partly *en face* or in profile is reminiscent of some of Modi's sculptures. He painted her again many times throughout 1918 and early 1919. In all, there are at least twenty-seven different portraits of her, but a precise number is difficult to ascertain with certitude because of possible forgeries and the absence as of this writing, of a globally accepted catalogue raisonné of Modigliani's work.

At first, Modi's portraits of Jeanne Hébuterne were flattering. She was thin, with a long oval face, a thoughtful countenance, and a gentle sensibility. *Portrait of a young woman* (Ceroni n° 224) was among several paintings studied by the Modigliani Technical Research Group in 2018. It was first exhibited in 1925 at the Galerie Bing & Cie in Paris. While the identity of the sitter has been disputed, mainly because the woman's eyes are dark rather than blue like Jeanne's in real life, the sitter's reddish-brown hair and long oval face are consistent with two similar paintings; *Head of Jeanne Hébuterne* (Ceroni n° 223) and *Jeanne Hébuterne in profile* (Ceroni n° 222), probably completed around the same time. The near-profile view of *Portrait of a young woman*, investigators say, is reminiscent of fifteenth-century Renaissance portraits. Infra-red imaging showed that, as was his custom, Modi began his composition with a dark black drawing reinforced with black paint to reinforce his forms. Studies confirm his use of a limited palette of pre-industrial standard pigments, except for a chrome orange used as a base color in the cheeks and lips. Because it appears the painting was made while tacked onto a wall or flat support rather than an easel, researchers believe it dates from Modi's time on the Riviera, when he had no fixed place to paint and had to improvise a means to support his canvases while he worked.[38]

Modi also did several portraits of Jeanne during various stages of her pregnancy. It is challenging to know which of these were completed when she was pregnant with Giovanna or during her second pregnancy, sometime after June 1919. In the *Portrait of the artist's wife* (Ceroni n° 219), Jeanne wears a dark blouse and reddish-brown skirt. She is seated with her arm resting on the back of a chair. Her hair is tied up in a bun. In *Jeanne seated in bed* (Ceroni n° 329), *Jeanne seated* (Ceroni n° 221),

and *Jeanne with a yellow sweater* (Ceroni n° 220), the sitter's face is soft and her gaze is distant. Her body displays the eloquent roundness of an advancing pregnancy. French essayist Claude Roy wrote that Modigliani bathed his girlfriend in "the light of adoration,"[39] but I wonder whether her exaggeratingly long, crane-like neck does not invite the suggestion of caricature.

§

CHAPTER 32

LETTERS TO MOTHER

"Dear mother, I am here, quite close to Nice. Very happy."

Amedeo Modigliani[1]

With increasing sales and the promise of showing his work in London, Modigliani had yearned for Paris. Still waiting in Cagnes to replace his lost identity papers, he wrote his mother on April 13, 1919. Nothing in this note suggests a losing battle with sobriety, depression, emotional anguish, or physical suffering.

"Dear mother,

I am here, quite close to Nice. Very happy. Once settled I will send you a definitive address. I kiss you very much,

Dedo"

Only a few weeks later, he received the necessary documents allowing him to travel (he had provided as his official address Villa La Riante, in Cagnes), and on May 31, 1919, Modi boarded a train to the French capital. Protected and financially secure for more than a year in the South of France, he had not succumbed to the lure and light of Mediterranean landscapes, but persisted single-mindedly with his style of portraiture. A chronicler of artists and writers during his earlier years

246

in Montmartre and Montparnasse, he did not portray refugees who left their homes with nothing more than a suitcase, nor documented the horrors of battle during the war years. Instead, he refined his line and cultivated his compositions, altering his palette in order to best serve the gentle contenance he ascribed to his young models. If he had once stretched his comfort zone to compete with ancient Italian masters by painting nudes, on the Riviera he turned his attention to painting portraits of children, house servants and other young people in addition to those of his friends and acquaintances. Perhaps this was because hiring models was expensive, or because his girlfriend's pregnancy kept children on his mind. Regardless, in each of the sixty or so portraits believed to have resulted from his sojourn in the South of France, Modi's subjects display an aura of grace and tender consideration for the fragility of their individual humanity.

Returning to Paris in the Spring of 1919, possibly bored with but still enamored by his love interest, Jeanne Hébuterne, whom he left in Nice with his infant daughter, Modi resumed his seductive ways at the side of Lunia Czechowska. He also painted with renewed energy. While not all of his portraits in the months ahead would be of the highest quality, modern analyses reveal a mature style anchored in Modi's knowledge of the early Italian Renaissance.[2] His sitters again included his friends and close acquaintances; Lunia, Hanka and Léopold Zborowski, the collector Roger Dutilleul, and later, Zborowski's young assistant, Paulette Jourdain, in addition to several as yet unidentified young men and women.

In August, the influential British art critic Roger Fry wrote a piece for *The Athenaeum,* saying, "Modigliani is still a finer draughtsman than he is a painter, but there is no denying his aptitude for developing a kind of pictorial-sculptural idea of form-a method, by the bye, which was common enough among painters of the Renaissance."[3] The *Exhibition of French Art 1914-1919* at the Mansard Gallery in London from August to September was a success that resulted in several sales and increased awareness of Modi's work among international collectors. Roger Fry also wrote in *The Athenaeum* that the exhibition was "such a show [of Vlaminck] and Modigliani as has never before been

seen in England."[4] Amedeo was severely ill, however, to the extent that he did not make the trip from Paris to London for the show, and many even feared he would die. One of the organizers of the exhibit, Osberet Sitwell, tells how Modi's dealer, Léopold Zborowski, received a telegram from his Parisian colleagues suggesting he hold up all sales during the exhibit until the outcome of Modi's illness was known and shares how Zborowski personally asked the Sitwells to refuse to sell any paintings should a possible purchaser appear![5] Shortly after the showing, the autumn issue of *Art and Letters*, an illustrated quarterly magazine edited by Osberet Sitwell featured Modi's drawing, *Woman's Head*, on its pages.[6]

It should be no surprise that a few weeks earlier, in a letter to his mother dated August 17, 1919, Modi was optimistic and in good spirits.

"*Dear Mother,*

Thank you for your postcard. I am having a magazine, L'Éventail, sent to you, with an article in it about me. I am having a show with some other people in London. I have asked them to send you the clippings. Sandro, who is now in London, will be going back through Paris before returning to Italy. My baby, whom we had to bring back from Nice and whom I have sent to the country near here, is very well. I am sorry not to have any photographs.

Kisses, Dedo"[7]

Nothing in this letter suggests Modi was ill, doubted his worth, or downplayed his success. Indeed, the article titled *Modigliani*, by his friend Francis Carco in *L'Éventail*, describes the artist's trajectory since 1913. It is packed with praise for Modi's work. "I know not whether anyone before Modigliani, has attached a greater intensity of expression on the face of a woman," Carco writes.[8] The magazine printed three reproductions of Amedeo's portraits and followed up with an issue on August 15th that reproduced four of Modigliani's wonderfully simple but precise drawings.[9]

With Lunia's help, Amedeo found a nursery for his daughter Giovanna in Chaville, about twelve kilometers from the center of Paris. He was painting steadily, but it is during these last months that Modi's myth grows out of proportion with reality. There are so many anecdotes and memories shared by friends and acquaintances recalling events even decades after the man's death that it is almost impossible to know what really happened. Biographers too, may have inadvertently mistaken certain facts or relied on testimonials whose veracity could not always be confirmed. Museum curators, auction houses, authors, and other aficionados face the pressures of romanticizing or embellishing. Sometimes, histories are fictionalized in an attempt to generate greater public awareness and commercial interest. "With sufficient perspective, nothing is good or bad," wrote Romanian/French philosopher Emile Cioran. "The historian who ventures to judge the past is writing journalism *in another century*."[10]

One month earlier, Modigliani pledged to marry Jeanne, who had arrived in Paris with the baby at the end of June. "Today, July 7, 1919," he wrote, "I pledge myself to marry mademoiselle Jane Hébuterne as soon as the documents arrive, (signed) Amedeo Modigliani, Léopold Zborowski, Jeanne Hébuterne, Lunia Czechowska."[11] The reason for this change of heart is unlikely to be known, nor can we know if Modi was sincere. In a mostly fictional story about Jeanne's last days, *Into the darkness laughing*, author Patrice Chaplin says Jeanne did not want to end up pregnant, unmarried, and ill like Modi's one-time lover and fellow consumptive, Simone Thiroux.[12]

Modi desperately wanted his own place to work, and with Zborowski's finances improving, Lunia and Hanka Zborowska cleaned his apartment at la Grande Chaumière and made it ready for work. The L-shaped studio was a few flights up from where Modi's friend, Ortiz de Zárate lived. Without gas or electricity, it was furnished with a small sofa, a table, a few chairs, and a coal stove. Coal was available across the street and paid for by Zborowski. Neither Modi nor Jeanne was inclined toward domestic chores, but a cleaning woman could be hired for only one franc per hour. The couple settled in more resolutely, and Modi painted parts of the wall orange and ochre to provide backdrops

for his paintings. Lunia said, "His joy was such that we were all shaken by it."[13] In one of Modi's last paintings of a pregnant Jeanne Hébuterne, *Jeanne Hébuterne before a door* (Ceroni n° 335, 1919), she is portrayed almost full-length, sitting on what appears to be a bench. The reddish shawl wrapped around her shoulders and torso covers most of her long-sleeved white blouse. The shawl's darker character barely lets it stand out from the warm colors of the window-paneled door and wall behind her, giving the painting what Alfred Werner called an *eleganza tutta Toscana* (*trans.* an elegance all Tuscan).[14] The tilt of Jeanne's oval face is so exaggerated that it appears as if her head is about to fall, almost as if in resignation, from the pedestal created by her long and thin, swan-like neck. Her almond-shaped eyes are painted a narrowly filled-light blue. They are placed asymmetrically and are without pupils or cross-hatching. Although Jeanne appears emotionless at first glance, her pursed lips, resigned body position, and distant look express melancholy. The whole creates an atmosphere about which David Franklin writes, "Beauty and the wounded suffering of regret are inextricably linked."[15]

The apartment setting is also found in several other portraits from the period: *Seated woman with baby* (Ceroni n° 334), *Paulette Jourdain* (Ceroni n° 333), and what was probably among the last paintings done by Modigliani before his death, *Mario Varvoglis* (Ceroni n° 336). The first shows a woman, presumably a 'nourice'– wet nurse or nanny, and a baby who could be Modigliani's daughter, Giovanna. This is only the second portrait Modi made of a woman holding an infant; the other is *Gypsy woman with baby* (Ceroni n° 247), which depicts a dark-haired woman with light blue eyes and Modi's typical warm orange skin tones.[16] The painting is currently in The National Gallery of Art in Washington D.C. It was possibly painted in 1918. The portrait of Paulette, who worked for Zborowski, was completed shortly after the girl's fifteenth birthday. Like several other paintings from this period, it is a large format (the canvas is 110.3 by 65.4 cm), showing the teenager seated in a black dress. Her dark auburn hair is tied back with a black ribbon. Modigliani expert Kenneth Wayne interviewed the eighty-eight-year-old Paulette in Paris in 1992. He learned that Modi made many drawings of her and that she came to Modi's apartment at 8 Rue la Grande Chaumière several times.

She recalled that Modigliani painted quickly and was quite confident, but at the end of their sessions, he always asked her to buy rum for him from across the street. He tenderly called her "fillette" (*trans.* little girl) and greeted her with a "*bonjour fillette!*" when she walked up the long, winding staircase leading to his studio.[17] She also recalled that Jeanne Hébuterne "puttered around in the other room."[18]

In November, four of Modi's paintings (*La fille du peuple, Portrait d'homme, Nue,* and *Portrait d'une jeune fille*) were shown in the 17th Salon d'Automne (November 1-December 10, 1919).[19] The Dada journal, *Littérature,* notified its readers of Modi's artwork exhibited alongside that of other well-known painters such as Francis Picabia, Zadkine, and Henri Matisse.[20] In yet another example of British recognition, the December 1919 issue of the short-lived modernist art journal, *Coterie: Art, Prose and Poetry* featured a Modigliani drawing of Paul Delay,[21] while the art critic and well-known enemy of dilettantism (particularly as it applied to studio art),[22] Wyndham Lewis wrote that Modi was the best-respected painter in Paris.[23]

Dozens of anecdotes suggest that Amedeo was more than a social drinker. However, for a man who reportedly spent much of his time either drunk, ill, or both, Modigliani's artistic output in 1919 is impressive. The Secretmodigliani.com website unofficially lists 120 paintings potentially attributable to him that year alone. Their inclusion in expert catalogues is variable. If even half of the paintings are authentic and recognized by Modigliani scholars, art conservators, collectors, and art historians, it means Modi completed more than one oil painting a week. Considering his purportedly turbulent lifestyle, domestic uncertainties, and ill health, the strain from his work must have been overbearing.

Contrary to what has been said of Modigliani, the artist was neither starving, destitute, or unknown during his lifetime. In a career spanning fourteen years, he had made countless pencil or graphite drawings, hundreds of works on paper using gouache, crayon, watercolor, charcoal, or oil, a couple of dozen stone sculptures, and perhaps four hundred or so oil paintings. His art was exhibited alongside some of the most famous names of the early twentieth century; Picasso, Cezanne, Derain, and

Matisse, among others, and his art dealer, Léopold Zborowski, who consistently gave him a weekly stipend, sold works to aficionados and major collectors alike. With sales to well-connected buyers increasing, a studio where he could paint without interruption, a live-in girlfriend pregnant with his second child, and a steady income from Zborowski, Amedeo lacked in neither food, recognition, love, nor lodging.

For the most part, Modi was a private man, an introvert whose sensitivities were transposed into his art. The German painter Ludwig Meidner remembered that in 1906, Modi had the gift of making friends everywhere, but Anna Akhmotova recalled Modi's personality in 1911. "He seemed to me to be encircled by a girdle of loneliness...,"she said. "I never heard him mention the name of an acquaintance, a friend, or a fellow painter, and I never heard him joke."[24] He was also prone to outbursts of anger, as he had shown during his stormy two-year relationship with Beatrice Hastings. In 1914, Béa described him as a "pale and ravishing villain."[25] Chana Orloff, the Ukrainian sculptor whose portrait Modi painted in 1912 said Jeanne Hébuterne told her she went almost every night to the police station to bring Amedeo home,[26] and the writer André Salmon said he watched an inebriated Modi screaming angrily and pulling Jeanne by the hair one night near the Luxemburg Gardens.[27] Now, during the summer of 1919, Modigliani was likely overwhelmed with the reality of taking on a wife who had neither the income nor the desire to care for their infant daughter. He had not yet recognized the child officially nor married his pregnant girlfriend, who was about to deliver their second child. Chronically ill, incessantly coughing, and in all probability drinking intermittently, Modi was never a man who welcomed responsibility. Almost nothing is known about his feelings, but in one off-the-cuff remark to Russian artist Marevna Verobev, Diego Rivera's former lover, he said, perhaps not jokingly, "I'm going to have two kids. It's unbelievable. It makes me sick."[28]

Among the documents Dr. Paul Alexander collected in the 1920s while preparing his never-published biography of Modigliani is a letter from Modi's mother written three years before her death. Dictated to her daughter, Margherita, and addressed to Paul Alexandre in December 1924, it tells of Modi's letters to his family overflowing with

tenderness and pride, informing his mother of his intention to bring his girlfriend and children to Italy to meet the family.

In a separate note, however, Margherita herself added;

"My poor brother almost always lived far from the family circle, but our occupations and interests were also of a different kind. The bond of affection was never broken, but the intimacy that results from the pursuit of common goals and aspirations was absent. Even my mother, who was so passionately devoted to our dear departed brother, was hardly aware of his plans and ideas."[29]

We may never know what childhood traumas or life-changing events prompted Modi to distance himself from his family. For a while, his older brother Emanuele sent him money when needed and paid his rent on occasion. Eugénie was constantly supportive while he was growing up. Perhaps, it was the booze, the drugs, or his unconventional lifestyle that altered Modi's relationship with his mother, but sometime in the winter of 1919, Modi wrote her:

"Dear Maman,

*I send you a photo. I am sorry to not have one of my daughter. She is in the country with the nanny. I am thinking, for the Spring, perhaps, a trip to Italy. I would like to spend some time there. It is not sure, but anyway, I think I will see Sandro again. It seems that Uberto is about to go into politics, let him do it.**

I kiss you very much, Dedo."[30, 31]

§

* Modigliani is referring to his childhood friend, Uberto Mondolfi (who was elected Mayor of Livorno in 1920) and his father Rodolfo who had helped Modi's mother, Eugénie Garsin, start her home school in the 1890s.

CHAPTER 33

AT LAST, PEACE

"He who makes peace in His heights, may He make peace upon us and upon all Israel."

The Kaddish[1]

Among Modigliani's last works is what is believed to be his only existing *Self Portrait* (Ceroni n° 337), possibly completed a few months before the sudden deterioration in his health in January 1920. Paulette Jourdain remembers it as earlier than 1919, however, and according to Hanka Zbworowska, the painting was done while Modi was still in the south of France.[2] The canvas may have been cut from the same roll of cloth as one of Modi's landscapes painted in Cagnes-sur-Mer (Ceroni n° 293). He painted himself sitting on a chair, holding his palette in one hand while his other hand rests on his thigh. His face is seen in a partial profile, and he wears a reddish-brown coat with a light blue scarf or sweater tied around his neck and over his shoulders.

According to Germaine Survage (Léopold Survage's wife), Modi's friends offered him clothes, but he always preferred to wear his brown velvet jacket: "He carried himself so magnificently, was so proud - always in his checkered shirt in small checks white and blue perfectly clean, his only shirt. Friends offered him clothes to replace his worn velvet, but he always refused."[3] In the painting, possibly done by looking at himself in a mirror, Modi's gaze extends beyond the picture frame.

Similar to several other paintings of this period, the work is done on a large French Marine 40 canvas (100 cm by 64.5 cm), readily found in Parisian art supply stores at the time, and turned vertically. Modi used a simple range of colors that are interestingly presented on the palette held oddly enough in his right hand – there is no indication that Modigliani ever painted with his left hand.[4] Paints are loosely applied in thin, transparent layers between diluted black outlines that are part of an underdrawing in charcoal. Imaging studies by the research group in Sao Paulo (the painting is owned and displayed at the Museo de Arte de Sao Paulo, Brazil) show differences in the careful detail that Modi used to paint his head and facial features compared with the looser brushstrokes used to paint his hands.[5]

Amedeo's figure stands out against a background filled with a large rectangular ochre wall and two smaller blue-greenish rectangles. He shows himself well-shaved with only the hint of a 5 o'clock shadow. He appears neither ill nor emaciated, but there are shadows beneath his narrow, dark-filled eyes. He is seated on a chair, presumably in front of the easel and canvas he is painting. His slightly tilted oval head rests on his oversized, elongated torso clothed in a burgundy suit painted in a style reminiscent of Cezanne's *Madame Cezanne in Red* (1890-1894), which is also exhibited at the Museo de Arte de Sao Paulo (MASP).[6]

Sometime after New Year's Eve, Amedeo did the portrait of Mario Varvoglis (Ceroni n° 336). He apparently left the unfinished oil painting on its easel, where it was found only after Modi's death. There are at least two if not three, preparatory drawings of the Greek composer. A pencil sketch that was originally in the Roger Dutilleul collection shows Varvoglis in his overcoat and hat, seated in almost the same position as in the painting.[7] Another is a head and shoulders view only, with Modi's customary New Year's greeting, *Il Novo Anno. Hic Incipit Vita Nova* written in the upper righthand corner.[8]

Around this time, Modi received a letter from Simone Thiroux, his former lover and mother of a two-year-old son he never acknowledged. She lived around the corner at 207 Boulevard Raspail, only three minutes from Modi's apartment on the Rue de la Grande Chaumière. Severely ill with pulmonary tuberculosis, Simone would die miserably in

a common ward at the Hôpital Cochin on October 6, 1920. The note to Modigliani is dated December 31, 1919, nine months before her death and only weeks before Modi's own demise.

Modigliani biographer William Fifield printed the English translation of the letter, which first appeared, presumably in Simone's handwriting, in Jeanne Modigliani's book *Man and Myth*, published in 1958.[9] There is no explanation of its provenance, nor why Amedeo would have kept the letter, especially as he had been living with another woman (Jeanne Hébuterne). Nor do we know why Simone would have written the letter at that particularly inopportune time in Modigliani's life – he died three weeks later. The letter from her is a heart-wrenching plea for love and reconciliation. There is no evidence Modigliani ever responded, either by mail or in person. Simone writes:[10]

31 December, 207 Boulevard Raspail,

My very dear friend,

My tenderest thoughts go out to you on the occasion of this new year, which I hope will be a year of reconciliation for us. I put aside all sentimentality and ask a single thing which you will not refuse me for you are intelligent and not a coward – it is a reconciliation which will permit me to see you from time to time. I swear on the head of my son, who is everything to me, that I have no devious intention. No – but I have loved you so much, and so much suffered, that I beg this as a last supplication. I shall be strong, you know that. My material situation is such that I can earn my living, even generously. My health is bad; the pulmonary tuberculosis does its work. Ups – downs –

I cannot go on. I beg, simply, a little less hate from you – I beg that you look at me kindly – console me a little, I am too unhappy, and beg but a bit of affection which would do me such good.

I swear I have no hidden motive.

I have for you all the tenderness that I must have for you,

Simone Thiroux
207 Blvd. Raspail

At the beginning of January 1920, Modi would have also received the last letter he would ever read from his mother. Surprisingly, Eugénie Garsin does not mention Modi's health, nor does she speak of Jeanne or her granddaughter, Giovanna, by name. She says nothing about Jeanne's pregnancy and never alludes to the upcoming birth of her son's second child. Instead, she employs a very formal and polite "you and yours" to address Modi's loved ones:

December, 27, 1919

I hope, my very dear Dedo, that this will arrive in time for the first morning of the New Year, as if it was a hearty kiss from your old Mama, bringing you all the blessings and good wishes possible. If telepathy is any good you will feel me near you and yours.
A thousand kisses, Maman."[11]

We can only surmise that Modi had not told his mother about his deteriorating health, of Simone's insistence he was the father of her child, or of Jeanne's second pregnancy. Yet, despite his talents for denial and his tendency toward introspection, any increasing severity of his illness since August must have alarmed him, and the prospect of having a young wife and fathering her two children must have weighed heavily on the artist. Friends said he often coughed violently and sometimes spat up blood. Aware of Modi's history of tuberculosis, Zborowski and Lunia urged him to return to Southern France where he could rest and take advantage of the warm Mediterranean weather. At the least, he could spend time in a sanatorium, they said, but Amedeo angrily refused.[12]

Instead, he probably relied even more on alcohol to relieve his symptoms and existential angst. One of his last sitters, a young Swedish woman named Thora Klinckowström, describes Modi's apartment; "A large table with his painting stuff, a glass, a bottle of rum was the whole environment, plus two chairs, some canvases, and an easel. He drank often and easily – against the cough, he declared, and he really did cough a lot."[13] Modi's behaviors became increasingly erratic.[14] One

evening, rowdy and argumentative, he was dragged "blind drunk" away from the brasserie, La Closerie des Lilas, shouting, *"leave me alone, I'm all right,"* whenever someone wanted to help him or suggested he seek medical attention.[15] Another time, Modi and his Italian friends left one of their drinking holes in Montparnasse to visit a draftsman named Benito, near the Rue d'Alésia. Modi was drenched from the rain, feverish, very drunk, and acting confused. Less than ten minutes from their destination and but a twenty-minute walk from La Rotonde, he stopped at what is now La Place Denfert-Rochereau, formerly known as the Place d'Enfer – the Place of Hell. Standing before the Lion de Belfort, a gigantic monument covered in copper plate, Modi muttered to himself and cursed the statue as if it were alive.[16]

The acute exacerbation of many chronic illnesses, especially respiratory diseases, and their complications can quickly turn a person's health from seemingly stable though worrisome to critical and life-threatening. The possibility of paranoid hallucinatory psychosis suggested in the anecdotes provided by Modi's friends is equally disturbing and could have had its origins in Modi's alcohol abuse, or signaled the onset of neurological infections such as meningitis or encephalitis.[17] Maria Wassilieff remembered seeing Modi only weeks before his death: "I couldn't believe the change in him," she noted. "He had lost all his teeth; his hair was flat, straight, he had lost all his beauty. *'Je suis foutu* – I'm done for, Marie,' he said."[18, 19]

One rainy evening Modi joked that he wanted to go up to La Butte, the hill in Montmartre, for what he called an altitude cure.[20] He found the painter, Suzanne Valadon, and her lover, André Utter, in a restaurant there. Valadon's son was Modi's friend, the painter Maurice Utrillo, who was institutionalized at the time. Modi was sullen, looking haggard and drunk. After a while, he began to chant in Hebrew, possibly the Kaddish, and finished the night sobbing on 55-year-old Valadon's shoulder.[21, 22, 23]

When Modigliani took to his bed a few days later, he was already deathly ill.

§

CHAPTER 34

───◆───

ANYONE MIGHT HAVE A SECRET LIFE

"... it's rare nowadays to find a man who has reached forty without either the syph or the legion of honor!"

André Gide[1]

Among many potentially myth-making stories about Modigliani are those in which he is portrayed as a prototypical Casanova.[2, 3] He spent some of his youth visiting brothels in Italy, drawing – and probably engaged like many men of his age, time and social circumstances, in leisurely sexual activities with prostitutes. According to his friends later in Montmartre and Montparnasse, he was naturally seductive and reportedly had love affairs with many women during his lifetime.[4] Regardless of the degree of promiscuity, such behaviors would have increased his risk for acquiring sexually transmitted infections (STIs), including syphilis and gonorrhea. The first spreads from person to person through contact with a syphilitic sore, known as a chancre in, on, or around the penis, vagina, anus, rectum, mouth, or lips (although it may also be transmitted *in utero* transplacentally). The average time from initial exposure to symptoms is three weeks (range approximately 10-90 days). The first signs of gonorrhea, however, usually appear within a few days after sexual contact, although not everyone may have symptoms. These include painful and frequent urination usually accompanied by urethral discharge and sometimes, lower abdominal pain. The illness used

to be called "the clap," from the French word for a rabbit cage – *clapier*, which in slang signified a brothel.

Not surprisingly, Modi's friends, acquaintances, and biographers avoid mentioning the possibility of his ever having a venereal disease, even as they exclaim the number of his sexual adventures. If there is any truth about the artist's womanizing, however, the possibility he acquired an STI is real, though it is unlikely he would have divulged this to anyone. Venereal diseases such as gonorrhea and syphilis were known in early twentieth century Paris as *maladies honteuses* – shameful illnesses. Besides, for a young man like Modigliani, suffering from tuberculosis was terrible enough.

The cafés, dance halls, and brasseries of Paris in the early 1900s were establishments where owners still closed their eyes on often openly flirtatious women who enticed potential clients to consume alcoholic beverages. Their clandestine sexual commerce was the subject of artists such as Edouard Manet, Degas, Henri Gervex, Renoir, and Giovani Boldini since the 1870s.[5] As the population grew in the French capital, so had the number of working-class men, artists, writers, and new bourgeois with sexual needs. Activity in brothels and brasseries was regulated, but illegal street-walking and sex behind closed doors, in small rooms attached to or built above various eateries and dance halls, and in private apartments were not easily prevented. Since the nineteenth century, solicitation, although prohibited, also occurred along tree-covered walkways, on bridges, in dimly-lit parks, public urinals, and in the shadows of arcades surrounding the city's famous open spaces.[6] The Champs-Elysées, the Bois de Boulogne, the Tuileries, the arcades of Palais Royal, and even the grand boulevards designed by nineteenth-century urban planners for an aspiring elite were a stage for discreet displays of affection and illicit sexual pleasures.[7] The profusion of *demimondaines*, or high-class prostitutes, according to Alain Corbin, was indicative of changing values and sexual demands whereby "the erotic was gaining ground over the genital."[8] A move towards increasing libertinism, particularly in artists' circles, also prompted promiscuity, and many single women behaved like men, choosing to change partners frequently.

Many French politicians and medical professionals believed sexually transmitted infections were signs of a depraved society. These illnesses were known to be a significant cause of personal suffering, as well as child mortality and infertility. Their prevalence troubled members of the pronatalist movement since the Franco-Prussian War. They argued that a healthy, well-populated army of young men was necessary to face future military aggression from Germany.[9, 10] With questions of public health and morality deeply connected, and with typical discrimination toward marginalized populations, some government authorities claimed that insalubrious housing in the poorer districts predisposed to sexual promiscuity. Other misogynistic leaders whispered that women's desire for upward social mobility, rather than insufficient social welfare programs to assist the impoverished, contributed to the rise in prostitution.

In France and elsewhere, women, and more particularly, female prostitutes, were almost always blamed for venereal diseases. Differences in perception regarding socially acceptable behaviors for men, however, were passed along from generation to generation, usually establishing a veritable double standard regarding concerns of morality. Gonorrhea was sometimes seen as a badge of honor for young males entering adulthood, while the shame and fear associated with syphilis, also called the "Great Pox," prevented men from sharing stories of their infidelities with their wives or girlfriends, which contributed to the spread of infection. Men who had sex with men were particularly frowned upon.[11]

Venereal disease became so prevalent in French society that it engendered a group of medical specialists called syphilologists. Encouraged by Dr. Alfred Fournier (1832-1914), who, in 1901, founded the Societé Française de Prophylaxie Sanitaire et Morale, physicians launched a public crusade against syphilis,[12] also called the third plague, the grey creeping death, and the scourge of humanity because its rotting, pustular rash was associated with almost every symptom known to man. "Know syphilis in all its manifestations and relations, and all other things clinical will be added unto you," Sir William Osler told the New York Academy of Medicine in 1897.[13] The disease was

endemic in Europe since the 1490s, and studies showed an estimated fifteen percent of the population harbored the disease by the end of the nineteenth century.[14, 15]

In 1905, the year before Modigliani arrived in Paris, German biologists Fritz Schaudinn and Erich Hoffmann identified the cause for syphilis to be a spirochaete, a transparent, corkscrew-shaped protozoon with thin flagella capable of self-propulsion.[16] It was called *Treponema pallidum* because of its twisted pale appearance.[17, 18] Easily transmissible during sex (and blood transfusions), or passed from an infected mother to her child during pregnancy or childbirth, the condition was, and still is, a source of painful symptoms and irreparable shame. Before antibiotics, sexual abstinence was the only alternative to infecting others and condemning them to a lifetime of misery. Still today, it is estimated that 30-60% of sexual contacts of individuals with early syphilis will acquire syphilis themselves.[19]

"Eros and Thanatos fiendishly reunited," wrote Claude Quetel in his history of a disease.[20] Its name comes from a poem called "*Syphilis, sive morbus Gallicus* (*trans.* syphilis or the French disease), a work in rhyme by Italian physician Girolamo Fracastoro in 1530, the same man who declared that phthisis was contagious. The poem tells the story of a shepherd named Syphilus who blamed the sun God for a drought that killed his flock. In retaliation for the insult, the God sent down a plague, and Syphilus was its first victim.[21]

The disease has four stages. Primary syphilis starts about three weeks after the initial infection. It is marked by a usually painless and well-circumscribed genital ulcer (called a chancre) that heals, leaving a crust but no scar. Up to six months after the primary lesion heals, a secondary stage is marked by fever, headaches, a sore throat, mucocutaneous lesions (including large wart-like greyish-white skin lesions called condylomata), painless swollen lymph glands, patchy hair loss, and sometimes a reddish-brown rash that covers the body, including the hands and feet. During this stage, spirochetemia is highest (spirochetes in the bloodstream and tissue). Progressive inflammation marked by fatigue, gastroenteritis, joint aches, and various other symptoms indicates that syphilis is a systemic infection of many organs.[22] *Treponema*

pallidum may invade the central nervous system in as many as forty percent of untreated individuals, where it may cause neurologic complications many years later.[23]

Symptoms of secondary syphilis usually resolve spontaneously within a few weeks (after which serology tests can remain positive), signaling a latent (hidden) stage that is divided into early (the first year) and later (more than one year after infection) periods. Latent syphilis can last for years. It includes symptomatic and asymptomatic infections of less than two years' duration and infection that may have been acquired more than two years prior to diagnosis (as well as all cases of tertiary syphilis).[24] Most untreated patients stay in this secondary stage for the rest of their lives, during which the disease is inactive yet still transmissible.[25, 26]

Before the discovery of effective antibiotics, approximately one-third of those infected with syphilis progressed to tertiary disease, usually ten to thirty years after initial infection. Also called late symptomatic syphilis, this stage is marked by one or more of three syndromes; destructive tumors called gummas, cardiovascular disease, and late neurosyphilis, but the bones, liver, and other organs are also affected.[27] During this third stage, transmission by sexual contact probably does not occur.[28] Tertiary neurologic involvement may lead to paresis and paralysis, neurasthenia, gait disturbances (Tabes dorsalis), meningitis, depression, and what became known as general paralysis of the insane.[29] In addition to neurologic symptoms, patients develop personality changes, shifting moods, or antisocial behavior.

Syphilis, therefore, was and still is called "The Great Imitator" because of the variety of ways it presents clinically.[30, 31] Neurosyphilis is particularly challenging because its diagnosis requires a careful assessment of the patient's physical signs and symptoms, a thorough medical history, and studies of cerebral spinal fluid (CSF). The term *neurosyphilis* applies to infection of the central nervous system, which can occur in any patient. The disease can be asymptomatic or self-limiting[32] and may present during any stage of infection. Symptoms can include ocular and vestibular disease, as well as strokes, seizures, meningitis (which may be transient or persistent), and meningovascular disease

from thrombosis and infarction of cerebral tissues. The incubation pe-
riod for meningovascular syphilis is usually six to twelve years.[33] Late
neurosyphilis includes general paralysis of the insane, dementia, and
Tabes Dorsalis from degeneration in the spinal cord.[34]

Like today, many patients with sexually transmitted illnesses were
secretive about their symptoms and histories of sexual exposures. For a
lucky few, the genital ulcer and a skin rash resolved and never returned.
In others, symptoms progressed, or the disease entered its latency phase.
Some individuals consulted quacks or refused to seek medical attention
until signs of advanced disease were present because they knew doctors
would advise against marriage or recommend abstinence from sexual
activity. Patients also refrained from saying where, when, or how they
became infected. Diagnoses were all the more difficult because doc-
tors were obliged to respect patient confidentiality. For example, they
could not inform a woman that her male spouse was infected, even if
that meant she might become ill and possibly die, or if infected, her
newborn infant might have physical deformities or premature death.
Doctors were also placed in a difficult position when patients refused
permission to reveal their diagnosis to prospective spouses and rela-
tions.[35] To complicate matters, some physicians inclined to practice a
misguided form of paternalism refrained from providing a diagnosis or
educating patients about their disease in order to protect them from
sentiments of depression or hopelessness. Similar practices occur today
when doctors intending to "do no harm" unilaterally choose to abstain
from sharing the truth about a diagnosis or prognosis.[36]

In 1907, August von Wassermann developed a blood test for de-
tecting syphilis in its early stages, but the illness remained incurable.
Treatment with arsenic, guaiac wood, potassium iodide, or intercourse
with a virgin was no longer recommended. Mercury iodide and mer-
curous chloride, also known as calomel, were used for a variety of skin
diseases, including syphilis, since the sixteenth century.[37] The adage, "A
night with Venus, and a lifetime with Mercury," was well known.[38] A
two-year regimen of the toxic metal was the norm, usually prescribed
as an ointment, liquid, vapor, and powder contained in a little blue pill.
Mercury causes hair loss, bleeding gums, migraines, intestinal bleeding,

neuropathies, kidney failure, foul breath, and blackened or loose teeth. The side effects were sometimes worse than some of the symptoms of syphilis itself.[39] In 1909, Salvarsan, also known as arsphenamine or compound 606, was discovered by a Japanese Professor, Sacachiro Hata, who worked with Dr. Paul Erlich (1854-1915), the same German chemist who demonstrated Mtb's acid-fast nature in 1882 and received the Nobel prize in 1908. Many of the initial symptoms of syphilis could now be controlled using this organic arsenic compound, but the expensive drug was not curative, needed to be administered by multiple injections for more than a year, and was associated with many side effects.[40] Four years later, in 1913, a Japanese bacteriologist, Hideo Noguchi, and his American colleague, J.W. Moore, discovered *Treponema pallidum* in the brains of patients who had died from general paralysis of the insane. This not only established a connection between insanity and syphilis but also confirmed that syphilis, like tuberculosis, was an *infectious* disease that could affect the central nervous system.

Paul Gauguin, Manet, Baudelaire, Oscar Wilde, Gustave Flaubert, Alphonse Daudet, and Guy de Maupassant had syphilis. The British poet John Keats, virtuoso violinist Paganini,[41] the philosophers Arthur Schopenhauer and Frederic Nietzsche,[42] and, it was widely rumored, Modigliani's literary hero Gabriele D'Annunzio did as well.[43] Without new revelations about Amedeo's medical history, however, there is no way to know whether he ever contracted a venereal disease or consulted doctors about suspicious symptoms (perhaps not coincidently, his friend and mentor Dr. Paul Alexandre was a dermatologist, a specialty whose practitioners were usually trained in Syphilology and other sexually transmitted disorders).[44]

In the early twentieth century, free clinics cared mostly for the poor, and there was virtually no privacy. Medical rounds in hospitals were carried out in full view by groups of doctors, nurses, and medical students to enhance clinical efficiency and medical training. In many instances, even genital exams were performed in front of others. More affluent patients saw physicians in the privacy of their homes, but before 1910 and the availability of Salvarsan, treatments for syphilis were expensive, painful, ineffective, and usually abandoned as soon as

troubling symptoms resolved.* By the time of the First World War, new specialty clinics called dispensaries (services annexes) were established to provide free and relatively confidential health care, which included intravenous injections of Salvarson for civilians and military personnel who could not afford frequent trips to a private physician.[45] At least three member hospitals of the Assistance Publique de Paris (Broca, Cochin, and Saint-Louis Hospitals) dedicated most of their activity to patients with syphilis and other sexually transmitted illnesses.[46] Professor Gaucher at the Hôpital Saint-Louis noticed an alarming increase in the number of patients with syphilis in his department, a rise from ten percent to sixteen percent of his patients overall, representing an increase of more than thirty percent since prewar numbers for soldiers hospitalized with the disease.[47]

As numbers of syphilitics also soared among civilians, an army of public hygiene officials did their best to combat high-risk sexual behaviors. Doctors emphasizing personal hygiene and safe-sex practices replaced police officers in the surveillance of prostitutes.[48] Rubber pessaries inserted into the woman's vagina to block the os (the entrance to the uterus) had long replaced sponges soaked in vinegar and other dangerous and ineffective methods of contraception, but these were useless at preventing the spread of venereal diseases.[49] With typical misogyny, however, blame and shame for sexually transmitted illnesses shifted from men to women. Posters warned against the dangers of courting *les filles publiques* (*trans.* public girls), also referred to both affectionately and derisively as lorettes, cocottes, grisettes, les grandes horizontales, courtesans, putains, and nanas depending on their social status and particular relationships with men.

Politicians tried to regulate prostitution by initiating mandatory health exams for women working the streets or in the brasseries and brothels. For soldiers engaging in sexual activity, post-coital chemical prophylaxis by intra-urethral antiseptic solutions such as potassium permanganate or silver nitrate, usually within three hours of intercourse,

*Despite our current era of antibiotic resistance, syphilis remains susceptible to penicillin.

was mandated by armies in an attempt to prevent venereal diseases.[50] Condoms, which were known since ancient times became more accessible (sheaths made of linen, fish, or animal intestines were used for centuries to cover the penile shaft and glans penis before the discovery of high-tensile strength latex rubber in the 1920s).[51] Although vulcanized rubber made them durable and reusable, these "prophylactics" were unpopular because wearing them was impractical and uncomfortable. American troops, however, were often denied condoms because officers felt they encouraged sexual relationships.[52] Military leaders also relied on education to dissuade troops from sexual encounters using slogans such as "A German bullet is safer than a whore."[53] Pamphlets and posters represented women as evil, even when the U.S. War Department found that thirteen percent of men drafted were already infected with syphilis or gonorrhea.[54] In Canada, it became a crime for women with venereal disease to infect, invite, or solicit sex with soldiers.[55] In France, prostitution remained legal, but brothels were outlawed in 1946, and paying for sex was made illegal in 2016.

In 1910, a study from Germany showed that among 98.9% of university males who had sexual relations before marriage, 40.5% had their first sexual experience with a professional prostitute and 54.5% with a "secret" prostitute.[56] By no means does this suggest similar behaviors in Italy or France or that Modi, in his youth, ever paid for sex, but if there is any truth to the number of Amedeo's sexual adventures, his chronically poor health, disappearing for days at a time, and his developing personality changes, mood swings, confusion, delusions, headaches, losing his teeth, gait disturbances (stumbling about), irritability (a frequent consequence of mercury poisoning), and meningitis at the end of his life, then the possibility of sexual transmitted illnesses and syphilis, the STI known as the great imitator, must at least be taken under consideration.

§

CHAPTER 35

―――•――

JUST ONE MORE FOR THE ROAD

"My devil had been long caged, he came out roaring."

Dr. Henry Jekyll (R.L. Stevenson)[1]

In a biography published almost forty years after her father's death, Jeanne Modigliani signaled that Modi's friends were inclined to "throw a bright halo around the days of their youth."[2] Stories of Modi's sexual adventures may have been grossly exaggerated, but dozens of purported eyewitness accounts of drunkenness permeate the Modigliani narrative. They fueled the legend he was a forlorn and often argumentative alcoholic embattled between the positive stimulus of his creative genius and the destructive allures of substance abuse. Even if the veracity of some stories can be questioned, there is ample indication that Amedeo had a long-lasting emotional and physical connection to alcohol while producing an amazing body of work and living in the shadow of life-threatening illness.

Drinking alcohol (ethanol) is the source of behavioral changes, clinical symptoms, anatomopathologic alterations, and adverse effects. These can be accompanied by cycles of impulsivity and compulsivity, and are sometimes associated with binges (i.e., episodes of daily drinking or intermittent bouts of heavy drinking), and denial (conscious and subconscious) of one's personal connection to

alcohol.* Whereas it is difficult to judge whether Modi's drinking consistently impaired his physical and psychosocial well-being or whether it had an effect on his art, his behaviors illustrate many signs and symptoms of what is now referred to as Alcohol Use Disorder (AUD), a term used by health care professionals and addiction specialists to describe individuals with a problematic use of alcohol (Appendix B – Alcoholism and Alcohol Use Disorder).[3]

AUD does not distinguish between socioeconomic class, level of education, culture, or profession. Some people's lives are significantly perturbed by their alcohol consumption. Others are *high functioning*.[4] The world is replete with individuals who succeed professionally despite drinking abundantly, and there are many examples of celebrities who have gone on record as having struggled with and overcome their alcohol use disorder.

Testifying in a victorious defamation trial against former partner Amber Heard, the actor Johnny Depp was asked if he would sometimes drink whisky in the morning. "Isn't happy hour anytime?" he answered, eliciting laughter in the courtroom.[5] Throughout the ages, drinking has been a source of conviviality, an affordable and popular socially accepted public activity expressed even in the French word for a gratuity – *pourboire* (from pour boire – for drinking).[6] In Modigliani's day, wine was considered "good for one's health and good for the nation," and the (ethyl) alcohol of distilled spirits was called "eaux-de-vie," from the Latin, Aqua vitae – water of life.[7, 8] As doctors argued about differences between drinkers (*buveurs*), drunkards (*ivrognes*), and alcoholic degenerates or lunatics with and without overt signs of mental illness, the public drank to add spark to their social gatherings, drown their miseries, celebrate their joys, or explore what they felt was the pure essence of their lives.[9]

In 1902, Harvard psychologist William James wrote about the mysticism of intoxication in *The Varieties of Religious Experience*; "The

*Today, self-recognition through the admission of having a problem with drinking is a transformative first step in Twelve-Step Recovery Programs, including Alcoholics Anonymous.

sway of alcohol over mankind is unquestionably due to its power to stimulate the mystical faculties of human nature, usually crushed to earth by the cold facts and dry criticisms of the sober hour."[10] Ten years later, Guillaume Apollinaire published *Alcools*, with its many puns and a wink to one of Modigliani's literary heroes, the poet Charles Baudelaire, who struggled with drugs and alcohol before dying from complications of neurosyphilis in 1867.[11] Baudelaire believed that beauty was not found within a subject, but in the quality brought to it through the vision of the subject's observer.[12] In a series of interrelated poems titled "Le Vin" – Wine, he metaphorically associated the drink with creativity and the Divine, also portraying alcohol as an evil influence conducive to debauchery and despair.[13] Baudelaire also wrote *Enivrez-vous* – Be Drunk; "You must be drunk always. That is everything: the only question. Not to feel the horrible burden of Time that crushes your shoulders and bends you earthward, you must be drunk without respite."[14]

Alcoholism was not yet considered an addictive disorder, and there was no sense that alcoholics drank because they could not help themselves, drank against their own wishes, or drank because of an emotional and ultimately physical tie to alcohol.[15, 16] We may never know the true extent of Modigliani's use of the intoxicating substance, but rather than mythologize his "alcohol addiction" or deny its existence as nothing more than legend-making and fabrication, we can acknowledge that Amedeo's friends and acquaintances provided us with a glimpse into his alcohol use disorder (AUD) and consequently, shed light on a life that Modi's friend, Jacques Lipchitz, graciously described as a "brief flash of brilliance."[17]

Amedeo Modigliani probably began drinking as an emerging adult, similar perhaps to almost nine million people between the ages of twenty-one and twenty-five in the United States who, in 2016, reported at least one recent episode of binge drinking that year (a binge was defined as 4+ drinks for females and 5+ drinks for males).[18] Although alcohol is barely mentioned during Modi's younger years, we learn from painter Curt Stoermer, that in 1909 Modigliani "loved the state of drunkenness. His laugh was like a fire that sparks off a blaze…

Modigliani drank simply for the hell of it. He despised sentimentality. Inebriation sharpened his concentration and the clarity in his Roman head."[19] He was frequently seen with Maurice Utrillo, who "could turn up drunk anywhere."[20] Speaking of Picasso's view of the two painters, Francis Carco said, "That Utrillo or Modigliani were drunk for the most part did not exasperate him [Picasso], but it did annoy him that they took advantage of their drunkenness to escape his control."[21]

In 1911, Anna Akhmatova found him to be a changed man "whose spirit had darkened and who had let himself go."[22] During those years, Modi lived in a variety of ramshackle studios. He was far from his attentive mother and without a paternal figure other than Dr. Paul Alexandre, only a few years his senior. He may have courted young women and models, but was not in a stable, mutually caring relationship. He could have been intermittently ill and angry about life and the cards he was unjustly dealt, or suffered from post-traumatic stress disorder linked to his near-death experiences as a child, his chronic health condition, and the knowledge he harbored a potentially and probably fatal disease.[23, 24] He may also have had low self-esteem: just because someone is talented does not mean they are gifted with an abundance of self-belief.

Alone and unbridled, Modi may have fallen into a trap not dissimilar to that experienced by many today, drinking during the lulls between creative productivity, or socializing within a pro-drinking environment while feeling engulfed by emotional, psychological, and financial pressures. The critic Adolphe Basler, was far from apologetic in his recollections of Modi's behaviors. "He had moved from the Rue Falguière to a tiny studio on the Boulevard Raspail. The austerity of these lodgings was pitiful…In the yard he worked away at his stone sculptures, but one encountered him increasingly rarely in a sober condition…He was the scourge of the bistros. His friends, used to his excesses, forgave him, but the landlords and waiters, who hailed from a different social stratum…treated him like a common drunk."[25]

The Italian writer Ardengo Soffici recalled seeing him in June, 1914; "…his words were incoherent and full of misery…He was drunk, of course, as on most days at this period, I was told."[26] The muralist, Carlo

Carrà, remembered seeing Modi that same year; "I was particularly struck by the deterioration of his physical condition," he said. "His eyes were ablaze, his mouth set in a bitter twist. Untreated tuberculosis and alcohol abuse had ravaged his face."[27] As the Great War loomed on the horizon, it seems Modi fostered what could be described as an unhealthy relationship with alcohol. If initially he was only inclined to binges, this relationship may have evolved and become characterized by denial, escalation, and an associated desire for secrecy regarding his other health problems. He may have felt the need to continue drinking or turn to other mood-altering substances in order to avoid the troubling symptoms of withdrawal.

Charles Beadle and Douglas Goldring said "Hashish helped Modigliani conceive extraordinary combinations of color… sometimes he even mixed hashish and cocaine, reinforcing their effects with alcohol, and then he became impossibly quarrelsome."[28] Moving between Montmartre and Montparnasse, Modi spent hours in cafés and brasseries, and was known to disappear for days on end. He was also a nocturnal character who loved to party and thrived on occasional disinhibited theatrics. Nina Hamnett described several of his public escapades in her book *Laughing Torso*, compassionately adding that "owing to the fact that he had T.B. and also drank a lot, and therefore had hangovers, I expect Modi had some pretty miserable moments."[29, 30]

Modi found a temporary drinking partner in his lover and second muse, Beatrice Hastings.[31] In addition to being called "an authentic great English poet," by Max Jacob, Béa had the reputation of being particularly fond of whisky.[32] Her friend Katherine Mansfield scolded her for excessive drinking, and André Salmon described her as becoming "so drunk that she believed the rat that lived in her studio glowed in the dark."[33] In one letter, Mansfield said Beatrice told her that – "it's no good me having a crowd of people – If there are more than four I go to the cupboard & nip cognacs until it's all over for me, my dear –."[34]

Hastings herself recalled that Modi "used to come home [drunk] and break the windows to get in…and… there would be 'a great scene'."[35] She idealized her two-year relationship with him in her surrealist text *Minnie Pinnikin*. "It was true he was really beautiful…The

✗ Alcohol helped him to "see his work"

sun that danced in his hair leaned forward to look into his eyes."[36] She also noted Modi was "slight, somewhat fragile, and extremely reserved until he was drunk." These too were times when Béa and Amedeo were prone to domestic violence.[37]

Ilya Ehrenburg's memories of Amedeo illustrate how alcohol can render someone almost unrecognizable; "I have seen him on bad days and on brighter ones. I have seen him calm, extremely courteous, clean-shaven, with a pale face that had just a touch of coarseness about it, and gentle, friendly eyes. I have seen him frantic, with black bristles sprouting all over his face: this Modigliani screamed piercingly, like a bird…"[38] Béa would tell him, "Modigliani, don't forget that you're a gentleman. Your mother is a lady of the highest social standing."[39]

According to Charles Beadle, there was a time when "streetsweepers once picked Modigliani bent double and dead-drunk, off a dust heap."[40]

In 1916, Lunia Czechowska marveled at Modi's distinction, noting that he drew without ever correcting himself. "From time to time he would reach out for a bottle of brandy (vieux marc)," she remarked, "and I soon noticed the effect the alcohol had on him. He became excited. I no longer existed. All he saw was his work."[41]

That same year, when Jacques Lipchitz commissioned a painting, Modigliani said, "My price is ten francs and a little alcohol, you know."[42]

After Modi left for Southern France in 1917, he probably stopped drinking, at least for a while. He indulged in a healthy respite with friends and a blissful relationship with his pregnant girlfriend, Jeanne Hébuterne for several months in Cagnes-sur-Mer.[43] Periods of abstinence are not always durable without considerable support, however, and according to Blaise Cendrars, "At Cagnes, Modigliani became weak for lack of alcohol, and fractious."[44] Later, Modi stayed in Nice with his friend, the Russian-born, Finnish painter Léopold Survage. According to Survage's wife, he and Modi "drank enormously" together.[45]

Biographer Meryle Secrest suggested that Modigliani feigned an addiction he did not have and cultivated a legend of drug and alcohol abuse to cover his increasingly troublesome symptoms of tuberculosis.

if this is the case, what are all these accounts of his drunken behavior?

"Here was no shambling drunk but a man on a desperate mission… It must have been a courageous and lonely masquerade."[46] In the early 1900s, however, drinking excessively was still considered evidence of a person's antisocial and irrational nature, and those who sought help or found themselves jailed or hospitalized risked being removed from society for months at a time and placed in special asylums.[47] It was also viewed as a social poison, a "cowardice of character" linked to degenerationism as a cause for social ills.[48, 49, 50, 51] While Secrest's hypothesis is partly correct (by insisting that he drank only to relieve his cough, Modi preserved his aristocratic flair and self-esteem), it is also more than likely Modi succumbed to the allures of alcohol's mood-altering effects, even as he drank to help palliate troubling pulmonary symptoms.

In 1919, Amedeo resumed an active nightlife in Paris and renewed his friendships with fellow drinkers Charles-Albert Cingria, Abdul-Wahab, and Nils de Dardel. Cingria recalled that Amedeo was courteous and always a gentleman; "Certainly, he drank, and sometimes grew excited, but no more and no less than others at that time…I seldom saw him exceed the accepted amount for any civilized being, which is one liter per meal."*[, 52, 53] Maurice de Vlaminck recalled that during the last years of Modi's life, he was "continually in a state of febrile agitation. The least vexation would make him wildly excited."[54] Fifteen-year-old Pauline Jourdain modeled for Amedeo and sometimes saw him weaving back and forth as he walked the city's streets; "But in the studio Modigliani was never drunk, and he was never drunk in Zborowski's house. But he didn't know that I happened to see him drunk all the same," she said. "Then I would hide or change streets."[55]

Modi was burdened with the pressures of parenthood, needed to earn a living that could support his live-in younger girlfriend and child, and withstood the angst of dealing with his would-be mother-in-law who opposed his relationship with her daughter. He struggled to find satisfactory models and hustled to honor his contract with his dealer

*One liter (1000 ml). A bottle of wine is 750 ml (approximately 25 ounces).

Léopold Zborowski, all while remaining creative and faithful to his artistic vision. Traumas resulting from the war, the effects of his turbulent love life on his psyche, the neurobiological consequences of drinking, and a steady stream of friend-enablers, in addition to the way he burned life's candle at both ends and needed to relieve or camouflage the nagging symptoms of pulmonary tuberculosis readily sustained the artist's penchant for booze.[56] Many years after Modigliani's death, Moïse Kisling remembered, "If you have two thousand francs a month and spend nineteen hundred on alcohol, you must expect to live in misery. Modi never knew when to stop."[57]

§

[Handwritten marginal notes:]

Henri not doc. price of his [?] assessment → he styles it was not a cover-up / pretense but a means to deal w/ physical symptoms of his disease.

alcoholism was not actual alcoholism but a pretend to cover up his sickness; what about all these accounts of his heavy drinking & erratic behavior? Were they merely constructed? But why?

CHAPTER 36

MEETING WITH THE INEVITABLE

"All days travel toward death, the last one reaches it."

Michel de Montaigne[1]

Descriptions of Amedeo's last days are anecdotal and sometimes contradictory. It appears that on January 14, 1920, Modi was cloistered in his room, physically weak, and not eating. "I have only a little piece of brain left," he muttered to Ortiz de Zárate, the man responsible for urging Modi to move from Italy to Paris in 1906.[2] Shivering, coughing, and with his mind in a fog, Amedeo huddled under blankets usually used to fight the cold and damp Parisian winter. He presumably suffered from severe kidney pains his doctors mistook for nephritis, but he was not hospitalized and had refused to see a physician.[3]

The coal stove in the corner of the room needed fuel, sometimes arranged to be brought up the stairs by Ortiz de Zárate, who lived in the same building.[4] Zárate's seven-year-old daughter remembered her father wanting to bring Modi food as well because Jeanne could not go to the market. Zborowski's young assistant, Paulette Jourdain, described Jeanne's general demeanor at the time; "For two or three days perhaps Jeanne simply sat there. She was incapable of doing anything – always was incapable, disequilibrated, morbid – never *did* anything."[5] Zárate's wife disapproved of Modigliani's lifestyle. Still, she cooked a few meals,

including a pôt-au-feu that her husband brought him.[6, 7] Leaving Modi and Jeanne to tend to themselves, Ortiz de Zárate left for several days. Léopold Zborowski, who also had looked in on Modigliani, became ill with influenza and could no longer visit. His partner, Hanka, came instead.[8, 9]

When Zárate returned, he noted that Modi's bedsheets were stained with oil from opened sardine cans, and the floor was littered with empty liquor bottles.[10] "I sent the concierge up with some soup..." he recalled many years later, "and I phoned for a doctor in whom I had confidence. . . After one look at the sick man, he [the doctor] said: Get him to the hospital at once."[11, 12] During this whole time, Jeanne was mostly silent and helpless. Strangely, we know nothing of her thoughts, actions, or feelings, although, in at least one account, she ran to Zborowski to say that Modi had become worse.[13] A doctor was summoned, but Modi's health did not improve.

A note from Zborowski to Amedeo's brother Emanuele is dated seven days after Modi's death and four days after his burial in the Père Lachaise cemetery. This extract from the letter tells a similar yet different story:[14]

January 31, 1920

Dear Modigliani,

Today Amedeo, my dearest friend, rests in the cemetery of Père Lachaise, covered with flowers, according to your wish and ours. The world of young artists made this a moving and triumphant funeral for our dear friend and the most gifted artist of our time.

A month ago, Amedeo badly wanted to leave for Italy with his wife and child. He awaited only the birth of his second child whom he wanted to leave in France with the nurse who is now taking care of little Jeanne.

His health, which was always delicate, became worse at that time. He paid no attention to our advice that he go to a sanitorium in Switzerland. If I would say to him, "Your health is bad, go and take care

of yourself," he would treat me as an enemy and would answer, "Don't give me lectures." He was a son of the stars for whom reality did not exist.

"Nothing led us to believe that the catastrophe was so near. He had appetite, he walked, and he was in good spirits. He never complained of anything. Ten days before his death, he had to go to bed, and he suddenly began to have great pain in his kidneys. The doctor said it was nephritis (before then he never wanted to see a doctor). He used to suffer from kidney pains, saying they would leave him quickly. The doctor came every day. The sixth day of his illness I became sick and my wife went to visit him in the morning. Upon her return I learned that Modigliani was spitting blood. We hurried to find the doctor who said that he had to be taken to a hospital but that it would be necessary to wait two days for the bleeding to stop. Two days later he was taken to the hospital; he was already unconscious. His friends and I did everything possible. We called several doctors but tubercular meningitis began to set in; it had been weakening him for a long time without the doctor recognizing it. Modigliani was lost. Two days later, Saturday evening at 8:50, your brother died – unconscious and without suffering."

The letter is replete with accusations of medical incompetence, which is unlikely considering the frequency with which physicians would have seen patients with similar symptoms. Regardless, Modi's diagnosis and cause of death could only have been confirmed by a battery of laboratory tests, precise radiographic imaging studies, and an autopsy, none of which were performed.[15] Aside from Modi's alcohol use disorder, history of pulmonary tuberculosis, chronic cough, witnessed hemoptysis, and changes in mental status, we do not know precisely what ailed Amedeo. He certainly may have had more than one illness, and considering the progression of his symptoms, his chance for survival without recourse to modern medical therapeutics was probably nil.

The original letter (in French) states Modi had 'mal aux reins,' from which he suffered regularly but which usually subsided spontaneously.[16] Mal aux reins is literally translated in English to mean pain

in the kidneys, and the doctor thought he had nephritis. However, 'nephritis' is an inflammatory condition often accompanied by blood or protein in the urine, physical signs such as swelling (edema) and high blood pressure, or other symptoms suggestive of an autoimmune disease. There is no documentary evidence of these in Modi's medical narrative related by friends and colleagues. Nephritis and *mal aux reins* could also misrepresent acute or sudden urinary tract infections or might have been used as a safe word to describe pain related to prostatitis, gonorrhea, and other sexually transmitted diseases. Modi was certainly at-risk for these disorders because of his sexually promiscuous activities during an era when the only safe-sex alternative was abstinence. Finally, it is possible that "mal aux reins" simply meant that Modigliani had lumbar strain; the words are frequently used in French to describe low back pain and should not be translated literally.

Whether Modi's hemoptysis – coughing up blood, was caused by chronic inflammatory changes from tuberculosis rather than local reactivation of his pulmonary disease, evolving pulmonary lesions, or potential contagiousness remains a mystery. Many individuals with tuberculosis and chronic cough have bronchiectasis, a dilation of the bronchial airways, which can both cause and be caused by chronic infections. Some patients with bronchiectasis cough up significant amounts of phlegm. Still others have a dry cough that becomes more of a nuisance than anything else. Recent studies confirm that bronchiectasis is prevalent (2%-64%) in patients with a history of pulmonary tuberculosis, especially in developing countries without good access to modern therapies.[17]

Bronchiectasis is only one of many possible consequences of having pulmonary tuberculosis.[18] Modi's respiratory symptoms, including the expectoration of bloody sputum, may have been related to a wide range of other pathologies such as lung parenchymal destruction with cavities or fibrotic scarring, infectious fungal diseases such as pulmonary aspergillosis, pleural thickening with or without associated partial lung collapse (atelectasis), superimposed viral or bacterial infectious bronchitis and pneumonia, airway obstruction and decreased ventilatory lung function (breathing capacity), and pulmonary vascular diseases

including pulmonary hypertension (elevated pressures in the pulmonary arteries). Some of these disorders are exacerbated by smoking, and as we know from photographs, Modigliani, like many of his friends, smoked cigarettes.[19] It is also possible that Modi fell victim to one of many respiratory viruses that winter, which may have caused or contributed to his rapid deterioration: The lethal 1918-1919 pandemic caused by Avian Flu virus H1N1, called *The Spanish Flu,* extended into the 1920s, killing mostly young adults in their twenties and thirties.[20, 21]

In Modi's day, it was extremely challenging for physicians to alter the natural course of respiratory illnesses. Despite advances in clinical examination and chest radiography, there were no computed tomography scans to assist with diagnosis nor modern medical treatments such as inhaled bronchodilators to relieve wheezing or shortness of breath. There were no scientifically-proven effective pharmaceutical therapies for tuberculosis, and there were no other antimicrobials, except for Salvarsan, which had no place in treating tuberculosis (Salvarsan and neo-salvarsan were among the most frequently prescribed drugs in France until Penicillin was developed in the 1940s).[22] Glucocorticoids such as Prednisone were not produced yet either, so illnesses such as rheumatoid arthritis, the destructive and inflammatory autoimmune joint disease that struck Renoir, were thought to have an infectious cause, and the allergic versus non-allergic origins of asthma was not characterized by Harvard physician, Francis Rackemann until 1918.[23]

Other questions relate to the role of alcohol during Modi's last days, including whether he might have died from alcohol-related complications. If we believe the anecdotes, Amedeo suffered from symptoms of both alcohol intoxication and withdrawal. He had signs of cognitive decline, manifested by increasing confusion, paranoid ideation, and unawareness of his surroundings. According to stories told by future Argentine diplomat Vicomte de Lascano Tégui and described by Charles Douglas, Modi experienced alcoholic hallucinosis when he raged at the monument of the Lion de Belfort and, later, imagined he was on the departure wharf for some "wondrous country."[24]

Tégui also described Modi as having delirium tremens, but this was not corroborated, and the Vicomte was not a medical doctor.[25]

Amedeo certainly had several risk factors for developing DTs, including a history of sustained drinking, being over thirty years old, and harboring at least one concurrent illness, but there is no documented history of alcohol withdrawal-type seizures, and we do not know precisely when Modi may have had his last drink.[26] While I am not suggesting that Modi died from alcohol-induced illness, if there is any truth in Zborowski's letter that Amedeo lost consciousness by the time he was hospitalized, this potential complication of DTs must be added to other potential neurologic causes for the man's demise.

Today, delirium tremens has a mortality of fifteen percent. In Modi's day, before greater awareness of the diagnosis and the availability of pharmacologic treatments such as benzodiazepines, opioid antagonists, and other drugs for AUD, mortality would have been higher.[27] Amedeo's family and friends may not have wanted his doctors to be fully aware of his problems with alcohol. Nor would his doctors have witnessed the progression of his symptoms unless they'd had the luxury of long-term follow-up. Considering the stigma associated with excessive drinking and with knowledge of Modi's medical history of pulmonary tuberculosis, it was logical for them to have opted for a tuberculous rather than alcohol-related cause of his recent changes in mental status and rapid deterioration.

In his letter to Amedeo's older brother shortly after Modi's death, Léopold Zborowski says tuberculous meningitis was the reason for Modi's death. To my knowledge, however, none of Modi's biographers and art historians have produced a medical justification for this single diagnosis, nor copies of Modi's medical records and test results from his hospitalization. The public death registers located in the municipal archives of the City of Paris provide the date, location, and time of Modi's demise.[28] Pushing investigations further, I found that tuberculous meningitis was indeed declared as the cause of the artist's death, on an entry pertaining to *Amedeo Modigliani - profession artiste peintre* and dated January 24, 1920 in the Declarations of Deaths register (August 24, 1919 - December 12,1921) of the Archives of the Assistance Publique des Hôpitaux de Paris.[29] While this provides medical administrative evidence of a cause for Modi's demise, it does not

mean that tuberculous disease was the sole cause of Amedeo's death, or that he had not contracted other illnesses. In those times, it was highly uncommon for French doctors to maintain detailed written records of a patient's disease progression or deterioration. The practice of routinely documenting a patient's clinical course, including laboratory data, findings on physical examination, and results from procedures and imaging studies during hospitalization, for example, only commenced after the Second World War. Also, very few individual medical charts from public assistance hospitals in early 20th century Paris were preserved in their totality. When they were, it was usually to provide documentation for history of medicine purposes or because a physician published a paper about a particular patient's case. Regardless, if ever there were medical records describing Modi's illnesses, they could have been permanently lost when the Hôpital de la Charité, where Modigliani died, was demolished between 1935 and 1937 to make way for a new Faculté de Médecine in Paris's 6ieme arrondissement.

Zborowski's comment that Modi was walking, eating, and in good spirits only a few days earlier runs contrary to others' descriptions of a haggard, argumentative, and confused man stumbling around Montparnasse. We can assume that Jeanne and some of Modi's friends who were present at the hospital would have learned, or least suspected, that Modi had a history of pulmonary tuberculosis (he was seen coughing up blood). Hopefully, they would have said something about this upon his admission to the hospital or told doctors of his symptoms while they were tending to him before Amedeo's hospitalization. While we may never know whether Modi's symptoms were manifestations of drunkenness, complications of AUD, another disease, or the signs of tuberculosis affecting Modi's central nervous system, it seems natural, therefore, that considering the young man's neurologic symptoms, Modi's doctors would have presumed a diagnosis of tuberculous meningitis, even in the absence of confirmatory tests.

Meningitis is defined as the inflammation (usually caused by viral or bacterial infections) of the meninges, from the ancient Greek word for membrane, comprised of three layers surrounding and protecting the central nervous system and spinal cord surface: the dura mater,

the arachnoid mater, and the pia mater. The dura mater is a thick, outermost membrane attached to the skull. The innermost pia mater is a collection of connective tissue and blood vessels that envelopes the brain and its convolutions, while the subarachnoid space is filled with cerebrospinal fluid (CSF), major blood vessels and basal cisterns (compartments filled with CSF). The cerebrospinal fluid was described by Italian anatomist Maria Valsalva (1666-1723) but was not systematically studied until the work of Italian anatomist Domenico Cotugno (1736-1822)[30] and later, the French physician and anatomist François Magendie, who gave CSF its name in 1825.[31]

The CSF serves as a shock absorber, circulates nutrients and chemicals removed from the blood, and removes waste products from the brain. Tuberculous meningitis, which is usually a chronic infection of the meninges, is caused when tuberculosis bacteria invade the fluid surrounding the brain and spinal cord, often creating small abscesses called microtubercles. When these microtubules rupture into the brain, spinal substance, or subarachnoid space, they contaminate the CSF and provoke a severe inflammatory response.

Meningitis was and still is the most lethal form of tuberculosis. It is considered a medical emergency and can occur as the only manifestation of tuberculosis or concurrent with pulmonary or other sites of infection.[32] The first time for which the tuberculous origin of meningitis was diagnosed with certainty dates to the 1830s when Étienne Rufz de Lavison (1805-1884) published a series of ten autopsied cases in children of what was then known as dropsy of the ventricles; increased fluid in the ventricles of the brain, also referred to as hydrocephalus.* Rufz discovered tubercles in the meninges and other structures in the brains of all his patients, as well as tuberculous lesions in the lungs, establishing the connection between tuberculosis elsewhere in the body

* Rufz made this the subject of his doctoral thesis *Hydrocéphale Aiguë, Fiévre Cérébrale, Meningite, Meningo-Céphalite* defended on February 14, 1835. A member of the *Academie de Medecine* and Professor-Chair of Clinical Medicine at La Charité Hospital, Doctor Jean-Baptiste Bouillaud (1796-1891) presided over the jury. By a strange coincidence, Modigliani was given a diagnosis of tuberculous meningitis after his death in the common medical ward named after the famous professor, La Salle Bouillaud at the same La Charité Hospital.

and tuberculous meningitis.[33,] These findings were corroborated by others in the following years.[34]

From a clinical perspective, the diagnosis was suspected in the presence of what became known as a meningeal syndrome: headache, fever, and a stiff neck. The ability for a clinical diagnosis improved after Russian-Baltic neurologist Vladimir Kernig (1840-1917) and Polish pediatrician Jósef Brudziński (1874-1917) described specific maneuvers in 1882 and 1909 respectively that suggested meningeal inflammation based on physical examination.[35] A bacteriological diagnosis only became possible in 1891 after an English physician, Walter Essex Wynter, inserted a thin tube through an incision over the vertebrae to remove fluid and relieve pressure in the spinal canal of four patients he diagnosed with tubercular meningitis (they all died).[36] That same year, German physiologist, Heinrich Irenaeus Quincke, introduced the technique of lumbar puncture using a needle (similar to what is done today) to sample the cerebrospinal fluid.[37] Quincke was the first to analyze the CSF and measure its pressure using a manometer.[38] Robert Koch had identified the causative organism of tuberculosis in 1882, and by 1909, lumbar puncture was well-established as a diagnostic tool.[39] The procedure became more popular as instrumentation improved[40] and after Mestrezat's publication of his monograph in 1912 describing lumbar puncture and the composition of cerebrospinal fluid in different diseases, including tuberculous meningitis.[41]

This is especially important because the initial signs and symptoms of tuberculous meningitis are vague. Patients often display nonspecific symptoms, such as fatigue, irritability, and loss of appetite. Symptoms usually evolve for two to eight weeks before more obvious signs of infection, such as headaches, fever, vomiting, confusion, neck stiffness, or seizures develop. Diagnosis today is based on clinical presentation, medical history, results from cerebrospinal fluid examination, and results from neuroimaging studies.[42] Regardless of its origins, meningitis is a medical emergency that requires immediate and appropriate treatment to prevent complications and death (Appendix C – Tuberculous Meningitis).

Examining the likelihood of Modigliani's diagnosis, it is clear the description provided of Modi's clinical signs and symptoms are not

solely suggestive of tuberculous meningitis. All of the initial symptoms described by Modi's friends; his stumbling about, his fatigue, his lack of appetite, and even headache or fever are vague and nonspecific (Zborowski wrote that Modi was up and about and in good spirits only days before taking to his bed). Of course, Modi's hemoptysis was chronic and probably related to his tuberculosis, but it remains unclear whether the blood in his sputum was caused by reactivation disease, chronic tuberculosis-related changes in his lungs and airways, or triggered by an exacerbation of some other respiratory illness unrelated to pulmonary tuberculosis. Modi's subsequent symptoms of confusion, behavioral changes, loss of consciousness, and coma suggest a neurologic condition, most likely from a number of infectious causes, but some of his behaviors could also have been alcohol-related.

Further distinctions are impossible without an intake record of Modi's arrival at the hospital, but there are no medical records available that describe findings from the doctors' physical examination of their patient or provide insight as to their differential diagnosis. Nor was there an autopsy. While it is possible Amedeo had a lumbar puncture while still alive, there is no evidence of one, and none of Modi's friends describe the procedure in their narratives of his hospitalization. Considering that no effective medical therapies were available for tuberculous or other forms of infectious meningitis, Amedeo Modigliani's untimely death was inevitable.

§

CHAPTER 37

❧✦❧

ON MASKS AND OTHER THINGS

"I wish instead that my life were like a richly abundant river running joyfully over the earth."

Amedeo Modigliani (1901)[1]

On Friday, January 23, 1920, an unresponsive Amedeo Modigliani was directly admitted to the Hôpital de la Charité on nearby 47 Rue Jacob, in Saint Germain, not far from Montparnasse.[2] He was assigned to bed n° 27 in the vast medical ward of the Salle Bouillaud (matriculation n° 754), where he died on Saturday, January 24, at 8:45 pm, having never regained consciousness.[3] The cause of death – tuberculous meningitis – was noted on his death certificate dated January 25, which curiously also identifies him as married to Jeanne Hébuterne,[4] and was shared in a letter dated January 31, 1920, from Zborowski to Modi's brother Emanuele.[5]

As a memento for family and friends, Moïse Kisling, assisted by the astrologer Conrad Moricand, attempted to make a death mask. In this centuries-old act of defiance, they were not creating a relic to be used in Modi's funeral ritual as might have been done by the early Egyptians and Romans, but to honor the character, soul, and spirit of their deceased friend. Masks were particularly popular in the nineteenth century when postmortem portraits became a common genre of Euroamerican photography.[6] According to German art historian Ernst

Benkard, "Death masks command our utmost reverence, for the face is symbolic and perpetuates the final impression of a human spirit whom we once knew, or who had made his mark on all men's minds."[7]

Kisling's and Moricand's efforts were unsuccessful, and their plaster mold did not set solidly. They turned to Modi's friend, Jacques Lipchitz, for help. The sculptor repaired their plaster cast and cleaned it of hair and other tissues that tore from Modi's face at the time of the initial setting.[8] In 1926, an expert mask-maker, the German sculptor George Kolbe (1877-1947), wrote that it was essential that masks be made as soon as possible after a person's death to "perpetuate the moment of glorious consummation."[9, 10] Kisling never explained why his efforts to make Modi's mask had failed, nor shared his reasons for making one.

Lipchitz subsequently produced twelve plaster molds of the mask.[11] Bronze casts were also made, several of which found their way into private collections and museums.[12] In 1929, Man Ray photographed the mask, further highlighting the prominent cheekbones, downturned mouth, and hollow cheeks, which suggest Modi had perhaps lost some if not all of his teeth.

Kisling also collected money to help pay for Modi's funeral. Although biographers have not published photos of the procession, many friends, fellow artists, former models, and passers-by joined the funeral cortège in its eight-kilometer march from the hospital to the Père Lachaise cemetery. On Tuesday, January 27, Modi was laid to rest under a grey slab of cement not far from the Avenue Circulaire, in what is now the 96th division of the cemetery. Emanuele Modigliani handled most expenses, and a Rabbi officiated the burial ceremony. Dozens of attendees may have recalled these lines from *Alcools*, by Guillaume Apollinaire.

"And you drink this alcohol burning like your life,
Your life that you drink like eau-de-vie."[13]

The grief-stricken, almost nine-month-pregnant Jeanne Hébuterne was not at the funeral. According to Paulette Jourdain, she spent the

night of Modi's death alone at a nearby hotel.[14] Then, on Sunday, she went to her parent's home at 8 *bis* Rue Amyot, behind the Panthéon and a thirty-minute walk from her home at 8 rue de la Grande Chaumière. Sometime after midnight, the twenty-two-year-old flung her body from their fifth-floor window in what must have been a desperately intentional gesture of strife, revolt, despair, and revenge against a family that never supported her relationship with Modigliani, killing herself and her unborn child. According to municipal archives, death was declared at 3 a.m. Monday, January 26, after which she was transported to her apartment at la Grande Chaumière. The register identified her as being single.[15,*]

§

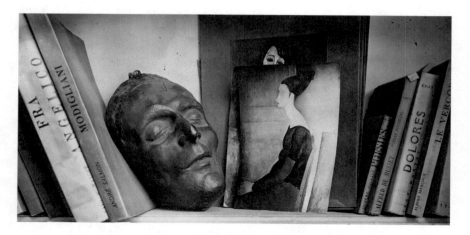

Moise Kisling's Studio with cast of Modigliani's death mask and print of Jeanne Hébuterne seated in profile (Digital image, Gelatin silver print).

* Jeanne was buried in Bagneux cemetery outside Paris, and moved to rest beside Modigliani in May, 1925. Giovanna Modigliani was officially adopted by Modi's sister Margherita and raised in Italy. She died in France on July 29, 1984.

EPILOGUE

Less than a year after his burial, Modi's work was exhibited at the Galerie Montaigne in Paris. A year after that, a retrospective including forty of his paintings and drawings was held at the Galerie Bernheim-Jeune, followed by several exhibitions during which prices for a "Modigliani" soared. As Modi's paintings escalated in value,[1] American collectors such as Dr. Albert Barnes and Chester Dale purchased his nudes and many portraits. By the late-1920s, Modi's art was in American Museums.

The widespread appeal of his work, combined with a posthumous celebrity status caused by the romanticization of his short but intense life, contributed to making Modigliani one of the most copied artists in the world.[2] Yet, his portraits have been described as "wooden-necked monstrosities"[3, 4] and as a "caricature of swans."[5] His nudes were said to be scandalous,[6] charmingly artificial,[7] and his colors as having "the hue of an uncooked steak of salmon."[8] One reviewer of the Tate London exhibit in 2017 even claimed Modigliani lacked originality: "This copious survey of his work…begins with him copying Cézanne and ends with him still copying Cézanne – plus a few others. He had a great eye for what the geniuses of his time were doing and a bare-faced cheek in stealing from them."[9]

Despite the criticisms, an overabundance of inauthentic drawings, countless forgeries, and still-unresolved controversy surrounding catalogues of his major works, the auction price for a painting by Modigliani can be exorbitant. In 2010, *Nude sitting on a divan* (Ceroni n° 192)

sold at Sotheby's for almost $70 million, and a carved limestone head sold for $53 million. In February 2013, a portrait of Jeanne Hébuterne sold at Christie's in London for $42 million, and in November 2014, Modigliani's sculpture, "*Tête*," sold at Christie's New York for $70.7 million. In 2015, Modi's *Reclining Nude Open Arms* (Ceroni n° 198) sold for $170.4 million, the second-highest price ever paid at auction for a painting. In May 2018, his *Reclining nude (on the left side)* (Ceroni n° 184) sold at Sotheby's for a record $157.2 million, almost $150 million more than it had reportedly last sold for eighteen years earlier.[10]

The gallerist Klaus Perls, former owner of Modi's *Reclining nude* (Ceroni n° 199), now hanging in New York's Metropolitan Museum of Art, said Modigliani "came into his own in 1916. Those last four years; that's really all that Modigliani is."[11] Undoubtedly, some of the artist's best work was done during the last years of his life, a time during which he frequently succumbed to raucous and irreverent drunkenness. However, the technical analysis of Amedeo's work suggests that even before 1916, Modi experimented with pose, mood, painting materials, and technique.[12] His expert draftsmanship and sculptural talents are manifest in hundreds of his drawings and a couple of dozen works in stone, while even his earlier portraits reveal Modigliani's ability to sense what people keep most secret within themselves, behind their eyes and in what might be called their soul.

His artistic style matured throughout what many would consider a tumultuous and emotionally disturbed life, but contrary to legend, there is nothing to suggest Modi was resigned to poverty or disillusioned about his place in the art world. As Kenneth Wayne, former curator of the Albright-Knox Art Gallery in Buffalo and founder of the Modigliani Project, wrote in his preface to *Modigliani and the Artists of Montparnasse*, "Modigliani was indeed a major figure during his own lifetime. His contemporaries took notice of the fact that he was gifted in three media: painting, sculpture, and drawing...The large number of lifetime exhibitions is an indication of the artist's ambition."[13] Italian art historian, Alessandro Bettagno, wrote that "Amedeo Modigliani will remain forever – in art – a uniquely personal genius."[14]

Modi had seventeen major exhibits to his name, including a one-person show that eventually resulted in several sales. He repeatedly exhibited at the Salon d'Automne (1907, 1912, 1919) and the Salon des Indépendents (1908, 1910, 1911). He was managed by two exceptional art dealers, who, thanks to their eye, built exceptional collections that included some of the most prominent artists of the early twentieth century. Although he abandoned sculpture for reasons that remain unclear – Zadkine said simply that "little by little, the sculptor died,"[15] – several of his pieces were shown in galleries or came into the hands of collectors. Modi's art was displayed in Great Britain, the United States, and Switzerland, where he continuously received good press. He had commissions from important art collectors such as Roger Dutilleul, sold to aficionados such as Hugh Blaker and Frank Burty Haviland, and he had a generous and assured monthly income in exchange for paintings (via Zborowski) from the American collector Jonas Netter.[16]

Throughout his short career, and without adhering to any particular art movement, Modigliani's work garnered the admiration of his colleagues. His creations are virtually timeless, partly because he did not succumb to the pressures of genres, popular appeal, or commercial attractiveness. Modi ignored the often-covert pressures to change stylistically and, except for his series of nudes, remained authentic to his vision of portraiture. In all, the number of paintings listed in the five probably incomplete and sometimes inaccurate *catalogues raisonnés* of his work is as high as 417 (Ceroni, Pfannstiel, Lanthemann, Parisot, and Patani). The Milanese expert Ambrogio Ceroni's list of 337 paintings is among the most trusted but is not considered definitive by most Modigliani scholars.[17] Considered a verified, comprehensive annotated listing of every known work by a given artist, new catalogues raisonnés of Modigliani's art are in progress, one by French art historian Marc Restellini,[18] and the other by the founder of the Modigliani Project in New York City, Kenneth Wayne.[19] An international team of art historians, curators, and art conservation experts are studying Modi's existing works and more than eighty paintings and other pieces not in the Ceroni compilation.[20, 21, 22, 23] These combined efforts are essential to

understanding the artist's working practices and to helping fight the wave of fakes that have flooded the art market.[24]

Those who knew Modigliani agree he was imbibed with culture and charm. He was a man whom collector Roger Dutilleul described as "an artiste très fin – a very fine (as in refined) artist." His friend, Jacques Lipchitz, said he was endowed with a "*riche nature* –so lovable, so gifted with talent, with sensitivity, with intelligence, with courage,"[25] and Sonable, writing about Modi's nudes said, "They are the vessels of Modigliani's immense love of all created things."[26] David Morris believes the nudes are where Modigliani "emerges unmistakably as the painter of eros: eros as a life-affirming, life-enhancing, life-giving power."[27]

Modi's friend, the Polish artist Simon Mondzain, described him as "a very friendly person with an innate distinction."[28] Ilya Ehrenburg said, "Women could not take their eyes off him."[29] The poet Max Jacob provided an elegant but hagiographical apology for Modi's sometimes insufferable aristocratic demeanor; "His unbearable pride, grim ingratitude, arrogance; all of these expressed nothing else but his longing for crystalline purity."[30] In 1943, however, Jacob wrote his friend, the young poet Michel Manoll, that "Modigliani was the most unpleasant man I ever knew – Proud, furious, insensitive, mean and rather stupid, sneering, infatuated; and all the same maybe only he and Picasso will remain as the painters of the period."[31]

Modigliani had many flaws and imperfections. He fled responsibility and was overly seductive, sometimes acting like a rake toward women. He neglected the value of money and material goods, was reluctant to express his feelings, and had a tendency to act out in public despite his mostly introverted personality. He also distanced himself from his family and loved ones, although he wrote his mother regularly and visited his baby daughter outside Paris only weeks before taking to his bed for the last time. His former dealer, Paul Guillaume, said he was shy and dignified, but "he would lose no time in getting drunk whenever he could."[32] Whether Modi sunk into the depths of his addictive behaviors as a result of psychological unrest, emotional turmoil, his need to self-medicate, or his quest to emulate at least in part the lives of his literary icons such as Lautréamont and D'Annunzio is left

to our imaginations. Regardless, the man pursued his art voraciously and usually to his own detriment.

History will decide whether the myth of *Modigliani, artiste-peintre* as a lover, saint, sinner, or martyr will endure. Modigliani's work, however, inevitably transcends whatever we learn of the man. There is truth that his often selfish and self-indulgent behaviors caused pain and hurt to those who loved him. This does not detract from the profound serenity displayed in some of Modi's paintings, nor obviate that what emanates from the artist's palette is a sense of mastery and expert draftsmanship. The American collector, Maud Dale, described his portraits as "descriptive passages…a sort of dramatic energy is given to most of them by the very impressive simplicity with which they are presented."[33]

After his death, the artist's legend grew exponentially, in part because virtually everyone who knew him added a new anecdote as if they could recall word for word entire conversations from times long past. Biographers struggle to distinguish reality from myth in many stories about Modi's life, relationships, and conduct. Whether he deserves to be romanticized, glorified, victimized, painted to be among the last bohemian bad boys, unjustifiably overpriced, or valued for his uniquely stylized contributions to twentieth century art is debatable. What seems certain, however, is that Modigliani, like many creative souls, was tormented by his inner demons while suffering from the effects of a debilitating and contagious respiratory infectious disease called tuberculosis. His chronically poor health, coupled with a foreboding that his incurable illness destined him for an early death, contributed to his reckless behaviors. This explains but does not condone his often-irresponsible actions, and particularly, if some of the stories about him are to be believed, his excessive drinking and mistreatment of some of the women in his life. Still, the talented artist had the good fortune to be loved by many, cherished by most, remembered, and respected professionally by all. Perhaps, Lunia Czechowska described Modigliani's essence best when she said, "He was simple, yet noble."[34]

§

There are certain sores in life, that, like a canker, gnaw at the soul in solitude and diminish it.

– Sadegh Hedayat, *The Blind Owl*[1]

ACKNOWLEDGMENTS

My understanding of Modigliani was enhanced over many years, beginning with my reading of *The Unknown Modigliani*, which contains drawings preserved by Dr. Paul Alexandre's son, Noël. It continued thanks to personal insights from British gallerist and art expert Richard Nathanson (now deceased), and to my good fortune being able to attend informative exhibits of Modi's work at the Jewish Museum in Brooklyn (2004), Le Centre Pompidou in Paris (2013), the Tate Modern in London (2018), The Albertina in Vienna (2021), the LAM Villeneuve d'Ascq in France (2022), The Barnes Museum in Philadelphia (2023), and The Musée de l' Orangerie in Paris (2023).

For their guidance and encouragement, I thank Modigliani biographers Jeffrey Meyers and Alain Amiel, museum curator Kenneth Wayne, web editor Jorge Moragas, art conservation expert Marie-Amélie Senot, art historians Pauline Clement-Bayer and Alessandro De-Stefani, addictions expert Elliot Hiller, my new friends Antoine d'Ornano and Yves Bakra, infectious disease specialist Dr. Claudia Vujacich, and tuberculosis experts Professor Tony Catanzaro and Dr. Soo Wei Foo. My appreciation also to Professor Nadia Lasserson and her family, psycho-pédagogue Delphine Coutier, Dr. Chris Mourant, and Dr. Gerri Kimber. My thanks also to art historian and author, Jeanine Warnod, who graciously showed me her father's early works and shared with me her stories of Montmartre and Montparnasse.

I sincerely appreciate the help I received from archivists at Le Vieux Montmartre (Musée de Montmartre), and from Stéphanie Verdaven at the Bibliothèque Dominique Bozo of the Lille Métropole Musée d'Art moderne d'art contemporain et d'art brut (LaM), as well as from librarians at the Kandinsky Library (Centre George Pompidou in Paris), the Bibliothèque Nationale de France, the Bibliothèque Interuniversitaire de Medicine (Université de Paris), the Départment de L'Histoire de la Médicine in Paris, and from the staff at the Wellcome Collection, King's College, and Courtauld Libraries in London, librarians at the Library of the National Gallery of Art in Washington D.C., The Getty Library and Research Institute in Los Angeles, and the Thomas J. Watson Library of the Metropolitan Museum of Art in New York. I received useful information from Thomas Haggerty (Bridgeman Images) and Daniel Trujillo (Artists Rights Society). My sincere thanks to Helene Servant, Altea Swan, and Sophie Pierresteguy from the Service des Archives de l'Assistance Publique des Hôpitaux de Paris, who generously helped me find photographs and surviving records from the now demolished Hôpital de la Charité. I also want to acknowledge the help I received from several friends and family while writing this book: Roy Zipstein, Greg Shed, Elyse Roberts, Mark Savage, Caroline Lehr, Michele Swift, Kyra Landzelius, Pierre Colt, Edwige Pionnier-Colt, André Matar, Georges Renouf, and Dr. September Williams.

Finally, I cannot say enough to express my thanks and admiration for my patients, too many of whom had their own ultimately fatal swords of Damocles dangling above them. They taught me the value of empathy, understanding, and mindfulness so crucial to becoming a good doctor.

§

APPENDIX A

IT'S ALL ABOUT Mtb

ycobacterium Tuberculosis bacillus (Mtb) is the principal cause of tuberculosis in humans. This respiratory pathogen is believed to have killed more people in the history of humankind than any other infectious microorganism. The genus, Mycobacterium, which contains over 190 species, received its name in 1896 based on the fungus-like features and other phenotypic characteristics of Mtb on culture (from the Greek μύκης-mykes).[1]

Mtb is a large, non-spore-forming, nonmotile rod-shaped bacterium with a thick, lipid-rich cell wall (made from long-chain mycolic fatty acids) that makes it very resistant to degradation over long periods. It is thought to have entered human populations from an environmental mycobacterium, probably spanning soil, marine, and freshwater ecosystems during the Middle Paleolithic period between 30,000 and 250,000 years ago. Pathogens would have then dispersed around the world with modern human expansion and evolved through a cumulative process of genome adaptation.[2]

Compared with most other bacteria, *M. tuberculosis* grows slowly, divides every 12-24 hours, and takes up to eight weeks to become visible on culture media. In order to detect *Mycobacterium tuberculosis* in sputum – also known as a sputum smear, more than 10,000 organisms per ml of sputum are needed to visualize the bacilli with a 100X microscope objective. Organisms are identified using acid-fast stains such as

Ziehl-Neelsen, which fail to decolorize them because of the organism's wax-like cellular wall. Bacilli are also seen using electron microscopy. These particular characteristics of the bacilli, in addition to their genetic homogeneity and the ability of tuberculosis to enter a state of dormancy, contribute to the illness's chronic nature and our ability to extract ancient DNA for use in modern genomic research.

Tuberculosis is biologically different from other infectious diseases because the infecting Mtb organism is not spread preferentially through the bloodstream. Instead, it takes up residence in tissues, where it causes caseous necrosis, a form of cell death where proteinaceous tissues take on a white, cheese-like appearance often enclosed by a distinct border that initially helps contain the infection and protects other underlying tissues from attack. When this inflammatory reaction occurs in the periphery of the lung, often close to the visceral pleura, it forms a nodular-shaped abnormality (that can be seen on radiographic images) called a tuberculoma or Ghon focus.[3]

Tuberculosis-related lung disease, as well as extrapulmonary tuberculosis, have been with humanity since early civilization. The disease is ubiquitous, affecting virtually every pulmonary (lungs and pleura) and extrapulmonary organ system, including kidneys, lymph nodes (especially of the neck as in scrofula, also called "the King's evil"), the mesentery system (as in tabes mesenterica), the genito-urinary system, the gastrointestinal tract, and the membranes surrounding the brain (meninges). In bones, tuberculosis causes characteristic skeletal changes such as arthritis, a collapse of the spinal column (Pott's disease, see Quasimodo, the hunchback of Notre-Dame described by Victor Hugo)[4], inflammation (osteomyelitis), and periosteal reactive lesions (formation of irregular new bone around and over lesions caused by some abnormal stimulation such as trauma, disease, or infection). These paleopathological changes provide signs of tuberculosis disease in archeological remains such as ancient fossils.[5]

Several other types of mycobacteria may cause tuberculosis disease in humans or animals. These closely related, genetically homogenous bacteria and members of the genus of Actinomycetota are grouped under the term *Mycobacterium tuberculosis* complex (MtbC). This includes

the major cause of tuberculosis, *Mycobacterium tuberculosis* sensu stricto (Mtb), and eight other mycobacterium bacterial species. *Mycobacterium bovis* infects cattle and animals such as elk, bison, deer, and goats. It can spread to humans through dairy products or direct contact with wounds, as occurs during the slaughter or hunting of an infected animal. Like *M. tuberculosis*, it can also spread in the air through aerosol droplets. It is estimated that before antibiotics, six percent of human deaths from tuberculosis were caused by *M. bovis*. Today, *M. bovis* organism still devastates cattle and livestock worldwide but accounts for less than two percent of all cases of tuberculosis disease in humans. *M. bovis* has been virtually eradicated by pasteurization and national animal surveillance programs, except in developing countries where zoonotic transmission – spread from animals to humans – remains a serious contributor to the global disease burden.[6]

Other mycobacteria included in MtbC are; *M. Microti*, initially described as a cause for tuberculosis in wild rodents; two rare, genetically diverse mycobacteria named *M. africanum*, responsible for fifty percent of human tuberculosis cases in Western Africa, and *M. canettii*, discovered in 1969 and a rare cause of human tuberculosis in the Horn of Africa. *M. caprae* is another pathogen in cattle, and *M. pinnippedii* is a pathogen for seals. Each of these mycobacteria may cause tuberculosis in humans. *M. Tuberculosis*, *M. bovis*, and *M. africanum* may also infect and be deadly in nonhuman primates. Two other mycobacteria, *M. orygis* (antelopes) and *M. mungi* (mongoose), cause disease in animals but not in humans.

The Mtb genome was discovered in 1998. It contains 4.4 million base pairs and encodes for approximately 4000 genes. Genomics and biomolecular studies, including whole genome sequencing, are helping researchers better understand the origins, evolution, and genetic diversity of mycobacteria, as well as providing information about the epidemiology of Mtb and its response to medical treatments. Still, fifteen years later, Spanish genomics researcher Iñaki Comos said the disease was "a formidable challenge for years to come."[7]

Until recently, it was thought that human tuberculosis arose as a zoonosis from newly domesticated cattle in East Africa after cattle had

been domesticated in the Near East and the Indus Valley approximately 10,000 years ago. According to theories supported by the presence of characteristic paleopathological changes to the spine, joints, and bones in human skeletal remains and mummified tissues from the Neolithic period (approximately 10,000 BCE to 1,700 BCE, depending on region) at sites in Germany, Sweden, Italy, Hungary, Syria, and Upper Egypt, *M. bovis* would have first infected humans, then evolved into Mtb.[8, 9, 10] In 2001, however, erosive changes suggestive of tuberculosis were found in the fossil remains of a 17,000-year-old Pleistocene bison from Natural Trap Cave, Wyoming. This was an era well before the domestication of cattle. DNA analysis showed patterns similar to *M. tuberculosis* and *M. africanum* (which cause tuberculosis in humans) yet distinct from present-day *M. bovis*, suggesting tuberculosis spread differently from what was traditionally thought.[11]

Today, many experts believe that modern strains of Mtb may have originated from a common ancestor tens of thousands of years ago and that human tuberculosis has co-evolved with its human host for thousands of years (there is archeological evidence of modern humans in Europe and East Asia between 30,000 and 46,000 years ago).[12, 13, 14, 15, 16, 17, 18, 19, 20] Some uncertainty remains because results from studies using statistical methods to infer past evolutionary history – molecular clock studies – suggest a common ancestor is more recent (perhaps closer to only 6000 years old) and that any spread of MtbC would have been within an already global human population, rather than carried out of Africa tens of thousands of years before.[21, 22, 23]

§

APPENDIX B

———————

ALCOHOLISM AND ALCOHOL USE DISORDER

More than one hundred years ago, doctors Benjamin Rush (1745-1813) and Thomas Trotter (1760-1832) characterized the dangers of ardent spirits and the temporary madness of drunkenness[1,2] It was not until 1956, however, that "alcoholism" was officially designated by the American Medical Association as a disease deserving of hospitalization and treatment.[3] The term "alcoholism" was first introduced in 1849 by Swedish physician Magnus Huss (1807-1890) in his book, *Alcoholismus chronicus*.[4] Huss described a collection of symptoms, behaviors, and changes in anatomopathology he regarded as the essential consequences of years of excessive drinking.[5] This work was recognized by the *Academie Francaise* for its contribution to medical science. "There may be a good many drunkards in France," Huss was told when he received the Prix Montyon in 1854, "but happily there are no alcoholics."[6]

In 1994, the American Psychiatric Association replaced the colloquial term "alcoholism," which describes a person's unhealthy and often longstanding use of alcohol, with the terms "alcohol abuse" and alcohol dependence" in their fourth edition of the *Diagnostic and Statistical Manual of Mental Disorders* (DSM-IV). For historical interests, alcohol abuse was defined as recurrent alcohol use resulting in failure to fulfill major roles at work, school, or home. It can include binge drinking or moderate drinking as a form of relaxation, conviviality, self-soothing, or self-medication. Individuals do not suffer from physical symptoms

of withdrawal if they abstain from alcohol. Dependence, on the other hand, describes individuals with a history of excessive drinking, who use alcohol despite repeated problems with drinking, have a craving for alcohol, a difficulty stopping after starting to drink, and who are prone to withdrawal symptoms when access to alcohol is either prevented or impossible.[7] In the *Big Book*, the international organization Alcoholics Anonymous uses a nonclinical approach for their members and the general public to help individuals recognize, define, acknowledge, and hopefully control their own alcoholism.[8]

To avoid the stigma and confusion linked to the inconsistent use of ambiguous words such as alcoholism, alcohol abuse, and alcohol dependence among medical and allied health professionals, the DSM-5 (published in 2013) introduced the term "Alcohol Use Disorder" (AUD).[9, 10] From a disease-concept perspective, AUD is considered a treatable medical condition characterized by an impaired ability to stop or control alcohol use despite adverse social, occupational, or health consequences.[11] Social drinkers, on the other hand, are more able to control or limit what they drink.

In 2018, the World Health Organization estimated that 237 million men and 46 million women worldwide had AUD, with the highest prevalence in high-income countries.[12] According to the 2021 National Survey on Drug Use and Health (NSDUH) 28.6 million adults ages 18 and older had AUD in the United States that past year.[13, 14] A study from 2008 showed that more than thirty percent of alcohol dependent subjects were young adults.[15] Other studies found that alcoholism directly affected almost one in every three families in the United States.[16] Many people with AUD have coexisting psychiatric, personality, or concurrent substance use disorders that render its management more complex.[17, 18, 19] Unfortunately, only a minority of individuals with signs or symptoms suggestive of AUD seek treatment (which includes behavioral modification, psychological counseling, participation in support groups or Twelve-Step Recovery Programs, and FDA-approved pharmacotherapy).[20, 21]

The diagnosis of AUD is centered on specific behaviors rather than the amount or frequency of alcohol consumed. Based on the number

of criteria present during a twelve-month period, the disorder is designated as mild (2-3 criteria), moderate (4-5 criteria), or severe (6 or more criteria).[22]

1. Alcohol is often taken in larger amounts or over a longer period than was intended.
2. There is a persistent desire or unsuccessful efforts to cut down or control alcohol use.
3. A great deal of time is spent in activities necessary to obtain alcohol, use alcohol, or recover from its effects.
4. Craving, or a strong desire or urge to use alcohol.
5. Recurrent alcohol use resulting in a failure to fulfill major role obligations at work, school, or home.
6. Continued alcohol use despite having persistent or recurrent social or interpersonal problems caused or exacerbated by the effects of alcohol.
7. Important social, occupational, or recreational activities are given up or reduced because of alcohol use.
8. Recurrent alcohol use in situations in which it is physically hazardous.
9. Alcohol use is continued despite knowledge of having a persistent or recurrent physical or psychological problem that is likely to have been caused or exacerbated by alcohol.
10. Tolerance or needing increased amounts of alcohol to achieve intoxication, or having a diminished effect with continued use of the same amount of alcohol.
11. Withdrawal, or the characteristic withdrawal syndrome for alcohol, or drinking alcohol (or taking a related substance such as a benzodiazepine) to relieve or avoid withdrawal symptoms.
 *(Modified from American Psychiatric Association. Diagnostic and statistical manual of mental disorders. 5th ed. Washington, DC: American Psychiatric Association; 2013).[23]

After ingestion, alcohol (ethanol – its chemical formula is C_2H_5OH) is absorbed into the bloodstream through the tissue lining

of the stomach and intestines, and is quickly distributed to the heart and other major organs. It reaches the brain in less than five minutes, where it easily crosses the blood-brain barrier A potent central nervous system depressant, its effects are directly proportional to the concentration of alcohol in the blood, which depends on the amount and rate of alcohol consumption versus the rate at which the body metabolizes (eliminates) it, mostly through the liver, but also in sweat, urine, breath, feces, milk, and saliva).[24]

The earliest signs of alcohol intoxication include euphoria, increased sociability, talkativeness, slowed motor performance, disinhibition, and loss of judgment (intoxicated persons often deny any deterioration in cognitive function). These symptoms occur at blood alcohol concentrations of 50 mg/dL (approximately 1-2 drinks). Decreased thinking ability and diminished motor response occur at 80 mg/dL (0.08 g/100 ml of blood), a level above which persons age twenty-one and older are charged with Driving Under the Influence (DUIs) in most parts of the United States. Mood disturbances such as excessive anger or sadness, and incoordination (stumbling about or falling) occur when blood alcohol levels exceed 100 mg/dL, unless the intoxicated person developed tolerance, which itself signals chronic alcohol consumption. Today, breath analyzer tests are used to estimate a person's blood alcohol content, whereas urine tests for alcohol biomarkers such as the liver metabolite ethyl glycuronimide (EtG) detect levels of drinking for up to five days before the test.[25]

Not every drinker has AUD, and not every person with AUD drinks every day. Some individuals go days, weeks and longer before drinking again or going on a binge.[26] Some individuals drink alone, or at odd times during the day, or secretly store their alcohol. Some deny their alcohol consumption, which may go undetected by friends, family, and professional colleagues for years. The term "high functioning," while not defined medically, describes individuals who may drink excessively, binge, or have problematic drinking but are able to carry out tasks of daily living, including work, social, and professional activities without always visibly manifesting signs of inebriation.[27] The Centers for Disease Control defines drinking in moderation as two drinks

or less for men per day and one drink or less for women.[28] Excessive drinking is defined as four or more drinks on one occasion for women, five or more drinks on an occasion for men, as well as drinking during pregnancy, or drinking under the minimum legal age of twenty-one. Heavy drinking is defined as fifteen drinks or more per week for men and eight drinks or more per week for women.[29]

Individuals with AUD are subject to relapse or continued drinking. Recent studies suggest that some of alcohol's toxic effects occur through changes to neurotransmitter systems (opioid, dopamine, serotonin etc) that alter brain circuits controlling motivation, reward, stress response, and decision-making.[30, 31, 32] Also, some individuals might require alcohol to avoid the emotional and physical discomforts of withdrawal symptoms that are associated with abstinence. Many users experience a shift from reward craving, defined as the impulsive drive to ingest alcohol for its positive effects on creativity and well-being, to relief craving, defined as the compulsive drive to consume alcohol in order to avoid or remove these negative symptoms.[33] These range from a simple headache and sluggishness similar to a "hangover" from too much drinking, to insomnia, tremors, paranoid delusions, and vivid dreams or hallucinations – called "alcoholic hallucinosis." Withdrawal is also associated with affective symptoms such as anxiety, depression or dysphoria (a profound sense of unease and dissatisfaction). Alcohol-related seizures and delirium tremens (DTs)* must be differentiated from epilepsy or seizures resulting from brain tumors, head injury, or meningitis.[34]

§

*DTs are considered a rare but life-threatening medical emergency characterized by tremors, confusion, signs of agitation, cardiovascular collapse, hallucinations, and unawareness of one's environment.

APPENDIX C

TUBERCULOUS MENINGITIS

Tuberculous meningitis occurs as a complication of acute primary tuberculosis, or more frequently as a reactivation of latent infection or complication of an existing tuberculous lesion. It is suspected in anyone with suggestive symptoms, a risk of exposure, or a history of tuberculosis disease. Typically, it has been a disease of young children, and more recently of individuals infected with HIV. Central nervous system disease accounts for up to ten percent of infections in patients with tuberculosis, and tuberculous meningitis represents up to five percent of all cases of extra-pulmonary tuberculosis.[1, 2] The incidence of tuberculous meningitis usually reflects the incidence of tuberculosis in the community.

Even today, methods used for diagnosis are unreliable and clinical management is complicated due to an incomplete understanding of the disease's immunopathogenesis.[3] Tuberculous meningitis is usually organized into three stages based on clinical findings during physical examination. These are determined, in part, by the extent and severity of impairment of a patient's state of consciousness, usually measured using the Glasgow Coma Score; the lower the score the greater the extent and severity of impaired consciousness.[4] *Stage I* (alert): the patient is alert and oriented without focal neurological deficits. *Stage II* (lethargy): the patient has a Glasgow coma score of 14 to 11 and has focal deficits. *Stage III* (coma): the patient has a Glasgow coma score of 10

or less with or without focal deficits).[5] Other findings on clinical examination include but are not limited to papilledema, which is sometimes present on fundoscopic examination (swelling of the optic nerve may cause vision disturbances), cranial nerve palsies or hemiparesis, and the "meningeal symptoms" of headache, fever, and neck stiffness, the last of which is the most frequent physical finding in all stages of the disease, but may be absent early in the illness. Symptoms may be present days or weeks before presentation to medical professionals.

The diagnosis of tuberculous meningitis can be made on examination of the cerebral spinal fluid (CSF), usually obtained by lumbar puncture. This typically shows raised protein, moderately low glucose and chloride, and lymphocyte predominance, which may help distinguish tuberculous meningitis from other illnesses including viral and other bacterial or fungal meningeal infections. CSF adenosine deaminase may be elevated, and intracranial pressure is usually raised. Because the overall staining sensitivity for cerebrospinal fluid is less than twenty percent, and clear evidence of active tuberculosis is present in less than half the cases, making a diagnosis of tuberculous meningitis on examination of the CSF can be difficult. Under the microscope, the Gram stain for bacteria is negative, and acid-fast bacilli suggestive of tuberculosis are rarely found. Tuberculous bacilli may be cultured from the CSF, which can take several weeks. For these reasons, finding central nervous system abnormalities such as tuberculomas, meningeal enhancement, inflammatory exudates, hydrocephalus, and vasculitis on modern neuroimaging studies such as computed tomography (CT) or magnetic resonance imaging (MRI) helps confirm the diagnosis.[6]

Without effective and early therapeutic intervention, symptoms progress to stupor, delirium, coma, and ultimately death.[7] Today, corticosteroids sometimes help diminish swelling and inflammation. Drugs such as aspirin and host-directed immune interventions might prevent pathogenicity and complications such as excessively low serum sodium (hyponatremia), hydrocephalus, raised intracranial pressure, tuberculomas, vasculitis, and stroke.[8] Because disease progression is not linear and any delays in diagnosis are life-threatening, empiric treatment with

antituberculosis medications is almost always started without requiring bacteriologic proof. With modern medical therapies, usually for up to a year, more than eighty percent of patients survive, but up to twenty-five percent may have residual brain damage.[9]

§

ILLUSTRATIONS

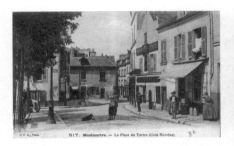

Figure 1: Early 20th century postcards of Montmartre (c. 1905-1912).

Figure 2: Hotel du Tertre, *Le Vieux Montmartre*, Sketch by André Warnod (c. 1913).

Figure 3: Boulevard du Montparnasse and the Rue Delambre with the Café du Dôme on the left and the Café de la Rotonde on the right (a) Carte postale (c. 1905); (b) Same intersection (2023).

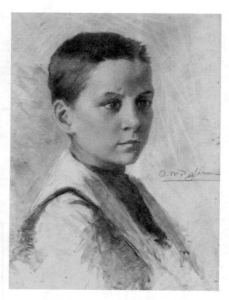

Figure 4: Eugenie Garsin and Flaminio Modigliani (c.1884).

Figure 5: Self-portrait signed a. Modigliani, pencil and chalk on paper (c. 1899?).

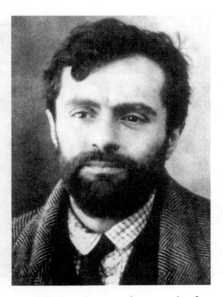

Figure 6: Modigliani seated in his studio on Rue Ravignan (c. 1915).

Figure 7: Last known photograph of Modigliani (c. 1919).

Figure 8: Modigliani smiling, standing in the street (c. 1915).

Figure 9: Modigliani with Picasso and André Salmon, (August 12, 1916).

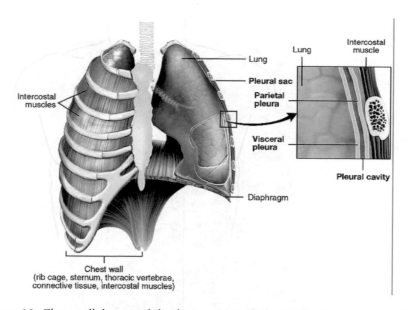

Figure 10: Chest wall, lung, and diaphragm. Parietal pleura lines the interior of the rib cage. Visceral pleural lines the outer surface of the lung. Between the parietal and visceral pleura is the nearly virtual pleural space that may fill with fluid (pleural effusion), air (pneumothorax), blood (hemothorax), or pus (empyema).

Figure 11: (A) Sputum sample showing reddish-violet stained acid-fast bacilli singly and in groups. Pus cells appear blue as they take up the methylene blue counterstain;

(B) Fibrocaseous, fibrocavitary with bronchiectasis, and multiple millet seed miliary tuberculosis in resected and lung pathology specimens;

(C) Ghon focus;

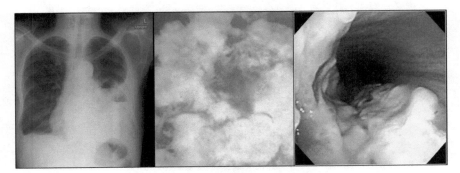

(D) Chest radiograph shows left pleural effusion, thoracoscopic image of parietal pleural tuberculosis, bronchoscopic image of caseous necrosis in the airways.

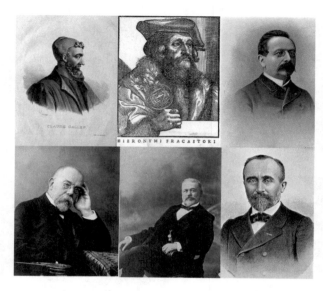

Figure 12: Pioneers in tuberculosis research: (a) Galen (b) Girolamo Venetis Fracastore; (c) Jean Antoine Villemin; (d) Robert Herman Koch; (e) Carlo Forlanini; (f) Louis T. Landouzy.

Figure 13: Treatment modalities from earlier times: (a) Pharmacy jar for leeches; (b) Edward Jenner's lancets; (c) English scarification (six blades); (d) Advertisement for Vin Mariani; (e) Advertisement for Bayer company drugs, British Medical Journal, 1899; (f) Berck seaside sanatorium, Region Haut-de-France.

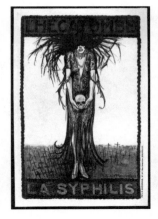

Figure 14: A triple scourge: Public Health posters against syphilis, alcoholism, and tuberculosis: (a) *A woman (femme fatale) holding a skull; representing syphilis* (1923); (b) *A man drinking in a tavern in the company of figures representing poverty and death induced by alcohol* (1905); (c) "*Cracher par terre c'est attenter a la vie d'autrui*" (1916) (*trans.* spitting on the ground is a threat to an other's life.

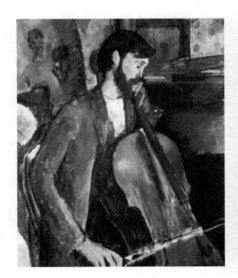 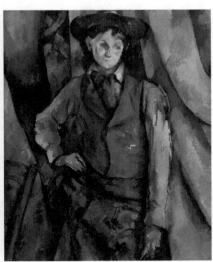

Figure 15: Amedeo Modigliani *Study for The Cellist* (Ceroni n° 22A, 1909); (b) Paul Cezanne *Le garcon au gilet rouge* (1888-1890).

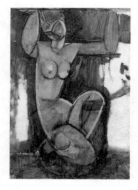

Figure 16: (a) *Caryatid bended knee* Oil on canvas (unsigned, Ceroni n° 35, c. 1911-13?); (b) *Caryatid* blue crayon over graphite (c. 1912-1914); (c) *Pink Nude - Caryatid* watercolor, gouache, blue crayon or pencil, graphite pencil on blue wove paper (c. 1914).

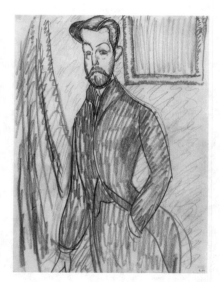 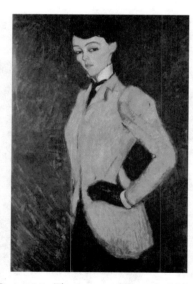

Figure 17: *Portrait of Paul Alexandre* (1881-1968), three-quarter view, left hand in his pocket (1909). Cat. 331. Black crayon on paper 27 x 19.8 (private collection).

Figure 18: *The Amazon* (Ceroni n° 21, 1909), Oil on canvas.

 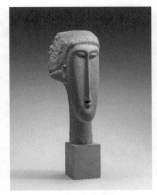 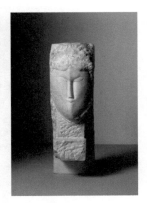

Figure 19: (a) *Tête de Femme*, Limestone CIII (c. 1911-1913); (b) *Head of a Woman*, Limestone CXVII (c. 1911-1912); (c) *Tête de femme*, White Carrara marble CVI (c. 1913).

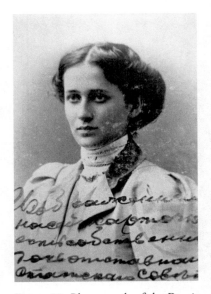

Figure 20: Photograph of the Russian poet Anna Akhmatova (c. 1911).

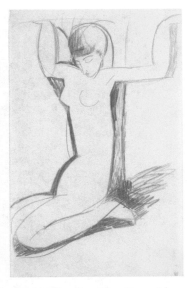

Figure 21: *Kneeling Blue Caryatid* (Anna Akhmatova) drawing by Modigliani – Blue crayon (c. 1911).

Figure 22: *Anna Akhmatova*, drawing by Modigliani (c. 1911).

Figure 23: Postcard from Modigliani to Paul Alexandre, (6 May, 1913):
"Flatterer and friend, happiness is an angel with a grave face. No sonnet needed.
The resuscitated one, soon I write."

Figure 24: *Beatrice Hastings by Modigliani*/illustration

Figure 25: Photograph of Beatrice
Hastings, age 19 (c. 1898).

Figure 26: *Beatrice Hastings*, drawing
by Modigliani, black crayon on paper
(c. 1915).

Figure 27: *Woman seated in front of a fireplace-Beatrice Hastings* (Ceroni n° 58, 1915).

Figure 28: *Beatrice Hastings in checkered shirt* (Ceroni n° 109, 1916).

Figure 29: *Beatrice Hastings at the theater* (Ceroni n° 110, 1916).

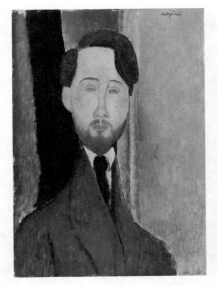

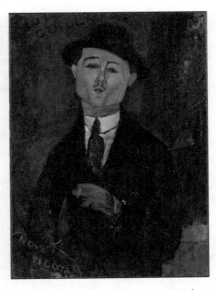

Figure 30: *Léopold Zborowski* (Ceroni n° 309, c. 1919?).

Figure 31: *Paul Guillaume, Novo Pilota* (Ceroni n° 100, 1915).

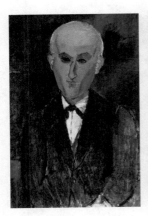

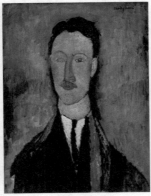

Figure 32: *Max Jacob* (Ceroni n° 105, c. 1916?)

Figure 33: *Portrait of the Artist Léopold Survage* (Ceroni n° 211, 1917/1918).

Figure 34: *Jacques et Berthe Lipchitz* (Ceroni n° 161, 1916/1917).

Figure 35: *Olympia* (Édouard Manet,1862).

Figure 36: *Origine du monde* (Gustave Courbet, 1866).

Figure 37: *Rolla* (Henri Gervex, 1878).

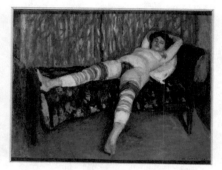

Figure 38: *La saltimbanque au repos* (Charles Camoin, 1905).

Figure 39: Catalogue for Modigliani exhibit at the Galerie Berthe Weill, Paris, December, 1917.

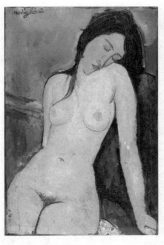

Figure 40: Modigliani: *Sitting nude* (aka Courtauld Nude, Ceroni n° 127, 1916/17).

Figure 41: Iris Tree (photo by Man Ray, c. 1923).

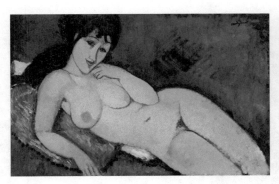

Figure 42: Modigliani: *Nu étendu - Nude on a blue cushion* (Ceroni n° 146, 1916/17).

Illustrations

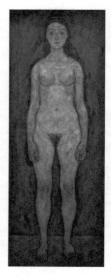

Figure 43: Egon Schiele, *Mädchen* (1917).

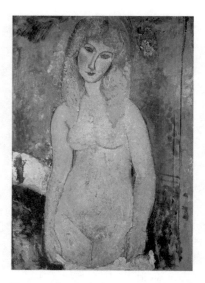

Figure 44: Modigliani: *Standing nude with dropped chemise* (Ceroni n° 193, 1917).

Figure 45: Paul Guillaume and Modigliani in Nice on the Promenade des Anglais (c. 1917-1918).

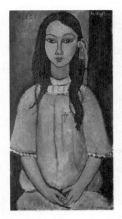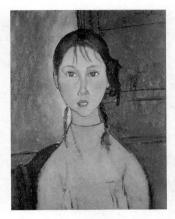

Figure 46: (a) *Alice* (Ceroni n° 69, 1918); (b) *Girl with pigtails* (Ceroni n° 243, 1918); (c) *Little girl in blue* (Ceroni n° 245, 1918).

Figure 47: Modigliani's background colors often reflected those of Le Vieux Nice.

Figure 48: Modigliani: *Paysage dans le midi* (Ceroni n° 293, 1919).

Figure 49: Rachel Bakra Osterlind sitting in front of her portrait by Modigliani (In Cagnes-sur-Mer, 1919).

Figure 50: Four drawings by Modigliani, (*L'Éventail*, August 15, 1919).

Figure 51: Simone Yvonne Emilie Thiroux, Municipal death act registered October 6, 1920, Archives Municipales de Paris, France.

Figure 52: Letter from Simone to Modigliani (reproduced from J. Modigliani, *Modigliani sans légende*).

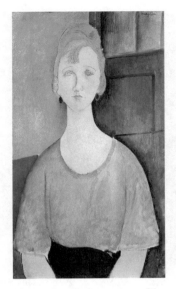

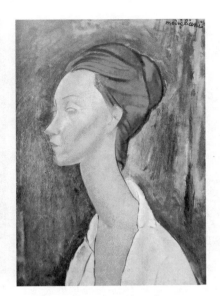

Figure 53: *Girl in a green blouse* (Ceroni n° 114, 1917).

Figure 54: *Lunia Czechowska* (Ceroni n° 320, 1919).

Figure 55: Photograph of Jeanne Hébuterne in studio.

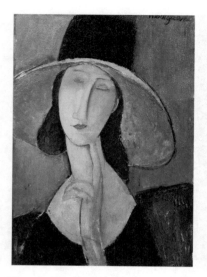

Figure 56: *Jeanne Hébuterne with large hat* (Ceroni n° 180, 1917).

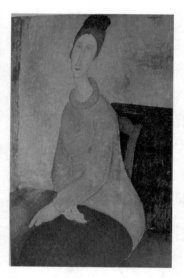

Figure 57: *Jeanne Hébuterne with yellow sweater* (Ceroni n° 389, 1918-19).

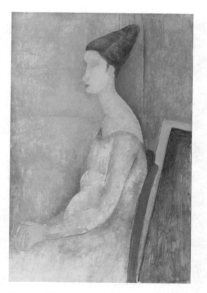

Figure 58: *Jeanne Hébuterne seated in profile in a white dress* (Ceroni n° 261, 1918-19).

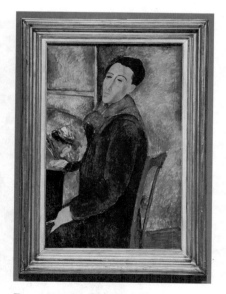

Figure 59: *Modigliani Self-portrait* (Ceroni n° 337, 1919).

Figure 60: (a & b) Stairway and studios at 8 Rue de la Grande Chaumière.

Figure 61: The Lion of Belfort where Modigliani was seen drunkenly yelling in January, 1920. (Paris, le Lion de Belfort [place Denfert-Rochereau, 14e] : [photographie de presse]).

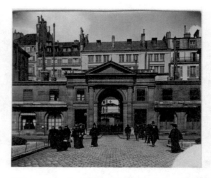

Figure 62: (a & b) Hôpital de la La Charité (Archives APHP): (a) Entrance on 47 rue Jacob (c. 1900); (b) Common ward, La Salle Andral, 1927.

Figure 63: (a & b) Municipal archives of Paris, 1920: (a) Amedeo Modigliani death act 6D204, n° 222; (b) Jeanne Hébuterne death act 5D226, n° 139.

Figure 64: Death Registry of La Charité Hospital (1920), entry n° 79, p. 40, Ref. CHR3/Q/2/66 indicates Modigliani's cause of death as tuberculous meningitis (méningite tuberculeuse).

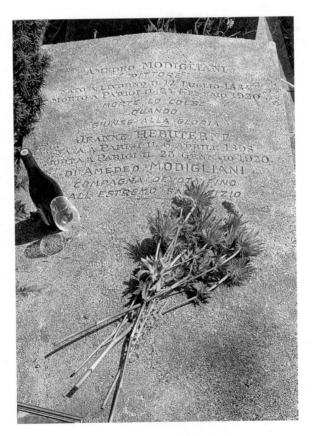

Figure 65: Tomb of Amedeo Modigliani and Jeanne Hébuterne in Paris's Père Lachaise Cemetery.

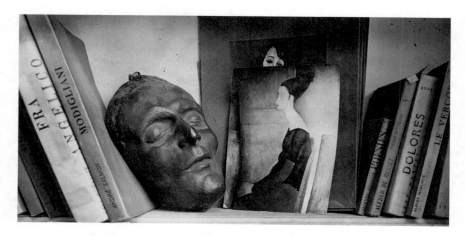

Figure 66: Moise Kisling's Studio with cast of Modigliani's death mask and print of Jeanne Hébuterne seated in profile (Digital image, Gelatin silver print).

IMAGE LEGENDS

Preface: Amedeo Modigliani (c. 1918).

Figure 1: (a & b) Early 20th century postcards of Montmartre (c. 1905-1912).

Figure 2: Hotel du Tertre, *Le Vieux Montmartre*, Sketch by André Warnod (c. 1913).

Figure 3: Boulevard du Montparnasse and the Rue Delambre with the Café du Dôme on the left and the Café de la Rotonde on the right (a) Carte postale (c. 1905); (b) Same intersection (2023).

Figure 4: Eugenie Garsin and Flaminio Modigliani (c.1884).

Figure 5: Self-portrait signed a. Modigliani, pencil and chalk on paper (c. 1899?).

Figure 6: Modigliani seated in his studio on Rue Ravignan (c. 1915).

Figure 7: Last known photograph of Modigliani (c. 1919).

Figure 8: Modigliani smiling, standing in the street (c. 1915).

Figure 9: Modigliani with Picasso and André Salmon, (August 12, 1916).

Figure 10: Chest wall, lung, and diaphragm. Parietal pleura lines the interior of the rib cage. Visceral pleural lines the outer surface of the lung. Between the parietal and visceral pleura is the nearly virtual pleural space that may fill with fluid (pleural effusion), air (pneumothorax), blood (hemothorax), or pus (empyema).

Figure 11: (A) Sputum sample showing reddish-violet stained acid-fast bacilli singly and in groups. Pus cells appear blue as they take up the methylene blue counterstain; (B) Fibrocaseous, fibrocavitary with bronchiectasis, and multiple millet seed miliary tuberculosis in resected and lung pathology specimens; (C) Ghon focus; (D) Chest radiograph shows left pleural effusion, thoracoscopic image of parietal pleural tuberculosis, bronchoscopic image of caseous necrosis in the airways.

Figure 12: Pioneers in tuberculosis research: (a) Galen (b) Girolamo Venetis Fracastore; (c) Jean Antoine Villemin; (d) Robert Herman Koch; (e) Carlo Forlanini; (f) Louis T. Landouzy.

Figure 13: Treatment modalities from earlier times: (a) Pharmacy jar for leeches; (b) Edward Jenner's lancets; (c) English scarification (six blades); (d) Advertisement for Vin Mariani; (e) Advertisement for Bayer company drugs, British Medical Journal, 1899; (f) Berck seaside sanatorium, Region Haut-de-France.

Figure 14: A triple scourge: Public Health posters against syphilis, alcoholism, and tuberculosis: (a) *A woman (femme fatale) holding a skull; representing syphilis* (1923); (b) *A man drinking in a tavern in the company of figures representing poverty and death induced by alcohol* (1905); (c) "*Cracher par terre c'est attenter a la vie d'autrui*" (1916) (*trans.* spitting on the ground is a threat to an other's life.

Figure 15: Amedeo Modigliani *Study for The Cellist* (Ceroni n° 22A, 1909); (b) Paul Cezanne *Le garcon au gilet rouge* (1888-1890).

Figure 16: (a) *Caryatid bended knee* Oil on canvas (unsigned, Ceroni n° 35, c. 1911-13?); (b) *Caryatid* blue crayon over graphite (c. 1912-1914); (c) *Pink Nude - Caryatid* watercolor, gouache, blue crayon or pencil, graphite pencil on blue wove paper (c. 1914).

Figure 17: *Portrait of Paul Alexandre* (1881-1968), three-quarter view, left hand in his pocket (1909). Cat. 331. Black crayon on paper 27 x 19.8 (private collection).

Figure 18: *The Amazon* (Ceroni n° 21, 1909), Oil on canvas.

Figure 19: (a) *Tête de Femme*, Limestone CIII (c. 1911-1913); (b) *Head of a Woman*, Limestone CXVII (c. 1911-1912); (c) *Tête de femme*, White Carrara marble CVI (c. 1913).

Figure 20: Photograph of the Russian poet Anna Akhmatova (c. 1911).

Figure 21: *Kneeling Blue Caryatid* (Anna Akhmatova) drawing by Modigliani – Blue crayon (c. 1911).

Figure 22: *Anna Akhmatova*, drawing by Modigliani (c. 1911).

Figure 23: Postcard from Modigliani to Paul Alexandre, (6 May, 1913): "Flatterer and friend, happiness is an angel with a grave face. No sonnet needed. The resuscitated one, soon I write."

Figure 24: *Beatrice Hastings by Modigliani*/illustration

Figure 25: Photograph of Beatrice Hastings, age 19 (c. 1898).

Figure 26: *Beatrice Hastings*, drawing by Modigliani, black crayon on paper (c. 1915).

Figure 27: *Woman seated in front of a fireplace-Beatrice Hastings* (Ceroni n° 58, 1915).

Figure 28: *Beatrice Hastings in checkered shirt* (Ceroni n° 109, 1916).

Figure 29: *Beatrice Hastings at the theater* (Ceroni n° 110, 1916).

Figure 30: *Léopold Zborowski* (Ceroni n° 309, c. 1919?).

Image Legends

Figure 31: *Paul Guillaume, Novo Pilota* (Ceroni n° 100, 1915).

Figure 32: *Max Jacob* (Ceroni n° 105, c. 1916?)

Figure 33: *Portrait of the Artist Léopold Survage* (Ceroni n° 211, 1917/1918).

Figure 34: *Jacques et Berthe Lipchitz* (Ceroni n° 161, 1916/1917).

Figure 35: *Olympia* (Édouard Manet,1862).

Figure 36: *Origine du monde* (Gustave Courbet, 1866).

Figure 37: *Rolla* (Henri Gervex, 1878).

Figure 38: *La saltimbanque au repos* (Charles Camoin, 1905).

Figure 39: Catalogue for Modigliani exhibit at the Galerie Berthe Weill, Paris, December, 1917.

Figure 40: Modigliani: *Sitting nude* (aka Courtauld Nude, Ceroni n° 127, 1916/17).

Figure 41: Iris Tree (photo by Man Ray, c. 1923).

Figure 42: Modigliani: *Nu étendu - Nude on a blue cushion* (Ceroni n° 146, 1916/17).

Figure 43: Egon Schiele, *Mädchen* (1917).

Figure 44: Modigliani: *Standing nude with dropped chemise* (Ceroni n° 193, 1917).

Figure 45: Paul Guillaume and Modigliani in Nice on the Promenade des Anglais (c. 1917-1918).

Figure 46: (a) *Alice* (Ceroni n° 69, 1918); (b) *Girl with pigtails* (Ceroni n° 243, 1918); (c) *Little girl in blue* (Ceroni n° 245, 1918).

Figure 47: Modigliani's background colors often reflected those of Le Vieux Nice.

Figure 48: Modigliani: *Paysage dans le midi* (Ceroni n° 293, 1919).

Figure 49: Rachel Bakra Osterlind sitting in front of her portrait by Modigliani (In Cagnes-sur-Mer, 1919).

Figure 50: Four drawings by Modigliani, (*L'Éventail*, August 15, 1919).

Figure 51: Simone Yvonne Emilie Thiroux, Municipal death act registered October 6, 1920, Archives Municipales de Paris, France.

Figure 52: Letter from Simone to Modigliani (reproduced from J. Modigliani, *Modigliani sans légende*).

Figure 53: *Girl in a green blouse* (Ceroni n° 114, 1917).

Figure 54: *Lunia Czechowska* (Ceroni n° 320, 1919).

Figure 55: Photograph of Jeanne Hébuterne in studio.

Figure 56: *Jeanne Hébuterne with large hat* (Ceroni n° 180, 1917).

Figure 57: *Jeanne Hébuterne with yellow sweater* (Ceroni n° 389, 1918-19).

Image Legends

Figure 58: *Jeanne Hébuterne seated in profile in a white dress* (Ceroni n° 261, 1918-19).

Figure 59: *Modigliani Self-portrait* (Ceroni n° 337, 1919).

Figure 60: (a & b) Stairway and studios at 8 Rue de la Grande Chaumière.

Figure 61: The Lion of Belfort where Modigliani was seen drunkenly yelling in January, 1920. (Paris, le Lion de Belfort [place Denfert-Rochereau, 14e] : [photographie de presse]).

Figure 62: (a & b) Hôpital de la La Charité (Archives APHP): (a) Entrance on 47 rue Jacob (c. 1900); (b) Common ward, La Salle Andral, 1927.

Figure 63: (a & b) Municipal archives of Paris, 1920: (a) Amedeo Modigliani death act 6D204, n° 222; (b) Jeanne Hébuterne death act 5D226, n° 139.

Figure 64: Death Registry of La Charité Hospital (1920), entry n° 79, p. 40, Ref. CHR3/Q/2/66 indicates Modigliani's cause of death as tuberculous meningitis (méningite tuberculeuse).

Figure 65: Tomb of Amedeo Modigliani and Jeanne Hébuterne in Paris's Père Lachaise Cemetery.

Figure 66: Chapter 37: Moise Kisling's Studio with cast of Modigliani's death mask and photo of Jeanne Hébuterne seated in profile (Digital image, Gelatin silver print).

§

IMAGE CREDITS and COPYRIGHTS

Preface: Photo by Vaux, Marc (1895-1971). Credit: PVDE/Bridgeman Images.

Figure 1: (a & b) Collection Association Le Vieux Montmartre, with permission.

Figure 2: Reproduced from, *Le Vieux Montmartre*, p. 3 Eds. Maison Figuière, 1913. © 2023 Artists Rights Society (ARS), New York / ADAGP, Paris, also with permission, Jeanine Warnod.

Figure 3: (a) Postcard, c. 1905, Bibliothèque Historique de la Ville de Paris (public domain); (b) photo courtesy Henri Colt, 2023.

Figure 4: Public domain, Wikimedia Commons

Figure 5: Private collection. Attribution, Public Domain.

Figure 6: Photo ©RMN-Grand Palais / Art Resource, NY (musée de l'Orangerie) / Archives Alain Bouret, photo Dominique Couto.

Figure 7: Photo, Fototeca Gilardi / Bridgeman Images.

Figure 8: With copy of The Eye in hand, Anonymous. Photo © RMN-Grand Palais (musée de l'Orangerie) / Archives Alain Bouret, image Dominique Couto.

Figure 9: Photo © Paris Musées, Musée Carnavalet, Dist, RMN-Grand Palais / Image ville de Paris. © ARS / Comité Cocteau, Paris / ADAGP, Paris 2023.

Figure 10: Original source Anatomy & Physiology, Jun 19, 2013 Connexions http://cnx.org/content/col11496/1.6/, Creative Commons Attribution 3.0, altered Black/white by Henri Colt.

Figure 11: (A) Photo courtesy of Dr. Rohitha S Chandra, Consultant Microbiologist, Lisie Hospital, Kochi, Kerala; (B) Gupta M, et al., Patholog Res Int. 2016;2016:8132741, open access; (C) ShareAlike 2.0 Generic (CC BY-SA 2.0); (D) Photo courtesy Henri Colt.

Figure 12: Original source Wellcome Collection including (a) Lithograph by P. R. Vignéron; (b) publisher not identified; and (f) By Charraire, c. 1896. Attributions 4.0 International (CC BY 4.0).

Figure 13: Original source Wellcome Collection Attributions (a-d) International (CC BY 4.0) including (b) England Science Museum, London, and (c) M. Boularan, 1899, except for Image (e) Région Hauts-de-France - Inventaire general. 20066200539NUC2, Auteur inconnu. Stein, Eddy (reproduction) with permission.

Figure 14: (a) Colour lithograph by L. Raemakers, ca. 1923. Raemaekers, Louis, 1869-1956 Date: [1923?] Welcome Collection public domain reference 658805i Creative Commons; (b) Colour lithograph by J.-J. Waltz (Hansi), 1905, Welcome Collection public domain reference 543163i; (c) A. Delerieu 1916, Pigelet & F, P., Paris (drukker). Comité central d'assistance aux anciens militaires tuberculeux. Poster, Hoover Institute collections, public domain (no restrictions).

Figure 15: (a) Abelló Collection, Madrid, Source http://www.secretmodigliani.com/ Public Domain, Wikimedia Commons; (b) National Gallery of Art, collection of Mr. and Mrs. Paul Mellon, in honor of the 50th anniversary of the National gallery of Art, accession n° 1995.475. Public Domain.

Figure 16: (a) Kunstsammlung Nordhein-Westfalen, Dusseldorf (Inv. n° 0128). Public Domain, Wikipedia Commons; (b) Philadelphia Museum of Art (The Louise and Walter Arensberg Collection, 1950, accession n° 1950-134-150), Public domain; (c) Barnes Foundation, Accession n° BF 292, Public domain, with permission.

Figure 17: Photo © Fine art images / Bridgeman Images.

Figure 18: Amedeo Modigliani, Public domain, via Wikimedia Commons.

Figure 19: (a) Centre Pompidou - Musée National d'art moderne de Paris, inventory n° AM 903 S. Digital images ©CNAC/MNAM. Dist. RMN-Grand Palais / Art Resource, NY ; (b) National Gallery of Art, Chester Dale Collection, Accession n° 1963.10.241, Public domain ; (c) Musée d'Art Moderne, d'Art Contemporain et d'Art Brut; Villeneuve d'Asq, France. Dation en 1993, Musée national d'art moderne / Centre de création industrielle, Dépôt au LaM, Lille métropole musée d'art moderne, d'art contemporain et d'art brut, Villeneuve d'Ascq, Copyright photographique, Philip Bernard, with permission.

Figure 20: Photo © Effigie / Bridgeman Images.

Figure 21: Photo © Fine art images / Bridgeman Images.

Figure 22: Photo © Bridgeman Images.

Figure 23: Noel Alexandre, *The Unknown Modigliani, Drawings from the collection of Paul Alexandre,* (p. 111). Original photograph by Hugo Maertens. Harry N. Abrams, Inc, 1993.

Figure 24: Original source ADAM 300, 1963-1965, Eds. Miron Grindea, ADAM/ Curwen, London 1963, with permission (private collection, Nadia Lasserson).

Figure 25: Beatrice Hastings photograph source T.B.H Library, Toronto.

Figure 26: PVCE / Bridgeman Images.

Figure 27: Private Collection, VAC Foundation, Moscow. Attributions public domain, Wikimedia Commons.

Figure 28: Whitehead, Collection, Attributions public domain, Wikimedia Commons.

Figure 29: Portrait de Beatrice Hastings – Accession n° BF 361, Barnes Foundation, Attributions public domain.

Figure 30: Source. Barnes Foundation, Accession n° BF 261, with permission.

Figure 31: Musée de l'Orangerie © RMN-Grand Palais / Art Resource, NY (Musée de l'Orangerie) / Hervé Lewandowski RF 1960 44.

Figure 32: Cincinnati Art Museum, Attributions Google Art Project, Public Domain, Wikimedia Commons.

Figure 33: Atheneum Art Museum, Helsinki, Finland accession n° A IV 2971 (Finnish National gallery), Attributions Google Art Project, Public Domain, Wikimedia Commons.

Figure 34: The Art Institute of Chicago, Helen Birch Bartlett Memorial Collection. Accession n° 1926.221., Attributions Google Art Project, Public Domain, Wikimedia Commons.

Figure 35: Photo © RMN-Grand Palais / Art Resource, NY, Musée d'Orsay, Paris, France.

Figure 36: Photo © RMN-Grand Palais / Art Resource, NY, Musée d'Orsay, Paris, France.

Figure 37: Photo, © RMN-Grand Palais / Art Resource, NY, Musée des Beaux Arts, Bordeaux.

Figure 38: Photo, © RMN-Grand Palais / Art Resource, NY, Musée d'Orsay, Paris, France.

Figure 39: Source, Kandinsky Library, Centre George Pompidou, (photo courtesy Henri Colt).

Figure 40: Courtauld Institute of Art, London, P.1932.SC.271. Public Domain, Wikimedia Commons.

Figure 41: Man Ray, photo of Iris Tree, ©Man Ray 2015 Trust / Artists Rights Society (ARS), NY / ADGAP, Paris 2023.

Figure 42: National Gallery of Art (Chester Dale Collection), Washington D.C., Accession n°1963.10.46. Public domain.

Figure 43: Private collection, Wikimedia Commons, photograph by Ji-Elle, 2012-09-01.

Figure 44: Private collection, Public Domain.

Figure 45: Anonymous, Photo © RMN - Grand Palais (musée de l'Orangerie) / Art Resource, NY / Archives Alain Bouret.

Figure 46: (a) Collection J. Rump, Statens Museum for Kunst, Copenhagen, Denmark, Wikimedia Commons; (b) Collection Nagoya City Art Museum, Japan; (c) Private collection, WikiArt.

Figure 47: Photo courtesy Henri Colt.

Figure 48: (a) Private collection. Source photographer https://www.christies.com/lot/lot-6397648, public domain via Wikimedia Commons.

Figure 49: Photo ©Association A. Osterlind (with permission).

Figure 50: Four drawings by Modigliani, p. 201, N. 7, *L'Éventail*, Geneva, Dir. Francois Laya, August 15, 1919.

Figure 51: Simone Yvonne Emilie Thiroux, Registre des actes de décès 14D316, index 735 (n° 5250), Archives Municipales de Paris, France (Photo ©Henri Colt).

Figure 52: Letter from Simone to Modigliani, reproduced from Jeanne Modigliani, *Modigliani sans légende*. plate 44, Gründ, Paris, 1958).

Figure 53: National Gallery of Art, Chester Dale collection, Washington, accession number 1963.10.45, public domain.

Figure 54: Private collection. Attribution, public domain, Wikimedia Commons.

Figure 55: Public domain, (https://commons.wikimedia.org/wiki/File:Jeanne1.jpg).

Figure 56: Private collection, Attributions public domain, Wikimedia Commons

Figure 57: Solomon Guggenheim Museum, Accession 375.33, Attributions public domain, Wikimedia Commons.

Figure 58: Barnes Foundation, Philadelphia, Accession n° BF 422, public domain with permission.

Figure 59: Museu de Arte Contemporânea da Universidade de Sao Paulo. Source, exhibit 'Modigliani up Close', Barnes Foundation, Philadelphia, (Photo courtesy Henri Colt).

Figure 60: (a & b) Photos courtesy Henri Colt.

Figure 61: Paris, le Lion de Belfort [place Denfert-Rochereau, 14e]: [photographie de presse] / [Agence Roll El-13 (1606) Bibliothèque nationale de France (with permission).

Figure 62: Hôpital de la La Charité (Archives APHP): (a & b) With permission from the Archives Assistance Publique des Hôpitaux de Paris; (a) Archives AP-HP, cote FRAPHP075/CHR/3FI3/10/005; (b) Archives AP-HP, cote FRAPHP075/CHR/3FI3/10/061.

Figure 63: (a & b) État-civil. Municipal death acts for Amedeo Modigliani and Jeanne Hébuterne: (a) Registre de l'état civile des actes de décès, Modigliani, 6D204, n° 222, Archives Municipales de Paris, France ; (b) Registre de l'état civile

des actes de décès: Hébuterne, 5D226, n° 139, Archives Municipales de Paris, France. (Photo courtesy Henri Colt).

Figure 64: Extract from Registre Declarations de Décès du 24 Aout 1919 - 12 Decembre 1921. Modigliani entry n° 79, p. 40. Reference CHR3/Q/2/66. Archives des Hôpitaux de l'Assistance Publique de Paris. (Photo courtesy Henri Colt).

Figure 65: Photo courtesy Pauline Clement-Bayer (with permission, ©Henri Colt).

Figure 66, Chapter 37: Digital image, © CNAC/MNAM, Dist. RMN-Grand Palais / Art Resource, NY (photo, Philippe Migeat, artist André Kertesz – RMN. Musée National d'Art Moderne/Centre Georges Pompidou/Paris/France.

§

SELECTED BIBLIOGRAPHY

Akhmatova, Anna. *My Half-Century: selected prose.* Ed. Ronald Meyer, Northwestern University Press, Evanston, IL, 1997.

Alexandre, Noël. *The Unknown Modigliani. Drawings from the Collection of Paul Alexandre.* Harry N. Abrams, New York, 1993.

Amiel, Alain. *Modigliani sur la Côte d'Azur : entre Nice et Cagnes-sur-Mer.* Editions Mémoires Millenaires, Saint-Laurent-du-Var, 2023.

Barnes, David S. *The Making of a Social Disease: Tuberculosis in Nineteenth-Century France.* University of California Press, Berkeley, 1995.

Berger, John. *Ways of Seeing.* British Broadcasting Corp. and Penguin Books, Penguin Books, London, 1972.

Booth, Martin. *Cannabis: a history.* Doubleday, Great Britain, Picador USA, 2003.

Braun, Emily. *Modigliani and his Models.* Royal Academy of Arts, London, 2006.

Buckley B, Fraquelli, Simonetta, Ireson, Nancy. *Modigliani Up Close.* The Barnes Foundation, Yale University Press, New Haven, 2022.

Butler, Stephen. *Modigliani et l'École de Paris.* Museum of Art Tokyo. Studio Editions, London, 1994.

Carco Francis. *The last Bohemia, from Montmartre to the Latin Quarter.* Henry Holt and Co, (*trans.* Madeleine Boyd), New York, 1928.

Carco, Francis. *L'ami des peintres.* Editions Gallimard, 8ᵉ ed. Paris, 1953.

Carco, Francis. *Le Nu Dans la Peinture Moderne (1863-1920).* Les Éditions G Crès et Cie, Paris, 1920.

Ceroni, Ambrogio. *Modigliani: Les Nus.* La Bibliothèque des Arts, Düdingen, Switzerland, 1989.

Ceroni, Ambrogio, Cachin Françoise. *Tout l'oeuvre peint de Modigliani.* Les Classiques de l'Art, Flammarion, Paris, 1972.

Ceroni, Ambrogio. *Amedeo Modigliani,* including "Les Souvenirs de Lunia Czechowska" Edizione del Milione, Milan, 1958.

Ceroni, Ambrogio. *Amedeo Modigliani: Dessins et Sculptures.* Edizioni Del Milione, Milan, 1965.

Chaplin, Patrice. *Into the darkness laughing: the story of Modigliani's last mistress, Jeanne Hébuterne.* Virago press, 1990.

Clarke, Kenneth. *The Nude: A study in ideal form.* Bollingen Series XXXV. Princeton University Press, Princeton, New Jersey, 1956.

Cocteau, Jean. *Modigliani.* Fernand Hazan Eds, Paris, 1950.

Cocteau, Jean. *Opium: The diary of his cure.* Peter Owen, London, 1930.

Colt, Pierre. *L'art qui parle.* Edition Ciais, Nice, France, 2012.

Coquiot, Gustave. *Les Peintres Maudits.* Andre Delpeuch, Eds. Paris, 1924.

Crespelle, Jean-Paul. *Modigliani: Les femmes, les amis, l'oeuvre.* Presses de la Cité, réédition numérique, January, Paris, 1969.

Cumston, Charles Greene. *An Introduction to the History of Medicine.* Dorset Press, New York, 1988.

Dale, Maud. *Modigliani.* Modern Art, Alfred A. Knopf, New York, 1929.

Davis, John A. *Italy in the Nineteenth Century: 1796-1900.* Oxford University Press, Oxford, 2000.

Day, Catherine. *Consumptive Chic: A History of Beauty, Fashion, and Disease.* Bloomsbury Academic, London, 2017.

Douglas, Charles [pseudonym of Douglas Goldring]. *Artist Quarter,* Faber and Faber, London, 1941.

Ehrenburg, Ilya. *People and Life: Memoirs of 1891-1917.* Cox and Wyman, London, 1962.

Fifield William. *Modigliani.* William Morrow, New York, 1976.

Force, Cristel H. *Pioneers of the Global Art Market: Paris-based dealer networks 1850-1950.* Bloomsbury publishing, New York, 2020.

Franck, Dan. *Bohemian Paris: Picasso, Modigliani, Matisse and the birth of modern art.* Grove Press, New York, 1998.

Fraquelli, Simonetta and Ireson, Nancy. *Modigliani.* Tate Publishing, London, 2017.

Glasscheib, Hermann Samuel. *The March of Medicine: The emergence and triumph of modern medicine.* G.P. Putnam's Sons, New York, 1964.

Goldwater, Robert. *Primitivism in Modern Art.* Belknap Press of Harvard University Press, Cambridge, MA, 1966 (enlarged edition, 1986).

Gray, Stephen. *Beatrice Hastings: A Literary Life.* Viking, 2004.

Grindea, Miron. "300," *ADAM International Review* n° 300, Curwen press, London, 1963.

Hall, Douglas. *Modigliani.* Phaidon Press, London, 1993.

Hamnett, Nina. *Laughing Torso.* Reminiscences of Nina Hamnett. Ray Long & Richard R. Smith, New York, 1932.

Hayden, Deborah. *Pox. Genius, Madness, and the Mysteries of Syphilis.* Perseus Books, New York, 2003.

Hodgson, Barbara. *In the arms of Morpheus. The tragic history of Laudanum, Morphine, and Patent medicines.* Firefly books, New York, 2001.

Johnson, Benjamin and Brown, Erika Jo. *Beatrice Hastings: On the Life & Work of a Lost Modern Master*. Unsung Masters Series volume 7. Pleiades Press & Gulf Coast, Warrensburg, Missouri, 2016.

Klein, Mason. *Modigliani unmasked: Drawings from the Paul Alexandre collection*. The Jewish Museum, New York. Yale University Press, New Haven and London, 2017.

Klüver Billy. *A Day with Picasso*. MIT Press, Cambridge, 1997.

Klüver, Billy and Martin, Julie. *KiKi's Paris: Artists and Lovers* 1900-1930. Harry N. Abrams, New York, 1989.

Lacourt, Jeanne-Bathilde. *Amedeo Modigliani: L'Oeil Interieur*. Gallimard, Paris, 2016.

Landouzy, Louis. *La Tuberculose Maladie Sociale*. Levallois-Perret, Paris, 1903.

Lanier, Doris. *Absinthe: The Cocaine of the Nineteenth Century*. McFarland & Company, Jefferson, North Carolina, 1995.

Lanthemann, Joseph. *Modigliani catalogue Raisonné*. Graficas Condal, Baracelona, Spain, 1970.

Lipchitz, Jacques. *Amedeo Modigliani* (1884-1920). Pocket Books, Harry N. Abrams, pub, New York, 1954.

Malraux, André. *The Voices of Silence*. Bollingen Series XXIV-A. Princeton University Press, New Jersey, 1990.

Mann, Carol. *Modigliani*. (pp. 198-116). Thames and Hudson, London, 1980.

Mann, Thomas. *The Magic Mountain*, (trans. H. T Lowe Porter). London: Vintage, 1999.

Mann, Vivian. *Gardens and Ghettos: The Art of Jewish Life in Italy*. University of California Press, Berkely CA, 1989.

Mansfield, Katherine. *The Collected Letters of Katherine Mansfield* (Vincent O'Sullivan and Margaret Scott, Eds). Volume 1., volume 1 (1903-1917), Clarendon Press, Oxford, 1984.

Marevna, Vorobev. *Life with the Painters of La Ruche*. Constable and Company, London (WJ Mackay Limited, Chatham), 1972.

McCormack, Catherine. *Women in the Picture: What culture does with female bodies*. W.W. Norton & Company, New York, 2021.

Meyers, Jeffrey. *Modigliani, a life*. Harcourt Press, New York, 2006.

Michel, Michel-Georges. *Les Montparnos*. Editions Mondiales, Paris, 1957.

Modigliani, Jeanne. *Jeanne Modigliani Raconta Modigliani*. Archives Légales Amédéo Modigliani. Edizione Graphis Arte, Rome, 1984.

Modigliani, Amedeo. *Amedeo Modigliani Lettres et Notes,* (compiled and edited by Olivier Renault, Les Éditions Mille et Une Nuits, Librairie Artheme Fayard, Paris, 2020.

Modigliani, Jeanne. *Modigliani, une biographie*. Éditions Adam Biro, Paris 1990.

Modigliani, Jeanne. *Modigliani: Man and Myth*. The Orion Press, New York, 1958.

Modigliani, Jeanne. *Modigliani sans légende*. Gründ, Paris, 1958.

Morris, David B. *Eros and Illness*, Harvard University Press, Cambridge MA, 2017.

Mourant, Chris. *Katherine Mansfield and Periodical Culture*. Edinburgh University Press, Edinburgh, 2020.

Murger, Henri. *Scenes de la vie de bohème*. 1849. Bohemians of the Latin Quarter. English Translation Project. Societé des Beaux Arts, Paris, 1905.

Murray, John, Nadel's Jay. *Murray and Nadel's Textbook of Respiratory Medicine*. Elsevier, Philadelphia, 2016.

Musée de L'Orangerie Exhibit Catalogue for *Modigliani: A painter and his art dealer*. Editorial direction by Fraquelli S & Girardeau C. Flammarion, Paris, 2023.

Nicoïdski, Clarisse. *Modigliani*. Editions Plon, Paris, 1989.

Olivier, Fernande. *Loving Picasso: The private journal of Fernande Olivier*. Harry N. Abrams, publisher, New York, 2001.

Olivier, Fernande. *Picasso et ses amis*. Stock, Paris, 1933.

Parisot, Christian. *Modigliani in Venice, between Leghorn and Paris*. Carlo Delfini, Eds. Catalogue, Sassari, 2005.

Parisot, Christian. *Modigliani. Catalogue Raisonné*. Editions Graphis Arte, Livorno, 1990.

Parisot, Chriistian. *Modigliani*. Editions Gallimard, Paris, 2005.

Pfannstiel, Arthur S. *Modigliani et son oeuvre: Étude Critique et Catalogue Raisonné*. La Bibliothèque des Arts, Paris, 1956.

Piccioni, Leone & Ceroni, Ambrogio. *I dipinti di Modigliani* (Classici dell'arte 40), Editors Rizzoli, Milan 1970.

Quetel, Claude. *History of Syphilis*. Polity Press, Cambridge UK, 1990.

Reeder, Roberta. *Anna Akhmatova: poet and prophet*. St. Martin's Press, New York, 1994.

Renault, Olivier. *Montparnasse: Entre Bohème et Années Folles*. Parigramme, Paris, 2018.

Restellini, Marc. *L'Angelo dal volto severo*. Catalogue Milano, Palazzo Reale 21 marzo-6 luglio 2003, Skira, Geneva-Milan, 2003.

Riposati, Massimo. *Modigliani, Simone Thiroux un amore segreto / a secret love*. Edizioni Carte Segrete, Rome, 2009.

Rose, June. *Modigliani, The Pure Bohemian*, St. Martin's Press, New York, 1990.

Roy, Claude. *Modigliani*. Skira-Rizzoli International Publications, Geneva, 1985.

Salmon, André. *A Memoir*. G.P Putnam Sons, New York, 1961

Schmalenbach, Werner. *Modigliani*. Prestel-Verlag Press, Munich, 1990.

Schuster, Bernard, Pfannstiel Arthur S. *Modigliani: A study of his sculpture*. Bibliothèque Modigliani Centennial Edition. NAMEGA Corp, 1986.

Schweiller, Giovanni. *Modigliani*. Arte Moderna Italiana N. 8, Ulrico Hoepli, Milano, 1927.

Secrest, Meryle. *Modigliani: A life*. Alfred A. Knoff, New York, 2011.

Seigel, Jerrold. *Bohemian Paris: Culture, Politics, and the Boundaries of Bourgeois Life*, 1830-1930. The Johns Hopkins University Press, Baltimore, 1986.

Sichel, Pierre. *Modigliani, a biography*. New York: E. Dutton and Company, 1967.

Sitwell, Osbert. *Laughter in the room next door*. MacMillan and Co, London, 1949.

Selected Bibliography

Soby, James Thrall. *Introduction to Modigliani paintings, drawings, sculpture*. The Museum of Modern Art, New York, in collaboration with the Cleveland Museum of Art, New York, 1951.

Warnod, Jeanine. *Washboat Days: Montmartre, Picasso and the Artists Revolution*. Orion Press, Grossman Publishers, New York, 1972.

Warnod, Jeanine. *L'Ecole de Paris*. Editions Musée du Montparnasse, Paris, 2012.

Warren, Rosanna. *Max Jacob: a life in art and letters*. W.W. Norton, New York, 2020.

Wayne, Kenneth. *Modigliani and the artists of Montparnasse*. Harry N. Abrams, New York, 2002.

Weill Berthe. *Pan! dans l'Oeil!* Librairie Lipschutz, Paris, 1933.

Werner, Alfred. *Modigliani*. Harry N. Abrams, New York, 1985.

Wight, Frederick. *Modigliani Paintings and Drawings*. Museum of Fine Arts Boston, Los Angeles County Museum. Fine Arts Productions, UCLA, 1961.

Zadkine, Ossip. *Le maillet et le ciseau. Souvenirs de ma vie*. Albin Michel, Paris, 1968.

Zborowska, Anna. *Modigliani et Zborowski*. L'Echoppe, Paris, 2015.

§

ENDNOTES

CHAPTER 1: THE TIMES

1. Murger H. *Scenes de la vie de bohème*. 1849. Bohemians of the Latin Quarter. English Translation Project. Societe des Beaux Arts, Preface XXXVI, Paris, 1905.
2. Secrest, M. (2011). *Modigliani: A life.* (p. 26), Alfred A. Knoff, New York.
3. Davis, J. A. (2000). *Italy in the nineteenth century: 1796-1900,* (pp. 1-3). Oxford University Press.
4. Rimbaud, A. (1945). *A Season in Hell and, The Drunken Boat.* Chichester: New Directions.
5. Rimbaud, A. (1966). *My Bohemian Life. Rimbaud.* Complete Works. (p. 63). Chicago: University of Chicago Press.
6. Rimbaud, A. (1961). *A Season in Hell and The Drunken Boat.* (p. 2). First lines from *A Season in Hell* (*trans.* L. Varèse). New Directions Publishing, Penguin Books, Canada. Original French : "Jadis, si je me souviens bien, ma vie était un festin / où s'ouvraient tous les coeurs, où tous les vins coulaient."
7. Murger, H. (2006). *Scenes de la vie de bohème.* Bohemians of the Latin Quarter. English Translation Project Gutenberg, Release.
8. Carco, F. I., & Seigal, J. (1986). *Bohemian Paris: Culture, politics, and the boundaries of bourgeois life 1830-1930.* Viking Penguin Inc.
9. Charles, D. (1941). *Artist Quarter.* Faber and Faber, London.
10. Coquiot, G. (1924). *Les Peintres Maudits* (pp. 101-112). André Delpeuch, Paris.
11. Michel, M.-G. (1957). *Les Montparnos.* Editions Mondiales, Paris.
12. Brooks, D. (2000). *Bobos in paradise: The new upper middle class and how they got there.* Simon and Schuster, New York.
13. Cate, P. D. (1996). *The Spirit of Montmartre.* In Cate, P. D., & Shaw, M. (Eds.), The Spirit of Montmartre: Cabarets, Humor and the Avant-Garde, 1875-1905. (p. 7). Jane Voorhees Zimmerli Art Museum.
14. Jackson, J. H. (2006). Artistic Community and Urban Development in 1920s Montmartre. *French Politics, Culture, & Society, 24*(2), (pp. 1-25). Berghahn Books.

15. Kenny, N. (2004). *Je Cherche Fortune: Identity, Counterculture, and Profit in Fin-de-Siècle Montmartre*. Urban History Review / Revue d'histoire Urbaine, 32(2), 21–32. Retrieved from http://www.jstor.org/stable/43562327

16. Warnod, A. *Le vieux Montmartre*. (pp. 183-185). Figuière Presse, Paris, 1913.

17. Renault, G., & Chateau, H. (2010). *Montmartre*. (p. 46). Nabu Press, Paris.

18. *Dictionnaire des Lieux à Montmartre* (2001). (p. 73). Éditions André Roussard.

19. Julian, P. (1982). *La Belle Époque: An essay*. Exhibition catalogue, Metropolitan Museum of Art.

20. Baudelaire, C. (1863). *The Painter of Modern Life*. Le Figaro. (Originally published in Le Figaro, in 1863). Da Capo Press.

21. Saxton, L. (2015). *Before addiction: The medical history of alcoholism in nineteenth-century France* (Doctoral Thesis). City University of New York. Retrieved from https://academicworks.cuny.edu/cgi/viewcontent.cgi?referer=&httpsredir=1&article=2136&context=gc_etds.

22. Quetel, C. (1990). *History of Syphilis*. Polity Press, London.

23. Haine, W. S. (1998). *The World of the Paris Café: Sociability among the French Working Class, 1789-1914*. The Johns Hopkins University Press.

24. Warnod, A. (1925, January 27). L'École de Paris. *Comœdia*, 1.

25. Le Bal, M. (2022). *Montparnasse: Quand Paris Eclairait le Monde*. Albin Michel, Paris.

26. Carco, F. (1953). *L'ami des peintres* (8e ed.). Editions Gallimard, Paris.

CHAPTER 2: THE FAMILY / THE TRIBE

1. Cherubini, D. (2017). G.E. Modigliani in the Zimmerwald Movement: 'War Against War' and the United States of Europe. In J.Q. Olmstead (Ed.), *Reconsidering Peace and Patriotism during the First World War*, 61-69. Palgrave Macmillan. DOI: 10.1007/978-3-319-51301-0_5

2. Secrest, M. (2011). *Modigliani: A life*. Alfred A. Knoff, New York.

3. Alexandre, N. (1993). *The Unknown Modigliani: Drawings from the Collection of Paul Alexandre*. Harry N. Abrams, New York.

4. Auenbrugger, L. (1761). *Inventum novum ex percussione thoracis humani ut signo abstrusos interni pectoris morbos detegendi*. Typis, Joannis Thomae Trattner.

5. Greene, R. (1992). Fleischner Lecture: Imaging the respiratory system in the first few years after discovery of the X-ray: contributions of Francis H. Williams, M.D. *AJR Am J Roentgenol, 159*(1), 1-7. doi: 10.2214/ajr.159.1.1609679.

6. Hilton, M. R. (2014). *Bar Mitzvah: A History*. Jewish Publication Society; University of Nebraska Press.

7. Seroussi, E. (2002). Livorno: A Crossroads in the History of Sephardic Religious Music. In E. Horowitz & M. Orfali (Eds.), *The Mediterranean and the Jews: Vol. 2: Society, Culture, and Economy in Early Modern Times*, 266. Bar Ilan University Press.

8. Mann, V. B. (1990). *Gardens and Ghettos: The art of Jewish life in Italy*. The Jewish Museum; University of California Press.

9. Johnson, R., Ravenhall, M., Pickard, D., Dougan, G., Byrne, A., & Frankel, G. (2018). Comparison of Salmonella enterica Serovars Typhi and Typhimurium Reveals Typhoidal Serovar-Specific Responses to Bile. *Infect Immun, 86*(3), e00490-17. doi: 10.1128/IAI.00490-17.

10. Basnyat, B., Qamar, F. N., Rupali, P., Ahmed, T., & Parry, C. M. (2021). Enteric fever. *BMJ, 372*, 1-7. doi:10.1136/bmj.n437

11. Gilchrist, M. R. (1998). Disease & Infection in the American Civil War. *The American Biology Teacher, 60*(4), 258–262. doi: 10.2307/4450468.

12. Department of Commerce and Labor. (1907). *Mortality Statistics 1905, Sixth annual report with revised rates 1901-1904.*

13. DiBacco, T. V. (1994, January 25). When typhoid was dreaded. *The Washington Post.* Retrieved from https://www.washingtonpost.com/archive/lifestyle/wellness/1994/01/25/when-typhoid-was-dreaded/9b2abb2d-ac05-42ae-802a-34122b16c322/.

14. History of Vaccines. (n.d.). *Typhoid Fever*. Retrieved from https://www.historyof-vaccines.org/content/articles/typhoid-fever

15. Ivanoff, B., Levine, M. M., & Lambert, P. H. (1994). Vaccination against typhoid fever: Present status. *Bulletin of the World Health Organization, 72*(6), 957-971. PMID: 7867143; PMCID: PMC2486740.

16. Marineli, F., Tsoucalas, G., Karamanou, M., & Androutsos, G. (2013). Mary Mallon (1869-1938) and the history of typhoid fever. *Annals of Gastroenterology, 26*(2), 132-134.

17. Walter, E. J., Hanna-Jumma, S., Carraretto, M., & Forni, L. (2016). The pathophysiological basis and consequences of fever. *Critical Care, 20*(1), 200. doi: 10.1186/s13054-016-1375-5.

18. Osler, W. (1896). The study of the fevers of the South. *JAMA, 26*, 999-1004.

19. Grodzinsky, E., & Sund Levander, M. (2019). History of the Thermometer. In *Understanding Fever and Body Temperature,* 23-35. doi:10.1007/978-3-030-21886-7-3.

20. Basnyat, B., Qamar, F. N., Rupali, P., Ahmed, T., & Parry, C. M. (2021). Enteric fever. *BMJ, 372*, n437. https://doi.org/10.1136/bmj.n437.

21. Hasday, J. D., Shah, N., Singh, I., et al. (2011). Fever, hyperthermia and the lung: It's all about context and timing. *Trans Am Clin Climatol Assoc, 122*, 34-47.

22. Today we know that relative bradycardia is a nonspecific clinical sign because it also occurs in noninfectious diseases such as lymphoma and adrenal insufficiency, and as a result of other infectious diseases, including Typhus, Malaria, Dengue fever, and Legionella. See Ye, F., Hatahet, M., Youniss, M. A., et al. (2018). The clinical significance of relative bradycardia. *WMJ, 117*(2), 73-78.

23. Davis, T. M. E., Makepeace, A. E., Dallimore, E. A., & Choo, K. E. (1999). Relative Bradycardia Is Not a Feature of Enteric Fever in Children. *Clinical Infectious Diseases, 28*(3), 582–586.

24. Goldberg, D. R. (2009). Aspirin: Turn-of-the-century miracle drug. *Science History Institute*. Retrieved from https://www.sciencehistory.org/distillations/aspirin-turn-of-the-century-miracle-drug.

25. Riess, L. (1875). Über die innerliche Anwendung der Salicylsäure. *Berliner Klinische Wochenschrift, 12*, 673–676.

26. Johnston, C. H. (1893). The cool bath in the treatment of typhoid fever. *Transactions for the Michigan State Medical Society for the year 1893*. John Borman and Son printers, 115-120.

27. Rainsford, K. D. (2004). *Asprin and Related Drugs*. Retrieved from: https://rgmaisyah.files.wordpress.com/2009/05/aspirin-and-related-drugs-k-d-rainsford_-2004.pdf.

28. Mackowiak, P. A. (2000). Brief History of Antipyretic Therapy. *Clinical Infectious Diseases, 31*(Supplement_5), S154–S156. https://doi.org/10.1086/317510.

29. McTavish, J. R. (1987). Antipyretic treatment and typhoid fever: 1860-1900. *J Hist Med Allied Sci, 42*(4), 486-506. https://doi.org/10.1093/jhmas/42.4.486.

30. Secrest, M. (2011). *Modigliani: A life* (p. 50). Alfred A. Knoff, New York.

CHAPTER 3: MACCHIA – THE BLOT

1. Chip, H. B. (1968). *Theories of Modern Art: A source book by artists and critics*. University of California Press. In *Cubism*, Guillaume Apollinaire. (p. 224), Berkeley.

2. Modigliani, J. (1958). *Modigliani: Man and Myth*. The Orion Press, New York.

3. Mann, V. B. (1989). *Gardens and Ghettos: The Art of Jewish Life in Italy*. University of California Press.

4. Secrest, M. (2011) *Modigliani: A life*. (p. 54), Alfred A. Knoff, New York.

5. Werner, A. (1985). *Modigliani*. Harry N. Abrams, New York.

6. Schmalenbach, W. (1990). *Modigliani*. (p. 48), Prestel-Verlag Press.

7. Modigliani. (1981). XXe Anniversaire. Amedeo Modigliani 1884-1920. Catalogue d'exposition – 26 Mars – 28 Juin – Musée D'art Moderne de la Ville de Paris.

8. Giusti, F. (2009). Le parole di Orfeo: Dante, Petrarca, Leopardi, e gli archetipi di un genere. *Italian Studies, 64*(1), 56-76. https://doi.org/10.1179/174861809X405791.

9. Mangiafico, L. (n.d.). Nine ways of looking at D'Annunzio. *Open Letters Monthly*. Retrieved from https://www.openlettersmonthlyarchive.com/olm/maybe-nine-ways-of-looking-at-dannunzio.

10. D'Annunzio, G. (1990). *Di me a me stesso* (A. Andreoli, Ed.). Milano: Mondadori. (Original Italian): "Di me a me stesso / La poesia italiana comincia con 200 / versi di Dante e – dopo un lungo / intervallo – continua in me."

11. Lawlor, L., & Moulard-Leonard, V. (2021). Henri Bergson. In *The Stanford Encyclopedia of Philosophy* (Fall 2021 Edition), E. N. Zalta (Ed.). Retrieved from https://plato.stanford.edu/archives/fall2021/entries/bergson/.

12. Bergson, H. (2002). *Essai sur les données immediates de la conscience* (J.-M. Tremblay, Ed.). Chicoutimi, Quebec.

13. Bergson, H. (2011). *Matter and Memory* (6ᵗʰ edition, P. N. Paul & W. S. Palmer, *trans*.). London: DigiReads.
14. Kropotkin, P. (2007). *The Conquest of Bread*. Vanguard Press.
15. Meyers, J. (2006). *Modigliani, a life*. (p. 12). Harcourt Press, New York.
16. Christie's. (n.d.). *Live auction 15483: Impressionist and modern art evening sale. Lot 31B*. Retrieved from https://www.christies.com/en/lot/lot-6155257.
17. Ceroni, A., & Cachin, F. (1972). *Tout l'oeuvre peint de Modigliani*. Les Classiques de l'Art, Flammarion.
18. Piccioni L., Ceroni, A. (1970). *I dipinti de Modigliani*, Rizzoli Editore, Milan. Also see https://commons.wikimedia.org/wiki/Amedeo_Modigliani_catalogue_raisonné,_1970_Ceroni.

CHAPTER 4: THE SWORD OF DAMOCLES

1. Modigliani, M. (1958). *Modigliani: Man and Myth*. The Orion Press, New York.
2. Rose J. (1990). *Modigliani, The Pure Bohemian*. St. Martin's Press, New York.
3. Modigliani, M. (1958). *Modigliani: Man and Myth*. The Orion Press, New York.
4. Drolet, G. J. (1942). Epidemiology of tuberculosis. In B. Goldberg (Ed.), *Clinical Tuberculosis* (pp. A3–A70). F. A. Davis.
5. Certain groups are at increased risk: In the United States, for example, these include Asian persons, Black or African-Americans, Hispanic or Latino persons, children under the age of fifteen, pregnant people, the homeless, international travelers, people with certain medical comorbidities including HIV/AIDS, and residents of correctional facilities. See Center for Disease Control. (n.d.). *TB in specific populations*. Retrieved from https://www.cdc.gov/tb/topic/populations/default.htm.
6. Dormandy, T. (1999). *The White Death: A History of Tuberculosis*. (p. xiii), Hambledon Press London, England.
7. Sontag, S. (1977). *Illness as Metaphor*, (pp. 21-22) Farrar, Straus and Giroux.
8. Day, C. A. (2017). *Consumptive Chic: A History of Beauty, Fashion, and Disease*. Bloomsbury Academic, London.
9. Nightingale, F. (2004). Florence Nightingale on public health care. In L. McDonald (Ed.), *Notes on Nursing for the Labouring Classes*, 6(121). Wilfrid Laurier University Press.
10. Severn, J. (2014). *Joseph Severn Letters and Memoirs* (F. Grant Scott, Ed.). Routledge.
11. Tiemersma, E. W., van der Werf, M. J., Borgdorff, M. W., Williams, B. G., & Nagelkerke, N. J. (2011). Natural history of tuberculosis: duration and fatality of untreated pulmonary tuberculosis in HIV-negative patients: a systematic review. *PLoS One*, 6(4), e17601. doi: 10.1371/journal.pone.0017601.
12. Shiferaw, M. B., Sinishaw, M. A., Amare, D., Alem, G., Asefa, D., & Klinkenberg, E. (2021). Prevalence of active tuberculosis disease among healthcare workers and support staff in healthcare settings of the Amhara region, Ethiopia. *PLoS One, 16*(6), e0253177. doi: 10.1371/journal.pone.0253177.

CHAPTER 5: IT'S ALL GREEK TO ME

1. Graham, D. W. (2021). Heraclitus. In E. N. Zalta (Ed.), *The Stanford Encyclopedia of Philosophy* (Summer 2021 Edition). Retrieved from https://plato.stanford. edu/archives/sum2021/entries/heraclitus/.

2. Berger, H. W., & Mejia, E. (1973). Tuberculous pleurisy. *Chest, 63*, 88-92.

3. Cumston, C. G. (1988). *An Introduction to the History of Medicine.* (p. 147). Dorset Press.

4. Charalampidis, C., Youroukou, A., Lazaridis, G., Baka, S., Mpoukovinas, I., Karavasilis, V., Zarogoulidis, P. (2015). Pleura space anatomy. *Journal of Thoracic Disease, 7*(Suppl 1), S27-32. doi: 10.3978/j.issn.2072-1439.2015.01.48.

5. Lee, P., & Colt, H. G. (2005). *Flex-Rigid Pleuroscopy Step-by-Step*. CMP Medica Asia.

6. Colt, H. G., & Mathur P. N. (1999). *Manual of Pleural Procedures* (pp. 3-33). Lippincott, Williams & Wilkins, Philadelphia.

7. Iniesta, I. (2011). Hippocratic Corpus. *BMJ*, 342, d688. doi: 10.1136/bmj. d688

8. Meinecke, B. (n.d.). Consumption (Tuberculosis) in classical antiquity. Retrieved from https://www.ncbi.nlm.nih.gov/pmc/articles/PMC7942748/pdf/ annmedhist148008-0069.pdf

9. Pease, A. S. (1940). Some remarks on the diagnosis and treatment of tuberculosis in antiquity. *Isis, 31*(2), 380-393. Retrieved from https://www.jstor.org/discover /10.2307/225758?uid=3737536&uid=2&uid=4&sid=21102645880757.

10. Sharma, O. A. (1981). Avicenna's description of tuberculosis. *Bulletin of the Indian Institute of History of Medicine Hyderabad*, 1-4, 83-86.

11. Berry, S. M. (2016). *Vico's prescient evolutionary model for Homer. Prophet of modern oral-evolutionary theories*. Retrieved from http://nrs.harvard.edu/urn-3:hul. ebook:CHS_BerryS.Vicos_Prescient_Evolutionary_Model_for_Homer.2016.

12. Haselwerdt, E. (2019). The semiotics of the soul in ancient medical dream interpretation: perception and the poetics of dream production in Hippocrates' on regimen. *Ramus, 48*, 1-21.

13. Von Staden, H. (1992). The discovery of the body: human dissection and its cultural contexts in ancient Greece. *The Yale Journal of Biology and Medicine, 65*, 223-241.

14. Pease, A.S. (1940). Some remarks on the diagnosis and treatment of tuberculosis in antiquity. *Isis. 31*(2). 380-393. Retrieved from https://www.jstor.org/discover /10.2307/225758?uid=3737536&uid=2&uid=4&s id=21102645880757. Retrieved May 22, 2022.

15. Meinecke B. (n.d.). *Consumption (Tuberculosis) in classical antiquity.* https://www. ncbi.nlm.nih.gov/pmc/articles/PMC7942748/pdf/annmedhist148008-0069. pdf

16. Polianski, I. J. (2021). Airborne infection with Covid-19? A historical look at a current controversy. *Microbes and Infection, 23*(9-10), 104851. doi: 10.1016/j. micinf.2021.104851

17. Hippocrates. (1931). *Volume IV: Nature of Man* (W. H. S. Jones, *trans.*). Loeb Classical Library, No 150. Harvard University Press.

18. Kingsley, K., Scarlett, & Parry, R. (2020). Empedocles. In E. N. Zalta (Ed.), *The Stanford Encyclopedia of Philosophy* (Summer 2020 Edition). Retrieved from https://plato.stanford.edu/archives/sum2020/entries/empedocles/.

19. Crowley, T. J. (2020). Aristotle, Empedocles, and the Reception of the Four Elements Hypothesis. In H. C. C. & R. Habash (Eds.), *Brill's Companion to the Reception of Presocratic Natural Philosophy in Later Classical Thought*. Koninklijke Brill.

20. Lagay, F. (2002). The Legacy of Humoral Medicine. Virtual Mentor, History of Medicine. American *Medical Association Journal of Ethics, 4*(7), 2-6-208.

21. World Health Organization (2023). *Key Facts*: Tuberculosis, April 21. Retrieved from https://www.who.int/news-room/fact-sheets/detail/tuberculosis.

22. Global tuberculosis report 2022. Geneva: World Health organization; 2022. licence: cc bY-Nc-sa 3.0 iGo.

CHAPTER 6: CONTAGION

1. Chekhov, A (1886). Letter to N.A. Leikin, Moscow, April 6, 1886. Project Gutenberg Ebook of Letters of Anton Chekhov to his family and friends (*trans.* Constance Garnett), released September, 2004 [Ebook #6408]. Retrieved October 22, 2023 from https://www.gutenberg.org/files/6408/6408-h/6408-h.htm#link2H_4_0003.

2. Laënnec, R. T. H. (1927). *Traité de l'auscultation médiate et des maladies des poumons et du cœur* (2nd ed.). [Facsimile reprint]. Paris: Masson.

3. Bishop, P. J. (1981). Laënnec: A great student of tuberculosis. *Tubercle, 62*, 129-134.

4. Laënnec, R. T. H. (1827). *Treatise of the Diseases of the Chest and on mediate auscultation* (J. Forbes, *trans.*). London: T&G Underwood. Retrieved from https://iiif.wellcomecollection.org/pdf/b21987610.

5. Nelson, K. E., & Williams, C. F. (2014). *Infectious Disease Epidemiology: Theory and Practice* (3rd ed.). Burlington, MA: Jones & Bartlett Learning.

6. Howard-Jones, N (1984). Robert Koch and the cholera vibrio: a centenary. *Br Med J (Clin Res Ed)*, 288, 379-381.

7. Rosen, G. (1993). *A History of Public Health*. Baltimore, MD: Johns Hopkins University Press.

8. Dubos, J. (1952). *The White Plague: Tuberculosis, Man and Society*. Boston, MA: Little, Brown & Co.

9. Ackerknecht, E. H. (1964). Johann Lucas Schoenlein 1793-1864. *Journal of the History of Medicine and Allied Sciences, 19*(2), 131-138.

10. Frith, J. (2014). History of Tuberculosis. Part 1-Phthisis, consumption, and the White Plague. *Journal of Military and Veterans' Health, 22*(2), 1-10. Retrieved from https://jmvh.org/article/history-of-tuberculosis-part-1-phthisis-consumption-and-the-white-plague/.

11. Daniel, T. M. (2015). Jean-Antoine Villemin and the infectious nature of tuberculosis. *International Journal of Tuberculosis and Lung Disease, 19*(3), 267-268. doi: 10.5588/ijtld.06.0636.

12. Villemin, J. A. (1868). *De la virulence et de la spécificité de la tuberculose.* Paris, France: V. Masson.

13. Villemin, J. A. (1868). *Etude sur la tuberculose.* Paris, France: Baillière et Fils.

14. Shampo, M. A., & Rosenow, E. C. (2009). A history of Tuberculosis on stamps. *Chest, 136,* 578-582.

15. Koch, R. (1882). Die Atiologic der Tuberkulose. *Berliner Klinische Wochenschrift, 15,* 221-230.

CHAPTER 7: TUBERCLES

1. Laënnec R.T.H. (1827). *Treatise of the Diseases of the Chest and on mediate auscultation.* Forbes J Translation. London, T&G Underwood. Retrieved from https://iiif.wellcomecollection.org/pdf/b21987610.

2. Mattern, S. P. (2013). *The Prince of Medicine: Galen in the Roman Empire.* (P. 285). Oxford, UK: Oxford University Press.

3. Gleason, M. W. (2007). Shock and Awe: The Performance Dimension of Galen's Anatomy Demonstrations. Princeton/Stanford Working Papers in Classics Paper No. 010702. SSRN. Retrieved from https://ssrn.com/abstract=1427007.

4. Celsus. (1971). De Medicina (W. G. Spencer, Translation.). Cambridge, MA: Harvard University Press. (Original work published in 1935). Retrieved from http://data.perseus.org/citations/urn:cts:latinLit:phi0836.phi002.perseus-eng1:4.11.

5. Re Kazana, A. A., & Gourgoulianis, K. I. (2022). Royal disease (Vasilios nósos): Substantiating one of the names of tuberculosis in Greek, from "Atakta" dictionary by Adamantios Korais (1832-1835). *Infezioni in Medicina, 30*(1), 143-149. doi:10.53854/liim-3001-19.

6. Jouanna, J., & Allies, N. (2012). Air, miasma and contagion in the time of Hippocrates and the survival of miasmas in post-Hippocratic medicine (Rufus of Ephesus, Galen and Palladius). In P. van der Eijk (Ed.), *Greek Medicine from Hippocrates to Galen: Selected Papers.* 119–136. Brill.

7. Mucke, M., & Schnalke, T. (2021). Anatomical theatre. EGO (European History Online). Retrieved from https://ieg-ego.eu/en/threads/european-networks/visual-media/martin-mucke-thomas-schnalke-anatomical-theatre.

8. von Staden, H. (1995). Anatomy as Rhetoric: Galen on Dissection and Persuasion. *Journal of the History of Medicine and Allied Sciences, 50*(1), 47–66. doi:10.1093/jhmas/50.1.47

9. Fracastoro, G. (1546). *De contagione et contagiosis morbis et eorum curatione, libri tres.* Venezia.

10. Pesapane, F., Marcelli, S., & Nazzaro, G. (2015). Hieronymi Fracastorii: the Italian scientist who described the "French disease". *Anais Brasileiros de Dermatologia, 90*(5), 684-686. doi:10.1590/abd1806-4841.20154262.

11. Nutton, V. (1990). The Reception of Fracastoro's Theory of Contagion: The Seed That Fell among Thorns? *Osiris, 6,* 196-234. Retrieved from http://www.jstor.org/stable/301787

12. Sabbatani, S. (2004). L'intuizione di Girolamo Fracastoro sul contagio della tisi ed i suoi oppositori. Storia di un'idea [Historical insights into tuberculosis. Girolamo Fracastoro's intuition on the transmission of tuberculosis and his opponents. History of an idea]. *Infez Med, 12*(4), 284-291. PMID: 15729021.

13. De le Boë Sylvius, F. (1667). *Praxeos medicae.* append. Tract. IV. (De phtisi), par 51. In A. Amerio (Ed.), Il *termine Tisi: Sua Evoluzione Storica.* 743-750. Atti del XXI Congresso Internazionale di Storia della medicina Vol. 1. Siena, 1968.

14. Klippe, H. J., & Kirsten, D. (2011). Marcello Malpighi (1628-1694) und die Begriffe Miliar und Tuberkel. Eine Ergänzung der bisherigen historischen Terminologie [Marcello Malpighi (1628-1694) and the terms miliary and tubercle. A completion of hitherto existing historical terminology]. *Pneumologie.*

15. Webb, W. H. (1885). Facts serving to prove the contagiousness of tuberculosis: with results of experiments with germs traps used in detecting tubercle-bacilli in the air of places of public resort. *JAMA, 4*(16), 421-430.

16. Morton, R. (1694). *Phthisiologia: or, a Treatise of Consumptions.* London: Smith & Walford.

17. Doetsch, R. N. (1978). Benjamin Marten and his "New Theory of Consumptions". *Microbiol Rev, 42*(3), 521-528. doi: 10.1128/mr.42.3.521-528.1978. PMID: 362148; PMCID: PMC281442.

18. Marten, B. (1720). *A new theory of consumptions: more especially of a phthisis, or consumption of the lungs.* R. Knaplock, A. Bell, J. Hooke and C. King. Retrieved from https://iiif.wellcomecollection.org/pdf/b20458290.

19. Meli, D. M. (2015). The Rise of Pathological Illustrations: Baillie, Bleuland, and Their Collections. *Bulletin of the History of Medicine, 89*(2), 209-242. Retrieved from https://www.jstor.org/stable/26309017.

20. Baillie, M. (1797). *The Morbid Anatomy: Some of the most important parts of the human body* (2nd ed.). London. Retrieved from https://wellcomecollection.org/works/vwvrnq6r.

21. Baillie, M. (1797). *The Morbid Anatomy: Some of the most important parts of the human body* (2nd ed.). London. Retrieved from https://wellcomecollection.org/works/vwvrnq6r.

22. Glasscheib, H. S. (1964). *The March of Medicine: The emergence and triumph of modern medicine.* New York: G.P. Putnam's Sons.

23. Bayle, G. L. (1815). *Researches on Pulmonary Phthisis* (W. Barrow, Translation.). London: Longman, Hurst, Rees, Orme and Brown.

24. Bayle, G. L. (1810). *Recherches sur la phtzisie pulmonaire.* Paris: Gabon.

25. Kockerling, F., & Koeckerling, D. (2013). Cornelius Celcsus - Ancient encyclopedist, surgeon- scientist, or master of surgery? *Langenbeck's archives of surgery / Deutsche Gesellschaft fur Chirurgie, 398,* 609-616.

CHAPTER 8: LET IT BLEED

1. Broussais, Francois Jean-Victor. (1834). *Examen des Doctrines Médicales et des Systèmes de Nosologie*, vol IV, p.123. Published chez Mlle Delaunay Librairie, Paris.

2. Cumston C.G. (1988). *An Introduction to the History of Medicine.* (pp. 168-175). Dorset Press.

3. King H. (n.d.). *Hippocrates Now.* Bloomsbury Studies in Classical Reception. Retrieved from https://library.oapen.org/bitstream/handle/20.500.12657/23773/1006370.pdf?sequence=1&isAllowed=y.

4. Stefanakis, G., Nyktari, V., Papaioannou, A., Askitopoulou, H. (2020). Hippocratic concepts of acute and urgent respiratory diseases still relevant to contemporary medical thinking and practice: a scoping review. *BMC Pulmonary Medicine, 20*(1), 165. doi:10.1186/s12890-020-01193-9.

5. Laios, K., Androutsos, G., Moschos, M. M. (2017). Aretaeus of Cappadocia and pulmonary tuberculosis. *Balkan Medical Journal, 34,* 480.

6. Aretaeus. (1972). *The Extant Works of Aretaeus, The Cappadocian. In F. Adams (Ed.), De Causis et Signis Morborum, Book I, CH VIII. Cure of Phthisis.* Boston: Milford House Inc. (Original work published in 1856).

7. Hippocrates. (n.d.). *Airs, Waters, and Places. Part I.* Retrieved from http://classics.mit.edu/Hippocrates/airwatpl.html.

8. Schneeberg, N. G. (2002). A twenty-first-century perspective on the ancient art of bloodletting. *Transactions & Studies of the College of Physicians of Philadelphia, 24,* 157-185.

9. Jones, W. H. S. (1868). *Hippocrates Collected Works* I. Cambridge, MA: Harvard University Press. Retrieved from http://daedalus.umkc.edu/hippocrates/HippocratesLoeb1/page.ix.php.

10. Boyan, M. (2007). Galen: On Blood, the Pulse, and the Arteries. *Journal of the History of Biology, 40*(2), 207-230.

11. Crivellato, E., Mallardi, F., & Ribatti, D. (2006). Diogenes of Apollonia: A pioneer in vascular anatomy. *Anatomical Record Part B: The New Anatomist, 289B*(4), 116-120. doi:10.1002/ar.b.20106.

12. Wilson, L. G. (1959). Erasistratus, Galen, and 'the pneuma." *Bulletin of the History of Medicine, 33*(4), 293–314.

13. Durling, R. J. (1988). The innate heat in Galen. *Medizinhistorisches Journal, 3/4,* 210-212.

14. Bedford, E. (1951). The ancient art of feeling the pulse. *British Heart Journal, 13*(4), 423–437. doi:10.1136/hrt.13.4.423.

15. Jouanna, J. (2000). 'La lecture du traité hippocratique de la Nature de l'homme. Les fondements de l'hippocratisme de Galien'. In M.-O. Goulet-Cazé (Ed.), *Le commentaire entre tradition et innovation: Actes du Colloque international de l'Institut des Traditions Textuelles, Paris and Villejuif, 22–25 septembre 1999.* 273–292. Paris.

16. Galen. (n.d.). De plac. Hipp. et Plat. 8.4, 21–23. In *CMG V 4,* 502, 22–504, 2.

17. Retief, F. P., & Cilliers, L. (2005). Tumours and cancers in Graeco-Roman times. *In Health and Healing, Disease and Death in the Graeco-Roman World. Acta Theologica*. Supplementum 7, 200-212.

18. Mattern, S. P. (2013). *The Prince of Medicine: Galen in the Roman Empire.* Oxford University Press.

19. Brain, P. (1979). In defense of ancient bloodletting. *South African Medical Journal*, July 28, 149-154.

20. Lonie, I. M. (1964). Erasistratus the Erasistrateans, and Aristotle. *Bulletin of the History of Medicine, 38*(5), 426–443.

21. Lupines are also known as Bluebonnets, a flower in the pea family. See Meinecke, B. (2021). Consumption (Tuberculosis) in classical antiquity. *Annals of Medical History, 148*(2), 69-89. Retrieved from https://www.ncbi.nlm.nih.gov/pmc/articles/PMC7942748/pdf/annmedhist148008-0069.pdf.

22. Bernard de Clairvaux. (1867). *Oeuvres completes de Saint Bernard* (Vol. 4, Translated to French by L'Abbe Charpentier). p. 85. Louis Vives, Eds., Paris.

23. Gil-Sotres, P. (1994). *Practical medicine from Salerno to the black death*: 'Derivation and revulsion', (pp. 110-155). Cambridge University Press.

24. Yapijakis, C. (2009). Hippocrates of Kos, the Father of Clinical Medicine, and Asclepiades of Bithynia, the Father of Molecular Medicine. *In Vivo, 23*(4), 507-514.

25. Larwood, J., & Hotten, J.C. (1875). *The history of signboards. From the earliest times to the present day*. (pp. 341-342). Chatto and Windus, London.

26. Correspondance complète et autres écrits de Guy Patin edited by Loïc Capron-Paris. (2018). *Bibliothèque interuniversitaire de santé*. À Charles Spon, April 29, 1644. Note 47. Retrieved from https://www.biusante.parisdescartes.fr/patin/?do=pg&let=0104&cln=47.

27. Tajadod, H. (2014). Paracelsus, the founder of chemical therapeutic who initiated the application of chemistry to life. *Basic Sciences of Medicine, 3*, 60-62.

28. Donaldson, I.M.L. (2016). van Helmont's proposal for a randomised comparison of treating fevers with or without bloodletting and purging. *Journal of the Royal College of Physicians of Edinburgh, 46*, 206-213.

29. Kuriyama, S. (1995). Interpreting the history of bloodletting. *Journal of the History of Medicine and Allied Sciences, 50*(1), 11-46.

30. Olsan, L.T. (2003). Charms and prayers in medieval medical theory and practice. *Social History of Medicine, 16*, 343-366.

31. Dossey, L. (2013). The royal touch: a look at healing in times past. *Explore, 9*, 121-127.

32. Comrie, J.D. (1910). Early knowledge regarding phthisis. Edinburg. Retrieved from https://www.ncbi.nlm.nih.gov/pmc/articles/PMC5254742/pdf/edinbmedj73988-0023.pdf.

33. Maclennan, W.J. (2002). Illness without doctors: medieval systems of healthcare in Scotland. The *Journal of the Royal College of Physicians of Edinburgh, 32*(1), 59-67.

34. Rogers, T. (1691). Samuel 2:6: (p. 11). *Practical Discourses on Sickness & Recovery*. London: Thomas Parkhurst.
35. Newton, H. (2015). 'Nature Concocts & Expels': The Agents and Processes of Recovery from Disease in Early Modern England. *Social History of Medicine, 28*(3), 465-486. doi: 10.1093/shm/hkv022.
36. The Editors of Encyclopaedia Britannica. (2022). Thomas Sydenham. Encyclopedia Britannica. Retrieved from https://www.britannica.com/biography/Thomas-Sydenham.
37. Cummins, S.L. (1946). Phthisis in the Seventeenth Century. *Proceedings of the Royal Society of Medicine, 39*, 629-632.
38. Ishizuka, H. (2012). 'Fibre body': the concept of fibre in eighteenth-century medicine, c.1700-40. *Medical History, 56*(4), 562-584. doi: 10.1017/mdh.2012.74.
39. Furhad, S., & Bokhari, A.A. (2022). Cupping Therapy. *StatPearls*. Retrieved from https://www.ncbi.nlm.nih.gov/books/NBK554545/.
40. Davis, A., & Appel, T. (1979). Bloodletting instruments in the National Museum of History and Technology. *Smithsonian Institution Press.*
41. Banerjee, A.K. (1989). John Keats: his medical student years at the United Hospitals of Guy's and St Thomas' 1815-1816. *Journal of the Royal Society of Medicine, 82*(10), 620-621. doi: 10.1177/014107688908201019.
42. Smith, H. (2004). The Strange Case of Mr. Keats's Tuberculosis. *Clinical Infectious Diseases, 38*(7), 991-993. doi: 10.1086/381980.
43. Coxe, J.R. (1846). *Writings of Hippocrates and Galen*. Lindsey and Blakiston, Philadelphia.
44. Grace, P.A. (2021). Therapeutic bloodletting in Ireland from the medieval period to modern times. *Proceedings of the Royal Irish Academy: Archaeology, Culture, History, Literature, 121*, 227-248. Retrieved from Project MUSE.
45. Davis, A., & Appel, T. (1979). Bloodletting instruments in the National Museum of History and Technology. *Smithsonian Studies in History and Technology, 41*, 10-15.
46. Brain, P. (1986). *Galen on Bloodletting: A Study of the Origins, Development and Validity of his Opinions, with a Translation of the Three Works*. Cambridge University Press.
47. Durrant, C.M. (1843). On the nature, diagnosis, and treatment of incipient phthisis. *Boston Medical and Surgical Journal, 28*, 449-453.
48. Laënnec, R. T. H. (1827). *Treatise of the Diseases of the Chest and on mediate auscultation*. Translated by Forbes, J. London: T&G Underwood.
49. Seigworth, G. S. (1980). Bloodletting Over the Centuries. *New York State Journal of Medicine,* Dec, 2022-2028. Retrieved from www.pbs.org/wnet/redgold/basics/bloodlettinghistory.html.
50. Chaddock, A. Leeches: An early Nineteenth-century obsession. Retrieved from https://oldoperatingtheatre.com/leeches-an-early-nineteenth-century-obsession/.
51. Soth, A. (April 18, 20). Why did the Victorians harbor warm feelings for leeches. *JSTORE Daily*. Retrieved from https://daily.jstor.org/why-did-the-victorians-harbor-warm-feelings-for-leeches/.

52. Greenstone, G. (2010). The history of bloodletting. *BCMJ*, *52*(1), 12-14.

53. Morabia, A. (2006). Pierre-Charles-Alexandre Louis and the evaluation of bloodletting. *J R Soc Med*, *99*, 158-160. doi:10.1258/jrsm.99.3.158

54. Edgecumbe, R. (1909). *Byron: The last phase*. 163. Charles Schribner's Sons, New York.

55. Trousseau, A. (1867). Lectures on clinical medicine, delivered at the Hôtel-Dieu, Paris, volume 1 (Hardwicke, R., *trans*. pp. 665-668). London: Bazire PV.

56. Hempel, C. J. (1859). *Materia Medica and Therapeutics for the use of practitioners and students of medicine*, (p. 216). Philadelphia: Radde publisher.

57. Sullivan, R. (1994). Sanguine Practices: A Historical and Historiographic Reconsideration of Heroic Therapy in the Age of Rush. *Bulletin of the History of Medicine*, *68*(2), 211-234. Retrieved from http://www.jstor.org/stable/44444366.

58. Niebyl, P. H. (1977). The English bloodletting revolution. Or modern medicine before 1850. *Bulletin of the History of Medicine*, *51*(3), 464–483. Retrieved from http://www.jstor.org/stable/44451270.

59. Morabia, A. (2006). Pierre-Charles-Alexandre Louis and the evaluation of bloodletting. *J R Soc Med*, *99*(3), 158-160. doi:10.1258/jrsm.99.3.158

60. King, L. S. (1961). The bloodletting controversy: a study in the scientific method. *Bull Hist Med*, *35*, 1–14.

61. Morabia, A. (1996). P.C.A. Louis and the birth of clinical epidemiology. *Clin Epidemiol*, *49*, 1327-1333.

62. Louis, P. C. A. (1828). Recherche sur les effets de la saigne´e dans plusieurs maladies inflammatoires. *Arch Gen Med*, *21*, 321–336.

63. Louis, P. C. A. (1835). *Recherches Sur Les Effets De La Saignée Dans Quelques Maladies Inflammatoires Et Sur L'action De L'émétique Et Des Vésicatoires Dans La Pneumonie*, (p.23). Librairie de l'Académie royale de médecine, Paris.

64. Hughes, B. J. (1866). Observations on the restorative treatment of pneumonia. *Br Med J*, *1*, 627–630. http://dx.doi.org/10.1136/ bmj.1.285.627.

65. Foucault, M. (1994). *Birth of the Clinic: An archeology of medical perception*. Vintage Books, New York.

66. Jones, A. W. (2011). Early drug discovery and the rise of pharmaceutical chemistry. *Drug Test Anal*, *3*(6), 337-344. doi:10.1002/dta.301.

CHAPTER 9: BEWARE (OF KISSING)

1. Robin, A. (1919). On the mortality from tuberculosis in France. *Bulletin general de therapeutique*, November 23rd.

2. Bryan, C. S. (2019). New observations support William Osler's rationale for systemic bloodletting. *Proc (Bayl Univ Med Cent)*, *32*(3), 372-376. doi:10.1080 /08998280.2019.1615331

3. Osler, W. (1892). *Principles and Practice of Medicine* (p. 530), 1st ed. London & New York: Appleton & Co.

4. Barnes, D. S. (1995). *The Making of a Social Disease: Tuberculosis in Nineteenth-Century France*. University of California Press, Berkeley. Retrieved from http://ark.cdlib.org/ark:/13030/ft8t1nb5rp/.
5. Glasscheib, H. S. (1964). *The March of Medicine*. Putnam's Sons, New York.
6. Kubba, A. K., & Young, M. (1998). The long suffering of Frederic Chopin. *Chest, 113*, 210-216.
7. Liebson, P. R. (2021). Dr. Edward Livingston Trudeau and aeration of the white plague. *Hekint*. Retrieved from https://hekint.org/2021/10/01/dr-edward-livingston-trudeau-and-aeration-of-the-white-plague/.
8. Grancher, J. (1898). Sur la prophylaxie de la tuberculose. *Bulletin de l'Académie de Médecine, 3rd series, 39*(470), 478-479.
9. Mitchell, A. (1988). Obsessive questions and faint answers: the French response to tuberculosis in the belle epoque. *Bull Hist Med, 62*(2), 215-235.
10. Report by Gustave Lagneau. (1889). Séance du 24 décembre 1889. *Bulletin de L'Académie de Médecine, 22*, 688-695.
11. Poncelet, S. (2020). *Le dispensaire antituberculeux ou la difficile émergence d'un etablissement prophylactique (1901-1943)* (Thesis for Doctorate in History, presented September 14, 2020, p. 75).
12. Coker, R. J. (2000). Fevered lives: tuberculosis in american culture since 1870. *BMJ, 320*(7246), 1412. doi:10.1136/bmj.320.7246.1412.
13. Ott, K. (1996). *Fevered Lives: Tuberculosis in American Culture since 1870*. Cambridge, Massachusetts: Harvard University Press.
14. Curtis, V. A. (2007). Dirt, disgust and disease: a natural history of hygiene. *J Epidemiol Community Health, 61*(8), 660-664. doi:10.1136/jech.2007.062380.
15. Statement by Emile Dubois, CMP. (1897, March 31). Proces-verbauz.
16. Risse, G. B. (1999). Human bodies revealed: Hospitals of post-revolutionary Paris. *In Mending Bodies, Saving Souls: A history of Hospitals* (Ch. 6, pp. 289-339). Oxford University Press, New York. Retrieved from https://www.researchgate.net/publication/303121113_Human_Bodies_Revealed_Hospitals_of_Post-Revolutionary_Paris.
17. Robin Albert. (1919). On the mortality from tuberculosis in France. *Bulletin general de therapeutique.*
18. Séance du 31 mai 1898. (1898). *Bulletin de L'Académie de Médecine, 39*, 628-635.
19. Barnes, D. S. (1995). *The Making of a Social Disease: Tuberculosis in Nineteenth-Century France*, p.16. University of California Press, Berkeley.
20. Fuster, E. M. (1903). La Tuberculose, Maladie Sociale. Societé de Médecine Publique et de Génie Sanitaire, Séance du 25 Novembre, 1903. In *Revue D'Hygiène et de Police Sanitaire*, p.27. Masson et Cie, Eds, Paris.
21. France, Assemblée Nationale, Chambre des deputés. (1915). *Documents parlementaires, Annex 535*, January 19, 1915, p. 58.
22. Barnes, D. S. (1995). *The Making of a Social Disease: Tuberculosis in Nineteenth-Century France*. Berkeley: University of California Press. Retrieved from http://ark.cdlib.org/ark:/13030/ft8t1nb5rp/.

23. Landouzy, L. (1903). *La Tuberculose Maladie Sociale*. 23. Levallois-Perret, Paris.
24. Barnes, D. S. (1995). *The Making of a Social Disease: Tuberculosis in Nineteenth-Century France*. (pp. 93-94). Berkeley: University of California Press. Original citation from Paul Cuq. "Le Baiser et ses dangers au point de vue de la tuberculose," La Medication Martiale: Journal d'études cliniques et thérapeutiques (H. Schaffner Dir.) 1904;479-481.

CHAPTER 10: WAKE UP !

1. Walensky, R. (2023). A letter from Rochelle P. Walensky, CDC Director, on World Tuberculosis Day, March 24, 2023. Retrieved from https://www.cdc.gov/tb/publications/letters/2023/dr-walensky-wtbd.html. Accessed October 15, 2023.
2. Gandy, M., & Zumla, A. (2003). *The Return of the White Plague: Global Poverty and the 'New' Tuberculosis* (Epilogue, p. 237). New York: Verso.
3. Global tuberculosis report 2021. Geneva: World Health Organization; 2021. License: CC BY-NC-SA 3.0 IGO.
4. World Health Organization. (2021). *Global tuberculosis report 2021*. Geneva. Retrieved from https://www.who.int/news-room/fact-sheets/detail/tuberculosis.
5. Houben, R. M., & Dodd, P. J. (2016). The Global Burden of Latent Tuberculosis Infection: A Re-estimation Using Mathematical Modelling. *PLoS Medicine*, *13*(10), e1002152. doi:10.1371/journal.pmed.1002152.
6. Gandy, M., & Zumla, A. (2003). *The Return of the White Plague: Global Poverty and the 'New' Tuberculosis* (Introduction, p. 9). New York: Verso.
7. Chandra, P., Grigsby, S. J., & Philips, J. A. (2022). Immune evasion and provocation by Mycobacterium tuberculosis. *Nature Reviews Microbiology, 20*, 750–766. doi:10.1038/s41579-022-00763-4.
8. Editorial. (2019). End the tuberculosis emergency: a promise is not enough. *The Lancet, 394*, 1482.
9. Bloom, B. R., Atun, R., Cohen, T., et al. (2017). Tuberculosis. In K. K. Holmes, S. Bertozzi, B. R. Bloom, et al. (Eds.), *Major Infectious Diseases* (3rd ed., Chapter 11). Washington, D.C.: The International Bank for Reconstruction and Development / The World Bank. doi:10.1596/978-1-4648-0524-0_ch11.
10. Murray, C., Styblo, K., & Rouillon, A. (1990). Tuberculosis in developing countries: burden, intervention and cost. *Bulletin of the International Union against Tuberculosis and Lung Disease, 65*, 6.
11. Berger, H. W., & Mejia, E. (1973). Tuberculous pleurisy. *Chest, 63*, 88-92.
12. Berger, H. W., & Mejia, E. (1973). Tuberculous pleurisy. *Chest, 63*, 88-92.
13. Horsburg, C. R., & Rubins, E. J. (2011). Latent tuberculosis infection in the United States. *New England Journal of Medicine, 364*, 1441-1448.
14. Grosset, J. (2003). Mycobacterium tuberculosis in the extracellular compartment: an underestimated adversary. *Antimicrobial Agents and Chemotherapy, 47*(3), 833-836. doi:10.1128/AAC.47.3.833-836.2003.

15. Puccini, G. (1952). *La Bohème. Libretto, Acte IV (Rodolfo). Capitol Records (Translation William Weaver)*. Retrieved from http://www.murashev.com/opera/La_bohème_libretto_Italian_English.

16. Tiemersma, E. W., van der Werf, M. J., Borgdorff, M. W., Williams, B. G., & Nagelkerke, N. J. (2011). Natural history of tuberculosis: duration and fatality of untreated pulmonary tuberculosis in HIV-negative patients: a systematic review. *PLoS One, 6*(4), e17601. doi:10.1371/journal.pone.0017601.

17. Kiazyk, S., & Ball, T. B. (2017). Latent tuberculosis infection: An overview. *Canada Communicable Disease Report, 43*(3-4), 62-66. doi:10.14745/ccdr.v43i34a01.

18. Gill, W. P., Harik, N. S., Whiddon, M. R., Liao, R. P., Mittler, J. E., et al. (2009). A replication clock for Mycobacterium tuberculosis. *Nature Medicine, 15*, 211–214.

19. Young, D. B., Gideon, H. P., & Wilkinson, R. J. (2009). Eliminating latent tuberculosis. *Trends Microbiol. 17*(5):183-188.

20. Campbell, M. C., & Tishkoff, S. A. (2008). African Genetic Diversity: Implications for human demographic history, modern human origins, and complex disease mapping. *Annu Rev Genomics Hum Genet, 9*, 403-433.

21. Comas, I., & Gagneux, S. (2009). The past and future of tuberculosis research. *PLoS Pathogens, 5*(10), e1000600. doi:10.1371/journal.ppat.1000600.

22. Ai, J. W., Ruan, Q. L., Liu, Q. H., et al. (2016). Updates on the risk factors for latent tuberculosis reactivation and their managements. *Emerging Microbes & Infections, 5*(1), 1-8. doi:10.1038/emi.2016.10.

23. Shea, K. M., Kammerer, J. S., Winston, C. A., Navin, T. R., & Horsburgh, C. R. Jr. (2014). Estimated rate of reactivation of latent tuberculosis infection in the United States, overall and by population subgroup. *American Journal of Epidemiology, 179*(2), 216-225. doi: 10.1093/aje/kwt246.

24. Souders, C. R., & Smith, A. T. (1952). The Clinical Significance of Hemoptysis. *The New England Journal of Medicine, 247*, 790-793.

25. Seedat, U. F., & Seedat, F. (2018). Post-primary pulmonary TB haemoptysis - When there is more than meets the eye. *Respiratory Medicine Case Reports, 25*, 96-99. doi: 10.1016/j.rmcr.2018.07.006.

26. Centers for Disease Control and Prevention. (n.d.). TB in specific populations. Retrieved from https://www.cdc.gov/tb/topic/populations/default.htm.

27. Bodington, G. (1840). An essay on the treatment and cure of pulmonary consumption (pp. 10-13). Longman, Orme, Brown, Green, and Longmans.

28. Lomax, E. (1977). Heredity or acquired disease? Early nineteenth century debates on the cause of infantile scrofula and tuberculosis. *Journal of the History of Medicine and Allied Sciences, 32*(4), 356-374.

29. Zimmer, A. J., Klinton, J. S., Oga-Omenka, C., et al. (2022). Tuberculosis in times of COVID-19. *Journal of Epidemiology and Community Health, 76*, 310-316.

30. Walensky, R. (2022). A letter from Rochelle P. Walensky, CDC Director, on World TB Day. Retrieved from https://www.cdc.gov/tb/publications/letters/2022/dr-walensky-wtbd.html.

31. Colt, H., & Murgu, S. (2012). *Bronchoscopy and Central Airway Disorders: A Patient-Centered Approach.* (pp. 53-63). Elsevier, Philadelphia.

32. Migliori, G. B., Loddenkemper, R., Blasori, F., et al. (2007). 125 years after Robert Koch's discovery of the tubercle bacillus: the new XDR-TB threat. Is "science" enough to tackle the epidemic? *European Respiratory Journal, 29*(3), 423-427. doi: 10.1183/09031936.00001307

33. Connel, D. W., Berry, M., Cooke, G., & Kon, O. M. (2011). Update on Tuberculosis: TB in the early 21st century. *European Respiratory Review, 120,* 71-84.

CHAPTER 11: SURVIVING TUBERCULOSIS

1. Santos, A. P. (2018, October 11). Surviving tuberculosis. Rappler. Retrieved from https://www.rappler.com/science/214074-survivors-human-face-tuberculosis/.

2. Montaigne, M. (2003). *The Complete Works* (*trans.* D. M. Frame). Everyman's Library, (p. 70.) Alfred A. Knopf, New York.

3. World Health Organization. (2020). Global Tuberculosis Report 2020. Geneva. License: CC BY-NC-SA 3.0 IGO.

4. Lee-Rodriguez, C., Wada, P. Y., Hung, Y., & Skarbinski, J. (2020). Association of Mortality and Years of Potential Life Lost With Active Tuberculosis in the United States. *JAMA Network Open, 3*(9), e2014481. doi: 10.1001/jamanetworkopen.2020.14481.

5. Romanowski, K., Baumann, B., Basham, C. A., Ahmad Khan, F., Fox, G. J., & Johnston, J. C. (2019). Long-term all-cause mortality in people treated for tuberculosis: a systematic review and meta-analysis. *The Lancet Infectious Diseases, 19,* 1129-1137. doi: 10.1016/S1473-3099(19)30309-3.

6. Loveday, M., Hlangu, S., Larkan, L. M., Cox, H., Daniels, J., Mohr-Holland, E., & Furin, J. (2021). "This is not my body": Therapeutic experiences and post-treatment health of people with rifampicin-resistant tuberculosis. *PLoS One, 16*(10), e0251482. doi: 10.1371/journal.pone.0251482.

7. Rachow, A., Ivanova, O., Wallis, R., et al. (2019). TB sequel: incidence, pathogenesis and risk factors of long-term medical and social sequelae of pulmonary TB - a study protocol. *BMC Pulmonary Medicine, 19,* 4. doi: 10.1186/s12890-018-0777-3.

8. World Health Organization. (n.d.). Tuberculosis fact sheet. Retrieved from https://www.who.int/en/news-room/fact-sheets/detail/tuberculosis.

9. Allwood, B., van der Zalm, M., Makanda, G., & Mortimer, K. (2019). The long shadow post-tuberculosis. *The Lancet Infectious Diseases, 19,* 1170-1171.

10. Alexandre, N. (1993). Biographical notes, Margherita Garsin-Modigliani. In *The Unknown Modigliani: Drawings from the Collection of Paul Alexandre* (p. 28). Harry N. Abrams, New York.

11. Modigliani, J. (1958). *Modigliani: Man and Myth* (p. 50). The Orion Press, New York.

12. Maskell, N. A., & Light, R. W. (2016). Pleural Infections. In V. C. Broaddus, R. J. Mason, J. D. Ernst, T. E. King, S. C. Lazarus, J. F. Murray, J. A. Nadel, A. S. Slutsky, & M. B. Gotway (Eds.), *Murray and Nadel's Textbook of Respiratory Medicine (Sixth Edition)* (pp. 1425-1438). W.B. Saunders.

13. Berger, H. W., & Mejia, E. (1973). Tuberculous pleurisy. *Chest, 63,* 88-92.

14. Sakula, A. (1983). Carlo Forlanini, inventor of artificial pneumothorax for treatment of pulmonary tuberculosis. *Thorax, 38,* 326-332.

15. Sakula A. (1983). Carlo Forlanini, inventor of artificial pneumothorax for treatment of pulmonary tuberculosis. *Thorax. 38.* 326-332.

16. Mann, T. (1999). *The Magic Mountain* (*trans.* H.T. Lowe Porter). Vintage International, Canada.

17. Forlanini, C. (1906). Zur Behandlung der Lungenschwindsucht durch kunstliche erzeugten Pneumothorax. *Deutsche Medizinische Wochenschrift, 32,* 1401-1405.

18. Forlanini, C. (1934). A Contribution to the Surgical Therapy of Phthisis: Ablation of the Lung? Artificial Pneumothorax? *Gazetta degli Ospedali e delle cliniche di Milano,* August 23, 1882, year III, No. 68, p. 537 and, 3, 537 and 585, 601, 609, 617, 625, 651, 865, 689, 705.

19. Hansson, N., & Polianski, I. J. (2015). Therapeutic Pneumothorax and the Nobel Prize. *Annals of Thoracic Surgery, 100*(2), 761-765. doi:10.1016/j.athoracsur.2015.03.100

20. Caciora, S. V. A., & Abrudan, I. O. (2013). Sleepless nights: the experience of narcotics in the Parisian artistic environment during the great period of the early twentieth century. *European Journal of Science and Theology, 9,* 185-194.

21. Inglis, L. (2019). *Milk of Paradise: A history of opium.* Heroic Chic, HIV, and Generation Oxy. Picador (MacMillan).

22. Hodgson, B. (2001). *In the arms of Morpheus: The tragic history of Laudanum, Morphine, and Patent medicines.* Firefly Books, New York.

23. Eddy, N. M., Friebel, H., Hahn, K. J., & Halbach, H. (1968). Codeine and its alternates for pain and cough relief. *Bulletin of the World Health Organization, 38,* 673-741.

24. Scott, I. (2014). Heroin: A Hundred-Year Habit. History Today, 48(6). Retrieved from http://www.historytoday.com/ian-scott/heroin-hundred-year-habit.

25. Hakosalo, H. (2020). Lust for life: Coping with tuberculosis in late nineteenth-century Europe. *Medical History, 64*(4), 516–532. doi:10.1017/mdh.2020.43.

26. Martini, M., Barberis, I., Bragazzi, N., & Paluan, F. (2017). The Fight Against Tuberculosis in the Mid-nineteenth Century: The Pivotal Contribution of Edoardo Maragliano (1849–1940). In *Advances in Experimental Medicine and Biology, 1057,* 125.

27. DeWitt, L. M. (1918). The Use of Gold salts in the Treatment of Experimental Tuberculosis in Guinea pigs: XVIII. Studies on the Biochemistry and Chemotherapy of Tuberculosis. *The Journal of Infectious Diseases, 23,* 426-437.

28. Riva, M. (2014). From milk to rifampicin and back again: History of failures and successes in the treatment for tuberculosis. *Journal of Antibiotics, 67,* 661–665.

29. The Eclectic Medical Journal. (1887, August). Bergeon's gaseous enemata for Phthisis. Scudder JM (Eds.).
30. Smith, B. (1985). Gullible's Travails: Tuberculosis and Quackery 1890-1930. *Journal of Contemporary History, 20*(4), 733-756.
31. Riva, M. (2014). From milk to rifampicin and back again: history of failures and successes in the treatment for tuberculosis. *J Antibiot. 67*. 661–665. https://doi.org/10.1038/ja.2014.108
32. Bryder, L. (2014). The Medical Research Council and treatments for tuberculosis before streptomycin. *Journal of the Royal Society of Medicine, 107*(10), 409-415. doi:10.1177/0141076814548663
33. The Tuberculosis Congress at Naples. (1900, May 19). *British Medical Journal, 1*(2055), 1250-1252.
34. Earl, M. (n.d.). John Keats: «La Belle Dame sans Merci.» Retrieved from https://www.poetryfoundation.org/articles/69748/john-keats-la-belle-dame-sans-merci.

CHAPTER 12: RX: SANATORIUMS

1. Bethune, N (1934). 'The T.B.'s Progress,' *The Fluoroscope* 1, no. 7 (15 August, 1932), Bethune's contemplations about his stay at the Trudeau Sanatorium in 1927. From, Hannant, L. (2017). *The Politics of Passion: Norman Bethune's Writing and Art*, p. 32. University of Toronto Press.
2. Landau, E. (1995). *Tuberculosis*. A Venture Book (Franklin Watts), New York.
3. Rosenblatt, M. B. (1973). Pulmonary tuberculosis: Evolution of modern therapy. *Bulletin of the New York Academy of Medicine, 49*(3), 163-196.
4. Bodington, G. (1840). An essay on the treatment and cure of pulmonary consumption. Longman, Orme, Brown, Green, and Longmans.
5. Castiglioni, A. (1933). *History of Tuberculosis*, Section 1. Medical Life, (PP. 50 & 81).
6. Barnes, D. S. (1995). *The Making of a Social Disease: Tuberculosis in Nineteenth-Century France*. University of California Press. Retrieved from http://ark.cdlib.org/ark:/13030/ft8t1nb5rp/.
7. Elylers, E. (2014). Planning the nation: The sanatorium movement in Germany. *The Journal of Architecture, 19*(5), 667-692.
8. Ochsner-Pischel, M. (2005). Erfinder der Freiluftliegekur - Peter Dettweiler und die Lungenheilanstalt in Falkenstein im Taunus - Eine Würdigung zum 101. Todesjahr [Initiator of the open-air rest cure: Peter Dettweiler and the sanatorium at Falkenstein (Taunus) in Germany]. *Pneumologie.*
9. Les Hopitaux marins de Berk-Plage. (n.d.). Dossier IA62002963 | Réalisé par Laget Pierre-Louis (Rédacteur). Retrieved from https://inventaire.hautsdefrance.fr/dossier/les-hopitaux-marins-de-berck/bd328445-384b-440b-a92e-f5aac20cb86a.
10. Bani, W. (n.d.). Davos – From high-altitude sanatorium to a world-renowned holiday destination and economic capital. *Aspetar Journal*. Retrieved from https://www.aspetar.com/journal/viewarticle.aspx?id=294#.YvQahC-B3PU.

11. Warren, P. (2006). The Evolution of the Sanatorium: The First Half-Century, 1854-1904. *CBMH/BCHM, 23*(2), 457-476.
12. Manzini, E., & Di Mauro, S. (2012). In Dal Mal sottile alla tubercolosi resistente. *Un secolo di sanatori in Valtellina* (ed. Del Curto, D.), 39–43. Grafiche Rusconi, Bellano.
13. Osler, W. (1900). The Home Treatment of Consumption. *Maryland Medical Journal*, 43, 8-12.
14. Boseley, S. (2014, January 16). Heroin deaths in England and Wales reach highest number since records began. The Guardian.
15. Brown, L. (1903). An Analysis of 1500 Cases of Tuberculosis. *Chicago: American Medical Association.*

CHAPTER 13: INFLUENCERS

1. Lautréamont, Comte de. (1965). *Maldoror* (G. Werham, *trans.*). New Directions Publishing.
2. Werner, A. (1961). Modigliani as an art student. *Chicago Review, 14*(4), 103-112.
3. Secrest, M. (2011). *Modigliani: A life*. Alfred A. Knoff, New York.
4. Fifield, W. (1976). *Modigliani*. William Morrow, New York.
5. Werner, A. (1961). Modigliani as an art student. *Chicago Review, 14*(4), 103-112.
6. Modigliani, A. (n.d.). Lettera a Oscar Ghiglia, in Paolo D'Ancona, Cinque lettere giovanili di Amedeo Modigliani. *"L'Arté" XXXIII, maggio 1930,* 264.
7. Secrest M. (2011). *Modigliani: A life*. Alfred A. Knoff, New York. p. 70.
8. From Modigliani, A. (n.d.). Lettera a Oscar Ghiglia, in Paolo D'Ancona, Cinque lettere giovanili di Amedeo Modigliani. *"L'Arté" XXXIII, maggio 1930,* 264. *trans.* "Io scrivo per sfogarme con te e per affermarmi dinanzi a me stesso. lo stesso sono in preda allo spuntare e al dissolversi di energie fortissime," he wrote, adding "lo vorrei invece che la mia vita fosse come un fiume ricco di abbondanza che scorresse con gioia sulla terra. Tu sei ormai quello a cui posso dire tutto: ebbene io sono ricco e fecondo di germi ormai e ho bisogno dell'opera."
9. Rolleston, J. D. (1928). The History of Scarlet Fever. *The British Medical Journal, 2*(3542), 926-929.
10. Perera, T. B. (2022, May 1). Scarlet Fever. *National Library of Medicine StatPearls*. Retrieved from https://www.ncbi.nlm.nih.gov/books/NBK507889/.
11. Katz, A. R., & Morens, D. M. (1992). Severe Streptococcal Infections in Historical Perspective. *Clinical Infectious Diseases, 14*(1), 298-307.
12. Nicoïdski, C. (1989). *Modigliani* (pp. 46-49). Paris, France: Editions Plon.
13. Panzeri, L. (2005). Venice and the Biennale in the local dailies 1903-1905. In C. Parisot & Modigliani in Venice, between Leghorn and Paris (Eds.), *Modigliani in Venice, between Leghorn and Paris*, Catalogue (pp. 159-161). Sassari.
14. Payne, R. L. (2004). *A selection of modern Italian poetry in translation: Sergio Corazzini (Desolation of the poor sentimental poet) and Guido Gozzano (Absence)* (pp. 34-41). Montreal: McGill-Queen's University Press.

15. Bunyan, J. (1900). *The Life and Death of Mr. Badman* (p. 142). New York: R.H. Russell.
16. Lipchitz, J. (1954). *Amedeo Modigliani* (1884-1920). New York: Pocket Books, Harry N. Abrams, pub.
17. D'Ancona, P. (1930). Cinque letter Giovanili di Amedeo Modigliani. *L'Arte*, fasc. III (Turin, 1930, #3), 257-264. (Reproduced by A. Ceroni, Ed.). Milan: Edizioni del Milione.
18. Mauroner, F. (1955). *Acquaforte. Atti dell'Accademia di Scienze Lettere e Arti di Udine, 1951-1854*, series VI, volume XII, 304-344. Udine: Arti Grafiche Friulane.
19. D'Ancona, P. (1958). Cinque letter Giovanili di Amedeo Modigliani. *L'Arte*, fasc. III (Turin, 1930, #3), 257-264. "Da Venezia ho ricevuto gli insegnamenti più preziosi nella vita; da Venezia sembra di uscirmene adesso come accresciuto dopo un lavoro." (Reproduced by A. Ceroni, Ed.). Milan: Edizioni del Milione.
20. Nietzsche, F. (Year). *The Birth of Tragedy* (pp. 278-279). New York: The Modern Library.

CHAPTER 14: AMONG FUTURE GREATS

1. Brancusi, C. (1907). (*trans.* «Rien ne pousse à l'ombre des grands arbres»). Presumably said to to sculptor August Rodin's after Brancusi spent a month working in Rodin's atelier. Also, Mircea Goga, La Roumanie : Culture et civilization, (p. 289), Sorbonne PUPS, PARIS.
2. Douglas, C. (1941). *Artist Quarter*. London: Faber and Faber.
3. Meyers, J. (2006). *Modigliani, a life*. New York: Harcourt Press.
4. Sichel, P. (1967). *Modigliani, a biography*. New York: E. Dutton and Company.
5. Meidner, L. (1943). The Young Modigliani: Some Memories. *The Burlington Magazine for Connoisseurs*, 82(481), 87-91.
6. Rose, J. (1990). *Modigliani, The Pure Bohemian* (p. 51). New York: St. Martin's Press.
7. Meidner L. (1943). The Young Modigliani: Some Memories. *The Burlington Magazine for Connoisseurs*. 82(481). 87–91. *JSTOR*, http://www.jstor.org/stable/868534. Retrieved 26 Jul. 2022.
8. Frank R. (1951). "Cézanne and Redon." The Hudson Review. 4(2), 269–74. *JSTOR*, https://doi.org/10.2307/3856796. Retrieved 15 Dec. 2022.
9. Alexandre, N. (1993). *The Unknown Modigliani*, Drawings from the collection of Paul Alexandre. New York: Harry Abrams Inc, Fonds Mercator.
10. Doran, M., & Cezanne, P. (2001). *Conversations with Cezanne* (J. Gasguet, *trans.*) (M. Doran, Ed.), (p. 135). Berkeley: University of California Press. *Another person's advice...* The conversation supposedly took place in 1896. Gasguet actually published it in 1921.

CHAPTER 15: MODI'S 'CURSED' QUEST

1. Ellmann, R. (1987). *Oscar Wilde* (p. 44). New York: Alfred Knopf.
2. Rekland, T. (2006). Absinthe, the nervous system and painting. *In F. C. Rose (Ed.), The Neurobiology of Painting, International Review of Neurobiology*, vol. 74 (pp. 271-278). London: Elsevier.
3. Doris, L. (1995). *Absinthe: The Cocaine of the Nineteenth Century*. Jefferson, NC: McFarland & Company, Inc.
4. Warnod, J. (1972). *Washboat Days* (C. Green, *trans.*). New York: Orion Press, Grossman publishers.
5. Alexandre Noël. (1993). *The Unknown Modigliani. Drawings from the collection of Paul Alexandre* (p. 43). Harry N. Abrams Inc, New York. Fonds Mercator.
6. Alexandre Noël. (1993). *The Unknown Modigliani. Drawings from the collection of Paul Alexandre*. Harry N. Abrams Inc, New York. Fonds Mercator.
7. Richard, N. (2014). *Harris Lindsey*. Retrieved from http://www.masterdrawingsandsculptureweek.co.uk/exhibitors/richard-nathanson/.
8. Salmon, A. (1961). *A Memoir*. New York: G.P Putnam Sons.
9. Akhmatova, A., & Austin, U. (1989). Amedeo Modigliani. *The Threepenny Review, 38*, 29-30.
10. Booth, M. (2003). *Cannabis: a history*. Great Britain: Doubleday, Picador USA.
11. De Stefani, A. (2020). Un contributo per il giovane Modigliani: il mistero Maud Abrantès. Ricerche di storia dell' arte. Conceptual Art/Arte Povera. *Politiche e mercato negli anni Settanta, 132*, 93-107.
12. Berkowits, I., Fraquelli, S., & King A. (2022). *Modigliani Up Close. Buckley B, Fraquelli S, Ireson M. and King A Eds*, Catalogue from The Barnes Foundation, Yale University Press. New Haven (pp. 38-43).
13. Diogo de Macedo. (1930). *Cité Falguière*, Lisbon: Seara Nova.
14. Meidner, L. (1943). The Young Modigliani: Some Memories." *The Burlington Magazine for Connoisseurs, 82* (481), 88. *JSTOR*, http://www.jstor.org/stable/868534. Retrieved 26 Jul. 2022
15. Lautréamont. (1943). *Poésies*. From, Maldoror, *trans*. Guy Wernham, New Directions Publishing, New York.
16. Werner, A. (1961). Modigliani as an art student. *Chicago Review. 14*(4), 103-112.
17. Cocteau, J. (1968). *Opium: The diary of his cure*. Peter Owen, London, [1930] (*trans*. M Crosland and S Road). (p. 36).
18. Olivier, F. (1933). *Picasso et ses amis*. Paris, Stock, (pp. 56-57).
19. Olivier, F. (2001). *Loving Picasso: The private journal of Fernande Olivier*. Harry N. Abrams, publisher, New York. (pp. 215-216).
20. Bajac, E. R. (2009). *Les Paradis Perdus*. La Société française de l'entre-deux-guerres et la question des drogues. Presses Universitaires de Rennes. (pp. 29-74). Available on the Internet: <http://books.openedition.org/pur/126045>. ISBN: 9782753566958. DOI: https://doi.org/10.4000/books.pur.126045.

21. Brouadel, P. (1906). *Opium, Morphine, et Cocaine: intoxication aigue par l'Opium, mangeurs et fumeurs d'Opium, morphinomanes et cocaïnomanes.* Librairie JB Baillière et Fils, Paris.

22. Richardson, B. W. (1828-1896). On ether-drinking and extra-alcoholic intoxication. *The Gentleman's Magazine,* (pp. 452-458). Wellcome Collection. https://wellcomecollection.org/works/r3rn6s7q.

23. Duncum, B.M. (1946). Ether anaesthesia: 1842-1900. *Postgrad Med J.,* *22*(252), 280-90. doi: 10.1136/pgmj.22.252.280. PMID: 20276652; PMCID: PMC2478430. https://www.ncbi.nlm.nih.gov/pmc/articles/PMC2478430/pdf/postmedj00647-0015.pdf

24. Lorrain, J (2016). *Nightmares of an ether-drinker.* Translation and Introduction by Brian M. Stableford. Snuggly Books, United Kingdom.

25. Warren, R. (2020). *Max Jacob: a life in art and letters* (pp. 130-131). New York: W.W. Norton.

26. Douglas, C. (1941). *Artist Quarter* (pp. 53-55). London: Faber and Faber.

27. Shingler, K. (2012). Saints and Lovers: Myths of the Avant-Garde in Michel Georges-Michel's Les Montparnos. *French Cultural Studies, 23*(1), 17–29. doi: 10.1177/0957155811427631.

28. McBride, C. A. (n.d.). The Modern Treatment of Alcoholism and Drug Narcotism. Bibliolife.

29. Quoted in Ceroni, A. (1958). Amedeo Modigliani, peintre (p. 17). (R. Nathanson, *trans.*). Retrieved from https://richardnathanson.co.uk/publications/30/.

30. Hall, D. (1993). *Modigliani.* London: Phaidon Press.

31. Survage, L. (1947). My speech on Modigliani in Paris, 1947. *Archive Collection, Finnish National Gallery.* Retrieved March 3, 2023, from https://research.fng.fi/2016/11/28/article-my-speech-on-modigliani-in-paris-in-1947/.

32. Cocteau, J. (1950). *Modigliani.* (p. 4). Paris, Fernand Hazan (Eds.).

33. Rose, J. (1990). *Modigliani, The Pure Bohemian* (pp. 121, 231). New York: St. Martin's Press.

34. Heinich, N. (1999). Paradigme ou modèle: Les héririés de Van Gogh et les paradoxes de l'authenticité. RACAR: revue d'art Canadienne / *Canadian Art Review, 26*(1/2), 69-72.

CHAPTER 16: STONES

1. Modigliani, Amedeo (1908). Extract from a letter to his brother Umberto. *Amedeo Modigliani Lettres et Notes,* (compiled and edited by Olivier Renault, French translation from orig. edition *Le Lettere,* Milan, Abscondita, 2006). Les Éditions Mille et Une Nuits, Librairie Artheme Fayard, Paris, 2020, (p. 31).

2. Brancusi, C. (n.d.). La Baronne R.F. Retrieved from https://www.centrepompidou.fr/en/ressources/oeuvre/cpjb5k.

3. Zadkine, O. (1930). *Souvenirs.* Paris Montparnasse, (p. 12).

Endnotes

4. Jain sculptures, which antedate Buddhism and Hinduism, are also known as "Tirthankaras." Carved figures are usually shown sitting like yogis in the lotus position. Their faces project serenity and wisdom. See Diogo de Macedo. (1930). *Cité Falguière*. 14. (pp. 441-42 and 54-55), Lisbon: Seara Nova.

5. Modigliani, J. (1958). *Modigliani: Man and Myth* (pp. 107-108). New York: The Orion Press.

6. Piccioni L, Ceroni, A. (1970). *I dipinti de Modigliani* (Cat. N°12), Rizzoli Editore, Milan. Also see https://commons.wikimedia.org/wiki/Amedeo_Modigliani_catalogue_raisonné,_1970_Ceroni.

7. Genty-Vincent, A., Laval, E., Senot, M.-A., & Menu, M. (2020). Modigliani's studio practice revealed by MA-XRF and non-invasive spectral imaging techniques. *X-Ray Spectrom,* 1-9. https://doi.org/10.1002/xrs.3211.

8. *Les Secrets de Modigliani*: *Techniques et pratiques artistiques d'Amedeo Modigliani.* (2022). Éditions invenit, Lille.

9. Fontoura, P., & Menu, M. (2022). Exploration visuelle des peintures d'Amedeo Modigliani: étude d'occulomotricité. In *Les Secrets de Modigliani*: Techniques et pratiques artistiques d'Amedeo Modigliani (pp. 177-185). Éditions invenit, Lille.

10. Jean Alexandre to Paul Alexandre, May 28, 1909, translated in Richard Nathanson, "Amedeo Modigliani: The Final Known Study for L'Amazone, 1909," Retrieved from https://richardnathanson.co.uk/publications/25/ on March 11, 2023.

11. Ceroni, A. (1965). *Amedeo Modigliani: Dessins et Sculptures*. Edizioni Del Milione, Milan.

12. Fergonzi, F. (2013). *Filologia del 900: Modigliani, Sironi, Morandi, Martini*. Mondadori Electra, Milan.

13. De Stefani, A. (2022). Modigliani's sculptures: Toward a new timeline. *In B. Buckley, S. Fraquelli, M. Ireson, & A. King (Eds.), Modigliani Up Close*. Catalogue from The Barnes Foundation (pp. 13-23). Yale University Press, New Haven.

14. Hochart, C., Genty-Vincent, A., Coquinot, Y., & Menu, M. (2022). Etude des traces d'outils et des pierres de trois sculptures de Modigliani. In *Les Secrets de Modigliani*: Techniques et pratiques artistiques d'Amedeo Modigliani (pp. 125-135). Éditions invenit, Lille.

15. Brown, R. (2019). Amedeo Modigliani's Tête, 1911-1912. In, Impressionist and Modern Art, Evening Sale (June 18, 2019), New York (p. 27). Christies. Retrieved from https://www.christies.com/features/Lot-31-A-Modigliani-Tete-9820-6.aspx on January 9, 2023.

16. De Stefani, A. (2015). Modigliani alla Cité Flaguière: la prima fase della scultura nel suo contesto immediato. *Studiolo*, 12, 242-267.

17. Werner, A. (1985). *Modigliani*. Harry N. Abrams, New York.

18. Buckley, B., Fraquelli, S., Ireson, M., & King, A. (Eds.). (2022). *Modigliani Up Close: Carving a niche*. Catalogue from The Barnes Foundation (pp. 108, 89-122). Yale University Press, New Haven.

19. Buckley, B., Fraquelli, S., Ireson, M., & King, A. (Eds.). (2022). *Modigliani Up Close: Carving a niche*. Catalogue from The Barnes Foundation (pp. 108, 89-122). Yale University Press, New Haven.

20. Ceroni, A. (1965). *Amedeo Modigliani: Dessins et Sculptures*. Edizioni Del Milione, Milan.

21. Brown, R. (June 18, 2019). Amedeo Modigliani's *Tête*, 1911-1912. *Impressionist and Modern Art, Evening Sale*, New York, Christies, 27. https://www.christies.com/features/Lot-31-A-Modigliani-Tete-9820-6.aspx. Retrieved January 9, 2023.

22. De Stefani, A. (2022). Modigliani's sculptures" Toward a new timeline. *Modigliani Up Close*. Buckley B, Fraquelli S, Ireson M. and King A Eds. Catalogue from The Barnes Foundation, Yale University Press, New Haven. (pp. 13-23).

23. Schuster, B., & Pfannstiel, A. S. (1986). *Modigliani: A study of his sculpture*. Bibliothèque Modigliani Centennial Edition. NAMEGA Corp, USA. (pp. 39-51).

24. De Stefani, A. (2022). Modigliani's sculptures" Toward a new timeline. *Modigliani Up Close*. Buckley B, Fraquelli S, Ireson M. and King A Eds. Catalogue from The Barnes Foundation, Yale University Press, New Haven. (pp. 13-23).

CHAPTER 17: ANNA

1. Akhmatova, A. *My Half-Century: selected prose* (1997). Amedeo Modigliani, (p. 76), Bolshevo 1958–Moscow 1964 (translated by Christopher Fortune). Ed. Ronald Meyer, Northwestern University Press, Evanston, IL.

2. Akhmatova, A. *My Half-Century: selected prose* (1997). Ed. Ronald Meyer, (p. 2). Northwestern University Press, Evanston, IL.

3. Chukovskaya, L. *The Akhmatova Journals* Volume I, 1938-1941 (1994). Translated by Milena Michalski and Sylva Rubashova, (p. 73). Farrar, Straus & Giroux, New York.

4. Chukovskaya, L. *The Akhmatova Journals* Volume I, 1938-1941 (1994). Translated by Milena Michalski and Sylva Rubashova, (p. 119). Farrar, Straus & Giroux, New York.

5. Akhmatova, A. (2004). *The word that causes death's defeat: Poems of memory:* Translated, with an introductory biography, critical essays, and commentary by Nancy K. Anderson (p. 7). Yale University Press, New Haven.

6. Hemschemeyer, J. (1990). from *The Complete Poems of Anna Akhmatova: Translator's Introduction. Agni, 29/30*(1990), (pp. 174–192). Retrieved from http://www.jstor.org/stable/23008721 on March 15, 2023.

7. Tyrkova-Vil'iams, A (1989). *A. teni minuvshego*, quoted in A. Akhmatova, Desiatye gody, ed. R.D. Timenchik (Moscow), (p. 30).

8. Akhmatova, A. (2018). Memories of Modigliani. Archives of The London Magazine (translated by B. Wall). *The London Magazine*, 4(5). Retrieved from https://www.thelondonmagazine.org/archive-memories-of-modigliani-by-anna-akhmatova/

9. Polivanov, K (1994). *Anna Akhmatova and Her Circle (trans.* Patricia Beriozkina). Autobiographica prose, (p. 3). University of Arkansas Press, Fayetteville.

10. Akhmatova, A. (2004). *The word that causes death's defeat: Poems of memory:* Translated, with an introductory biography, critical essays, and commentary by Nancy K. Anderson (p. 9). Yale University Press, New Haven.

11. Luknitskaya, V. (1990). *Nikolai Gumilyov. Zhizn' poeta po materialam domashnego arkhiva sem'I Luknitskikh* (p. 10) Leningrad: Lenizdat.

12. Akhmatova, A. (2018). Memories of Modigliani. Archives of The London Magazine (translated by B. Wall). *The London Magazine*, 4(5). Retrieved from https://www.thelondonmagazine.org/archive-memories-of-modigliani-by-anna-akhmatova/

13. Lacourt, J. B. (2016). Amedeo Modigliani: L'Oeil Interieur. L'art qui sépare et qui unit le grand oeuvre de Modigliani 1909-1915, Aux sources de la sculpture (p. 32). Gallimard, Paris.

14. Alexandre, N. (1993). *The Unknown Modigliani, Drawings from the collection of Paul Alexandre* (pp. 164, 182, 183, 111). Harry N. Abrams Inc, New York. Fonds Mercator.

15. Klein, M. (2017). *Modigliani unmasked: Drawings from the Paul Alexandre collection* (pp. 43-45, also particularly p. 58). The Jewish Museum, New York. New Haven and London: Yale University Press.

16. Akhmatova, A (1997). *My Half-Century: selected prose.* Amedeo Modigliani, (p. 80), Bolshevo 1958–Moscow 1964 (translated by Christopher Fortune). Ed. Ronald Meyer, Northwestern University Press, Evanston, IL.

17. Nathanson, R. Amedeo Modigliani, 'Anna Akhmatova' 1911. Retrieved from https://richardnathanson.co.uk/publications/18/ on March 24, 2023.

18. Routledge, C. (2009, March 30). *Featured Poem.* Retrieved from https://www.thereader.org.uk/featured-poem-3/. *Claire de lune* (Paul Verlaine, 1869, in the original French, 2ⁿᵈ stanza: Tout en chantant sur le mode mineur / L'amour vainqueur et la vie opportune / Ils n'ont pas l'air de croire à leur bonheur / Et leur chanson se mêle au clair de lune.

19. Reeder, R. (1994). *Anna Akhmatova: poet and prophet.* (pp. 37-38), St. Martin's Press, New York.

20. Akhmatova, A (1997). *My Half-Century: selected prose.* Pages from a Diary, (p. 9), Bolshevo 1958–Moscow 1964 (translated by Christopher Fortune). Ed. Ronald Meyer, Northwestern University Press, Evanston, IL.

21. Reeder, R. (1994). *Anna Akhmatova: poet and prophet.* (p. 46), St. Martin's Press, New York.

22. Connelly, C. (2019, March 3). Great European Lives: Anna Akhmatova. Retrieved from https://www.theneweuropean.co.uk/brexit-news-great-european-lives-anna-akhmatova-charlie-connelly-41124/.

23. Strakhovsky, L. I. (1947). Anna Akhmatova-poetess of tragic love. *The American Slavic and East European Review*, 6(1/2), 1-18.

24. Reeder, R. (1994). *Anna Akhmatova: poet and prophet.* (pp. 37-38), St. Martin's Press, New York.c

25. Akhmatova, A. (1912). "When you're drunk you're so much fun". Probably composed in Paris 1911. Originally published in In *Vecher*, Saint Petersburg,

1912. English version from a translation by A. Kneller, https://ruverses.com/anna-akhmatova/when-you-re-drunk-you-re-so-much-fun/ Retrieved on March 13, 2023.

26. Becker, J. (Director). (1958). *Les Amants de Montparnasse* (Montparnasse 19).

27. Harrington, A. K. (2011). Anna Akhmatova's Biographical Myth-Making: Tragedy and Melodrama. *The Slavonic and East European Review, 89*(3), 455-493. Retrieved from https://doi.org/10.5699/slaveasteurorev2.89.3.0455 on March 15, 2023.

28. Akhmatova, A., & Austin, U. (1989). Amedeo Modigliani. *The Threepenny Review, 38,* 29-30.

29. Akhmatova A. (1964). Memories of Modigliani. *London Magazine,* August. 4(5). https://www.thelondonmagazine.org/archive-memories-of-modigliani-by-anna-akhmatova/.

30. Akhmatova, A (1997). *My Half-Century: selected prose.* Pages from a Diary, (pp. 76-77), Bolshevo 1958–Moscow 1964 (translated by Christopher Fortune). Ed. Ronald Meyer, Northwestern University Press, Evanston, IL.

31. Akhmatova, A. (2018). Memories of Modigliani. Archives of The London Magazine (translated by Bernard Wall). Originally published *The London magazine* 1964 (August);4(5). https://www.thelondonmagazine.org/archive-memories-of-modigliani-by-anna-akhmatova/

32. Akhmatova, A. (1997). *My Half-Century: Selected Prose* (p. 26), Eds. and *trans.* Ronald Meyer Northwestern University Press, Evanston, IL.

CHAPTER 18: POSTCARDS FROM HOME

1. Modigliani, Amedeo (1913). From a postcard to Paul Alexandre mailed on May 6, 1913. Alexandre, N. (1993). *The Unknown Modigliani, Drawings from the collection of Paul Alexandre* (p. 111). Harry Abrams Inc, New York: Fonds Mercator.

2. Goldwater, R. (1986). *Primitivism in Modern Art.* (p. 236). Cambridge, MA: Belknap Press of Harvard University Press.

3. Modigliani, J. (1958). *Modigliani: Man and Myth* (p. 50). New York: The Orion Press.

4. Alexandre, N. (1993). *The Unknown Modigliani, Drawings from the collection of Paul Alexandre* (pp. 193-230). Harry Abrams Inc, New York: Fonds Mercator.

5. Fergonzi, F. (2013). *Filologia del 900: Modigliani, Sironi, Morandi, Martini* (pp. 12-21). Milan: Mondadori Electra.

6. Sculptures de A. Modigliani. (1912, October 12). *Têtes formant un ensemble décoratif. L'illustration.* 268.

7. Le Salon d'Automne. (1912, October 20). *Maitres Cubes. Comoedia illustré,* 62.

8. Le Salon d'Automne. (1912, October 5). *La Vie Parisienne,* 713.

9. Guillaume, P. (1933). Modigliani créateur de l'actuel type de beauté féminine. Les Arts à Paris, (p. 11), no. 21, Paris, (June, 1935).

10. Lipchitz, J. (1954). *Amedeo Modigliani (1884-1920)*. New York: Pocket Books, Harry N. Abrams, pub.

11. Jedlicka, G. (1953). *Modigliani, 1884-1920* (p. 34). Erlenbach-Zürich: E. Rentsch.

12. Epstein, J. (1940). *Let there be sculpture* (pp. 38-40). New York: M. Joseph.

13. Corbett, C. (December 16). A fleeting passion [Lecture]. Barnes Museum, Philadelphia, PA, USA.

14. Buckley, B., Fraquelli, S., Ireson, M., & King, A. (Eds.). (2022). *Modigliani Up Close* (Chapters 15-17, pp. 96-107). New Haven: Yale University Press.

15. Lipchitz, J. (1954). *Amedeo Modigliani (1884-1920)*. New York: Pocket Books, Harry N. Abrams, pub.

16. Letters from Guiuseppe Emanuele Modigliani to Madame Tépaz included in the auction "Collection Baudelaire & Grands Ecrivains," Osenat, Fontainebleau, November 4, 2018, no. 121.

17. Sichel, P. (1967). *Modigliani, a biography* (p. 193). New York: E. Dutton and Company.

18. Alexandre, N. (1993). *The Unknown Modigliani, Drawings from the collection of Paul Alexandre* (p. 65). Harry N. Abrams Inc, New York: Fonds Mercator.

19. Alexandre, N. (1993). *The Unknown Modigliani, Drawings from the collection of Paul Alexandre* (p. 104). Harry N. Abrams Inc, New York: Fonds Mercator.

20. Douglas, C. (1941). *Artist Quarter* (p. 125). London: Faber and Faber.

21. Sichel, P. (1967). *Modigliani, a biography* (p. 224). New York: E. Dutton and Company.

22. "Flagroneur et ami, le bonheur est un ange au visage grave. point de sonnet.. le rescuscité, bientot j'écris." Alexandre, N. (1993). *The Unknown Modigliani, Drawings from the collection of Paul Alexandre* (p. 111). Harry N. Abrams Inc, New York: Fonds Mercator.

23. Alexandre, N. (1993). *The Unknown Modigliani, Drawings from the collection of Paul Alexandre* (pp. 105-107): Harry N. Abrams Inc, New York: Fonds Mercator.

CHAPTER 19: WAR

1. Morning, A. (aka Beatrice Hastings). (1914). Impressions of Paris. *The New Age,* August 13, 1914. In *Beatrice Hastings: On the Life & Work of a Lost Modern Master*. Benjamin Johnson & Erika Jo Brown (Eds.). Unsung Masters Series volume 7 (p. 113). Warrensburg, Missouri: Pleiades Press & Gulf Coast.

2. https://www.secretmodigliani.com/works/14-5.html. Retrieved December 16, 2022.

3. Guillaume, P. (1930). Typed letter to Max Jacob dated March 19,1930. Musée de L'Orangerie archives. In, Exhibit Catalogue for *Modigliani: A painter and his art dealer*, (p. 149). Editorial direction by Fraquelli S & Girardeau C. Flammarion, Paris (2023).

4. Zadkine, O. (1968). *Le maillet et le ciseau. Souvenirs de ma vie* (p. 92). Paris: Albin Michel. In the original French: "Les séances de pose et de peinture avaient

lieu dans une cave éclairée par une forte lampe électrique et où siégeait un litre de vin sur la table.»

5. Since 1907 Beatrice Hastings also had an affair with Alfred Richard Orage, her boss and editor of the magazine where she worked. The artist and writer, Wyndham Lewis was also a former lover.

6. Nina Hamnett's first ever retrospective was held at the Charleston Gallery in Lewes, East Essex, England in 2021.

7. Hamnett, N. (1932). *Laughing Torso. Reminiscences of Nina Hamnett* (pp. 78, 60). New York: Ray Long & Richard R. Smith.

8. Hamnett, N. (1932). *Laughing Torso. Reminiscences of Nina Hamnett* (p. 78). New York: Ray Long & Richard R. Smith.

9. Hamnett, N. (1932). *Laughing Torso. Reminiscences of Nina Hamnett* (p. 60). New York: Ray Long & Richard R. Smith.

10. Mourant, C. (2020). *Katherine Mansfield and Periodical Culture* (p. 81). Edinburgh: Edinburgh University Press.

11. Johnson, B., & Brown, E. J. (Eds.). (2016). *Beatrice Hastings: On the Life & Work of a Lost Modern Master*. Warrensburg, MO: Pleiades Press & Gulf Coast.

12. Les Montparnos. (n.d.). Chez Rosalie. Retrieved from https://blogmontparnos.paris/chez-rosalie/

13. Klüver, B., & Martin, J. (1989). *KiKi's Paris: Artists and Lovers 1900-1930* (pp. 66-69). New York: Harry N. Abrams.

14. WW I Essentials. (n.d.). National WW I Museum and Memorial. Italy enters World War I. Retrieved December 16, 2022, from https://www.theworldwar.org/learn/about-wwi/italy-enters-world-war-i.

CHAPTER 20: AFFIRMATION

1. Cocteau, J. (1950). *Modigliani*. (p. 5). Paris, Fernand Hazan Eds.

2. Godias, J. D. (1945). World War I and tuberculosis. *American Journal of Public Health*, 35, 690-697.

3. Rosmer A. Trotsky in Paris during World War I. The *New International, Vol. XVI No. 5, September–October 1950*, 263–278. https://www.marxists.org/archive/rosmer/1950/07/trotsky.html.

4. Wierling, D. (2015, January 29). Coffee. Online International Encyclopedia of the First World War. Retrieved from https://encyclopedia.1914-1918-online.net/article/coffee.

5. Hotel Raspail Montparnasse. (n.d.). Retrieved from https://www.hotelraspailmont-parnasse.com/en/2016/07/29/raspail-montparnasse-hotel-a-journey-through-time/.

6. Les Soirees de Paris. (n.d.). Retrieved from https://www.lessoireesdeparis.com/2020/01/14/limage-presque-introuvable/.

7. Bette, P. (n.d.). Women's mobilization for war (France). Internet Encyclopedia of the First World War. Retrieved from https://encyclopedia.1914-1918-online.net/

pdf/1914-1918-Online-womens_mobilization_for_war_france-2014-10-08. pdf.

8. Quetel, C. (1990). *History of Syphilis* (p. 176). Polity Press.

9. Murray, J. F. (2015). Tuberculosis and World War I. *Am J Respir Crit Care Med, 192*(4), 411-414. doi: 10.1164/rccm.201501-0135OE.

10. Cendrars, B. (1916). *La Guerre au Luxembourg. Six dessins de Kisling.* Paris: Dan Niestlé.

11. Jacob, M. (1953). *Correspondence de Max Jacob:* Tome I, Quimper-Paris, 1876-1921. Letter to Apollinaire, January 7, 1915 (p. 110). Edited by François Garnier. Paris: Editions de Paris.

12. Jacob, M. (1984). *Lettres de Max Jacob a Jean-Richard Bloch:* Tome II, no. 666 (October 1984). Letter to Bloch, late December 1914, early January 1915 (p. 145). Edited by Michel Trebitsch. Paris.

13. Corbett, C. (December 16). A fleeting passion [Lecture]. Barnes Museum, Philadelphia, PA, USA.

14. Malraux, A. (1990). *The Voices of Silence* (p. 414). Bollingen Series XXIV-A. Princeton University Press.

15. Kramer, H. (2004, June 7). Modigliani's back-so are those eyes, elongated torsos. The Observer. Retrieved from https://observer.com/2004/06/modiglianis-backso-are-those-eyes-elongated-torsos/.

16. Restellini, M. (2003). *L'Angelo dal volto severo.* Catalogue Milano, Palazzo Reale 21 marzo-6 luglio 2003 (p. 3). Geneva-Milan: Skira.

17. Franck, D. (1998). *Bohemian Paris: Picasso, Modigliani, Matisse and the birth of modern art.* New York: Grove Press.

18. Klüver, B. (1997). *A Day with Picasso* (p. 20). Cambridge: MIT Press.

19. Force, C. H. (2020). *Pioneers of the Global Art Market: Paris-based dealer networks 1850-1950.* In Christel H. Force (Ed.), *A viking sailing over the savage sea, far, far to the north:* Walther Halvorsen (Kindle edition, pp. 237, 258). New York: Bloomsbury Publishing.

CHAPTER 21: PORTRAITS (OF BÉA)

1. Modigliani, A. *Beatrice Hastings with feathered hat.* Oil on canvas, text "Madam Pompadour / 1915" center left. Currently at the Art Institute Chicago, Chicago, USA (Inv. N° 1938.217).

2. Hastings, B. (2002). *Minnie Pinnikin.* In *Modigliani and the artists of Montparnasse,* Kenneth Wayne (Ed.), (pp. appendix).New York: Abrams HN.

3. Hastings, B. (1944, January). Death of Beatrice Hastings. Canadian Theosophist, XXIV, 346-347. Retrieved from https://www.theosophycanada.com/hastings-death-of-beatrice-hastings.php.

4. Hastings, B. (2002). *Minnie Pinnikin.* In, *Modigliani and the artists of Montparnasse.* Kenneth Wayne, (pp. appendix). Abrams HN. New York.

5. Crespelle, J. P. (1969). *Modigliani: Les femmes, les amis, l'oeuvre.* Paris: Presses de la Cité, réédition numérique.

6. Salmon, A. (1961). *A Memoir*. New York: G.P. Putnam Sons.
7. Mansfield, K. (1954). *Journal of Katherine Mansfield*, J. M. Murry, Ed., (p. 285). London: Constable and Co. Retrieved from https://nzetc.victoria.ac.nz/tm/scholarly/tei-MurJour-t1-body-d1-d10-d1.html.
8. Anonymous (Beatrice Hastings). (2016). *Madame Six* (p. 6). In, *Beatrice Hastings: On the Life & Work of a Lost Modern Master*. Benjamin Johnson & Erika Jo Brown (Eds.). Unsung Masters Series volume 7. (p. 136), Warrensburg, Missouri: Pleiades Press & Gulf Coast.
9. Kingsbury, C. (2016). The Lost Bacchante: Beatrice Hastings and the War Years. *Beatrice Hastings: On the Life & Work of a Lost Modern Master*. In Benjamin Johnson & Erika Jo Brown (Eds.). Unsung Masters Series volume 7 (pp. 244-256). Warrensburg, Missouri: Pleiades Press & Gulf Coast.
10. Carrà, C. (1997). *La mia vita*. Milan: S.E. Cited by Franco Tagliapietra in Christian Parisot (Eds.), *Modigliani in Venice, between Leghorn and Paris* (Catalogue, pp. 128-129). Sassari: Carlo Delfini.
11. Scholes, R. (2006). *Paradoxy of Modernism*. Yale University Press.
12. Mourant, C. (2018). Fireworky: Beatrice Hastings as editor, critic and 'crusading, anti-philistine woman'. TLS. *Times Literary Supplement*, 5991, 16. Retrieved from Gale Literature Resource Center database.
13. Howell, A. (2013). The art of unfinished [Blog post]. The Society of Figurative Arts and Artists. Retrieved from https://tsofa.com/infinito/.
14. Rudigier, A., & Jestaz, B. (2016). Le non finito dans la sculpture florentine et la notion de disegno. Note complémentaire. *Bulletin Monumental, 174*(3), 357-373. doi:10.3406/bulmo.2016.12841.
15. Modigliani, A. (1976). Letter to Oscar Ghiglia. *In W. Fifield (Ed.), Modigliani* (p. 47). William Morrow, New York.
16. Benezra, N. (1986). A study in irony: Modigliani's Jacques and Berthe Lipchitz. *Art Institute of Chicago Museum Studies, 12*(2), 189-199.
17. 'Madame Six' (the book was published in 1925), is what doctors and nurses impersonally called Béa when she was hospitalized in a maternity ward for what may have been a miscarriage or other gynecological issue (i.e., her hospital bed was bed n° 6).
18. Gray, S. (2004). *Beatrice Hastings: A Literary Life*. Viking.
19. Wight, F. W. (1961). Modigliani Paintings and Drawings (Chana Orloff) (p. 20). Fine Arts Productions, UCLA.
20. A fascinating set of photographs are found at https://www.secretmodigliani.com/1916-w-16.html.
21. Alberge, D. (2018, February 28). Modigliani portrait comes to light beneath artist's later picture. *The Guardian*. Retrieved from https://www.theguardian.com/artanddesign/2018/feb/28/modigliani-portrait-comes-to-light-beneath-artists-later-picture.
22. See https://www.secretmodigliani.com/1917-w-79.html.

CHAPTER 22: IT'S ALL IN THE DETAILS

1. Warnod, J. (2012). *L'Ecole de Paris*. Editions Musée du Montparnasse, Paris, (p. 239). As told by Léon Indenbaum to Jeanine Warnod.
2. Survage, L. (1947). My speech on Modigliani. Retrieved from https://research. fng.fi/wp-content/uploads/2015/07/Léopold_survage_modigliani_speech.pdf.
3. Foujita, T. (1958). Recollections of Modigliani by those who knew him. *Italian Quarterly*, University of California, Los Angeles, Spring, 50.
4. The conquest of absinthe - French national curse suppressed. (1915, April 3). *The Times*, 40819, 7.
5. Prestwich, P. E. (1979). Temperance in France: The Curious Case of Absinthe. Historical Reflections / *Réflexions Historiques*, 6(2), 301-319.
6. Padosch, S. A., Lachenmeier, D. W., & Kröner, L. U. (2006). Absinthism: a fictitious 19th-century syndrome with present impact. Substance Abuse Treatment, Prevention, and Policy, 1, 14. doi:10.1186/1747-597X-1-14.
7. Ledermann, S. (1956). *Alcohol, alcoholism, alcoolisation* (Vol. 1, p. 65). Paris.
8. Warnod, J. (2012). *L'Ecole de Paris*. Editions Musée du Montparnasse, Paris, (p. 239).
9. Colt, H. Personal communication with Jeanine Warnod, Paris, September 30, 2023.
10. Cook, P.J, Skog, O.J. (1995). Alcool, Alcoolisme, Aloolisation. *Alcohol Health Res World*, 19(1):30-31.
11. *Les Secrets de Modigliani: Techniques et pratiques artistiques d'Amedeo Modigliani*. (2022). Éditions invenit.
12. Crespelle, J. P. (1969). *Modigliani: Les femmes, les amis, l'oeuvre* (p. 172). Presses de la Cité.
13. Lipchitz, J. (1954). *Amedeo Modigliani* (1884-1920). Pocket Library of Great Art. Harry N. Abrams.
14. Buckley, B., Duffy, M., Langley, A., & Porell, M. (n.d.). The Modigliani Technical Research Study: Modigliani's Paris portraits 1915-1917. *The Burlington Magazine* April. CLX. 311-318.
15. Survage, L. (1947). My speech on Modigliani. Retrieved from https://research. fng.fi/wp-content/uploads/2015/07/Léopold_survage_modigliani_speech.pdf.
16. Fifield, W. (1976). *Modigliani*. William Morrow, New York.
17. Braun, E. (2004). The Faces of Modigliani: Identity Politics Under Fascism. In M. Klein (Ed.), *Modigliani: Beyond the Myth*. The Jewish Museum.
18. Wayne, K. (2016). Modigliani entre 1914 et 1916: Beatrice Hastings, portraits d'artistes et proto-surrealism. *L'Oeil Interieur*. Gallimard.
19. Noce, V. (2020, December 15). Revealed: the secrets behind Antonia, Modigliani's 'most complex work'. The Art Newspaper. Retrieved from https://www. theartnewspaper.com/2020/12/15/revealed-the-secrets-behind-antonia-modiglianis-most-complex-work.
20. King, A., Ireson, N., Fraquelli, S., & Townsend, J. H. (2018). Modigliani technical research study: Introduction to Modigliani's materials and

techniques. *Burlington Magazine, 160*(1380). Retrieved August 14, 2022, from https://www.burlington.org.uk/archive/article/the-modigliani-technical-research-study-an-introduction-to-modiglianis-materials-and-techniques.

21. À la Modigliani: Portrait of Lunia Czechowska. (2018, October 24). Retrieved August 13, 2022, from http://www.theconservationcenter.com/articles/2018/10/24/-la-modigliani-portrait-of-lunia-czechowska.

22. Ceroni, A. (1958). *Amedeo Modigliani*, including "Les Souvenirs de Lunia Czechowska" (Edizione del Milione, Ed.). Milan, Italy.

CHAPTER 23: TURNING THE PAGE

1. King James Bible. Ecclesiastes 3:1-8 (KJV).
2. Grindea, M. (1963). *ADAM International Review, 300* (p. 9), Curwen Press, London.
3. Christian Parisot (*Modigliani in Venice: Between Leghorn and Paris,* catalogue, pg 77) and biographer Meryle Secrest say the sketch is of Modi's lover and third muse, Jeanne Hébuterne, but there is no written evidence to substantiate this claim.
4. Douglas, C. (1941). *Artist Quarter.* London, England: Faber and Faber.
5. Riposati, M. (2009). *Modigliani, Simone Thiroux un amore segreto / a secret love* (pp. 40-49). Rome, Italy: Edizioni Carte Segrete.
6. Riposati, M. (2009). *Modigliani, Simone Thiroux un amore segreto /* a secret love (p. 53). Rome, Italy: Edizioni Carte Segrete.
7. Barsanti, A. (2022, March 30). Il giallo sul falso Modigliani e la presunta truffa da 10 milioni di euro. Roma Today. Retrieved August 16, 2022, from https://www.romatoday.it/cronaca/modigliani-jeune-femme-falso-processo.html.
8. Carco, F. (1920). *Le Nu Dans la Peinture Moderne* (1863-1920). Paris, France: Les Éditions G Crès et Cie.
9. Simone, Y. E. (n.d.). Registre des actes de décès 14D316, index 735 (n° 5250). Paris, France: Archives Municipales de Paris.
10. Modigliani, J. (1958) *Modigliani: Man and Myth* (p. 80). New York: The Orion Press.
11. Douglas, Charles. (1941). *Artist Quarter,* Faber and Faber, London. (p. 269).
12. Apra, Nietta. (1945). *Tormento di Modigliani.* Ed. Bietto, Milan.
13. Clarisse, N. (1993). *Il Romanzo di Modigliani.* Plon, Paris.
14. Pierre, S. (1967). *Modigliani, a biography* (p. 341). New York.: E. Dutton and Company.
15. Godias, J. D. (1945). World War I and tuberculosis. *Am J Pub Health. 35.* 690-697.
16. Gunn, S. M. (1919). The fight against tuberculosis in France. *Am J Pub Health, 1919*(9), 767-775.https://ajph.aphapublications.org/doi/pdf/10.2105/AJPH.9.10.767.
17. Carrà C. (1942). *La mia vita.* S.E. Milan, 1997. Cited by Franco Tagliapietra, Contacts and contrasts with the Italian avant-garde movement. In, Christian

Parisot, *Modigliani in Venice, between Leghorn and Paris*. Carlo Delfini, Eds. Catalogue, (p. 129), Sassari, 2005.

18. Gunn, S.M. (1919). The fight against tuberculosis in France. *Am J Pub Health*. 9. 767-775.https://ajph.aphapublications.org/doi/pdf/10.2105/AJPH.9.10.767.

19. White, R. (2019). *Joseph Altounian's Collection Pays Testimony to Friendship with Amedeo Modigliani. Art and Collections*. https://www.artsandcollections.com/joseph-altounians-collection-pays-testimony-to-friendship. Retrieved August 18, 2022.

20. Survage, L. (1947). 'My speech on Modigliani', Paris. *Archive Collections, Finnish National Gallery, Helsinki*. Retrieved. from https://research.fng.fi/wp-content/uploads/2015/07/Léopold_survage_modigliani_speech.pdf.

21. Ceroni, A. (1958). *Amedeo Modigliani*, including "Les Souvenirs de Lunia Czechowska" (p. 21), Edizione del Milione, Milan.

22. Buckley, B., Duffy, M., Langley, A., & Porell, M. (2018). The Modigliani Technical Research Study: Modigliani's Paris portraits 1915-1917. *The Burlington Magazine* April. CLX. 311-318.

23. Orloff, C. (1958). Recollections of Modigliani by those who knew him'. Collected by Frederick S. Wight. *Italian Quarterly*. (p. 45), University of California, Los Angeles, Spring, 1958.

24. Foujita, T. (1958). Recollections of Modigliani by those who knew him'. Collected by Frederick S. Wight. *Italian Quarterly*. University of California, Los Angeles, Spring. 51.

CHAPTER 24: 1917

1. Barbusse, H. (1918). *The Inferno*. Translation, Edward J O'Brien. Boni and Liveright, New York. (p. 248).

2. Rivers, W.H.R. (1918). The repression of war experience. *Proc R Soc Med*, 11(Sect Psych), 1-20.

3. Demm, E. (2017). Propaganda at Home and Abroad (Version 1.1), *In 1914-1918-online. International Encyclopedia of the First World War, ed. by Ute Daniel, Peter Gatrell, Oliver Janz, Heather Jones, Jennifer Keene, Alan Kramer, and Bill Nasson, issued by Freie Universität Berlin*, Berlin, 06-07. DOI: 10.15463/ie1418.10910/1.1.

4. Renault, O. (2018). *Montparnasse: Entre Bohème et Années Folles*. (pp. 13-14). Parigramme, Paris.

5. Lafayette. (2022). we are here. https://sites.lafayette.edu/lafayettewwi/pershing-at-picpus/gilmer/ Retrieved, August 22, 2022.

6. Stockman, D.E. (2017). *Humanization of the Enemy: The Pacifist Soldier and France in World War One* (2017). Senior Theses. 56. https://doi.org/10.33015/dominican.edu/2017.HCS.ST.06.

7. Nivet, P. Refugees (France). 1914-1918 Internet Encyclopedia of the First World War. https://encyclopedia.1914-1918-online.net/article/refugees. Retrieved August 24, 2022.

8. Fell, A.S. (2018). Remembering First World War Nursing: Other Fronts, Other Spaces, *Journal of War & Culture Studies*. *11*(4), 269-272, DOI: 10.1080/17526272.2018.1523779.

9. Courington, F.W. (1986). Calverley RK. Anesthesia on the Western Front: The Anglo-American Experience of World War I. *Anesthesiology*. 65. 642-653.

10. McDonald, J.M. (2016). Anesthesia on the Western Front-Perspectives a century later. *Anesth Intensive Care*. 15-23.

11. Sabbatani S, & Fiorino S. (2017). The treatment of wounds during World War I. *Le Infezioni in Medicina*. 2. 184-192.

12. La Guerre, l'A.P.: l''Assistance publique dans la Grande Guerre. https://archives.aphp.fr/assistance-publique-dans-la-grande-guerre/#1586948909308-a1483671-2165. Retrieved, August 23, 2022.

13. Corbin, A. (1990). *Women for Hire: Prostitution and Sexuality in France after 1850* (A. Sheridan, *trans*.). Cambridge.

14. Steward, J., & Wingfield, N.M. (2016). Venereal Diseases , in: 1914-1918-online. International Encyclopedia of the First World War, ed. by Ute Daniel, Peter Gatrell, Oliver Janz, Heather Jones, Jennifer Keene, Alan Kramer, and Bill Nasson, issued by Freie Universität Berlin, Berlin. DOI: 10.15463/ie1418.10968.

15. Rosenthal, L. (2018). Venus in the trenches: The treatment of venereal disease in the Canadian Expeditionary Force, 1914-1918. *Theses and Dissertations (Comprehensive)*. 2107. https://scholars.wlu.ca/etd/2107.

16. Hayden, D. (2003). *Pox. Genius, Madness, and the Mysteries of Syphilis*. Perseus Books, New York. (pp. 47-52).

17. Hanley, A.R., (2017). *Medicine, Knowledge and Venereal Disease in England 1886-1916.* (pp. 117–132). Palgrave MacMillan.

18. Bogaert, Kandace (2017). "Patient Experience and the Treatment of Venereal Disease in Toronto's Military Base Hospital during the First World War." p. 15. *Canadian Military History 26*, 2. Military History Commons, https://scholars.wlu.ca/cmh.

19. Grayzel, S. R. (1997). Mothers, Marraines, and Prostitutes: Morale and Morality in First World War France. *The International History Review*, *19*(1), 66–82. http://www.jstor.org/stable/40108084. Retrieved 22 Aug. 2022.

20. Conner, S.P. (2017). The paradoxes and contradictions of prostitution in Paris. (p. 171-200). In, *Selling Sex in the City: A Global History of Prostitution, 1600s–2000s*. García, MR, van Voss, LH., & van Nederveen Meerkerk, E. (Eds.). Leiden, The Netherlands: Brill. Retrieved Aug 22, 2022, from https://brill.com/view/book/9789004346253/front-4.xml.

21. Bizard, L. (1917). *Les Maladies Venériennes: Conference faite aux jeunes Soldats appartenant aux Corps de Troupes du Gouvernement Militaire de Paris.* (pp. 13), 16, 23. Eds., Maloine et fils, Paris.

22. Corbin, A. (1990). *Women for Hire: Prostitution and Sexuality in France after 1850*, Translation, Alan Sheridan, (p. 335). Cambridge.

23. De Santis, M., De Luca, C., Mappa, I., Spagnuolo, T., Licameli, A., Straface, G., & Scambia, G. (2012). Syphilis Infection during pregnancy: fetal risks and clinical management. *Infect Dis Obstet Gynecol. 430585*. doi: 10.1155/2012/430585.

24. Centers for Disease Control and Prevention. (2022). Congenital syphilis fact sheet. Retrieved October 23, from https://www.cdc.gov/std/syphilis/stdfact-congenital-syphilis.htm.

25. Vandenbroucke, G. (2014). Fertility and Wars: The case of World War I in France. *American Economic Journal: Macroeconomics, American Economic Association, 6*(2). 108-136.

26. French Academy of Medicine. (n.d.). https://fam.fr/en/french-academy-of-medicine/.

27. Rapport Doléris. (1917, January 30) 'Sur la proposition de voeux relatifs à la protection maternelle et infantile dans les usines de guerre'. *Bulletin de l'Académie de Médecine*, 116-119.

28. Ministère des Armées. (n.d.). *Veuves et orphelins de la Première Guerre mondiale.* Chemins de Mémoire, https://www.cheminsdememoire.gouv.fr/fr/veuves-et-orphelins-de-la-premiere-guerre-mondiale. Retrieved August 26, 2022.

29. Faron, O. (2001). Une loi pour les orphelins (3). *In, O. Faron, Les enfants du deuil: Orphelins et pupilles de la nation de la première guerre mondiale (1914-1941).* (pp. 86-121). La Découverte, Paris.

30. Baxter, J. (2014). *Paris at the End of the World: The City of Light During the Great War 1914-1918.* (p. 15). New York: HarperCollins.

31. Centre Robert Schuman. (n.d.). World War I Casualties. Retrieved August 25, 2022, from http://www.centre-robert-schuman.org/userfiles/files/REPERES%20–%20module%201-1-1%20-%20explanatory%20notes%20–%20World%20War%20I%20casualties%20–%20EN.pdf.

32. Notz, W. (1918). The World's coal situation during the war. *J Political Economy, 26*(6), 567-611.

33. Chancerel, P. (2015, May 19). Labour (France). *International Encyclopedia of the First World War*. Retrieved March 12, 2022, from https://encyclopedia.1914-1918-online.net/article/labour_france.

34. Moore, R. (2018). *Performing propaganda: Musical Life and Culture in Paris during the First World War.* Suffolk : The Boydell Press.

35. Barbusse, H. (1917). *Under Fire: The story of a squad* (Le Feu). Translation, Fitzwater Wray. New York, EP: Dutton and Co. "

CHAPTER 25: TIME TICKS

1. Modigliani, A. (1918/1919). *"La vita è un dono, dei pochi ai molti, di coloro che sanno e che hanno a coloro che non sanno e che non hanno."* See, drawing of Lunia Czechowska in Mann, C (1980). *Modigliani*. (pp. 166-167). Thames and Hudson, London. According to Chhristian Parisot and biographer Meryl Secrest, the text was written on several drawings, including those of Thora Klincköwstrom

and Lunia Czechowska. Parisot, C. (2005), *Modigliani* (p. 308). Editions Gallimard, Paris, and Secrest, M. (2011). *Modigliani: A life* (p. 290). Alfred A. Knoff, New York.

2. Crespelle, J.P. *Modigliani: Les femmes, les amis, l'oeuvre* (p. 191). Presses de la Cité, réédition numérique, January 1969.

3. Rose, J. (1990). *Modigliani, The Pure Bohemian* (p. 165). New York: St. Martin's Press.

4. Zborowska, A. (2015). *Modigliani et Zborowski* (p. 24), L'Echoppe, Paris.

5. Description; https://www.pearlmancollection.org/artwork/leon-indenbaum/ Retrieved, August 20, 2022.

6. Sichel, P. (1967). *Modigliani, a biography* (p. 353). New York: E. Dutton and Company.

7. Rose, J. (1990). *Modigliani, The Pure Bohemian.* (p. 165). New York: St. Martin's Press.

8. De Chirico, G. (1927). Interview with Pierre Lagard. *"L'Italie et nous'* from "Comœdia", Paris 12 December 1927. Metaphysical Art, Paris, 12 December, 1927. Republished in *Metaphysical Art, 2016*(14), 16. Retrieved August 20, 2022, from https://fondazionedechirico.org/wp-1-content/uploads/2019/07/61.-METAPYSICAL-ART-n.14-16-2016-Mr.-de-Chirico-a-Painter-Predicts-and-Hopes-for-the-Triumph-of-Modernism-401-402.pdf

9. Boccioni, U., Carra, C., Russolo, L., Balla, G., & Severini, G. (1910, April 11). *Futurism: An anthology.* (p. 64-67). Rainey L, Poggi C, Wittman L eds. New Haven: Yale University Press.

10. Boccioni, U., Carra, C., Russolo, L., Balla, G., & Severini, G. (1910, February 11). Manifesto of the Futurist Painters. *Futurism: An anthology.* (p. 62-62). Rainey L, Poggi C, Wittman L eds. New Haven: Yale University Press.

11. Alexandre, N. (1993). *The Unknown Modigliani, Drawings from the collection of Paul Alexandre.* (p. 67). New York, Fonds Mercator: Harry N. Abrams Inc.

12. Desvignes-Nicolas Hacquebart, and Loeb, Albert et Sonia. (2017). *13 rue Bonaparte, l'aventure de Jacques Povolozky et de Pierre Loeb, deux marchands d'avantgarde,* (pp. 95-110). Éditions Artbiblio.

13. Elena Povolozky. (n.d.). Retrieved August 20, 2022, from https://www.phillipscollection.org/collection/elena-povolozky.

14. Brown K. (2018, February 28). Did Modigliani paint over his ex-lover. A newly discovered underpainting suggests he might have. ArtNet News. https://news.artnet.com/art-world/modigliani-tate-portrait-girl-1232936. Retrieved March 12, 2023.

15. Wright, B. (2017). *Soutine's Portraits: Cooks, Waiters & Bellboys.* Serres K and Wright B eds. (p. 22). The Courtauld Gallery and Paul Holberton Publishing, London.

16. Sidorova, A. (2016, February 11). American collectors make d'Orsay Museum the largest donation since World War II. *Art news* Gallerix. Retrieved August 23, 2022, from https://gallerix.org/news/world/201611/krupneyshee-pozhertvovanie/.

17. Thompson, H.S. (1966). *Hell's Angels: the strange and terrible saga of the motorcycle gangs.* Ballantine Books.
18. Ehrenburg, I. (1962). *People and Life: Memoirs of 1891-1917.* Translation Anna Bostock and Yconne Kapp (p. 137). London: Cox and Wyman. Retrieved, August 24, 2022 from https://archive.org/stream/in.ernet.dli.2015. 461042/2015.461042.People-And_djvu.txt.
19. Secrest M. (2011). *Modigliani: A life* (p. 273). Alfred A. Knoff, New York.
20. Secrest, M. (2011). *Modigliani: A life* (p. 273). Alfred A. Knoff, New York.
21. Zadkine, O. (1968). *Le maillet et le ciseau. Souvenirs de ma vie* (p. 93). Albin Michel, Paris.
22. McLaughlin. G. T. (1973). Cocaine: The History and Regulation of a Dangerous Drug. *Cornell L. Rev.* 537 Available at: http://scholarship.law.cornell.edu/clr/vol58/iss3/2.
23. Morning, A. (aka Beatrice Hastings). (1915). Impressions of Paris. Beatrice Hastings, *The New Age,* January 21, 1915. In *Beatrice Hastings: On the Life & Work of a Lost Modern Master,* Benjamin Johnson & Erika Jo Brown (Eds.). Unsung Masters Series volume 7, (p. 124). Warrensburg, MO: Pleiades Press & Gulf Coast.
24. Kamienski, L. (1919). In, *1914-1918-online.* International Encyclopedia of the First World War, ed. by Ute Daniel, Peter Gatrell, Oliver Janz, Heather Jones, Jennifer Keene, Alan Kramer, and Bill Nasson Publisher: Freie Universität Berlin, Berlin.
25. Modigliani, J. (1958). *Modigliani: Man and Myth.* Introduction p. XVII. New York: The Orion Press.
26. Butler, S. (1994). *Modigliani et l'École de Paris.* Museum of Art Tokyo. (p. 5), Studio Editions, London.
27. Michel-Georges, M. (1957). *Les Montparnos.* Editions Mondiales, Paris.
28. Becker, J. (Director). (1958). *Les Amants de Montparnasse* (Montparnasse 19).
29. McIntyre, D. (1968). *Modigliani: a play in three acts.* Samuel French, Inc. New York.
30. Fifield, W. (1976). *Modigliani.* William Morrow (p. 36). New York.
31. Padwa, H. (2005). National Security and Narcotics Control in France, 1907-1920. *J Western Soc French History,* 33. Retrieved from http://hdl.handle.net/2027/spo.0642292.0033.021 Retrieved August 24, 2022.

CHAPTER 26: SEX SELLS, BUT DOES NUDITY?

1. Supangkat, J. (2005). *Provocative Bodies: Interpreting the works of Mochtar Apin 1990-1993.* (pp. 131-152). Jakarta; CP Foundation.
2. Zygmont, B. (2022, August 28). Venus of Willendorf. Khan Academy. Retrieved from https://www.khanacademy.org/humanities/prehistoric-art/paleolithic/paleolithic-objects/a/venus-of-willendorf.

3. Weber, G.W., Lukeneder, A., & Harzhauser, M. (2022). The microstructure and the origin of the Venus from Willendorf. *Sci Rep 12*(2926). https://doi.org/10.1038/s41598-022-06799-z.

4. Berger, J. *Ways of Seeing.* (1972). British Broadcasting Corp. and Penguin Books, (p. 54) Penguin Books, London.

5. *Origine du Monde.* (n.d.). In Wikipedia, https://en.wikipedia.org/wiki/L%27Origine_du_monde. Retrieved October 23, 2022.

6. Jones, J. (2013, February 8). Gustave Courbet's The Origin of the World still over-excites art critics. *The guardian* https://www.theguardian.com/artanddesign/jonathanjonesblog/2013/feb/08/gustave-courbet-origin-world-art. Retrieved August 29, 2022.

7. Sutton, B. (2014, June 5). Artist enacts 'Origin of the World' at Musée d'Orsay – And, Yes, That Means What You Think. https://news.artnet.com/art-world/artist-enacts-origin-of-the-world-at-musee-dorsay-and-yes-that-means-what-you-think-35011. Artnet, Retrieved September 27, 2022.

8. Chan, M. (1997). "Egon Schiele: The Léopold Collection Vienna." *MoMA, 26,* 2–7. JSTOR Retrieved from, http://www.jstor.org/stable/4381362 (29 Aug. 2022).

9. Raine, C. (2014). *Provocations to desire: Craig Raine delights in the nudes of Egon Schiele.* The New Statesman, October 31, Retrieved from, https://www.newstatesman.com/long-reads/2014/10/provocations-desire-craig-raine-delights-nudes-egon-schiele.

10. Clarke, K. (1956). *The Nude: A study in ideal form* (pp. 114-115). Bollingen Series XXXV. Princeton, New Jersey: Princeton University Press.

11. Eller, W. (2007). *Giorgione, Catalogue Raisonné* (p. 126). Michael Imhof Verlag.

12. Clark, K. (1956). *The Nude: A study in ideal form* (p. 127). Bollingen Series XXXV, Princeton, New Jersey: Princeton University Press.

13. McCormack, C. (2021). *Women in the Picture: What culture does with female bodies.* (pp. 16-18), New York: W.W. Norton & Company.

14. Ewing, W.A. (1994). *The Body: Photographs of the human form.* (p. 206). Chronicle Books, San Francisco.

15. In his concurring opinion about the case brought against a theater owner who showed the Louis Malle film, The Lovers, Justice Stewart concluded that, "Criminal laws are constitutionally limited to hard-core pornography." He added, "But I know it when I see it, and the motion picture involved in this case is not that." Paul, G. (1996). On 'I Know It When I See It. *The Yale Law Journal, 105*(4), 1023–47. JSTOR, https://doi.org/10.2307/797245. Retrieved 30 Aug. 2022.

16. Mulvey, L. (1975). *Visual Pleasure and Narrative Cinema, Screen, 16*(3), 6-18. https://doi.org/10.1093/screen/16.3.6.

17. O'Neill, P. (1992). The Painting of Nudes and Evolutionary Theory: Parleyings on Victorian Constructions of Woman. *Texas Studies in Literature and Language, 34*(4), 541–67. JSTOR, http://www.jstor.org/stable/40754994. Retrieved 28 Aug. 2022.

18. d'Orsay, M., & de Venus, N. (n.d.). https://www.musee-orsay.fr/en/artworks/naissance-de-venus-98. Retrieved August 29, 2022.

19. Berger, J. (1972). *Ways of Seeing*. British Broadcasting Corp. and Penguin Books (p. 47), Penguin Books, London.

20. Hall, J. (2014). To the rescue of civilization man. Tate, summer, 31. https://www.tate.org.uk/tate-etc/issue-31-summer-2014/rescue-civilisation-man. Retrieved, September 26, 2022.

21. Tennyson, A. (1890). *The Princess: A Medley. Part V* (p. 88). v 147. Cambridge Literature Series. Boston: Benj H Sanborn pubs.

22. Ellis, H. (1927). *Studies in the Psychology of Sex: The Evolution of Modesty, the Phenomena of Sexual Periodicity, Auto-Erotism*, 3rd ed. (Project Gutenberg, Philadelphia: F.A. Davis).

23. Glapka, E. (2018). If you look at me like at a piece of meat, then that's a problem' – women in the center of the male gaze. *Feminist Poststructuralist Discourse Analysis as a tool of critique, Critical Discourse Studies*, 15(1), 87-103, DOI: 10.1080/17405904.2017.1390480.

24. Berger, J. (1973). *Ways of Seeing* (p. 47), London: British Broadcasting.

CHAPTER 27: MODI'S GAZE

1. Zborowska, A. (2015). *Modigliani et Zborowski* (p. 9). Editions L'Echoppe. Paris.

2. ArtPrice (2018). H1 2018 Global Art Market Report, ArtPrice (online). Available from: https://it.artprice.com/artprice-reports/global-art-market-in-h1-2018-by-artprice-com/h1-2018-globalart-market-report-by-artprice-com [Retrieved February 21, 2019].

3. Gladwell, M. (2008). *Outliers: The story of success*. New York: Little, Brown, and Co.

4. Ericsson, K.A. (2004). Deliberate practice and the acquisition and maintenance of expert performance in medicine and related domains. *Academic Medicine*, 79(10), S70-81.

5. Alexandre, N. (1993). *The Unknown Modigliani: Drawings from the Collection of Paul Alexandre* (p. 91). Harry N. Abrams Inc., New York.

6. Scorsese, M. (2009). Commentary about film director Michael Powell. *Age of Consent*. The Collector's Choice.

7. Carcot, F. M. (1919, July 15) "*L'Éventail*." N°. 6, Direction, François Laya, Genéve.

8. Krebs S. M., & Paris. (2017). In, *Modigliani*. Eds., Fraquelli S and Ireson N (pp. 29-33) London: Tate Publishing.

9. Tilles, G. (n.d.). Syphilis, syphilitiques et syphiligraphes dans les Hôpitaux de l'Assistance Publique (pp. 113-148). Retrieved from https://blogs.aphp.fr/wp-content/blogs.dir/113/files/2014/09/3_livres_Tilles.pdf

10. Alexandre, N. (1993). *The Unknown Modigliani. Drawings from the Collection of Paul Alexandre* (pp. 75-76), Harry N. Abrams Inc., New York.

11. Alexandre, N. (1993). *The Unknown Modigliani. Drawings from the Collection of Paul Alexandre* (pp. 84-87), harry N. Abrams, Inc., New York.

12. Alexandre, Noël. (1993). *The Unknown Modigliani. Drawings from the Collection of Paul Alexandre* (p. 85). Harry N. Abrams Inc., New York.

13. Boccioni, U., Carra, C. D., Russolo, L., Balla, G., & Severini, G. (1910, April 11). *La Pittura Futurista. Manifesto Technico.* Retrieved from https://www.loc. gov/resource/gdcwdl.wdl_20026/?st=pdf&pdfPage=4.

14. Nathanson, R. (n.d.). Amedeo Modigliani, 'Study for The Standing Nude Sculpture' c.1911 - An Essay by Richard.pdf. Retrieved from https://richardnathanson. co.uk.

15. Secrest, M. (2011). *Modigliani: A life* (pp. 265). Alfred A. Knoff, New York.

16. Meyers, J. (2006). *Modigliani, a life* (pp. 186). New York: Harcourt Press.

17. De Chirico, G. (1942). *Discorso sul nudo in pittura.* In *L'Illustrazione Italiana*, illustrated with Ruben's The Three Graces, Milan 11 October 1942, p. 390. Republished in The Comedy of Modern Art. Metaphysical Art, The de Chirico Journals, 2016 / n° 14/16 (pp. 121-123), Rome.

18. Klüver, B., & Martin, J. (1989). *KiKi's Paris: Artists and Lovers* 1900-1930 (pp. 18-46). Harry N. Abrams Inc., New York.

19. Alexandre, N. (1993). *The Unknown Modigliani. Drawings from the Collection of Paul Alexandre* (p. 49), Harry N. Abrams Inc., New York.

20. Supangkat, J. (2005). *Provocative Bodies: Interpreting the works of Mochtar Apin 1990-1993* (pp. 131-152). Jakarta; CP Foundation.

21. Burnstock, A., Duvernois, I., & Stringari, L. (2018). The Modigliani Technical Research Study: Modigliani's painted nudes 1916-17. *The Burlington Magazine,* 160 (1318), 319-324.

22. Burnstock, A., Duvernois, I., & Stringari, L. (2018). The Modigliani Technical Research Study: Modigliani's painted nudes 1916-17. *The Burlington Magazine,* 160 (1318), 319-324.

23. Schweiller, G. (1927). Modigliani. *Arte Moderna Italiana N.* 8, (pp. 9-12). Milano: Ulrico Hoepli.

24. Braun, E. (2006). Carnal Knowledge. In, *Modigliani and his Models* (p. 45). Royal Academy of Arts.

25. Coquiot, G. (1920). *Les Indépendants*, (1884-1920). *Librairie Ollendorff*, Paris.

26. Meyers J. (2006). *Modigliani, a life* (p. 195) New York: Harcourt Press.

27. Fulford, R. (2016). The correspondence between Canadian artist Alex Colville and biographer Jeffrey Meyers is as revealing as it is delightful. *National Post*, December 13. Retrieved from https://nationalpost.com/entertainment/books/ the-correspondence-between-canadian-artist-alex-colville-and-biographer-jeffrey-meyers-is-as-revealing-as-it-is-delightful. (August 21, 2022).

28. Meyers, J. (2006). *Modigliani, a life* (p. 199). New York: Harcourt Press. Letter from Alex Colville to Jeffrey Meyers, August 4, 2004.

29. Secrest, M. (2011). *Modigliani: A life* (p. 264). Alfred A. Knoff, New York.

30. Rose, J. (1990). *Modigliani, The Pure Bohemian.* (p. 159). New York: St. Martin's Press.

31. Schmalenbach, W. (1990). *Modigliani* (p. 48). Munich: Prestel-Verlag Press.

32. Crotta, A., & Vermeylen, F. (2020). Does nudity sell? An econometric analysis of the value of female nudity in Modigliani portraits. *ACEI Working Paper Series*, AWP-02-2020. Retrieved August 19, 2022, from http://www.culturaleconomics. org/wp-content/uploads/2020/12/AWP_02_2020.pdf.

33. Sotheby's. (2018). Impressionist and Modern Art, May 14, 2018. Retrieved from https://www.sothebys.com/en/articles/at-157-2-million-modiglianis-greatest-nude-is-also-the-most-expensive-painting-ever-sold-at-sothebys. Accessed October 25, 2022.

34. Weill, B. (1933). *Pan! dans l'Oeil!* (p. 205). Paris: Librairie Lipschutz.

35. Wayne, K (2002). *Modigliani and the artists of Montparnasse* (p. 70) New York: Abrams HN.

36. Weill, B. (1933). *Pan! dans l'Oeil!* (p. 229). Paris: Librairie Lipschutz.

37. Braun, E. (2006). Carnal Knowledge. *Modigliani and his Models* (p. 62). Royal Academy of Arts.

38. Blaisdell, G. (1976). Women From all Directions. *Dented Fenders: Poems 1960-1975* (NP: Tribal Press).

39. Morris, D. B. (2006). Eros Modigliani. *The Iowa Review*, 36 (1), 149-169.

40. Ceroni, A. (1989). *Modigliani: Les Nus*. Düdingen, Switzerland: La Bibliothèque des Arts.

41. Carco, F. (1928). *The last Bohemia, from Montmartre to the Latin Quarter* (p. 237). Henry Holt and Co, (*trans.* Madeleine Boyd), New York.

42. Franklin, D. (2021). *Modigliani: Between Renaissance and Modernism* (p. 48). Stuttgart: Arnoldsche Art Publishers.

43. Schmalenbach, W. (1990). *Modigliani*. Modigliani by his contemporaries (pp. 47-52). Munich: Prestel-Verlag Press.

44. Salmon, A. (1920). *L'art vivant, 1920*. Paris: Edition G. Crès et Cie.

45. The exhibition's photographic record can be viewed at: https://www.moma.org/calendar/exhibitions/2916#installation-images Accessed October 31, 2022.

46. Soby, J. T. (1951). Introduction to Modigliani paintings, drawings, sculpture. *The Museum of Modern Art, New York, in collaboration with the Cleveland Museum of Art*. Retrieved from http://www.moma.org/calendar/exhibitions/2916.

47. Colt, P. (2012). *L'art qui parle*. Nice, France: Edition Ciais.

48. Carco, F. (1919, July 15). Modigliani. *L'Éventail*, 201.

CHAPTER 28: ADDICTION

1. Tree, I. (1920). Poems. In J. Lane company & J.J. Little and Ives Company (Eds.), *'I think myself,' Rockets and Ashes* (p. 30). New York: John Lane company.

2. Marrus, M. R. (1974). Social drinking in the 'Belle Epoque. *Journal of Social History*, 7(2), 115-141. Retrieved from http://www.jstor.org/stable/3786351.

3. LeBras, S. (2017, October). 1917: la guerre contre le vin est déclarée. *Mensuel 440*. Retrieved from https://www.lhistoire.fr/1917-la-guerre-contre-le-vin-est-déclarée.

4. Cronier, E., & Le Bras, S. (2020, July 21). Food and Nutrition (France). *International Encyclopedia of the First World War.* Retrieved from https://encyclopedia.1914-1918-online.net/article/food_and_nutrition_france.

5. Manning, J. (1997). Wages and purchasing power. In J.-L. Robert & J. Winter (Eds.), *Capital cities at war: Paris, London, Berlin 1914-1919,* vol. 1 (pp. 139, 151ff). Cambridge.

6. Chancerel, P. (2015, May 19). Labour (France). *International Encyclopedia of the First World War.* Retrieved from https://encyclopedia.1914-1918-online.net/article/labour_france.

7. Kemmerer, D. L. (1953). Inflation: The First World War. *Current History, 24*(141), 281-287. Retrieved from http://www.jstor.org/stable/45308416.

8. *Récits des petites communes: Bonnétage Durant la première guerre mondiale,* (p. 24-36). Retrieved from http://cdn1_4.reseaudespetitescommunes.fr/cities/746/documents/1pwvqhp79u4trvf.pdf.

9. Stauner, M. (n.d.). *Relevé de quelques prix et salaires aux 19ème et 20ème siècles.* Retrieved from http://nlghistoire.fr/documents/NLGH%20-%20prix%20&%20salaires%2019-20ème%20siècles%20a.pdf.

10. Rémy Allasure, J. Fourastié, & J. Guilhelm. (1970). *Document pour l'élaboration d'indices du coût de la vie en France de 1910 à 1965* (p. 28, 62, 72, 86). Paris: Armand Colin.

11. Lanthier, M. (2003). War widows and the expansion of the French Welfare State. *Proceedings of the Western Society for French History, 31,* 255-270. Retrieved from https://quod.lib.umich.edu/w/wsfh/0642292.0031.016/--war-widows-and-the-expansion-of-the-french-welfare-state?rgn=main;view=fulltext.

12. Restellini, M. (2012). *La Collection Jonas Netter, Modigliani, Soutine et L'Aventure de Montparnasse* (p. 11). Pinacothèque de Paris, 2012. Gourcuff Grandenigo, Paris.

13. Ehrenburg, I. (1918). *People and Life, Memoires 1891-1917* (p. 141). London: Cox and Wyman LTD, Macgibbon and Kee Trans. Retrieved from https://archive.org/stream/in.ernet.dli.2015.461042/2015.461042.People-And_djvu.txt

14. Ceroni, A (1972). *Tout l'oevre peint de Modigliani.* Modigliani à Paris (p. 6). Paris: Flammarion.

15. Bell, C (1923). *Since Cezanne* (p. 27). New York: Harcourt, Brace and Co.

16. Saint Sauveur, C. (2019, November 19). En 1917, quand les "midinettes" se revoltaient contre l'injustice salariale. *Le Parisien.* Retrieved from https://www.leparisien.fr/economie/emploi/en-1917-quand-les-midinettes-se-revoltaient-contre-l-injustice-salariale-10-11-2019-8190204.php.

17. Downs, L. L. (2006). Salaires et valeur du travail. L'entrée des femmes dans les industries mécaniques sous le sceau de l'inégalité en France et en Grande-Bretagne (1914-1920). *Travail, genre et sociétés, 15*(1), 31-49. doi:10.3917/tgs.015.0031.

18. Chancerelle, P. (2015). Labour (France). *International Encyclopedia of the First World War.* Retrieved from https://encyclopedia.1914-1918-online.net/pdf/1914-1918-Online-labour_france-2015-05-19.pdf.

19. Burns, E. M. (1923). The French minimum wage act of 1915. *Economica, 9,* 236-244

20. Salmon, A. (1926). Modigliani, sa vie, son oeuvre. Quoted in Ceroni A. *Tout l'oeuvre peint de Modigliani.* La fortune critique de Modigliani (p. 11). Flammarion, Paris, 1972.

21. Sisson, J. H. (2007). Alcohol and airway dysfunction in health and disease. *Alcohol, 41*(5), 293–307. doi:10.1016/j.alcohol.2007.06.003

22. Gupta, N. M., Deshpande, A., & Rothberg, M. B. (2020). Pneumonia and alcohol use disorder: Implications for treatment. *Cleveland Clinic Journal of Medicine, 87*(8), 493-500. doi:10.3949/ccjm.87a.19105

23. Parker, L. A. (2017). *Cannabinoids and the Brain.* Cambridge, MA: MIT Press.

24. Huestis, M. A., et al. (2015). Controlled Cannabis Vaporizer Administration: Blood and Plasma Cannabinoids with and without Alcohol. *Clinical Chemistry,* May. doi:10.1373/clinchem.2015.238287.

25. Toennes, S. W., Schneider, K., Wunder, C., Kauert, G. F., et al. (2013). Influence of Ethanol on the Pharmacokinetic Properties of Δ9-Tetrahydrocannabinol in Oral Fluid. *Journal of Analytical Toxicology, 37*(3), 152–158. doi:10.1093/jat/bkt002.

26. Ghaly, S. J. (2019, August 14). What is crossfading and how to do it properly. *Herb.* Retrieved from https://herb.co/learn/what-is-crossfading-and-how-to-do-it-properly/

27. Singh, A. K. (2019). Alcohol Interaction with Cocaine, Methamphetamine, Opioids, Nicotine, Cannabis, and γ-Hydroxybutyric Acid. *Biomedicines, 7*(1), 16. doi:10.3390/biomedicines7010016.

28. Ghaly, S. J. (2019, August 14). What is crossfading and how to do it properly. *Learn.* Retrieved from https://herb.co/learn/what-is-crossfading-and-how-to-do-it-properly/

29. Fournier, G. (1957). Cors de chasse (Souvenirs). Collection "Les Problèmes de l'art". Genève: Pierre Cailler.

30. Smith MA. (2021). Social learning and addiction. *Behavioural Brain Research* 398:1-10 https://doi.org/10.1016/j.bbr.2020.112954.

31. American Society of Addiction Medicine. (2019). 2019-Definition of Addiction. Retrieved from https://www.asam.org/quality-care/definition-of-addiction.

32. Aron, E.N. (2020). *The Highly Sensitive Person.* Citadel Press, New York.

33. National Academies Press. (2017). The Health Effects of Cannabis and cannabinoids: The current state of evidence and recommendations for research. Retrieved from https://www.nap.edu/read/24625/chapter/1.

34. Shivani, R., Goldsmith, J., & Anthenelli, R. M. (2002). Alcoholism and Psychiatric disorders. *Alcohol Research and Health, 26,* 90-98. Retrieved from https://pubs.niaaa.nih.gov/publications/arh26-2/90-98.htm.

35. Edenberg, HJ, Foroud T (2013). Genetics and alcoholism. *Nat Rev Gastroenterol Hepatol.* Aug;10(8):487-94. doi: 10.1038/nrgastro.2013.86. Epub 2013 May 28. PMID: 23712313; PMCID: PMC4056340.

36. Secrest, M. (2011). *Modigliani: A life.* (pp. 338-340). New York: Alfred A. Knoff. (Nothing has been made public about Giovanna's two daughters: Anne, born in 1946, and Laure Nechtschein-Modigliani, born in 1951).

37. Modigliani, A., Ceroni, A., & Czechowska, L. (1958). *Amedeo Modigliani, Peintre; [par] Ambrogio Ceroni. Suivi Des «souvenirs» De Lunia Czechowska* (p. 28). Milan: Edizioni Del Milione. Print. Monographies Des Artistes Italiens Modernes;6.

38. Warnod, J. (2008). Chez la Baronne d'Oettingen: *Paris russe, et avant-gardes* (1913-1935) (p. 109). Paris: Editions de Conti.

CHAPTER 29: BLUE SKIES AND SUNSHINE

1. de Vlaminck, M. (1925, November). Souvenir de Modigliani. *L'Art Vivant,* 21(2), 2.

2. Nieuwint, J. (2015). The German Paris Gun-Super Gun of WWI. *War History Online,* October 17. Retrieved fromhttps://www.warhistoryonline.com/featured/the-paris-gun.html?safari=1Retrieved September 2, 2022.

3. Sichel, P. (1967). *Modigliani, a biography* (p. 404). New York: E. Dutton and Company.

4. Zborowska, A. (2015). *Modigliani et Zborowski* (p. 34). Editions L'Echoppe, Paris.

5. Carco, F. (1927). *De Montmartre au Quartier Latin.* (p. 241). Albin Michel, Paris.

6. Amiel, A. (2023). *Modigliani sur la Côte d'Azur: entre Nice et Cagnes-sur-Mer* (pp. 82-83). Editions Mémoires Millenaires, Saint-Laurent-du-Var.

7. The disease was named *The Spanish Flu* because it presumably originated in Spain. Contemporary epidemiological studies identified the first known outbreak as occurring in Haskell County, Kansas. Censorship, denial, and misunderstanding throughout the pandemic contributed to its devastating effects.

8. Cendrars B. (1958). Recollections of Modigliani by those who knew him. Collected by Frederick S. Wight. *Italian Quarterly,* (pp. 46-49), University of California, Los Angeles, Spring, 1958.

9. Barry, J. M. (2004). The site of origin of the 1918 influenza pandemic and its public health implications. *Journal of Translational Medicine, 2*(1), 3. doi:10.1186/1479-5876-2-3

10. Centers for Disease Control and Prevention. (n.d.). History of the 1918 Flu Pandemic. Retrieved from https://www.cdc.gov/flu/pandemic-resources/1918-commemoration/1918-pandemic-history.htm.

11. Guenel, J. (2004). Spanish influenza in France from 1918-1919. *Histoire des Sciences Medicales, 38*(2), 165-175.

12. Blackshaw, G. (2007). The Pathological Body: Modernist Strategising in Egon Schiele's Self-Portraiture. *Oxford Art Journal, 30*(3), 377–401. doi:10.1093/oxartj/kcm036

13. Egon Schiele online. (n.d.). Girl (The Virgin) Mädchen (Die Jungfrau). Retrieved from http://egonschieleonline.org/works/paintings/work/p305.

14. Taylor, A. (2018, May 2). The Atlantic 100 years ago: France in the final year of World War I. Lewis Hine photography. *The Atlantic*.

15. Huusko, T. (2016). Amedeo Modigliani and the portrait of Léopold Survage. *FNG Research, 5,* 1-4.

16. Jolivet, S., & Le Flohic, A. G. (2022). Dossier pédagogique. Les Secrets de Modigliani. *Lille Métropole Musée d'art moderne, d'art contemporain et d'art brut,* Catalogue.

17. Léopold Survage in Maiolino, E. (Ed.). (1981). Modigliani Vivo: Testimonianze inedite e rare (pp. 63-68). [English translation in Schmalenbach, W. (Ed.), *Amedeo Modigliani* (pp. 202-203). Munich: Prestel-Verlag, 1990.]

18. Acharjee, N. (2019). Beauty of "Golden Ratio" in paintings, architecture, music, nature and technology. *Communique (An Academic Journal of Durgapur Government College), 11,* originally published in September 2018. Retrieved from https://www.researchgate.net/publication/335972358_Beauty_of_Golden_ Ratio_in_paintings_architecture_music_nature_and_technology.

19. André, W. (1990). Modigliani. In Schmalenbach, W. (Ed.), *Amedeo Modigliani* (p. 204). Munich: Prestel-Verlag.

20. Carco, F. (1953). *L'ami des peintres* (2nd ed., p. 38). Paris: Editions Gallimard.

21. Wayne, K. (2002). *Modigliani and the artists of Montparnasse* (pp. 69-70). New York: Abrams HN.

CHAPTER 30: READY...SET...SELL

1. Malraux, A. (1990). *The Voices of Silence* (p. 438). Princeton, NJ: Bollingen Series XXIV, Princeton University Press.

2. Franklin, D. (2021). *Modigliani: Between Renaissance and Modernism* (p. 7). Germany: Arnoldsche Verlagsanstalt.

3. Vitali, L. (1936). *Disegni di Modigliani. Arte Moderna Italiana N. 15.* Milano: Ulrico Hoepli Eds. [English translation in Schmalenbach, W. (Ed.), Amedeo Modigliani (p. 204). Munich: Prestel-Verlag, 1990.]

4. King, A., Duvernois, I., Fronek, J., et al. (2018). Modigliani in the South of France. The Modigliani Technical Research Study. *The Burlington Magazine, 160,* 394-399.

5. Survage, L. (n.d.). 'My speech on Modigliani in Paris in 1947'. *Finnish National Gallery, Helsinki, Archive Collections.* Retrieved from https://research.fng. fi/2016/11/28/article-my-speech-on-modigliani-in-parisin-1947.

6. Modigliani, J. (1958). *Modigliani: Man and Myth* (p. 82). New York: The Orion Press.

7. Ehrenburg, I. (1961). *People, Years, Life, Memories 1891-1921.* Alfred A Knopf, New York.

8. Soby, J.T. (1951). Introduction to Modigliani paintings, drawings, sculpture. *The Museum of Modern Art, New York, in collaboration with the Cleveland Museum of Art*. Museum of Modern Art. www.moma.org/calendar/exhibitions/2916.

9. Fry, R. (1919). Modern French Painting at the Mansard Gallery II. *The Atheneaeum* (London) (p. 755). August 15.

10. Ceroni, A. (1972). *Tout l'oevre peint de Modigliani*. Modigliani à Paris (p. 12). Paris: Flammarion. *Trans* of the original French. "Botticelli moderne, consumé par le feu de l'esprit, qui affine, rend presque immatérielles ses créatures afin d'en mieux laisser transparaître l'esprit méditatif et doucement mélancolique…"

11. Amiel, A. (2023). *Modigliani sur la Côte d'Azur : entre Nice et Cagnes-sur-Mer* (pp. 40-62) Editions Mémoires Millenaires, Saint-Laurent-du-Var.

12. Zborowska, A. (2015). *Modigliani et Zborowski* (p. 36). Editions L'Echoppe, Paris.

13. Bitsori, M., & Galanakis, E. (2003). Modigliani's «fillette en bleu»: A case of juvenile dermatomyositis? *International Journal of Dermatology, 42*, 327-329.

14. King, A., Duvernois, I., & Fronek, J. (2018). Modigliani in the South of France. The Modigliani Technical Research Study. *The Burlington Magazine, 160*, 394-399.

15. SecretModigliani.com. (n.d.). Retrieved from https://www.secretmodigliani.com/1918-w-118.html (Accessed September 4, 2022). Originally, Hugh Blaker diaries, University of Wales, March 31, 1932.

16. Tate. (n.d.). Lifestyle and legacy of the Bloomsbury Group. Retrieved from https://www.tate.org.uk/art/art-terms/b/bloomsbury/lifestyle-lives-and-legacy-bloomsbury-group (Accessed September 4, 2022).

17. Wayne, K. (2002). *Modigliani and the artists of Montparnasse*. New York: Abrams.

18. Sitwell, O. (1949). *Laughter in the room next door* (p. 154-159). London: MacMillan and Co.

19. Bennett, A. (1919). *Exhibition of French Art 1914-1919*. London, Mansard Gallery.

20. Modigliani, A., Ceroni, A., & Czechowska, L. (1958). *Amedeo Modigliani, Peintre; [par] Ambrogio Ceroni. Suivi Des «souvenirs» De Lunia Czechowska* (pp. 21-20). Milan: Edizioni Del Milione. Print. Monographies Des Artistes Italiens Modernes;6.

21. Sitwell, O. (1949). *Laughter in the room next door* (p. 150, 164, 166). London: MacMillan and Co.

22. Wayne, K. (2002). *Modigliani and the artists of Montparnasse*. New York: Abrams.

23. Bell, C. (1919). From, The Nation, August 16, 1919, The French Pictures at Heal's. In Sitwell, O. *Laughter in the room next door*. (Appendix A, p. 332). London: MacMillan and Co.

24. *US Art News.* (2021). The most expensive artworks ever sold at auction. Retrieved from https://usaartnews.com/art-market/the-most-expensive-artworks-ever-sold-at-auction, and Art Investments. Retrieved from https://artinvestment.ru/en/invest/rating/top_world_artists_auction_prices.html#a2 (Accessed September 4, 2022).

CHAPTER 31: BECOMING MODIGLIANI

1. Cioran, E. M. (1993). *The trouble with being born.* (p. 75). London: Quartet Books Limited, trans. Richard Howard. Original edition published in 1973 by Editions Gallimard).
2. Amiel, A. (n.d.). Modigliani a Nice et a Cagnes. [Video]. Retrieved from https://www.youtube.com/watch?v=TENQ37Gu81U (Transcript translated from French).
3. Amiel, A. (2023). *Modigliani sur la Côte d'Azur: entre Nice et Cagnes-sur-Mer.* (pp. 32-33). Editions Mémoires Millenaires, Saint-Laurent-du-Var.
4. Amiel, A. (2023). *Modigliani sur la Côte d'Azur: entre Nice et Cagnes-sur-Mer.* (pp. 28-30). Editions Mémoires Millenaires, Saint-Laurent-du-Var.
5. Zborowski, A. (2015). *Modigliani et Zborowski* (p. 36). Paris: L'Echoppe.
6. Zborowski, A. (2015). *Modigliani et Zborowski* (p. 38). Paris: L'Echoppe.
7. Martini, J. (n.d.). *L'Avenue de la Victoire à Nice.* Compte-rendu de D.E.S. de Géographie presenté en 1959 (E. Dalmasso).
8. Modigliani, J. (1958). *Modigliani: Man and Myth* (pp. 89-90). New York: The Orion Press.
9. Ôsterlind, A. (2015, January 13). *Repères biographiques.* https://anders-osterlind.org/2015/01/13/biographie-danders-osterlind/. Retrieved, August 10, 2022.
10. "Moi, Monsieur, je n'aime pas les fesses!" (As told by Anders Ôsterlind to his gallerist Ernest Brummer, see reference Ôsterlind/E. Brummer Paris Montparnasse, February 1930).
11. Sichel, P. (1967). *Modigliani, a biography* (p. 408). New York: E. Dutton and Company.
12. Brummer, E (1930). Modigliani chez Renoir. *Paris Montparnasse,* n° 13, p. 15., fevrier,.
13. Doran, M., & Cezanne, P. (2001). *Conversations with Cezanne.* Joachim Gasquet (p. 111). Eds. M. Doran. Berkeley: University of California Press.
14. Modigliani, J. (1958). *Modigliani: Man and Myth* (p. 110). New York: The Orion Press.
15. Survage, L. (1981). In E. Maiolino (Ed.), Modigliani Vivo: Testimonianze inedite e rare (p. 67). Turin.
16. Wayne, K. (2002). *Modigliani and the artists of Montparnasse.* (p. 73). Abrams HN. New York.
17. Fry, R. (1919). Line as a means of expression in modern art. *The Burlington Magazine for Connoisseurs, 34*(191), 62-69.
18. Pfannstiel, A. (1956). *Modigliani et son oeuvre: Étude Critique et Catalogue Raisonné* (p. 140). Paris: La Bibliothèque des Arts.
19. Modigliani, J. (1958). *Modigliani: Man and Myth. Letter from Modigliani to Zborowski, 27th February 1919* (p. 92). New York: The Orion Press.
20. Rose, J. (1990). *Modigliani, The Pure Bohemian* (p. 212). New York: St. Martin's Press.
21. Fifield, W. (1976). *Modigliani.* William Morrow (p. 260). New York.

22. Hatherley, L. I. (1985). Lactation and postpartum infertility: the use-effectiveness of natural family planning (NFP) after term pregnancy. *Clin Reprod Fertil,* *3*(4), 319-334. PMID: 3938342.

23. Chao, S. (1987). The effect of lactation on ovulation and fertility. *Clin Perinatol,* *14*(1), 39-50. PMID: 3549114.

24. There is question whether Modi fathered an illegitimate child named Lina Jacobelli as a result of having an affair with an Italian farmer's young wife (who already had six children) and who lived in a house in Haut-de-Cagnes, not far from the Ôsterlinds. See references; Patrice Chaplin, *Into the Darkness Laughing*, p. 103-108, Kindle edition, and Jeffrey Meyers, Modigliani, p. 216.

25. Riposati, M. (2009). *Modigliani, Simone Thiroux un amore segreto / a secret love* (pp. 62-63). Gente, Giuffreddi E. Article in Edizioni Carte Segrete, Rome.

26. *"Modigliani's son found in a small village serving as parish priest."* (1981, April 22). Jewish Telegraphic Agency. Retrieved from https://www.jta.org/archive/modiglianis-son-found-in-small-village-serving-as-parish-priest.

27. Ceroni, A. (1958). *Amedeo Modigliani*, including "Les Souvenirs de Lunia Czechowska" (pp. 28-32), Edizione del Milione, Milan.

28. Mckinster, Z. (2020, March 15). Some of the Profound Effects of World War I on France, Working Paper No. 52. *Portland State University Economics Working Papers,* 52, i + 16 pages + Appendix.

29. Seigel, J. (1986). *Bohemian Paris: Culture, Politics, and the Boundaries of Bourgeois Life, 1830-1930* (pp. 366-373). Baltimore: The Johns Hopkins University Press.

30. Vidal, P., Tibayrenc, M., & Gonzalez, J. P. (2007). Infectious diseases and arts. *In Encyclopedia of Infectious Diseases: Modern Methodologies.* Hoboken: John Wiley & Sons.

31. Cocteau, J. (1950). *Modigliani.* (p. 5). Paris, Fernand Hazan Eds.

32. Hillairet, J. (1963). *Dictionnaire Historique des Rues de Paris* (p. 596). Paris: Les Editions de Minuit (10th edition).

33. Sichel, P. (1967). *Modigliani, a biography* (p. 441). New York: E. Dutton and Company.

34. André, M. (1990). *The Voices of Silence* (p. 294). Bollingen Series XXIV, Princeton, New Jersey: Princeton University Press.

35. King, A., Ireson, N., Fraquelli, S., & Townsend, J. H. (2018). Modigliani Technical Research Study. Introduction to Modigliani's materials and techniques. *Burlington Magazine, 160* (1380). Retrieved from https://www.jstor.org/stable/44830512.

36. Newby, R.E., Thorpe, D.E., Kempster, P.A. and Alty, J.E. (2017). A History of Dystonia: Ancient to Modern. *Mov Disord Clin Pract*, 4: 478-485. https://doi.org/10.1002/mdc3.12493.

37. Martinez Castrillo J.C., Alonso Canovas A., and Garcia Ruiz P.J. Cervical Dystonia in Modigliani's Paintings: The Clue Was the Sensory Trick. (2018). *Mov Disord Clin Pract*, 5(3):346-347. doi: 10.1002/mdc3.12619. PMID: 30363431; PMCID: PMC6174471.

38. Bezur, A., Campos, P., Centeno, S., et al. (2018). Modigliani's late portraits. The Modigliani Technical Research Study. *Burlington Magazine*, CLX, 400-407. Retrieved from https://www.jstor.org/stable/44830513.

39. Roy, C. (1985). *Modigliani* (pp. 138-139). Skira-Rizzoli International Publications, Geneva.

CHAPTER 32: LETTERS TO MOTHER

1. Modigliani, A (1919). Post card dated April 13, 1919 addressed to his mother (Orig French : Chère maman, Je suis ici tout près de Nice. Très heureux. Sitôt fixé, je t'enverrai une address définitive. Je t'embrasse bien fort, Dedo). *Amedeo Modigliani Lettres et Notes,* (compiled and edited by Olivier Renault, French translation from orig. edition *Le Lettere,* Milan, Abscondita, 2006). Les Éditions Mille et Une Nuits, Librairie Artheme Fayard, Paris, 2020, (p. 61).

2. Bezur, A., Campos, P., Centeno, S., et al. (2018). Modigliani's late portraits. The Modigliani Technical Research Study. *Burlington Magazine*, CLX, 400-407. Retrieved from https://www.jstor.org/stable/44830513.

3. Roy, C. (1985). *Modigliani* (pp. 138-139). Geneva: Skira-Rizzoli International Publications.

4. Fry, R. (1919, August 15). Modern French Painting at the Mansard Gallery II. *The Athenaeum,* 755.

5. Sitwell, O. (1949). *Laughter in the room next door* (pp. 159-160). London: MacMillan and Co.

6. Art and Letters, London, 2(4), p. 149, Autumn 1919.

7. Modigliani, J. (1958). *Modigliani: Man and Myth* (p. 96). New York: The Orion Press.

8. Carcot, F. (1919, July 15). Modigliani. *L'Éventail* (p. 201), Direction Francois Laya, Editor W. Kundig, Geneva.

9. Modigliani A. *L'Éventail.* (1919, August 15). En hors text quatre dessins inédits de Modigliani. Numéro Sept, Direction François Laya, Genève, Editor W. Kundig, Paris.

10. Cioran, E. M. (1993). *The trouble with being born* (p. 135). London: Quartet Books Limited.

11. Modigliani, J. (1958). *Modigliani: Man and Myth* (p. 95) and plate 46; Declaration of Modigliani regarding his relationship with Jeanne Hébuterne, July 7, 1919. New York: The Orion Press.

12. Chaplin, P. (1990). *Into the darkness laughing: the story of Modigliani's last mistress, Jeanne Hébuterne* (p. 122). Virago press (kindle version, Lume Books, 2018).

13. Ceroni, A. (1958). *Amedeo Modigliani,* including "Les Souvenirs de Lunia Czechowska". Edizione del Milione, Milan.

14. Werner, A. (1985). *Amedeo Modigliani* (p. 126). New York: Harry N Abrams, Inc.

15. Franklin, D. (2021). *Modigliani: Between Renaissance and Modernism* (p. 84). Stuttgart.

16. Werner, A. (1985). *Amedeo Modigliani* (p. 122). New York: Harry N Abrams, Inc.

17. Modigliani, J. (1984). *Jeanne Modigliani Raconta Modigliani*. Archives Légales Amédéo Modigliani (p. 168) Rome: Edizione Graphis Arte.

18. Wayne, K. (2015, November 5). The true but secret story behind Amedeo Modigliani's favorite model Paulette Jourdain. *Artnet News*. Retrieved October 31, 2022, from https://news.artnet.com/market/amedeo-modigliani-model-paulette-jourdain-355346.

19. Catalogue des Ouvrages de Peinture, Sculpture, Dessin, Gravure, Architecture et Art Decoratif exposés au Grand Palais des Champs-Élysées. (1919). Paris: Societé Francaise d'Imprimerie. (Original work published 1919).

20. Littérature. (1919, December). Salon d'Automne, 1919, 32.

21. Coterie. (1919, December). Drawing of Paul Delay. No. 3. London, 1919.

22. Wagner, G. (1954). Wyndham Lewis and the Vorticist Aesthetic. *The Journal of Aesthetics and Art Criticism*, 13(1), 1-17. Retrieved from JSTOR, https://doi.org/10.2307/427013.

23. Wayne, K. (2006). Modigliani and England. In, *Modigliani and his Models* (pp. 45-72). Royal Academy of Arts.

24. Schmalenbach, W. (1990). *Modigliani*. Modigliani by his contemporaries (p. 184). Munich: Prestel-Verlag Press.

25. Morning, A. (1914, June 4) (Beatrice Hastings). "Impressions of Paris" (p. 115) *The New Age*.

26. Rose, J. (1990). *Modigliani, The Pure Bohemian* (p. 210). New York: St. Martin's Press.

27. Salmon, A. (1961). *A Memoir* (pp. 202-204). New York: G.P Putnam Sons.

28. Marevna, V. (1972). *Life with the Painters of La Ruche* (p. 149) London (WJ Mackay Limited, Chatham): Constable and Company.

29. Alexandre, Noël. (1993). *The Unknown Modigliani. Drawings from the Collection of Paul Alexandre* (pp. 26-32). New York, Harry N. Abrams.

30. Douglas, Charles (1941). *Artist Quarter* (p. 290) London: Faber and Faber.

31. Modigliani, J. *Modigliani: Man and Myth*. (pp. 15-16). New York: The Orion Press. 1958 (*trans*. H. Colt).

CHAPTER 33: AT LAST, PEACE

1. "*Oseh shawlom bim'ro'mawv, hu ya'aseh shawlom, awleinu v'al kol yisroel.*" Jewish Prayers. Mourners Kaddish. https://www.jewishvirtuallibrary.org/the-mourners-kaddish. Retrieved November 12, 2022."

2. Zborowska, A. (2015). *Modigliani and Zborowski*. Editions L'Echoppe, Paris.

3. Fifield, W. (1976). *Modigliani* (p. 260). New York: William Morrow.

4. Buckley, B., Fraquelli, S., Ireson, M., & King, A. (Eds.). (2022). *Modigliani Up Close*. New Haven: Yale University Press.

5. Magalhaes, A. G., Rizzutto, M. A., De Fariia, D. L. A., & de Campos, P. H. O. V. (2019). Tracing the material history of MA USP's Self-Portrait. *Anais do Museo Paulista*, 27, 1-37.

6. Magalhaes, A. G., Rizzutto, M. A., De Fariia, D. L. A., & de Campos, P. H. O. V. (2019). Tracing the material history of MA USP's Self-Portrait. *Anais do Museo Paulista, 27,* 1-37.

7. Levy, S., Wayne, K., Lacourt, J. B., et al. (2016). *Amedeo Modigliani: L'Oeil Interieur.* Paris: Gallimard.

8. Schmalenbach, W. (1990). *Modigliani.* Munich: Prestel-Verlag Press.

9. Modigliani, J. (1958). *Modigliani*: Man and Myth. New York: The Orion Press.

10. Fifield, W. (1976). *Modigliani* (p. 201). New York: William Morrow. Also see Modigliani J. *Modigliani: Man and Myth.* Letter from Simone Thiroux, plate 50, The Orion Press, New York, 1958. Also, in Rose J. *Modigliani, The Pure Bohemian.* St. Martin's Press, p. 208. New York, 1990, and in the original French in Modigliani, Jeanne. *Modigliani, une biographie.* p. 139., Éditions Adam Biro, Paris 1990.

11. Douglas, C. (1941). *Artist Quarter* (p. 290) London: Faber and Faber. Also reproduced in Sichel P. *Modigliani, a biography.* (p. 486). E. Dutton and Company, New York, 1967.

12. Carco, F. (1928). *The Last Bohemia: from Montmartre to the Latin Quarter* (pp. 30-31) New York: Henry Holt and Co.

13. Dardel, T. (1941). *Jag for till Paris* (I go to Paris). Stockholm: A Bonnier.

14. Sichel, P. (1967). *Modigliani, a biography* (pp. 494-496). New York: E. Dutton & Company.

15. Douglas, C. (1941). *Artist Quarter* (p. 291). London: Faber and Faber.

16. Secrest, M. (2011). *Modigliani: A life* (p. 302). Alfred A. Knoff, New York.

17. Cardinal, R. N., & Bullmore, E. T. (2011). Infectious and postinfectious syndromes. *In Cardinal and Bullmore* (Eds.), The diagnosis of psychosis (pp. 40-59). Cambridge, UK: Cambridge University Press.

18. Ceroni, A. (1967). *Amedeo Modigliani,* including "Les Souvenirs de Lunia Czechowska" (p. 21), Edizione del Milione, Milan. (1958), cited in Sichel Pierre. *Modigliani, a biography* (p. 491). New York: E. Dutton and Company.

19. Crespelle, J.P. (1969). *Modigliani: Les femmes, les amis, l'oeuvre* (p. 212). Presses de la Cité, réédition numérique, January.

20. Latourettes, L. (1929). Preface to Arthur Pfannstiel's *Modigliani,* Paris: Edition Séheur.

21. Douglas, C. (1941). *Artist Quarter* (p. 293). London: Faber and Faber.

22. Modigliani, J. *Modigliani sans Légende,* In, *XXᵉ Anniversaire. Amedeo Modigliani 1884-1920.* Catalogue d'exposition – 26 Mars – 28 Juin – Musée D'art Moderne de la Ville de Paris (1 Janvier, 1981), (p. 94), Paris, 1981.

23. Rose, J. (1990). Modigliani, *The Pure Bohemian.* St. Martin's Press (p. 209). New York.

CHAPTER 34: ANYONE MIGHT HAVE A SECRET LIFE

1. Gide, A. (1927). *The Counterfeiters (trans. Dorothy Bussy).* AA. Knopf, New York (Original work published 1925). Translation from the original French.

"Savez-vous qu'ils sont rares, de nos jours, ceux qui atteignent la quarantaine sans vérole et sans décorations !"

2. Rose, J. (1990). *Modigliani, The Pure Bohemian* (p. 41-42). New York, NY: St. Martin's Press.

3. Secrest, M. (2011). *Modigliani: A life* (p. 73-78). Alfred A. Knoff, New York.

4. Parisot, C. (2005), *Modigliani* (p. 106). Editions Gallimard, Paris.

5. Clayson, H. (2003). *Painted Love: Prostitution in French art of the Impressionist Era.* The Getty Research Institute Publications Program/Original edition Yale University.

6. Garg, R. (2020). Bourgeoning prostitution in 19th century Paris – "The city of pleasures." *International Journal for Technological Research in Engineering, 8*(2), 191-195.

7. Ross, I. A. (2011). Urban desires: Practicing pleasure in the 'City of Light,' 1848-1900 (Doctoral dissertation). University of Michigan.

8. Corbin, A. (1990). *Women for Hire: Prostitution and Sexuality in France After 1850* (A. Sheridan, *trans.*). Harvard University Press.

9. Grayzel, S. R. (1997). Mothers, Marraines, and Prostitutes: Morale and Morality in First World War France. *The International History Review, 19*(1), 66–82. http://www.jstor.org/stable/40108084.

10. Szreter, S. (Ed.). (n.d.). The Hidden Affliction: Sexually transmitted infections and infertility in history (p. 1-40). Boydel & Brewer. doi:10.1017/9781787445826.001

11. Revenin, R. (2005). *Homosexualité et prostitution masculines à Paris*, 1870-1918. L'Harmattan.

12. Toodayan, N. (2015). Jean Alfred Fournier (1832-1914): His contributions to dermatology. *Our Dermatol Online*, 4.

13. Osler, W. (1914). Aequanimitas. *Internal Medicine as a Vocation* (3rd ed.). HK Lewis, London.

14. Hayden, D. (2003). *Pox. Genius, Madness, and the Mysteries of Syphilis.* Perseus Books, New York.

15. Morris, H. (1912). A discussion on syphilis, with special reference to (a) its prevalence and intensity in the past and at the present day; (b) its relation to public health, including congenital syphilis; (c) the treatment of the disease. Proceedings of the Royal Society of Medicine, Vol V, 115-133. Bale and Danielsson. Retrieved from https://wellcomecollection.org/works/se567eyn.

16. Kohl, P. K., & Winzer, I. (2005). 100 Jahre Entdeckung der Spirochaeta pallida [The 100 years since discovery of Spirochaeta pallida]. *Hautarzt, 56*(2), 112-115. [German].

17. Tampa, M., Sarbu, I., Matei, C., Benea, V., & Georgescu, S. R. (2014). Brief history of syphilis. *Journal of Medical Life, 7*(1), 4-10.

18. LaFond, R. E., & Lukehart, S. A. (2006). Biological basis for syphilis. *Clinical Microbiology Reviews, 19*(1), 29-49.

19. French, P. (2007). Syphilis. *BMJ, 20*(334), 143-147. Erratum in: BMJ. 2007 Sep 1;335(7617):0.

20. Quetel, C. (1990). *History of Syphilis* (p. 196). Polity Press.

21. Frith, J. (2012). Syphilis-Its early history and treatment until penicillin and the debate on its origins. *Journal of Military and Veterans' Health, 20*(4).

22. Carlson, J. A., Dabiri, G., Cribier, B., & Sell, S. (2011). The immunopathobiology of syphilis: the manifestations and course of syphilis are determined by the level of delayed-type hypersensitivity. *The American Journal of Dermatopathology, 33*(5), 433-460.

23. Radolf, J. D., Tramont, E. C., & Salazar, J. C. (2014). *In: Mandell, Douglas and Bennett's Principles and Practice of Infectious Diseases* (Bennett, J. E., Dolin, R., & Blaser, M. J., eds., pp. 2684–2709). Churchill Livingstone Elsevier.

24. Rayment, M., & Sullivan, A. K. (2011). "He who knows syphilis knows medicine." The return of an old friend. *British Journal of Cardiology, 18*, 56-58.

25. Stoltey, J. E., & Cohen, S. E. (2015). Syphilis transmission: a review of the current evidence. *Sexual Health, 12*(2), 103-109.

26. Stamm, L. V. (1998). Biology of Treponema pallidum. In: *Holmes, K. K., Sparling, P. R., Mardh, P. A., et al. (Eds.), Sexually transmitted diseases, 3rd ed.* (pp. 467-472). New York: McGraw-Hill.

27. Clark, E. G., & Danbolt, N. (1955). The Oslo study of the natural history of untreated syphilis; an epidemiologic investigation based on a restudy of the Boeck-Bruusgaard material; a review and appraisal. *Journal of Chronic Diseases, 2*, 311-344.

28. Fenton, K.A, Breban R, Vardavas R, Okano JT, Martin T, Aral S, Blower S. (2008). Infectious syphilis in high-income settings in the 21st century. *Lancet Infect Dis* 8:244-253.

29. Hurn, J.D. (1998). The history of general paralysis of the insane in Britain, 1830 to 1950. PhD thesis, University of London, (pp. 6-16), March.

30. Sefton, A.M. (2001). The Great Pox that was…syphilis. *Journal Applied Microbiology* 91:592-596.

31. Jackson, R. (1980). Jonathan Hutchinson on syphilis. *Sex Transm Dis.* Apr-Jun;7(2):90–96. [PubMed: 6994262].

32. Lukehart S.A, Hook E.W, Baker-Zander S.A et al. (1988). Invasion of the central nervous system by Treponema pallidum: implications for diagnosis and treatment. *Ann Intern Med* 109:855-862.

33. Munshi, S, Raghunathan, S.K, Lindeman, I, Shetty, A.K. (2018). Meningovascular syphilis causing recurrent stroke and diagnostic difficulties: a scourge from the past. BMJ Case Rep 8:1-5. doi: 10.1136/bcr-2018-225255. PMID: 29884669; PMCID: PMC6011505.

34. Ha, T, Tadi P, Dubensky, L. (2023). Neurosyphilis. [Updated 2023 Feb 19]. In: *StatPearls* [Internet]. Treasure Island (FL): StatPearls Publishing; Jan-. Available from: https://www.ncbi.nlm.nih.gov/books/NBK540979/

35. Jabbour, N. (2000). Syphilis from 1880 to 1920: A Public Health Nightmare and the First Challenge to Medical Ethics. Essays in History, volume 42.

36. Jordan, P., Quadrelli, S., Heres, M., Belli, L., Ruhl, N. and Colt, H. (2014), Examining patients' preferences. *Intern Med J*, 44: 281-287. https://doi.org/10.1111/imj.12351.

37. Parascandola J. (2009). "From Mercury to Miracle Drugs: Syphilis Therapy over the Centuries." *Pharmacy in History* 51 (1):14–23.

38. Frith, J. Syphilis – Its early history and Treatment until Penicillin and the Debate on its Origins. *Journal of Military and Veterans' Health*, vol. 20, no. 4. Doi No 11.2021-47955651. https://jmvh.org/article/syphilis-its-early-history-and-treatment-until-penicillin-and-the-debate-on-its-origins/.

39. Gelpi, A, Tucker JD. (2015). After Venus, mercury: syphilis treatment in the UK before Salvarsan. *Sex Transm Infect*. Feb;91(1):68. doi: 10.1136/sextrans-2014-051778. PMID: 25609466; PMCID: PMC4317394.

40. Gelpi, A, Tucker JD. (2015). The magic bullet hits many targets: Salvarson's impact on UK health systems 1909-1943. *Sex Transm Infect* 91:69–70.

41. O.Shea, J.G. (1988). Was Paganini poisoned with mercury? *Journal Royal Society of Medicine* 81:594-597.

42. Wright, A.D. (1971).Venereal disease and the great pox. *Br J Vener Dis*. Aug;47(4):295-306. doi: 10.1136/sti.47.4.295. PMID: 4941840; PMCID: PMC1048214.

43. Hughes-Hallett L. (2014). *Gabriele D'Annunzio: Poet, Seducer, and Preacher of War*. Anchor Books (Random House) New York.

44. Alexandre P., (1924). *La Beauté de la chevelure*, éditions Javailier, 47 rue Poncelet, Paris.

45. Le Naour, Jean-Yves. (2002). « Sur le front intérieur du péril vénérien (1914-1918) », *Annales de démographie historique*, vol. n° 103, no. 1, pp. 107-120.

46. Tilles, G. Syphilis, syphilitiques et syphiligraphes dans les hôpitaux de l'Assistance publique. Historique de la semaine du 2 au 8 août 1914. Archives de l'Assistance publique-Hôpitaux de Paris, 603 FOSS 33.

47. Gaucher, E., Bizard, L. Statistique des syphilis contractées par les militaires depuis la mobilisation et traitées dans le service de clinique de l'hôpital Saint-Louis (août 1914-décembre 1915). *Ann Mal Vener*, 1916 :129-152.

48. Gilfoyle, Timothy J. 1999. "Prostitutes in History: From Parables of Pornography to Metaphors of Modernity." *The American Historical Review*, vol. 104, no. 1, pp. 117–41. *JSTOR*, https://doi.org/10.2307/2650183. Retrieved 2 Jan. 2023.

49. Bullough, Vern L. (1981). "A Brief Note on Rubber Technology and Contraception: The Diaphragm and the Condom." Technology and Culture, vol. 22, no. 1, pp. 104–11. JSTOR, https://doi.org/10.2307/3104294. Retrieved 29 Dec. 2022.

50. Rosenthal, L. Venus in the Trenches: The Treatment of Venereal Disease in the Canadian Expeditionary Force, 1914-1919 (2018). Theses and Dissertations (Comprehensive). 2107. https://scholars.wlu.ca/etd/2107.

51. Khan, F., Mukhtar, S., Dickinson, IK, Sriprasad, S. (2013). The story of the condom. *Indian J Urol*. Jan;29(1):12-5. doi: 10.4103/0970-1591.109976. PMID: 23671357; PMCID: PMC3649591.

52. Brandt AM. (1988). The Syphilis epidemic and its relation to AIDS. *Science*, 239;375-380 (4838).

53. Colonel Care Poster Series (n.d. 1918) in American Social Hygiene Association Papers, folder 113:6, University of Minnesota at Minneapolis-St. Paul.

54. U.S. War Department, *Annual Report, 1918* (Government Printing Office, Washington, D.C., 1918), p. 18; AG Love and CB Davenport, *Defects Found in Drafted Men* (Government Printing Office, Washington, D.C., 1920), p. 34.

55. Bogaert K. (2017). Patient Experience and the Treatment of Venereal Disease in Toronto's Military Base Hospital during the First World War. *Canadian Military History 26*, 2.

56. Meirowsky, E. "Über das sexuelle Leben unserer h€ohern Schüler", Zeitschrift f€ur die deutsche Gesellschaft zur Bek€ampfung Geschlechtskrankheiten 11 (1910/1911): 1–27, 41–62. Cited in, Todd, LM. *Sexual Treason in Germany during the First World War.* p. 23. Genders and Sexualities in History. Palgrave Macmillan, New Brunswick, Canada, 1917. Retrieved December 22, 2022. https://doi.org/10.1007/978-3-319-51514-4_1.

CHAPTER 35: JUST ONE MORE FOR THE ROAD

1. Stevenson, R.L. (1886*). The Strange Case of Dr. Jekyll and Mr. Hyde.* Standard eBooks (p. 72), based on Project Gutenberg Release Date: October 31, 1992 [eBook #43]. https://www.gutenberg.org/files/43/43-h/43-h.htm.

2. Modigliani, J. (1958). *Modigliani: Man and Myth*, (p. 74). The Orion Press, New York.

3. National Institute on Alcohol Abuse and Alcoholism: Understanding Alcohol Use Disorder. https://www.niaaa.nih.gov/publications/brochures-and-fact-sheets/understanding-alcohol-use-disorder. Retrieved August 21, 2023.

4. Benton, S.A. (2009). Understanding the high-functioning alcoholic: Professional views and personal insights. (pp. 5-15), Westport, CT: Praeger Publishers.

5. Johnny Depp vs Amber Heard defamation trial, Fairfax County, Virginia. April 21, 2022.

6. LeJeune, D. (2013). Boire et manger en France de 1870 au debut des années 1990. Cours de khâgne mis en ligne sur HAL-SHS (CNRS). DEUG. Khâgne du Lycée Louis le Grand, France. (pp. 1-29). ⟨cel-01476345⟩ https://hal.science/cel-01476345/document. Retrieved August 21, 2023.

7. Cayla, F. (1901). *Le Vin: le buveur de vin et le buveur de l'alcool.* (p. 7), Imprimerie Gounouilhou, Bordeaux.

8. LeJeune, D. (2013). Boire et manger en France de 1870 au debut des années 1990. Cours de khâgne mis en ligne sur HAL-SHS (CNRS). DEUG. Khâgne du Lycée Louis le Grand, France. (pp. 1-29). ⟨cel-01476345⟩ https://hal.science/cel-01476345/document. Retrieved August 21, 2023.

9. Marrus, M. R. (1974). Social drinking in the 'Belle Epoque.' *Journal of Social History,* 7(2), 115-141. Retrieved from http://www.jstor.org/stable/3786351.

10. James, W. (1917). *The Varieties of Religious Experience: A Study in Human Nature*, Lecture 16, Mysticism. (p. 387). Langmans, Green, and Co. New York.

11. Apollinaire, G. (1920). *Alcools*. Edition Gallimard, Paris.

12. Starkie, E. (1957). *Baudelaire*. Faber and Faber, (p. 532), London.

13. Avni, A. (1970). A Revaluation of Baudelaire's "Le Vin": Its Originality and Significance for Les Fleurs du mal. *The French Review*, *44*(2), 310–321. http://www.jstor.org/stable/385823.

14. Baudelaire, C. Translated by Keith Waldrop (2009). *Paris Spleen, little poems in prose*, (p. 71). "Be Drunk" (XXIII),Weslyan University Press, Middletown. Published posthumously in 1869, in the Original French, "Il faut etre toujours ivre. Tout est là: c'est l'unique question. Pour ne pas sentir l'horrible fardeau du Temps qui brise vos épaules et vous penche vers la terre, il faut vous enivrer sans trêve" – Baudelaire, Charles, *Le Spleen de Paris*, petits poèmes en prose. Edition Gallimard, (2006), Paris.

15. Prestwich, P.E. (1994). Drinkers, Drunkards, and Degenerates: The Alcoholic Population of a Parisian Asylum, 1867-1914. *Histoire Sociale-social History, 27*.

16. Saxton, L. (2015). Before addiction: The medical history of alcoholism in nineteenth-century France (Doctoral Thesis, pp. 6-9). City University of New York. Retrieved from https://academicworks.cuny.edu/cgi/viewcontent.cgi?referer=&httpsredir=1&article=2136&context=gc_etds.

17. Lipchitz, J. (1954). *Amedeo Modigliani (1884-1920)*. Pocket Books, Harry N. Abrams, pub, New York. Pocket library of creative art.

18. Substance Abuse and Mental Health Services Administration. (2016). Detailed Tables: Results from the 2016 National Survey on Drug Use and Health Rockville, MD: Center for Behavioral Health Statistics and Quality, Substance Abuse and Mental Health Services Administration Retrieved from https://www.samhsa.gov/data/sites/default/files/NSDUH-DetTabs-2016/NSDUHDetTabs-2016.htm#tab2-9B.

19. Schmalenbach, W. (1990). *Modigliani*. (p. 202). Prestel-Verlag Press, Munich. Quoting Carl Stoermer in Giovanni Schweiller, *Amedeo Modigliani – Selbstzeugniss*, (pp. 53-57).

20. Sichel, P. (1967). *Modigliani, a biography*. (p. 192), New York: E. Dutton and Company.

21. Carco, F. (1953). *L'ami des peintres* (8e ed.). (pp. 33-34). Editions Gallimard, Paris.

22. Akhmatova, A., & Austin, U. (1989). Amedeo Modigliani. *The Threepenny Review*, *38*, 29-30.

23. Sareen J. (n.d.). *Posttraumatic stress disorder in adults: epidemiology, pathophysiology, clinical manifestations, course assessment, and diagnosis*. https://www.uptodate.com/contents/posttraumatic-stress-disorder-in-adults-epidemiology-pathophysiology-clinical-manifestations-course-assessment-and-diagnosis. Retrieved November 22, 2022.

24. Sommer, J. L., Mota, N., Edmondson, D., & El-Gabalawy, R. (2018). Comorbidity in illness-induced posttraumatic stress disorder versus posttraumatic stress disorder due to external events in a nationally representative study. *General Hospital Psychiatry, 53*, 88. doi: 10.1016/j.genhosppsych.2018.05.004.
25. Basler, A. In Schmalenbach, W. (1990). *Modigliani*. (p. 185), Prestel-Verlag Press.
26. Schmalenbach, W. (1990). *Modigliani*. (p. 201). Prestel-Verlag Press, Munich. Quoting Ardengo Soffici in Modigliani. Dipinti e disegni (p. 108).
27. Schmalenbach, W. (1990). *Modigliani*. (p. 188). Prestel-Verlag Press, Munich. Quoting Carlo Carrà in Modigliani. Dipinti e disegni (p. 105).
28. Modigliani, J. (1958). *Modigliani: Man and Myth*, (p. 74). The Orion Press, New York.
29. Hamnett, N. (1932). *Laughing Torso. Reminiscences of Nina Hamnett* (pp. 54-78). New York: Ray Long & Richard R. Smith.
30. Douglas, C. (1941). *Artist Quarter* (pp. 216-127). London: Faber and Faber.
31. Mourant, C. (2019). 'Beatrice Hastings in Paris', *Katherine Mansfield Studies, 11*, 181-92.
32. Meyers, J. (2006). *Modigliani: A Life*. (p. 138). London, England: Gerald Duckworth & Co.
33. Johnson, B., & Brown, E. J. (Eds.). (2016). *Beatrice Hastings: On the Life & Work of a Lost Modern Master* (Unsung Masters Series volume 7, p. 248). Warrensburg, MO: Pleiades Press & Gulf Coast.
34. Mansfield, K. (1984). *The Collected Letters of Katherine Mansfield* (Vol. 1, 1903-1917) (V. O'Sullivan & M. Scott, Eds., (pp. 159-160). Oxford, England: Clarendon Press.
35. Hastings, B. (1932). Madame Six. *Straight-Thinker, 1*(2), 14.
36. Hastings B. (2002). Minnie Pinnikin. In *Modigliani and the artists of Montparnasse*. Kenneth Wayne, appendix, (p. 207). Abrams HN. New York.
37. Mann, C (1980). *Modigliani*. (pp. 198-116). Thames and Hudson, London.
38. Ehrenburg, I. (1962). *People and Life: Memoirs of 1891-1917*. Translation, Anna Bostock and Yvonne Kapp. (p. 148). Cox and Wyman, London. https://archive.org/stream/in.ernet.dli.2015.461042/2015.461042.People-And_djvu.txt. Retrieved, August 24, 2022.
39. Meyers, Jeffrey. (2006). *Modigliani, a life*. (p. 143). Harcourt Press, New York.
40. Modigliani, J. (1958). *Modigliani: Man and Myth*, (p. 73). The Orion Press, New York.
41. Ceroni, A. (1958). *Amedeo Modigliani*, including "Les Souvenirs de Lunia Czechowska" (p. 21), Edizione del Milione, Milan.
42. Lipchitz, J. (1954). *Amedeo Modigliani* (1884-1920). Pocket Books, Harry N. Abrams, pub, New York. Pocket library of creative art.
43. Amiel, A. (2023). *Modigliani sur la Côte d'Azur: entre Nice et Cagnes-sur-Mer*, Editions Mémoires Millénaires, Saint-Laurent-du-Var.
44. Cendrars, B. (1958). Recollections of Modigliani by those who knew him. Collected by Frederick S. Wight. *Italian Quarterly*. (pp. 50-51), University of California, Los Angeles, Spring, 1958.

45. Fifield, W. (1976). *Modigliani*. William Morrow (p. 259). New York.

46. Secrest, M. (2011). *Modigliani: A life*. (p. 184), Alfred A. Knoff, New York.

47. France, Conseil supérieur de l'assistance publique, Fascicule 52, (p. 36), March 1895.

48. Mann, K., Hermann, D., & Heinz, A. (2000). One hundred years of alcoholism: The twentieth century. *Alcohol and Alcoholism*, 35(1), 10-15. https://doi.org/10.1093/alcalc/35.1.10

49. Bynum, W. F. (1984). Alcoholism and degeneration in 19th century European medicine and psychiatry. *British Journal of Addiction*, 79, 59-70.

50. Saxton, L. (2015). Before addiction: The medical history of alcoholism in nineteenth-century France (Doctoral thesis, pp. 5-7). City University of New York.

51. Barnes, D. S. (1995). *The Making of a Social Disease: Tuberculosis in Nineteenth-Century France*. (p. 161). Berkeley: University of California Press. See Compte rendu du Congrés contre l'alcoolism et la tuberculose (Toulouse: Eduard Privat, 1903), 48-49.

52. Cingria, Charles-Albert. (1933). *Modigliani*, (original French: On a parlé de ses extravagances...Certes, il buvait et quelques fois il s'animait, mais ni plus ni moins que d'autres à cette époque. C'est la qualité de cette animation qui était remarquable chez lui. Il ne cessait pas d'être gentilhomme. Rarement je l'ai vu dépasser la dose acceptable à tout être civilisé, qui est un litre par personne). Catalogue Kunsthalle Basel (p. 4), 7 Jan, bis 4 feb. Design attributed Jan Tschichold, Basel.

53. Schmalenbach, W. (1990). Modigliani. (p. 189). Prestel-Verlag Press, Munich. Quoting Charles-Albert Cingria, Introduction to the catalogue of the Modigliani exhibition at the Kunsthalle Basel, 1934, (p. 3 ff).

54. Schmalenbach, W. (1990). *Modigliani*. (p. 204). Prestel-Verlag Press, Munich. Quoting Maurice de Vlaminck in Souvenir de Modigliani. *L'Art Vivant*, (pp. 1&2), N° 21, November, 1925.

55. Secrest, M. (2011). *Modigliani: A life*. (p. 288), Alfred A. Knoff, New York.

56. Fifield, W. (1976). *Modigliani* (pp. 193, 290). New York, NY: William Morrow.

57. Sichel, Pierre. (1967). *Modigliani, a biography*. (p. 451). E. Dutton and Company, New York.

CHAPTER 36: MEETING WITH THE INEVITABLE

1. Montaigne, M. de. (2003). *The Complete Works* (D. M. Frame, *trans.*). Essays: That to philosophize is to learn to die (p. 81). New York, NY: Everyman's Library, Alfred A. Knopf.

2. Rose, J. (1990). *Modigliani, The Pure Bohemian* (p. 211). New York, NY: St. Martin's Press.

3. Meyers, J. (2006). *Modigliani: A Life* (pp. 229-230). New York, NY: Harcourt Press.

4. A drawing by Modigliani's friend, the Tunisian painter Abdul Wahab, showed there was a coal stove in the corner of the room.

Endnotes

5. Fifield, W. (1976). *Modigliani* (p. 277). New York, NY: William Morrow.
6. Rose J. (1990). *Modigliani, The Pure Bohemian* (p. 210). New York: St. Martin's Press.
7. Secrest, M. (2011). *Modigliani: A Life.* (pp. 302-304). New York, NY: Alfred A. Knopf.
8. Secrest, M. (2011). *Modigliani: A Life.* (pp. 302-304). New York, NY: Alfred A. Knopf.
9. Meyers, J. (2006). *Modigliani: A Life.* (pp. 229-230). New York, NY: Harcourt Press.
10. Secrest, M. (2011). *Modigliani: A Life.* (pp. 302-304). New York, NY: Alfred A. Knopf.
11. Douglas, C. (1941). *Artist Quarter* (p. 298). London, England: Faber and Faber.
12. Salmon, A. (1961). *A Memoir* (p. 206). New York, NY: G.P Putnam Sons.
13. Sichel, P. (1967). *Modigliani, a biography* (p. 498). New York: E. Dutton and Company.
14. Modigliani, J. (1958). *Modigliani: Man and Myth.* (pp. 114-115), plate 49. New York: The Orion Press.
15. Meyers, J. (2006). *Modigliani, a life* (p. 229). New York: Harcourt Press.
16. Modigliani, J. (1990). *Modigliani, une biographie.* (pp. 134-135). Paris: Éditions Adam Biro.
17. Hashem, M. K., Nasim, Y. S. M., Mohamed-Hussein, A. A., et al. (2022). The clinical and functional characteristics of bronchiectasis among tuberculosis patients in Upper Egypt: a single-center study. *Egypt J Bronchol, 16*, 15. doi: 10.1186/s43168-022-00112-2
18. Choi, H., Lee, H., Ra, S. W., Kim, H. K., Lee, J. S., Um, S.-J., Kim, S.-H., Oh, Y.-M., Kwon, Y.-S., on behalf of the KMBARC. (2021). Clinical Characteristics of Patients with Post-Tuberculosis Bronchiectasis: Findings from the KMBARC Registry. J. *Clin. Med., 10*, 4542. doi: 10.3390/jcm10194542. The reference here and in the discussion refers to bronchiectasis that is not associated with cystic fibrosis or Alpha 1 antitrypsin disease.
19. Johnson, N. A. (2018). The 1918 flu pandemic and its aftermath. *Evo Edu Outreach*, 11, 5. doi: 10.1186/s12052-018-0079-5.
20. Taubenberger J.K. (2006). The origin and virulence of the 1918 "Spanish" influenza virus. *Proceedings of the American Philosophical Society, 150*(1), 86–112.
21. Johnson, N.A. (2018). The 1918 flu pandemic and its aftermath. *Evo Edu Outreach* 11, 5 https://doi.org/10.1186/s12052-018-0079-5.
22. Aminov, R. I. (2010). A brief history of the antibiotic era: lessons learned and challenges for the future. *Front Microbiol,* 1, 134. doi: 10.3389/fmicb.2010.00134.
23. McFadden, E. R. (2004). A Century of Asthma. *American Journal of Respiratory and Critical Care Medicine, 170*(3), 215–221.
24. Douglas, C. (1941). *Artist Quarter,* (p. 294). Faber and Faber, London.
25. Tégui, Emilio de Lascano. In Schmalenbach, W. *Modigliani.* (1990). (pp. 195-196). Prestel-Verlag Press, Munich, 1990. Quoting From Giovanni Scheiwiller,

Amedeo Modigliani. Selbstzeuguisse, Photos Zeichmungen, (p. 76f), 1958. "The 'delirium tremens,' the unleashed frenzy, appeared on his [Modigliani's] foamy lips. He was furious with the whole world. No friend, not a single friend. And on this cold night he demanded of his companions that they sit down with him on a bench which in his delirium appeared to him like the departure quay for some wondrous country."

26. Hoffman, R. S., & Weinhouse, G. L. (2022). Management of severe alcohol withdrawal syndromes. UptoDate. Retrieved from https://www.uptodate.com/contents/management-of-moderate-and-severe-alcohol-withdrawal-syndromes.

27. Anton, R. F., Schacht, J. P., & Book, S. W. (2014). Pharmacologic treatment of alcoholism. In E. V. Sullivan & A. Pfefferbaum (Eds.), *Handbook of Clinical Neurology* (Vol. 125: Alcohol and the Nervous System, Ch. 30, (pp. 527-542). Elsevier, Philadelphia.

28. Modigliani. (n.d.). Registre des actes de décès 6D204, n° 222, Archives Municipales de Paris, France.

29. Modigliani. (n.d.). Registre Declarations de Décès du 24 Aout 1919-12 Decembre 1921. Modigliani entry n° 79, p. 40. Reference CHR3/Q/2/66. Archives des Hôpitaux de l'Assistance Publique de Paris.

30. Di Ieva, A., & Yaşargil, M. G. (2008). Liquor cotunnii: the history of cerebrospinal fluid in Domenico Cotugno's work. *Neurosurgery, 63*, 352-358.

31. Magendie, F. (1842). Recherches physiologiques et cliniques sur le liquide céphalo-rachidien ou cérébro-spinal. Paris: Méquignon-Marvis.

32. Chin, J. H. (2014). Tuberculous meningitis: Diagnostic and therapeutic challenges. *Neurol Clin Pract, 4*(3), 199-205. doi: 10.1212/CPJ.0000000000000023.

33. Rufz, E. (1835). Quelques recherches sur les symptômes et sur les lésions anatomiques de l'affection décrite sous les noms d'hydrocéphale aiguë, fièvre cérébrale, méningite, méningo-céphalite chez les enfans. Thèse Paris n°42: Paris: impr. Didot le Jeune.

34. Walusinski, O. (2021). History of the Concept of Tuberculous Meningitis. *Eur Neurol, 84*, 61-70. doi: 10.1159/000512468.

35. Ward, M. A., Greenwood, T. M., Kumar, D. R., Mazza, J. J., & Yale, S. H. (2010). Josef Brudzinski and Vladimir Mikhailovich Kernig: signs for diagnosing meningitis. *Clin Med Res, 8*(1), 13-17. doi: 10.3121/cmr.2010.862. See: Kernig's sign: Flexing a patient's hip, then extending the knee causes pain at angles less than 135° from the popliteal fossa. See: Brudzinski's sign: Severe neck stiffness causes the patient's hips and knees to flex after passive flexion of the neck.

36. Wynter, W. E. (1891). Four cases of tubercular meningitis in which paracentesis of the theca vertebralis was performed for the relief of fluid pressure. *Lancet, 1*, 981-982.

37. Pearce, J. M. (1994). Walter Essex Wynter, Quincke, and lumbar puncture. *J Neurol Neurosurg Psychiatry, 57*, 179.

38. Arribas, M. A. T. (2017). The history of cerebrospinal fluid: from classical antiquity to the late modern period. *Neurosciences and History, 5*(3), 105-113.

39. Marshall, P. (1909). A Clinical Investigation of Lumbar Puncture. *Edinb Med J*, 3(3), 231-255.

40. Calthorpe, N. (2004). The history of spinal needles: getting to the point. *Anaesthesia*, 59: 1231-1241. https://doi.org/10.1111/j.1365-2044.2004.03976.x

41. Mestrezat, W. (1912). *Le liquide céphalo-rachidien normal et pathologique: valeur clinique de l'examen chimique*. Editions Maloine, Paris.

42. Garg, R. K. (2010). Tuberculous meningitis. *Acta Neurol Scand*, 122(2), 75-90. doi: 10.1111/j.1600-0404.2009.01316.x

CHAPTER 37: ON MASKS AND OTHER THINGS

1. Modigliani, A (1901). Letter to Oscar Ghiglia, dated Rome, April 1901, (p. 110). English translation in Werner, A. Modigliani as an art student. *Chicago Review* 1961;14(4):103-114. From the original Italian: "Lo vorrei invece che la mia vita fosse come un fiume ricco di abbondanza che scorresse con gioia sulla terra."

2. Registre des Entrées 1920 : Modigliani, Reference CHR/1/Q2/196. Archives des Hôpitaux de l'Assistance Publique de Paris.

3. Registre de l'état civile des actes de décès: Modigliani, 6D204, n° 222, Archives Municipales de Paris, France.

4. Registre Declarations de Décès du 24 Aout 1919-12 Decembre 1921. Modigliani entry n° 79, p. 40. Reference CHR3/Q/2/66. Archives des Hôpitaux de l'Assistance Publique de Paris.

5. Modigliani, J. (1990). *Modigliani, une biographie* (p.. 138-139). Éditions Adam Biro, Paris.

6. Crowley, P. R. (2016). Roman Death Masks and the Metaphorics of the Negative. Grey Room, (64), 64-103. Retrieved from https://www.jstor.org/stable/26778435.

7. Benkard, E., & Green, M. M. (1929). *Undying faces: A collection of death masks; with a note from Georg Kolbe* (p. 17). London: Hogarth Press.

8. Sichel, P. (1967). *Modigliani, a biography* (p. 508). New York: E. Dutton and Company.

9. Kolbe, G. (1929). How death masks are taken. In Benkard, E., & Green, M. M. (1929). *Undying faces: A collection of death masks; with a note from Georg Kolbe* (p. 43). London: Hogarth Press.

10. Hylland, O. M. (2018). Faces of death. Death masks in the museum. In B. Brenna, H. Dam Christensen, & O. Hamran (Eds.), *Museums as Cultures of Copies: The Crafting of Artefacts and Authenticity* (pp. 172-186). 1st ed., Routledge. doi: 10.4324/9781351106498.

11. Lipchitz, J. (1953). *Amedeo Modigliani*. (p. 6), Harry N. Abrams pub., New York.

12. Bronze casts of the Modigliani death mask are in Jerusalem, Israel Museum, New York, Metropolitan Museum of Art, New York, Museum of Modern Art, Paris, Centre G. Pompidou, and Pasadena, Norton Simon Museum. Each measure 8 1/2 × 5 1/2 × 4 3/4 in., 4 lb. (21.6 × 14 × 12.1 cm, 1.8 kg).

13. Apollinaire, G. (1964). *Alcools Poems 1898-1913, Zone.* Translated by William Meredith, (pp. 12-13). New York: Doubleday & Company. *Translation of the original French:* "Et tu bois cet alcool brûlant comme ta vie / Ta vie que tu bois comme une eau-de-vie."

14. Modigliani, J. (1984). *Jeanne Modigliani Racconta Modigliani* (p. 174). Livorno: Giorgio and Guido Guastalla Eds. Edizoni Graphis Arte.

15. Registre de l'état civile des actes de décès: Hébuterne, 5D226, n° 139, Archives Municipales de Paris, France.

EPILOGUE

1. Kang, C. (2022). An early adopter: Albert C. Barnes and Amedeo Modigliani. In B. Buckley, S. Fraquelli, M. Ireson, & A. King (Eds.), *Modigliani Up Close* (pp. 27-34). New Haven: Yale University Press.

2. Rea, N. (2019, March 14). Italian police may have solved the mystery of who was behind an exhibition of fake Modigliani paintings in Genoa. Artnet News. Retrieved from https://news.artnet.com/art-world/fake-modigliani-paintings-1488106.

3. Grafly, D. (1923). "Old Portraiture Praised, Modernists' Art Decried." *The North American,* April 15, Philadelphia.

4. Ziegler, F. J. (1923). The Modernistic Annex. April 15, Philadelphia Record.

5. Braun, E. (2004). The Faces of Modigliani: Identity Politics Under Fascism. In M. Klein (Ed.), *Modigliani: Beyond the Myth* (p. 30). New York: The Jewish Museum.

6. Carco, F. (1919, July 15). Modigliani. l'*Éventail* (p. 201).

7. Hughes, R. (2004, June 10). And Now the Nudes. *The Guardian.* Retrieved from www.theguardian.com/artanddesign/2004/jun/ao/art.

8. Glover, M. M. (2017, November 21). Modigliani, Tate Modern, review: This exhibition is just right. *Independent.* Retrieved from https://www.independent.co.uk/arts-entertainment/art/reviews/modigliani-tate-modern-review-a8067546.html.

9. Jones, J. (2017, November 21). Modigliani review - 'a gorgeous show about a slightly silly artist.' The Guardian. Retrieved from https://www.theguardian.com/artanddesign/2017/nov/21/modigliani-review-tate-modern-a-gorgeous-show-about-a-slightly-silly-artist.

10. Boucher, B. (2015, November 9). A $170-million Modigliani nude breaks records at Christi's $ 491 million "Artist's Muse" sale. Artnet. Retrieved from https://news.artnet.com/market/christies-artists-muse-sale-491-million-359576.

11. Norman, G. (1993, April 3). Art Market: Mystery of Modiglianis: A cache of secret drawings has been discovered in Paris; shedding new light on the artist seen by many as the definitive doomed Bohemian. Independent. Retrieved from https://www.independent.co.uk/arts-entertainment/art-market-mystery-of-the-modiglianis-a-cache-of-secret-drawings-has-been-discovered-in-paris-shedding-new-light-on-the-artist-seen-by-many-as-the-definitive-doomed-bohemian-1453242.html.

12. Buckley, B., Duffy, M., Langley, A., & Porell, M. (2018, April). The Modigliani Technical Research Study: Modigliani's Paris portraits 1915-1917. *The Burlington Magazine*, CLX, 311-318.

13. Wayne, K. (2002). *Modigliani and the artists of Montparnasse* (pp. 12-13). New York: Abrams HN.

14. Bettagno, A. (2005). *Art schools in Italy and France. Modigliani: In Venice, Between Leghorn and Paris* (p. 13). Carlo Delfino eds.

15. Zadkine, O. (1930, February). *Souvenirs. Paris Montparnasse*, (p. 13). special issue.

16. Restellini, M. (2012). *La Collection Jonas Netter, Modigliani, Soutine et L'Aventure de Montparnasse* (p. 14). Pinacothèque de Paris, 2012. Paris: Gourcuff Grandenigo.

17. Ceroni, A., & Fraquelli, S. (n.d.). The catalogues raisonnés of Amedeo Modigliani. The Modigliani Technical Research Study. *The Burlington Magazine*, CLX, 218, 189-195.

18. Marc Restellini: http://www.restellini.com/en/marc-restellini/.

19. The Modigliani Project: https://modiglianiproject.org/newly-accepted-works.

20. Buckley, B., Fraquelli, S., Ireson, M., King, A., & Little, M. A. (2022). *Modigliani up close*. In, B. Buckley, S. Fraquelli, M. Ireson, A. King, & M. A. Little (Eds.), Modigliani Up Close (pp. 1-11). New Haven: Yale University Press.

21. King, A., Ireson, N., Fraquelli, S., & Townsend, J.H. (2018) Modigliani technical Research Study. Introduction to Modigliani's materials and techniques. *The Burlington Magazine. 160* (1380). Retrieved August 14, 2022.

22. Droguet, V., Delot. S., & Pallot-Frossard I. (2022). Prefaces. *Les Secrets de Modigliani: Techniques et pratiques artistiques d'Amedeo Modigliani.* Lille Métropole Musée d'Art Moderne, d'Art Contemporain et d'Art Brut. Catalogue, (pp. 11-14).

23. Schilling, E. (n.d.). Expanding the Modigliani Canon? The Barne's Foundation *Modigliani Up Close* will feature newly examined paintings. Visual art and exhibitions, October 31, 2022. https://www.broadstreetreview.com/features/the-barnes-foundations-modigliani-up-close-will-feature-four-newly-accepted-paintings. Retrieved October 31, 2022.

24. Esterow, M. (1917). The art market's Modigliani forgery epidemic. Vanity Fair, May 3. Retrieved November 2, 2022. https://www.vanityfair.com/style/2017/05/worlds-most-faked-artists-amedeo-modigliani-picasso.

25. Lipchitz, J. (1953). *Amedeo Modigliani.* New York: Harry N. Abrams pub.

26. Sonable, Y. (1958). *Modigliani Nudes.* Paris, Fernand Hazan: Tudor Publishing.

27. Morris, D.B. (2017). *Eros and Illness.* Eros Modigliani: Assenting to life. (pp. 135-161). Cambridge MA, Harvard University Press.

28. Modigliani, J. (1984). *Jeanne Modigliani Racconta Modigliani.* (p. 193). Rome: Edizioni Graphis Arte.

29. Ehrenburg, I. (1962). *People and Life 1891-1921* (p. 152). New York: Translation, Anna Bostock and Yvonne Kapp, Alfred A. Knopf.

30. Meyers, J. (2022). Modigliani and the poets. *Salmagundi*, 206-207, Spring-Summer 2020. Retrieved from. https://salmagundi.skidmore.edu/articles/189-modigliani-and-the-poets.

31. Jacob, Max (1985). Lettres à Michel Manoll. (p. 123). « Modigliani était l'être le plus antipathique que j'aie connu…n'empêche qu'il ne restera peut-être plus que Picasso et lui de cette époque de peintres. –. » Texte établi et annoté par by Maria Green, Mortemart, Rougerie.

32. Guillaume, P. (1920). *Deux peintres: Modigliani, Utrillo* (p. 6). Les Arts à Paris.

33. Dale, M. (1929). *Modigliani*. Modern Art (p. 10). New York: Alfred A. Knopf.

34. Ceroni, A. (1958). *Amedeo Modigliani*, including "Les Souvenirs de Lunia Czechowska" (p. 21). Edizione del Milione, Milan.

CLOSING EPIGRAPH

1. Hedayat, S. (originally 1938/1939 *Buf-I Kur*) *The Blind Owl*, (*trans*. Iraj Bashiri), Bashiri Working Papers on Central Asia and Iran, 3rd revised edition, 2013, (p. 16).

APPENDIX A – IT'S ALL ABOUT MTB

1. Lehmann, K. B., & Neumann, R. (1896). *Atlas und Grundriss der Bakeriologie und Lehrbuch der speziellen bakteriologischen Diagnositk* (1st ed.).

2. Guan, Q., Garbati, M., Mfarrej, S., Al Mutairi, T., Laval, T., et al. (2021). Insights into the ancestry evolution of the Mycobacterium tuberculosis complex from analysis of Mycobacterium riyadhense. *NAR Genomics and Bioinformatics*, 3(3), 1-16. lqab070. doi: 10.1093/nargab/lqab070.

3. Gupta, M., Lobo, F. D., Adiga, D. S., & Gupta, A. (2016). A Histomorphological Pattern Analysis of Pulmonary Tuberculosis in Lung Autopsy and Surgically Resected Specimens. *Patholog Res Int*. 8132741. doi: 10.1155/2016/8132741.

4. Hugo, V. (1900). *The Hunchback of Notre-Dame*. New York: The Co-operation Publication Society. Retrieved from https://archive.org/details/hunchbackofnotre1hugo/page/n7/mode/2up.

5. Pigrau-Serrallach, C., & Rodríguez-Pardo, D. (2013). Bone and joint tuberculosis. *Eur Spine J*, 22 Suppl 4(Suppl 4), 556-566. doi: 10.1007/s00586-012-2331-y.

6. Advani, J. H., Verma, R., Chatterjee, O., et al. (2019). Whole Genome Sequencing of Mycobacterium tuberculosis Clinical Isolates From India Reveals Genetic Heterogeneity and Region-Specific Variations That Might Affect Drug Susceptibility. *Frontiers in Microbiology*, 10, 1-15. Retrieved from https://www.frontiersin.org/article/10.3389/fmicb.2019.00309.

7. Comas, I., Coscolla, M., Luo, T., Borrell, S., Holt, K. E., Kato-Maeda, M., Parkhill, J., Malla, B., Berg, S., Thwaites, G., Yeboah-Manu, D., Bothamley, G., Mei, J., Wei, L., Bentley, S., Harris, S. R., Niemann, S., Diel, R., Aseffa, A., Gao, Q., Young, D., Gagneux, S. (2013). Out-of-Africa migration and Neolithic

coexpansion of Mycobacterium tuberculosis with modern humans. *Nat Genet*, *45*(10), 1176-1182. doi: 10.1038/ng.2744.

8. Nicklisch, N., Maixner, F., Ganslmeier, R., Friederich, S., Dresely, V., Meller, H., Zink, A., Alt, K. W. (2012). Rib lesions in skeletons from Early Neolithic sites in Central Germany: on the trail of tuberculosis at the onset of agriculture. *Am J Phys Anthropol, 149*, 391-404.

9. Weger, S. (2014). Presence of Mycobacterium tuberculosis in the Americas prior to European contact. *MMIC* 7050.

10. Buzic, I., & Giuffra, V. (2020). The paleopathological evidence on the origins of human tuberculosis: a review. *J Prev Med Hyg* , *61*(1 Suppl 1), E3-E8.

11. Rothschild, B. M., et al. (2001). Mycobacterium tuberculosis Complex DNA from an Extinct Bison Dated 17,000 Years Before the Present. *Clinical Infectious Diseases, 33*, 306.

12. Daniel, T. M. (2006). The history of tuberculosis. *Respiratory Medicine, 100*, 1862-1870.

13. Comas, I., & Gagneux, S. (2009). The past and future of tuberculosis research. *PLoS Pathog, 5*(10), e1000600. doi: 10.1371/journal.ppat.1000600.

14. Brites, D., & Gagneux, S. (2015). Co-evolution of Mycobacterium tuberculosis and Homo sapiens. *Immunol Rev, 264*(1), 6-24. doi: 10.1111/imr.12264.

15. Galagan, J. (2014). Genomic insights into tuberculosis. *Nat Rev Genet, 15*, 307-320. doi: 10.1038/nrg3664.

16. Cardona, P. J., Català, M., & Prats, C. (2020). Origin of tuberculosis in the Paleolithic predicts unprecedented population growth and female resistance. *Sci Rep, 10*, 42. doi: 10.1038/s41598-019-56769-1.

17. Chisholm, R. H., Trauer, J. M., Curnoe, D., & Tanaka, M. M. (2016). Controlled fire use in early humans might have triggered the evolutionary emergence of tuberculosis. *Proc. Natl. Acad. Sci.* USA, 113, 9051-9056.

18. Lewin, G. R., Carlos, C., Chevrette, M. G., et al. (2016). Evolution and Ecology of Actinobacteria and Their Bioenergy Applications. *Annual Review of Microbiology, 70*, 235-254. doi:10.1146/annurev-micro-102215-095748.

19. Cole, S. T., Brosch, R., Parkhill, J., Garnier, T., Churcher, C., Harris, D., Gordon, S. V., et al. (1998). Deciphering the biology of Mycobacterium tuberculosis from the complete genome sequence. *Nature, 393*(6685), 537-544.

20. Comas, I., Coscolla, M., Luo, T., Borrell, S., Holt, K. E., Kato-Maeda, M., Parkhill, J., Malla, B., Berg, S., Thwaites, G., Yeboah-Manu, D., Bothamley, G., Mei, J., Wei, L., Bentley, S., Harris, S. R., Niemann, S., Diel, R., Aseffa, A., Gao, Q., Young, D., Gagneux, S. (2013). Out-of-Africa migration and Neolithic coexpansion of Mycobacterium tuberculosis with modern humans. *Nature Genetics, 45*(10), 1176-1182. doi:10.1038/ng.2744.

21. Menardo, F., Duchêne, S., Brites, D., Gagneux, S. (2019). The molecular clock of Mycobacterium tuberculosis. *PLOS Pathogens, 15*(9), e1008067. doi:10.1371/journal.ppat.1008067.

22. Sabin, S., Herbig, A., Vågene, Å. J., et al. (2020). A seventeenth-century My-cobacterium tuberculosis genome supports a Neolithic emergence of the My-cobacterium tuberculosis complex. *Genome Biology*, *21*(1), 201. doi:10.1186/s13059-020-02112-1.

23. McDonald, S. K., Matisoo-Smith, E. A., Buckley, H. R., et al. (2020). 'TB or not TB': the conundrum of pre-European contact tuberculosis in the Pacific. *Philosophical Transactions of the Royal Society B: Biological Sciences*, *375*(1812), 20190583. doi:10.1098/rstb.2019.0583.

APPENDIX B – ALCOHOLISM AND ALCOHOL USE DISORDER

1. E.M.J. (1941). Classics of the Alcohol Literature: An early medical view of alcohol addiction and it's treatment. Dr. Thomas Trotter's "Essay, Medical, Philosophical, and Chemical, on Drunkenness." *Quarterly Journal of Studies on Alcohol*, 1941;2(3):584–591. https://sites.rutgers.edu/alcoholstudies-archives/wp-content/uploads/sites/ 619/2021/02/classic4_Trotter.pdf.

2. Katcher, B S. (1993). Benjamin Rush's educational campaign against hard drink-ing. *American journal of public health 83(2)*: 273-81. doi:10.2105/ajph.83.2.273.

3. American Medical Association House of Delegates Proceedings, Clinical Con-vention v.1966 i.000 Pub. Date 1966. Reaffirmation of the 1956 statement of the Council on Mental Health, Recommendation for the Admission of Alco-holics to General Hospitals. Proceedings, AMA House of Delegates, November 1956, (pp. 32-33).

4. "Alcoholismus Chronicus, or Chronic Alcohol Disease, &c." *The British and foreign medico- chirurgical review* vol. 9,18 (1852): 339-354.

5. E.M.J. (1943). Classics of the Alcohol Literature: Magnus Huss' *Alcoholismus Chronicus*. *Quarterly Journal of Studies on Alcohol*, 1943;4(1):85–92. https://doi.org/10.15288/qjsa.1943.4.085. Published Online: April 23, 2020. https://sites.rutgers.edu/alcoholstudies-archives/wp-content/uploads/sites/619/2021/02/classic9_Huss.pdf. Retrieved August 21, 2023.

6. Dastre, A. La lutte contre l'alcoolism. *Revue des deux mondes*, 1 August 1899 (p. 696).

7. American Psychiatric Association (1994). *Diagnostic and statistical manual of mental disorders*. 4th ed. American Psychiatric Association, Washington, D.C.

8. Alcoholics Anonymous (2013). *Alcoholics Anonymous, The Big Book.*" Fourth edition, Alcoholics Anonymous World Services, Inc., New York.

9. Food and Drug Administration (2015). *Alcoholism: Developing Drugs for Treat-ment Guidance for Industry*. Rockville, MD: Food and Drug Administration. Retrieved from http://www.fda.gov/downloads/drugs/ 10. guidancecompli-anceregulatoryinformation/guidances/ucm433618.pdf

10. American Psychiatric Association (2013). *Diagnostic and statistical manual of mental disorders: DSM-5*. American Psychiatric Association, Washington, D.C.

11. Alcohol's Effects on Health (2023). National Institute on Alcohol Abuse and Alcoholism. Understanding Alcohol Use Disorder. https://www.niaaa.nih.gov/publications/brochures-and-fact-sheets/understanding-alcohol-use-disorder. Retrieved August 21, 2023.

12. WHO (2018). Global Status report on alcohol and health 2018. (p. XV), Poznyak V., and Rekve, D., (editors), Geneva: World Health Organization; 2018. License: CC BY-NC-SA 3.0 https://www.who.int/publications/i/item/9789241565639. Retrieved August 23, 2023.

13. SAMHSA, Center for Behavioral Health Statistics and Quality. 2021 National Survey on Drug Use and Health. Table 5.6A—Alcohol use disorder in past year: among people aged 12 or older; by age group and demographic characteristics, numbers in thousands, 2021. [cited 2023 Jan 11]. https://www.samhsa.gov/data/sites/default/files/reports/rpt39441/NSDUHDetailedTabs2021/NSDUH-DetailedTabs2021/NSDUHDetTabsSect5pe2021.htm#tab5.6a. Retrieved August 24, 2023.

14. Substance Abuse and Mental Health Services Administration (SAMHSA) 2021 National Survey on Drug Use and Health (NSDUH): Methodological Summary and Definitions. https://www.samhsa.gov/data/sites/default/files/reports/rpt39442/2021NSDUHMethodSummDefs100422.pdf. Retrieved August 24, 2023.

15. Moss, H.B., Chen, C.M., & Yi, H.Y. (2008). Subtypes of alcohol dependence in a nationally representative sample. *Drug Alcohol Depend* 91, 149-58. In a sample of 1484 respondents to the National Epidemiological Survey on Alcohol and Related Conditions, researchers found that 19.5% were the "functional" type (cluster 2). Other subtypes were cluster 1 (young adult, 31.5%), cluster 3 (Intermediate familial, 18.8%), and cluster 4 (young antisocial, 21.1%). Only 9.2% were of a stereotypical "chronic severe" subtype (cluster 5) in which individuals had the greatest probability for antisocial personality disorder, concurrent psychiatric illness and substance abuse disorders, tobacco use, and a family history for alcohol dependence as compared with the other clusters.

16. Beresford, T.P., Wongngamnit, N., Temple, B.A. (2014). Alcoholism: diagnosis, prognosis, epidemiology, and burden of the disease. *Handbook of Clinical Neurology* vol 125: Alcohol and the Nervous System. Ch. 1., (pp. 3-13). E.V. Sullivan and A. Pfefferbaum Eds. Elsevier, Philadelphia.

17. Grant B.F., Stinson F.S., Dawson D.A., et al. (2004). Prevalence and Co-occurrence of Substance Use Disorders and Independent Mood and Anxiety Disorders: Results from the National Epidemiologic Survey on Alcohol and Related Conditions. *Arch Gen Psychiatry* 61(8):807–816. doi:10.1001/archpsyc.61.8.807.

18. Rich, J.S. & Martin, P.R. (2014). Co-occurring psychiatric disorders and alcoholism. *Handbook of Clinical Neurology, Alcohol and the Nervous System. 125,* Ch. 33., (pp. 573-588). EV Sullivan and A. Pfefferbaum Eds. Elsevier, Philadelphia.

19. Substance Abuse and Mental Health Services Administration (SAMHSA). Treating concurrent substance use among adults (Evidence-based resource guide

series). 4-5. https://store.samhsa.gov/sites/default/files/SAMHSA_Digital_Download/PEP21-06-02-002.pdf. Retrieved, December 28, 2022.

20. Finn, S.W., Mejldal, A. & Nielsen, A.S (2023). Public stigma and treatment preferences for alcohol use disorders. *BMC Health Serv Res 23*, 76 (2023). https://doi.org/10.1186/s12913-023-09037-y.

21. National Institute on Alcohol Abuse and Alcoholism. *Alcohol Facts and Statistics*. https://www.niaaa.nih.gov/publications/brochures-and-fact-sheets/alcohol-facts-and-statistics. Retrieved December 27, 2022.

22. National Institute on Alcohol Abuse and Alcoholism. Alcohol Use Disorder: *A Comparison Between DSM-IV and DSM-5*. https://www.niaaa.nih.gov/sites/default/files/ publications/AUD-A-Comparison.pdf. Retrieved August 20, 2023.

23. American Psychiatric Association (2013). *Diagnostic and statistical manual of mental disorders: DSM-5*. American Psychiatric Association, Washington, D.C.

24. Alcohol and the Human Body. https://www.intox.com/physiology/. Retrieved August 20, 2023.

25. McDonell, M.G., Skalisky J., Leickly E., et al. (2015). Using ethyl glucuronide in urine to detect light and heavy drinking in alcohol dependent outpatients. *Drug and alcohol dependence 157*: 184-187. doi:10.1016/j.drugalcdep.2015.10.004.

26. Walker L. (n.d.). What is a functional alcoholic? Signs of high-functioning alcoholism. American Addiction Centers. September 14, 2022.

27. Benton, S.A. (2009). Understanding the high-functioning alcoholic: Professional views and personal insights. Praeger Publishers, Westport, CT.

28. Centers for Disease Control and Prevention. What is Excessive Alcohol Use? https://www.cdc.gov/alcohol/onlinemedia/infographics/excessive-alcohol-use.html. Retrieved August 26, 2023.

29. National Institute on Alcohol Abuse and Alcoholism. Alcohol's Effects on Health: Drinking levels defined. https:// www.niaaa.nih.gov/ alcohol-health/overview-alcohol-consumption/moderate-binge-drinking. Retrieved August 23, 2023.

30. Reilly, MT., Noronha, A, Warren, K. (2014). Perspectives on the neuroscience of alcohol from the National Institute on Alcohol Abuse and Alcoholism. *Handbook of Clinical Neurology* vol 125: Alcohol and the Nervous System. Ch. 2, (pp. 15-29). EV Sullivan and A. Pfefferbaum Eds. Elsevier, Philadelphia.

31. Yang, W., Rohit, S., Oshin, M., et al. (2022). Alcohol Use Disorder: Neurobiology and Therapeutics. *Biomedicines 10*, no. 5: 1192. https://doi.org/10.3390/biomedicines10051192

32. Koob, G. F. (2014). Neurocircuitry of alcohol addiction: synthesis from animal models. In E. V. Sullivan & A. Pfefferbaum (Eds.), *Alcohol and the Nervous System 125*, 33-52. Elsevier, Philadelphia.

33. Moeller, F. G., Barratt, E. S., Dougherty, D. M., et al. (2001). Psychiatric aspects of impulsivity. The American Journal of Psychiatry, 158, 1783-1793.

34. Rahman, A., and Paul, M. Delirium Tremens [Updated 2023 Aug 14]. In: StatPearls [Internet]. Treasure Island (FL): StatPearls Publishing; 2023 Jan-. Available from: https://www.ncbi.nlm.nih.gov/books/NBK482134/.

APPENDIX C – TUBERCULOUS MENINGITIS

1. James, J. Central Nervous System Tuberculosis - The Gray Area in Tuberculosis Treatment. J Neurosci Rural Pract. 2019 Jan-Mar;10(1):6-7. doi: 10.4103/jnrp.jnrp_229_18. PMID: 30765962; PMCID: PMC6337993.

2. Thakur, K., Das, M., Dooley., K, Gupta, A. (2018). The global neurological burden of tuberculosis. *Semin Neurol* 38:226–237.

3. Manyelo, C.M., Solomons, R.S., Walzl, G., Chegou, N.N. Tuberculous Meningitis: Pathogenesis, Immune Responses, Diagnostic Challenges, and the Potential of Biomarker-Based Approaches. *J Clin Microbiol*. 2021 Feb 18;59(3):e01771-20. doi: 10.1128/JCM.01771-20. PMID: 33087432; PMCID: PMC8106718.

4. The Glasgow Coma Score objectively describes the extent of impaired consciousness in all types of acute medical and trauma patients. The score assesses eye-opening (scored 1-4), motor (scored 1-5), and verbal responses (scored 1-6). Increased severity is signaled by low scores in each of the aspects of responsiveness and on the total score (scored 3-15).

5. Center for Disease Control. (n.d.). Glasgow Coma Scale Score. Retrieved from https://www.cdc.gov/masstrauma/resources/gcs.pdf.

6. Chin, J. H. (2014). Tuberculous meningitis: Diagnostic and therapeutic challenges. *Neurol Clin Pract*, 4(3), 199-205. doi: 10.1212/CPJ.0000000000000023.

7. Sher, K., Abbasi, A., Bullo, N., & Kumar, S. (2013). Stages of tuberculous meningitis: a clinicoradiologic analysis. *Journal of College of Physicians and Surgeons Pakistan*, 23, 405-408.

8. Merkler, A. E., Reynolds, A. S., Gialdini, G., Morris, N. A., Murthy, S. B., Thakur, K., & Kamel, H. (2017). Neurological complications after tuberculous meningitis in a multi-state cohort in the United States. *Journal of Neurology Sciences*, 375, 460-463. doi: 10.1016/j.jns.2017.02.051

9. Mezochow, A., Thakur, K., & Vinnard, C. (2017). Tuberculous Meningitis in Children and Adults: New Insights for an Ancient Foe. *Current Neurology and Neuroscience Reports*, 17, 85. doi: 10.1007/s11910-017-0796-0.

§

INDEX

Index

Index

Index

ABOUT THE AUTHOR

Dr. HENRI COLT has worked for over three decades caring for critically ill and terminally ill patients. He is an Emeritus Professor of Pulmonary Medicine at the University of California and an international scholar. He has lectured on six continents about lung disease and emotional issues surrounding death and dying. He is also an award-winning medical educator, Pushcart Prize-nominated author, and philosophical practi-tioner. Dr. Colt grew up the son of a French-North African father and German mother, with his childhood years spent in New York and his teens in France. There, he discovered museums and galleries throughout Europe and developed his love for art, literature, philosophy, and science. Today, he lives in Laguna Beach California and Southern France.

§

talk about the
reasons for
underdrawing some
of his paintings — was
it merely cost saving issue?

Jacques Lipchitz, in
Amadeo Modigliani (1954)
writes that he always
associated M. with poetry.
It was Max Brody who introduced
L. to M. & somehow L. often
associated M.'s recitation of
the Divine Comedy w/ the atrocious
suffering (death) of Max Jacob in
concentration camp. In L.'s
words, M. knew what it was to
suffer too. Do you see suffering +
poetry in M.'s work?

I want to focus on his art not on his physical ailments though recognizing that they affected his art

What are the most significant characteristics of his personality that attracted you to write about him?

4 major ways of his ailments affecting his art

Why him? Just be it TB? But there were many others affected by TB. It has to be more than that.

The discussion about his drinking seem to be tentative — some accounts were strongly arguing for him having this destructive habit (plus hashish & other substances), other accounts seem to either refute it or claim not being aware. What was your final take on this & how important was it for you to your final account of M.? How does it, or

does not, relate to his
talent? In a similar vein,
• How important was it to
address his sexual
overtures? But also the
fact that he remained
"monogamously" incommitted?
(and also equally to acknowledge
his son, if this was actually
true (p 71). • Beatrice
• Jeanne
• What additional light does
his relationship (and then
"unrelationship") w/ Simone
shed on his personality,
but also his art? (thd
• Who was his largest influence
(among women) + why? What
were personality traits that
attracted him the most in
his partners? And again, how
does reflect on his art?
• The place/role/influence/
relationship w/ his mother—
most significant moments?
effect on his art?

Made in the USA
Columbia, SC
29 June 2024